How New York Stole the Idea of Modern Art

How New York Stole the Idea of Modern Art

Abstract Expressionism, Freedom, and the Cold War

SERGE GUILBAUT

Translated by Arthur Goldhammer

The University of Chicago Press
Chicago and London

The University of Chicago Press, Chicago 60637
The University of Chicago Press, Ltd., London

Library of Congress Cataloging in Publication Data

Guilbaut, Serge.
 How New York stole the idea of modern art.

 Bibliography: p.
 Includes index.
 1. New York School. 2. Abstract expressionism—
United States. 3. Avant-garde (Aesthetics)—History—
20th century—United States. 4. Art and society—United
States. I. Title.
N6512.5.N4G84 1983 709'.747'1 83-6506
ISBN 0-226-31038-8 (cloth)
ISBN 0-226-31039-6 (paper)

To Tom, Tim, Tom, and Carol

Contents

Acknowledgments

This book was researched and written while I was at U.C.L.A. during the period 1975–78. My experience there, compared to my tame life in French academia, was extraordinary and exhilarating. Thanks to the critical atmosphere and high level of discourse among students and faculty, on theoretical issues as well as their practical implementation, art history finally became alive and relevant. This book is the result of exhausting but stimulating conflicts.

All along, Timothy J. Clark has been for me the intellectual, the historian, and the theoretician who has most to offer. His scholarship and friendship have been invaluable for the completion of this work. My thanks also to Thomas Crow, who read and criticized parts of the manuscript. With Tom Cummins, Holly Clayson, and Carol Knicely, he was part of the incessant critical barrage I had to respond to while at U.C.L.A. I am grateful to Albert Boime, Arnold Rubin, and David Kunzle, who read and commented on the final product, to Carol Duncan for her continual encouragement, and to O. K. Werckmeister for his critical scepticism.

The recollections of individuals who participated in the events analyzed in the book were extremely fruitful. For their kindness, I would like to thank Stephen Browne, Oscar Collier, Clement Greenberg, Sidney Janis, Reuben Kaddish, Lester Longman, Charles Pollock, and Jack Tworkov. I want to express my special thanks to Betty Parsons, who opened her business files for me and who was extremely understanding and helpful, and to Rosalind Bengelsdorf Browne, who spent hours discussing with brilliance the aesthetic and political complexities of the 1940s.

Financial aid from several sources made this volume possible: the U.C.L.A. Dickson fellowship and a grant from the Social Sciences and Humanities Research Council of Canada as administered through the

University of British Columbia. Research in Paris and New York was made possible thanks to a Fulbright travel grant and through a Rockefeller travel grant for American Studies.

The Archives of American Art provided most of the exciting original documents used in the book; the staff and the Washington officer, Garnett McCoy, were most helpful. While I was doing research in Washington, D.C., Paul and Cheryl Douglass were always there to provide warmth and friendship.

I finally want to thank Henri Guilbaut who read and reread the manuscript with a professional eye and Luis Gomez for the chance to explore his exceptional collection of rare French avant-garde magazines.

Introduction

Ideally, the film theorist should be someone who both likes and dislikes the cinema. Someone who once loved film but who has stopped loving it in order to approach it from another angle, making cinema the object of the same visual instinct that had once made him a fan. Someone who has broken off his affair with the movies as people sometimes break off love affairs, not to take a new lover but to dwell upon the old one from a more elevated position. Someone who has incorporated the cinema into his own psyche, so that it is susceptible to self-analysis, but incoporated it as a distinct organism rather than an affliction of the Ego, an infection that paralyzes the rest of the self in a thousand tender and undemanding ways. Someone who has not forgotten what being a fan was like, with all its emotional vicissitudes and palpable immediacy, and yet who is no longer overwhelmed by those memories. Someone who has not allowed his past to give him the slip but who keeps it under close watch. To be and not to be: ultimately, in order to speak, one must both be and not be involved.
—CHRISTIAN METZ, LE SIGNIFIANT IMAGINAIRE

After the Second World War, the art world witnessed the birth and development of an American avant-garde, which in the space of a few years succeeded in shifting the cultural center of the West from Paris to New York. The purpose of this book is to investigate the history and significance of the dominant style of that avant-garde: abstract expressionism.

Until now, most studies of the art of this period have dealt with either the aesthetics of action (Margit Rowell, Harold Rosenberg) or the formal qualities of the work, focusing exclusively on the medium and stylistic influences (Clement Greenberg, William Rubin, Michael Fried, Irving

Sandler). By contrast, I examine the political and cultural implications of the period. My central thesis is that the unprecedented national and international success of an American avant-garde was due not solely to aesthetic and stylistic considerations, as both European and American commentators frequently still maintain,[1] but also, even more, to the movement's ideological resonance.

This book is a social study of abstract expressionism which attempts to grasp the reasons American avant-garde art took the abstract form that it did as well as the reasons that form proved so successful. The answers to these questions are complex, yet I believe that they stand out clearly once the works and the writings of the painters involved are set against the historical and economic background. Restoring the context of the movement in this way will, I trust, expose the emptiness of the traditional claim that postwar abstract expressionist art achieved dominance solely because of its formal superiority.

Prominent among the factors that helped to shape abstract expressionism and ensure its success was the slow process of de-Marxization and later depoliticization of certain groups of left-wing anti-Stalinist intellectuals in New York from 1939 on, coupled with the rapid rise of nationalist sentiment during the war. Later, as the Cold War intensified and the Marshall Plan finally won congressional approval, a wealthy and powerful middle class consolidated its position: these circumstances also play an important part in our story.

By looking at primary sources and well-known critical writings in the context of the history of the Cold War, I hope to shed light on the motives that drove abstract expressionist artists to elaborate a style equally aloof from the right and the left. This plastic style, in dialogue with European tradition, helped to forge a native image of American art that responded to the cultural needs of the new United States that emerged from World War II.

I reconstruct the slow process by which the emerging avant-garde elaborated, in 1947 and 1948, a new ideology in tandem with a new mode of pictorial production. Fluid at first, ideology and style both solidified quickly. Although their common source was left-wing anti-Stalinism, they succeeded in establishing a "third way," abstract and expressionist, that was said to avoid extremes both left and right, that was, or so it was claimed at the time, both liberated and liberating.

The new form did of course enter into dialogue with the modernist tradition, but more than that it seems to have provided a way for avant-garde artists to preserve their sense of social "commitment" (so important to artists of the Depression generation) while eschewing the art of propaganda and illustration. It was in a sense a political apoliticism. The purpose of this book is to focus attention on this game of concealment.

It is not my intention to impute to the artists of the avant-garde any precise political motive or to suggest that their actions were the product of some sort of conspiracy. What I argue is this: that from compromise to compromise, refusal to refusal, adjustment to adjustment, the rebellion of the artists, born of frustrations within the left, gradually changed its significance until ultimately it came to represent the values of the majority, but in a way (continuing the modernist tradition) that only a minority was capable of understanding. The ideology of the avant-garde was ironically made to coincide with what was becoming the dominant ideology, that embodied in Arthur Schlesinger, Jr.'s, book *The Vital Center* (though this change was not without problems for the artists involved).

The subject is of course not a new one. What I propose to do here, however, is to take a fresh look at an artistic movement and a style that have all too often been studied in isolation from the historical circumstances in which they were born. The task I have set myself is not a simple one, if only because this was the first time in American cultural history that a far-reaching avant-garde movement achieved such stunning success—particularly stunning in light of the difficulties that had always prevented modernism from gaining much of a foothold on the American cultural scene.[2]

I consider such matters as the nature of the New York avant-garde "phenomenon," the aims of the avant-garde, its function, its ideology, and its achievements. Another important and equally complex question addressed is this: Why did so many painters switch from doing realistic propaganda pictures in the thirties (whether of revolutionary, liberal, or reactionary inspiration) to painting in a resolutely avant-garde manner in later years?[3]

Avant-garde art succeeded because the work and the ideology that supported it, articulated in the painters' writings as well as conveyed in images, coincided fairly closely with the ideology that came to dominate American political life after the 1948 presidential elections. This was the "new liberalism" set forth by Schlesinger in *The Vital Center,* an ideology that, unlike the ideologies of the conservative right and the Communist left, not only made room for avant-garde dissidence but accorded to such dissidence a position of paramount importance.

To avoid misunderstanding, it is worth pointing out explicitly that the triumph of the avant-garde was neither a total victory nor a popular one, but rather a typically avant-garde victory, that is to say, fragile and ambiguous, since it was constantly threatened by opposing tendencies in the world of art. As a consequence, controversial avant-garde art became all the more precious a commodity after the United States entered the stifling period of McCarthyism.

There is no paradox in speaking of a victory of abstract expressionism as early as 1948, even if the avant-garde was then under attack from all sides, from the left, from the right, from the populists, and even from President Truman himself. This is where the true force of the historical contradiction comes into play. Truman, the "new liberal," reacted to modern art as the "last of the Donderoes" (George Dondero was the notorious senator from Michigan who made the equation "modern art equals communism" famous), but under his administration the United States Information Service and the Museum of Modern Art began, as early as 1947, to promote avant-garde art.

This divergence illustrates the degree to which culture had become politicized and important in a world sharply divided between the forces of good and the forces of evil, as the president intimated in a radio speech on March 17, 1948: "We must not be confused about the issue which confronts the world today—it is tyranny against freedom. . . . Even worse, communism denies the very existence of God."[4] On April 4 of the same year the president recorded in his diary, in an indirect but vigorous appraisal of modern art, his conviction that art was not innocent, that it was, in this period of intense psychological warfare, imbued with politics. And yet for him the new image of America as a cultural leader, so important for certain leading officials in his own government, made no sense:

> Took a walk at 10 A.M. Went to the Mellon Gallery and succeeded in getting the watchman on duty to let me in. Looked at the old Masters found in salt mine in Germany. Some very well-known paintings by Holbein, Franz Hals, Rubens, Rembrandt and others. It is a pleasure to look at perfection and then think of the lazy, nutty moderns. It is like comparing Christ with Lenin. May there be another awakening. We need an Isaiah, John the Baptist, Martin Luther—may he come soon.[5]

Pollock, Rothko, and Newman were not the prophets the president was looking for. Their recognition had to come from the Museum of Modern Art instead. This contradiction is among those that form the substance of this book.

If it is important to explain how and why the avant-garde conquered the domestic art market in the United States and appropriated the image of cultural leadership, it is equally important to analyze the role that the avant-garde played internationally and above all to comprehend the antagonistic relationship it maintained, often in spite of itself, with Paris.

Why Paris? Because, notwithstanding the ravages of war, Parisian art still represented Western culture and for New York artists was a taproot of modernist thought. For this reason I have attempted throughout this

study to bring out the links between what was going on in New York and what was going on in Paris.

In the immediate postwar period, Paris refused to see the radical changes that were affecting economic and artistic relations between Europe and the United States. When New York, through its spokesman Clement Greenberg, declared that it had at last achieved international status as a cultural center and even replaced Paris as the cultural symbol of the Western world, the French capital was not strong enough, either economically or politically, to protest. Momentum was all that Paris had going for it. It could do no more than try to ignore the onslaught, which it did with insouciant disdain. This self-satisfied do-nothingism, due only in part to the extreme political divisions within the art world, hastened Paris's downfall and put the Parisian muse to sleep until it was abruptly reawakened in the nineteen-sixties, when French collectors began to look overseas to fill their orders, as Pierre Cabanne explains:

> The France of the *prix de Rome*, the Institut, the *salon d'automne*, the France of conservators more interested in retirement than in finds, the France of ministerial flunkies—the whole free-masonry of paralysis and fear made its choice to stick with the stagnant conformism of the good old Ecole de Paris. What Sleeping Beauty needs now is not Prince Charming but a good, hard kick in the ass.[6]

France, which had lost nearly everything in the war—some said even her honor—set about holding on to what the entire world had for centuries recognized as hers: cultural hegemony. Hence for the United States to shift the center of artistic creation from Paris to New York was no mean undertaking.

My story ends in 1951, the year in which the New York avant-garde community organized the so-called Ninth Street Show, the symbol of both the triumph and the decadence of the avant-garde (some of the movement's best-known artists did not participate).[7] New York was confidently making ready to demolish Paris's ancient dreams, an American cultural wave was about to wash over Europe, at a time when the bellow of political propaganda had become deafening.

Why have I thought it necessary to take a fresh look at a subject studied so many times before? In part because the idealist notion that the victory of an American super-avant-garde, supposedly the last link in the modernist chain, was inevitable is current even now and in large part still informs the latest artistic strategies, both American and European.[8] In part too because no true critical history of this period exists that analyzes art in relation to the social and political factors that enter into aesthetic production.

The reader may have the impression that, because a number of works have been devoted to the history of the New York school, the history of this avant-garde has been written. It hasn't. Only the triumph of abstract expressionist art has been trumpeted. From Sam Hunter's *Modern American Painting and Sculpture* (1959) to Barbara Rose's *American Art since 1900* (1967) to Irving Sandler's *Triumph of American Painting* (1970), we have been treated to one positive, heroic, and optimistic account after another, in works reminiscent of the kind of history that used to be taught in high schools, recounting a dreary succession of battles won and lost.

As though in confirmation of my charge, Irving Sandler in his introduction states the hope that his work will embody Woodrow Wilson's conception of the historian as one who writes with "the sympathy of a man who stands in the midst and sees like one within, not like one without, like a native, not like an alien."[9] It goes without saying, I should think, that my own conception of the historian is diametrically opposed to this idealist definition. All the edifying and positive accounts of American art in these crucial years ultimately obscure what was alive, real, and contradictory in the works of the artists themselves. My own work is in one sense an attempt to incorporate the "negative" into the story, in the sense explained by Georges Duby:

> Part of what remains of the lives of men of the past is discourse, in both written and plastic form. The most startling discoveries that remain to be made, I think, will come from the attempt to find out what was left out of this discourse, whether voluntarily or involuntarily, to determine what was hidden, consciously or unconsciously.
>
> What we need are new scholarly tools, tools better adapted than those we now have to bringing out the negative in what we are shown, to laying bare the things that men deliberately cover up. At times these suddenly reveal themselves quite by accident, but most of the time they must be carefully deciphered between the lines of what is actually said.[10]

Because of the lack of critical analysis of the ideology that underlies the images and texts produced in this period, the supremacy of the new American art is often regarded as an ineluctable fact, almost a divine ordinance; its causes are not analyzed. The accounts of the past are constructed out of facts gathered with the express purpose of bolstering this proposition, whose truth has become axiomatic. The accent is placed on the idea that New York art was crucial to the further development of all art the world over and, further, that it somehow emerged from the final phase of the long march toward a purified modern art. These histories of course subscribe to the formalist analysis proposed by Alfred

Barr of New York's Museum of Modern Art, an analysis championed by Clement Greenberg throughout his career.[11]

The most popular treatment of the subject, widely regarded as authoritative, is Sandler's *Triumph of American Painting*.[12] This work discusses the output of each avant-garde artist in a formal way, classifying each work as an example of either "Action Painting" or "Color Field Painting." Two chapters are devoted to the "milieu," to the artistic environment in which the painters developed. Not once in his book, whose title is so revealing, does Sandler attempt to give a critical analysis of the documents at his disposal, of the conceptual systems of the artists he is describing, or of the function of the avant-garde itself. He ignores the ideological content of the signs he is manipulating. His analysis is flat and ahistorical, particularly in his confusing use of written documents, interviews, and critical reviews without systematic regard to chronology, which robs the discussion of all historical significance. He is moved by a desire to simplify and classify, to substitute a simple pattern for the incoherent jumble of disputes that erupted in the art world after the war, as political, economic, social, ideological, and symbolic systems collapsed all around. All the complexities are swept under the rug. The image thus constructed is appropriately clinical and statistical but false on account of what it sets aside, what it leaves out.

This isolated account (the history of a certain group of New York artists during a circumscribed period of time) gives the impression that Irving Sandler has, despite his vast knowledge, been content merely to describe the visible surface of things, refusing to explain or to analyze the subterranean rumors, protests, and frictions that tell us that something else is going on, something that is the real heart of the matter. Yet, as focused on the surface as Sandler invariably is, he lets slip a few words that reveal the hidden progress of another story, of history itself, even if history as such is constantly repressed, excluded from an account steadfastly determined to put a bright face on things. All but overwhelmed by the weight of the text, revealing words like "world war" and "cold war" occasionally slip through.

Only the history of the victors has no depth, as though it unfolded without any connection to the complexity of the living world from which art criticism and the museums have uprooted it. It is because Sandler's book is one-dimensional that it smacks of propaganda:

> The emphatic effort of the art historian towards his object often turns him—despite all technical sophistication in "reading" the work—into an uncritical admirer.[13]

And yet Sandler makes use of history in the first chapter of his book, in which he briefly describes the aesthetic problems raised by the Depres-

sion. This was a troubled time, during which political discussion took on such importance among artists that it becomes impossible for the historian to ignore. But Sandler mentions the history of this period only in order to draw a distinction between the art of the thirties and the art of the postwar period. Because the latter avoided any direct transposition of political issues and ideologies into art, it was able, so it seems to Sandler, to attain international status on a footing of equality with earlier modern art. Although he concedes that "political events strongly influenced the development of American art in the early 40's," he does not discuss what the importance of politics was. The rest of the book is virtually silent as to the relationship between the avant-garde and the outside world.

The elements of this kind of art history are familiar: detailed chronology, distribution of prizes (who did what first), study of influences, classification, group apologia, and hagiography. The cumulative effect of this fragmentation of history is descriptive, that is to say, de-scriptive: it is a way of demolishing history, of undoing it, of eliminating even the possibility of grasping the complex, fragile fabric of a society torn by war and in the process of knitting itself back together as best it could.

A whole social structure had been pulled down, political life had been reoriented from top to bottom, and intellectual life had been blown to bits. The cultural history of the postwar period is the history of the reconstruction of American culture on new foundations laid by changes in the world economy in general and the American economy in particular. It is the history of a transvaluation of social values, a reevaluation of cultural signs. How, then, can we write cultural history and say nothing of the broader history that informed it and was informed by it? The history of American art can be written only if society is not divided up into isolated cells, only if the mediations among social, economic, cultural, and symbolic facts are not obliterated.

It therefore becomes important not to despise or neglect the false paths taken, the forgotten artists, the rejected works that illuminate the picture from the other side and give it relief. To look in this way at many objects is not to fragment the field of research but rather to delimit it, to focus the investigation, to sharpen the definition of the object of study so that it can be subjected to detailed scrutiny.

It should be noted, moreover, that in recent years a number of works have appeared that in one degree or another bear witness to efforts to achieve a more critical understanding of this period: I am thinking of works by Dore Ashton, Max Kozloff, Eva Cockcroft, Jane de Hart Mathews, David and Cecile Shapiro, and, in France, Jean Laude.[14] I am therefore not the first or the only writer to criticize what can only be called the "establishment" in the history of American modern art. Indeed, the

establishment has not been humming along as smoothly during the past five years as it once did, in the face of a critical onslaught mounted largely by sociologists and historians determined to see art in its original context and to reestablish the link between art and politics, particularly between abstract art and the ideology of the Cold War. But these few voices have cried in the wilderness, all but drowned out by an endless cacophony of articles devoted to breathless discussions of stylistic influences on this or that artist extending back to the beginning of time. These articles are often the end product of theses written by students too wise to contradict the miles of pages filled by the friends, promoters, and admirers of the abstract expressionist artists, such as Clement Greenberg, Harold Rosenberg, Thomas B. Hess, Rudy Blesh, and Frank O'Hara, to name a few. This is the tragedy of American modern art history. Early polemical texts by the critics and interviews with artists, originally fired as shots in the battle of the avant-garde, have over the years acquired an unassailable sacred status. They are endlessly adapted, absorbed, combined, and served up time and time again. Ritual repetition has finally made them untouchable.

Dore Ashton's *The New York School: A Cultural Reckoning* does not avoid this pitfall, though Ashton does subscribe to the notion that an artist is rooted in his environment. Unfortunately she covers enormous ground (treating not only art but also philosophy, music, etc., from the thirties to the sixties). She mixes in anecdotes and miscellaneous facts and jumps about from, say, a likely literary influence on some painting to the presumed important impact of a piece of music on New York art in general. The facts, relationships, and tensions that constitute the cultural reality of the forties are buried beneath an avalanche of separate histories classified by theme, with the result that the chronological sequence is lost and along with it the only chance of really studying the relationship between the avant-garde and the milieu within which it evolved (or as Ashton says, the compost that makes the flower grow [p. 2]).

Following the example of Max Kozloff and Eva Cockroft, who published two attention-getting articles on the relations between art and politics in *Artforum* in 1973 and 1974, the historian Jane de Hart Mathews looked at the problems encountered by modern art in the United States during the McCarthy era. But like the two articles on which she patterned her work, Mathews explored a period during which art and politics were closely associated, when the links between the two were clearly visible and openly discussed and therefore hard to miss.[15]

It is not only in the United States that our subject has thus far proved impervious to critical scrutiny. French criticism, which since the sixties has striven to understand the reasons for the collapse of French cultural hegemony, has apparently been too fascinated by this period in the

history of American art to analyze the situation with the necessary critical eye. The leading French expert on American art, Marcelin Pleynet, has laced his numerous writings with the same old mythical figures, borrowed from American authors with little or no French readership.[16]

Jean Laude, no blind believer in the sanctity of either the avant-garde or the United States, has similarly proved unable to penetrate the smokescreen. Though he has made some efforts to analyze artistic facts in the light of history, he has been stymied by the ideological opacity of the secondary sources on which he relies. These reproduce the same liberal ideology criticized above. So Laude is caught in a vicious circle. The only way to break the circle is to be willing to undertake extensive work in the archives and to broaden the debate by looking at ways of thinking and writing about art other than those that dominated the scene at the time the avant-garde was being shaped.

Despite these timid attempts to modify the received view and to introduce an element of dialectic into the field of study, the demons have not yet been exorcised, as we can see by looking at the work done by Robert Hobbs and Gail Levine in organizing the 1978 New York show "Abstract Expressionism: The Formative Years."[17] Undaunted by the tediousness of their efforts, these two scholars focused attention on the same cast of characters and retold the same old story one more time, the only difference this time being that they provide even more detail than their predecessors with respect to dates, stylistic influences, and sequences of events. Indeed, the degree of detail and the volume of minutiae here reach nightmarish proportions.

In contrast to Gail Levine's simplistic "studies," Robert Hobbs's work attempts to shed new light on certain aspects of the artists' work. But his project was from the beginning flawed because its underlying idea was not to understand why these artists, now regarded as heros, succeeded where others failed, why precisely these aspirants to immortality stood out from the mass of unsuccessful candidates for posterity's attention, but rather to uncover as many early works, as many heroic but still stumbling efforts as possible, in order to reinforce the reigning mythology.[18] Wouldn't it have been more important to look at these works alongside others that shared the New York limelight at the time, sometimes even outshining the works of painters who later proved more successful? What has become of all the Byron Brownes, the Carl Holtys, the Karl Knaths, the Balcomb Greenes, and Charles Seligers? Once again abstract expressionism was sealed inside a belljar and protected from infection by any unwanted germs, from intrusion by any outsiders who might disturb the cherished harmony. Now museum pieces, the works featured in this kind of show have been labeled "Look but do not touch."

A brief look at the two articles published in *Artforum* by Kozloff and Cockcroft will help to clarify why in planning this work I chose the chronological and conceptual limits that I did. These two articles relate

information which, though never really hidden from view, has only recently been discovered by certain art historians: namely, the fact that abstract expressionism was used as a propaganda weapon during the Cold War. Because of avant-garde art's self-proclaimed neutrality, it was soon enlisted by governmental agencies and private organizations in the fight against Soviet cultural expansion. Though this fact was openly discussed during the fifties in the press and privately among artists, it has only recently been brought back into the limelight by Max Kozloff, whose article has the merit of viewing the supremacy of American art in a political context. Kozloff reminds us that art historians too suffer from what Russell Jacoby has called "social amnesia."[19] This amnesia was of course due in part to self-imposed censorship in response to the trauma of the McCarthy era.[20]

Eva Cockcroft raised, I think, the crucial questions when she wrote the following:

To understand why a particular art movement becomes successful under a given set of historical circumstances requires an examination of the specifics of patronage and the ideological needs of the powerful.[21]

But her study looks only at the triumphant years of abstract expressionism and the Museum of Modern Art, the nineteen-fifties.

Chronologically my work ends where Kozloff and Cockcroft begin, but conceptually I begin where they end. I dwell on the "apolitical" years sandwiched between two periods when art was directly and overtly associated with politics, on the years between the "social art" of the Depression and the use of abstract expressionism as propaganda in the fifties. It is to the silent interval from 1946 until 1951 that I wish to speak. The silence, moreover, is merely illusory: one has only to listen attentively for it to shatter.

In the hope of unraveling the complex web of relations between art and society, I look at the dating of various paintings and related texts, in the belief that their meaning remains mysterious and mystifying until they are seen against the background of events. In particular, I look at the writings and paintings of Barnett Newman, Mark Rothko, Adolph Gottlieb, and Jackson Pollock, and at the avant-garde's 1947–48 decision to abandon representative painting.[22] This will make it clear why a detailed knowledge of the history of the Cold War is crucial for understanding our subject and decisive for the analysis of the movement's artistic style.

It is scarcely my intention to rewrite the history of the Cold War. This is much studied and much disputed terrain, and anyone who ventures onto it runs the risk of becoming lost in a quagmire. Nor do I wish to involve myself in the Manichaean dispute over which side "started" the

Cold War—the debate seems to me an artifact of the period itself. But I do want to make use of the work of other historians, particularly the so-called revisionists. Though some of their ideas are simplistic, in general they emphasize the artificial nature of certain political crises and the degree to which these crises influenced American culture and the American people. Since the power and impact of the mass hysteria that gripped the Western world between 1946 and 1950 are central themes in the work of the painters being studied here, the political strategies adopted by the government and analyzed by the revisionist historians turn out to be important for us to understand.

I am not interested in apportioning responsibility for the Cold War between Russia and the United States. What does interest me is the way in which the public reacted to the image of the Soviet threat forged by government and the media. Understanding this reaction is more important for my purposes than understanding the reality of the crisis. I should also add that, in my view, the work of the revisionist historians in the United States has led to a useful reappraisal of the history of the Cold War, while so far the art history of the same period has been immune to such reappraisal. In art, Arthur Schlesinger's upbeat ideology still reigns supreme.

My ambition, then, is to contribute to a similar reappraisal of the history of abstract expressionism, while remaining on guard against the dangers of oversimplification. By injecting art history with a dose of real history, I hope to restore the original complexity of the subject, where other historians have let themselves become bogged down in minutiae. I therefore have little to say about formal influences, which are not central to my subject and have already been treated adequately by others. Instead, I try to reestablish the often difficult dialogue between abstract expressionism and politics, a dialogue that went on continuously throughout the period I investigate.

Although I avoid thematic and biographical studies, which tend to sever the connection between art and history, it is by no means my intention to eliminate, isolate, or ignore the artist or producer. In part I hope to give a materialist history of the art of the New York school by analyzing changes in the nature of the art market. But I also pay close attention to the aspirations and the subjective experience of American modern artists as well as to their response to the brutality of the Cold War as it intruded upon every sphere of American society.

I am of course not unaware of the unpopularity of the kind of approach I am proposing. This has to do with resistance to the idea of dragging art's ideal values through the mud of politics and ideology. This is an objection that I merely shrug off, for I am convinced that, while such treatment may somewhat dim art's ethereal luster, this loss will be more than compensated by the gain in reality and truth. The process of cre-

ation will be laid bare and the artist shown once more at grips with difficult everyday realities, with the problems of symbolic creation. In a 1949 letter to Mark Rothko, Andreas Feininger alluded to the artist's difficulty in holding the quotidian at bay:

> Aren't we all being villainously cheated of the enjoyment of living nowadays under the present hysteria—and doesn't a chap need just to keep hard at work, in order to keep going?[23]

Furthermore, it is obvious, I think, that to attempt "revision" at a time when the political climate in America is conservative in the extreme, not unlike the climate of the fifties, will in all likelihood not prove very popular. The subject of the Cold War has always been an explosive one: witness the series of controversies that rocked the world of American culture during the seventies. Two examples from the *New York Times* will suffice to make clear how difficult it is to base a critical study on a discussion of art's social role, and in particular how difficult it is to study postwar American art from this standpoint.[24]

In response to an *Artforum* article by Carol Duncan criticizing the show "The Age of Revolution,"[25] Hilton Kramer, the *Times* art critic and normally a rather mellow writer, reacted with unusual vehemence: the issue was an important one. Duncan had maintained in her article that the show was conceived in a completely ahistorical and hence mystifying way—particularly galling for an exhibition of revolutionary art:

> One was left with the impression that artists were motivated primarily by the history of art and sought only to imitate older art. Politics and history were referred to only in blatantly propagandistic works that featured kings or the Emperor.[26]

Kramer responded in an article entitled "Muddled Marxism Replaces Criticism at *Artforum*." He took the opportunity to attack the editorial policy of *Artforum* and indirectly to blast Max Kozloff and John Coplans, who were attempting, without sacrificing their connections in the art market, to broaden the discussion of artistic production to embrace the social and political context in which particular works are created. After calling Carol Duncan a "Maoist," Kramer pinpoints the crucial issue facing any contemporary art magazine:

> This is a pretty good description of what *Artforum* itself is now up to, and it will be interesting to see how long the magazine's Bourgeois advertisers—mainly art dealers plying a trade the magazine now seems to regard as a crime against humanity—will support its new line.[27]

Not very long, it seems, since Kozloff and his collaborators were in fact replaced a year and half later in a move to turn the magazine back toward a less dangerous formalism. What Hilton Kramer, joined by Robert Rosenblum, was attacking was the "deneutralization" of art, the unearthing of its roots, the laying bare of its hidden mechanisms and contradictions.

If, as must be apparent from the foregoing, it is difficult to "deneutralize" art, it is even more difficult to discuss the Cold War, which arouses passions that might have been thought extinguished. A second example gives proof of this assertion. With the release of several books and films dealing with this controversial period in American domestic politics, it was again Hilton Kramer, again using the *New York Times* (October 1976) as his forum, who revived an argument similar to one used twenty years earlier in support of the bill establishing the House Unamerican Activities Committee. Kramer attempted to discredit those who defended the "revisionist" historians. For a week the newspaper was flooded with letters in a mini-wave of hysteria reminiscent of the outbursts of the postwar years. It is, it seems, in bad taste to treat certain taboo subjects that slumber in the depths of consciousness, noxious subjects about which well-bred people avoid asking questions.

My work aims at the place where all these problems come together. I hope to fill a gap that has been noticed by a number of scholars. In a 1980 catalog of Pollock drawings, for example, Bernice Rose wrote:

> The question then is how, against the provincial background of America, and given American art as it existed up until 1946–47, it became possible to achieve such a radical transformation—not only of art itself but of the American role in art; how it was possible not only to join "the mainstream" but to go beyond it and to revolutionize it. Any explanation must consider the social and the political context and relevance of Pollock's subject matter, particularly as it addresses claims to the universality of individual experience. Here speculations must center on Pollock's subject as it is transformed from the figurative "American scene" and the symbolical/mythological and narrative images of the thirties and forties to the subjective and abstraction of his mature work, with its claims to universality—to "mirror the experience of our age"—and in what way it reflects society in general and American society in particular. This is a complex issue arising out of the peculiar set of conditions in America at the time, among them the political and social experiences of the Depression, and the isolation from the European scene and the actual theatre of the Second World War.[28]

Although I reject the idea expressed here that art automatically "reflects" society, these are the questions that I hope to be able to answer

in the pages that follow. Only when answers have been found can we begin to understand why it was no longer possible to say by 1948, as people had joked until then, that "America is the only country in the world that's gone from barbarism to decadence without being civilized in the meantime."[29]

1
New York, 1935—1941:
The De-Marxization
of the Intelligentsia

Some day it will have to be told how anti-Stalinism which started out more or less as Trotskyism turned into art for art's sake, and thereby cleared the way, heroically, for what was to come.

<div align="right">CLEMENT GREENBERG</div>

The Seventh Congress of the Komintern was held in Moscow from July 25 to August 20, 1935. During this congress Georgy Dimitrov set forth the tactics that were to be used to bring about the final defeat of fascist forces the world over. The strategy that Dimitrov expounded was based on class collaboration, on an international alliance of intellectuals, and on the integration, for tactical purposes, of liberals into the ranks of the revolutionaries; it was dubbed the strategy of the "Popular Front." Among other things, it attempted to accredit the myth that antifascist organizations in all parts of the world were in agreement as to the line to be followed, the myth of an idyllic alliance of men of good will united by their opposition to fascism. The organization of the Popular Front was supposed to eliminate all differences of opinion and sources of conflict among the various antifascist groups. At any rate, these differences would henceforth be kept quiet or swept under the rug for the good of the common cause.

To succeed in this, however, the Popular Front would have to attract prestigious figures, well-known bourgeois artists and writers, in order to confront the enemy with a strong and credible image, the image of a united and dynamic front. In order to carry out this seduction of bourgeois personalities, the Communists were obliged to tone down certain slogans that had been central to their campaigns of the early thirties, especially their harsh and unrelenting attacks on the capitalist system. Of particular interest for our purposes was the Popular Front's

rehabilitation of the notion of culture that had been defended by the bourgeoisie against earlier Communist attacks. The value of culture was reaffirmed by the Communist party, which saw an opportunity to strengthen its hold on certain national political organizations while at the same time increasing the unity of the masses.[1] By defending the national cultural heritage, the revolutionary party was able to forge an alliance with the middle classes, which might otherwise have been susceptible to a similar culturally based appeal from the fascists. The proletariat was thus given the tricky role of saving national culture, which the decadent and dispirited bourgeoisie was incapable of protecting against "fascist barbarism." As Pierre Gaudibert points out in the case of the French Communist party, this strategy enabled the Party to move "from revolutionary defeatism to Joan of Arc, from the raised fist to the outstretched hand, from the nowhere-land of Esperanto to the new politics of the family; values, feelings, and symbols all changed."[2]

The French Communist party's sudden infatuation with bourgeois culture engendered an epic battle to determine whether communists or fascists would emerge as the sole defenders of French cultural values, to decide which party would have the privilege of waving the tricolor and singing the national anthem: "On the ideological front we have provided the working class with new weapons while boldly recapturing what our enemies had stolen and desecrated. We have recaptured the Marseillaise and the tricolor flag once flown by our forefathers, the soldiers of the year II."[3] By carrying on French tradition the French Communist party claimed to embody "the genius of France."[4]

In the United States communism claimed to be "20th century Americanism," and Earl Browder, the leader of the American Communist party, was serene in his assurance that "we are the only true Americans."[5] American Communists also made efforts to keep the center from drifting toward the right. As in France, the Communists hoped to reduce the confusion in which intellectuals were working by offering them a stable framework to which they could attach the energies unleashed by the crisis of capitalism and within which they could confine their disillusionment. The Popular Front was a haven in which progressive intellectuals could work in a communal spirit and even achieve a certain prestige (the ranks of the American Communist party swelled from 12,000 in 1929 to 100,000 in 1939). As Daniel Aaron has observed, the choice to be a Communist was at this time easy and rational:

> Now you could be for every kind of social reform, for the Soviet Union, for the Communist Party, for proletarian Literature—for everything and anything that was at one time radical, rebellious, subversive, revolutionary and downright quixotic—and in doing so you were on

the side of all the political angels of the day; you were on the side of the Roosevelt administration, on the side of Labor, the Negroes, the middle classes; on the side of Hitler's victims, on the side of all the oppressed colonial peoples in the world. In short, this is the only period in all the world's history when you could be at one and the same time an *ardent revolutionary* and an *arch-conservative* backed by the governments of the United States *and* the Soviet Union.[6]

For the first time in American history it seemed that writers, theater people, and painters were not out of step with society, that their social role was finally being recognized. The Popular Front in which the artist played a part in a sense represented the end of his alienation, the first step toward participation in and acceptance by society in its common endeavor.[7] Artists therefore no longer described themselves as revolutionaries, as they had been wont to do in the early thirties, but rather as "the guardians of liberal and democratic ideals."[8] The Communist party recognized the seriousness of the situation and preferred to lead the intellectuals rather than to attack them.

Even before the Popular Front line had been officially laid down by the Soviet Communist party, American intellectuals had held their own first congress in April 1935, dubbed the "First American Writers' Congress." According to the appeal made by the magazine *Partisan Review* and the Communist party, the purpose of this congress was to gather together all writers opposed to capitalism. It was designed to call attention to the experiments of revolutionary writers with proletarian literature. Although Earl Browder in his inaugural address evinced interest in a broad alliance of Communist and liberal intellectuals to fight against fascism, invitations were sent only to Communist writers, and the list of participants is a roster of the Party faithful.[9]

At almost the same time left-wing artists launched an appeal (in the autumn of 1935) modeled on that of the writers and calling for a congress to be held on February 14, 1936, in response to the Popular Front. The First American Artists' Congress met with an enthusiastic response. Participants were able to attend three full days of debates in two different locations (Town Hall and the New School of Social Research). Among the thirty-four speakers were Lewis Mumford, Stuart Davis, Rockwell Kent, George Biddle, and Meyer Schapiro. Three hundred sixty delegates from all over the country attended.[10] This congress, the first of its kind in the United States, was aligned with the politics of the Popular Front.[11]

The keynote was sounded by Lewis Mumford, a liberal writer, who stressed the catastrophic state of the world and thus the importance of such a gathering of artists, not only to enable them to defend themselves

collectively against the Depression but also in order to raise against fascism the challenge of the liberating force of artistic creation, so feared by authoritarian regimes:

They [dictators] fear them [artists] because they fear free criticism. They rightly believe that if the forces represented by the artist are allowed to exercise their will, they will disrupt the Fascist regime. The irrepressible impulse of Art may upset the whole Fascist program.[12]

Max Weber, one of the few modern artists working in the United States, emphasized, and not without some touches of humor, the tragic situation confronting artists in New York, who had to try to survive without the support of galleries in the face of art criticism of mediocre quality, presumably with the aid of personal contacts: "In the beginning of his or her career, the artist is advised to make connections. We keep on connecting all our lives, and in the end most of us find ourselves connected with the poor house."[13]

The secretary of the movement, Stuart Davis, gave a clear statement of the problem raised by the congress: How was needed social commentary to be integrated into modern painting? In "Why an Artists' Congress?" he pointed out that "increasingly, expression of social problems of the day in the new American art makes it clear that in times such as we are living in, few artists can honestly remain aloof, wrapped up in studio problems."[14] He forcefully stated the artist's need to inject his work into political debate and rejected, with occasional vehemence, the idea of the egocentric artist, as is attested by his having broken off a long-time friendship with Arshile Gorky: "I took the business as seriously as the serious situation demanded and devoted much time to the organizational work. Gorky was less intense about it and still wanted to play."[15]

Stuart Davis also refers to another issue of crucial importance to the New York art world: the rejection of nationalism in painting. Whereas the French Communist party had a whole artistic tradition to build on, nothing of the kind existed in the United States. Because of differences in the recent history of the two countries, nationalism was seen by the American left as a reactionary threat. Davis stressed the idea that such popular slogans as Save America for Democracy as well as calls by some intellectuals for a new Americanism were hypocritical and smacked of fascist nationalism. In the United States nationalism stood, in politics, for the conservatism of the isolationists and, in painting, for the work of the regionalists.

The differences between the position of the French Communist party on nationalism and that of the American Communist party emerge clearly from the paper "Race, Nationality, and Art" presented to the congress

by Lynn Ward.[16] This paper contains an interesting critical discussion of the idea of "national art." Ward and Meyer Schapiro analyzed the ideological consequences of this idea in the United States:

> We have many appeals for an "American Art" in which the concept of America is very vague, usually defined as a "genuine American expression" or "explicitly native art" and sometimes includes a separation of American painters into desirable and undesirable on the basis of Anglo-Saxon surnames.
>
> In the face of this, we should recognize that the real basis for an emotional separation between the member of the tribe and the outsider is to be found in more or less obscure feelings of economic rivalry and insecurity; that this separation becomes an effective barrier to a valid solutioñ of the problems that face all artists; . . . that finally the word "American" used in that way has no real meaning. It suspends a veil of fictitious unity and blinds our eyes to the fact that there can be no art in common between the Americans who own Rockefeller Center, the Americans in the Legion in Terre Haute, and the Americans in, as a symbol, Commonwealth College in Arkansas.[17]

Art should therefore shun nationalism; but, according to Schapiro's paper "The Social Bases of Art," also read to the congress, art reacts to the social conditions under which it is produced.[18] The modern artist is a long way from expressing art's eternal situation. Rather, he expresses and reflects his own relations with history. Schapiro was severely critical of the individualistic artist who produced for a market that upheld the values of the dominant class while deluding himself that he was in fact independent. The artist's only obligation, according to Schapiro, was to demolish the illusion of freedom and individualism by allying himself with the proletariat in revolutionary action. Critical analysis of the artist's relation to the masses was essential so that the artist could become aware of his position. Pure individualism was to be rejected.

After the First American Artists' Congress of 1936, criticism of the Popular Front from a part of the intellectual left became more organized and virulent. The gulf between Trotskyists and Stalinists widened on two crucial points, around which polemics between the two camps continued to revolve until the outbreak of World War II. Despite news of the Moscow Trials the Communist party continued to support Stalinist Russia. That, and the Russo-German pact, drove a growing number of disillusioned intellectuals into opposition, because they could not support the uncritical stance of the Party. To many intellectuals, it seemed more and more clear that what was needed was independence from all political parties for artists and writers.

In June 1935 the League of American Writers sent its president, Waldo Frank, and Mike Gold to Paris to attend the First International Congress

of Writers for the Defense of Culture. The congress marked the recent signature by French premier Pierre Laval of a mutual assistance pact between France and the Soviet Union. Mike Gold published in *New Masses* an exultant series of articles analyzing the success of the Popular Front policy, as demonstrated by the Paris congress.[19] Another reason for Gold's satisfaction is evident in these articles: for the first time American writers shared the international limelight with prestigious writers from other countries, including Huxley, Aragon, Gide, Malraux, Pasternak, and Brecht.

But all was not well with the Popular Front. In Paris, the surrealists, after much hesitation,[20] finally found the opportunity to voice their fears as to the wisdom of its optimistic outlook. André Breton refused to defend the abstract notion of "culture," which as far as he was concerned stood for the culture of the enemy, the bourgeoisie.[21] Mistrustful, the surrealists on April 20 sent a letter to the organizers of the conference demanding that the question of freedom of expression for the artist be placed on the agenda. Coming as it did only a few months after the purges and trials of Soviet intellectuals in Moscow, this letter demanding greater critical freedom for the creators of art was unconsciously ironic, and its acceptance by the conference organizers rather improbable. The surrealists demanded "the right to pursue the search for new means of expression in literature and art and the right of writers and artists to continue to explore the problem of man in all its forms."[22] They protested against "touching declarations such as those of André Malraux, Waldo Frank, and Boris Pasternak—nothing but warmed-over platitudes, childish ideas, and boot-licking. Those who claim to be saving culture have chosen an unhealthy climate for their activities."[23]

Following the Paris congress, which demonstrated the strength of the Popular Front to the world and resulted in the creation of an International Association of Writers for the Defense of Culture,[24] opposition to the Popular Front in the United States was ambiguous: witness the discomfort of *Partisan Review*'s editors in questioning the value and quality of proletarian literature and the worth of the Popular Front.[25] *Partisan Review*'s suspension of publication in 1936 reflected not only the disillusionment of its editors Philip Rahv and William Phillips in the face of this failure, but also the disillusionment of intellectuals with the policies of the Soviet Union and the American Communist party, which favored a strategy of class alliance.[26]

On the whole, however, the Communist hold on the intelligentsia remained firm, although some Trotskyists were quick to react to the change in the Popular Front's line. George Novack, for example, observed that "Sinclair Lewis has been miraculously transformed from a petty-bourgeois writer, who turned his back upon the revolutionary struggle of the proletariat, into a literary hero of the Popular Front."[27]

James T. Farrell was fierce in his condemnation of the new intellectual vogue in favor of the front, which in his view consisted of "hastily enlisted commercial writers, high priced Hollywood scenarists, a motley assortment of mystery plot mechanics, humorists, newspaper columnists, strip teasers, band leaders, glamour girls, actors' press agents, Broadway producers, aging wives with thwarted literary ambitions, and other such ornaments of American culture."[28]

For *Partisan Review* the problem raised by the first writers' congress and the politics of the Popular Front was that of the relation between the American tradition on the one hand and Marxism and revolutionary literature on the other. In April 1936 the magazine published a symposium under the title "What Is Americanism?" to debate this question, which had become central to the problem of defining the role of the artist in a time of cultural crisis. Underlying the debate was another question, one that obsessed Rahv and Phillips, namely, How can literature maintain a revolutionary attitude and yet incorporate the discoveries of modernism? In other words, how could writers belonging to the new American avant-garde keep up high literary standards and continue their formal experiments while at the same time giving voice to their social conscience?

The most important and controversial of the replies to *Partisan Review*'s question was that of William Carlos Williams, who insisted that between Marxism and American tradition no alliance was possible. For Williams, Marxism ran counter to the American ideal in all its tenets.[29] In their comments, Rahv and Phillips accepted this analysis in some degree and in 1937 agreed that only a "Europeanization of culture," in other words, a more or less rapid abandonment of proletarian literature, could revitalize and save American art.[30] The examples to follow were European, namely, André Malraux and Ignazio Silone.

James T. Farrell's important *A Note on Literary Criticism*, published in 1936, attacked the vulgar, mechanical Marxism of Mike Gold and Granville Hicks as published in the pages of the Communist review *New Masses* and helped not only to clarify the situation but to hasten the split between the two magazines. Farrell had a long history of conflict with intellectuals associated with the American Communist party.[31] His articles in the *Nation*, the *New Republic*, and *Partisan Review* were the only ones at the time that were able to articulate a stringent Marxist critique of Stalinism and its cultural politics. This, in particular, was the task of *A Note on Literary Criticism*. For Farrell the quality of a work did not depend solely on whether or not it was "Marxist": the way in which the Marxist method was applied was equally important. Accordingly, he rejected the uncritical use of a "pedantic and mechanical" Marxism, which had led many writers to submit to political pressure from the party. In short, he rejected the Popular Front: "The united front in the

cultural and literary wing has reached the limit beyond which it is not even an absurdity."[32] This protest was important, because it provided an alternative for many intellectuals who found it difficult to find their place in the Communist party.

Farrell encouraged writers to master the literary tradition and to make use of formal innovations in writing (particularly Joyce's), thereby giving prominence to the idea of artistic independence. Writers should pay attention to the history of literature and to new literary discoveries in order to develop a modern style capable of being combined with a progressive content. Farrell's book aroused a considerable polemic on the left,[33] and even some of its admirers said that it had not been clear enough in pointing out the artistic failure of all the work that had been done in conformity with the cultural dicta laid down by the Communist party. One reviewer, V. F. Calverton, remarked that Farrell had attacked individual failures rather than the failure of the system itself.[34]

Another important development was the establishment in 1937 of the magazine *Marxist Quarterly*, published by a group of Trotskyite intellectuals at Columbia University (James Burnham, Lewis Corey, Louis M. Hacker, Sidney Hook, George Novack, and Meyer Schapiro). The editors stressed the complete independence of the journal vis-à-vis all parties and promised to use their critical intelligence to assure its political and intellectual independence.

Marxist Quarterly published Schapiro's article "Nature of Abstract Art," which was important not only for its intelligent refutation of Alfred Barr's formalist essay *Cubism and Abstract Art* but also because it marks a conceptual and ideological shift in Schapiro's work.[35] Whereas in 1936 Schapiro had argued in the *Social Bases of Art* that the artist had a place in the revolutionary process thanks to his alliance with the proletariat, by 1937 he was arguing in the "Nature of Abstract Art" that the artist was cut off from all revolutionary hope. Schapiro's pessimism was ambiguous, however. In contrast to writers like Barr, who argued that abstract art was isolated from social reality and governed by its own intrinsic system of rules, Schapiro maintained that all art, even the most abstract, is rooted in the conditions under which it is produced. The abstract artist, according to Schapiro, works under the illusion of freedom and does not understand the complexity of his situation or the tenuousness of his position, hence he does not grasp the full implications of his work. By attacking abstract art in this way, by demolishing the artist's illusion of independence vis-à-vis outside powers while at the same time giving prominence to the relations between abstract art and the society in which it is produced, Schapiro implied that the significance of abstraction was greater than the formalists allowed.

This assertion was a tricky one that cut two ways, for while it demolished the illusory independence emphasized by Barr it also undermined

the Communist criticism that abstract art was the product of an ivory tower, bearing no relation to society. The argument that abstract art is not independent outflanked both camps. Painters on the left who rejected the notion of "pure art" but who were discouraged by the aesthetics of Communism saw in this "negative" account of the ideological work done by abstract art something positive, a way out of the impasse. It was easy enough for the Communists to dismiss a style of art presumed to be cut off from reality and isolated in an ivory tower. But if Schapiro was right and abstract art was rooted in the social fabric, responding to social conflicts and contradictions, then it was theoretically possible for a left-wing artist to use abstraction (and thus to take advantage of twentieth-century discoveries in the plastic arts) without being ashamed of it.

Even though it was Schapiro's wish not to formulate a program or to propose a solution to the problems of artists, his ambiguous thesis, published when it was (at a time when a growing number of artists were beginning to seek a modernist solution in the wake of their disillusionment with the Popular Front aesthetic), could hardly help making a chink in the theoretical armor of both camps (for, in fact, the opposing positions of Communists and formalists on the question of abstract art agreed on one point, that abstract art was isolated from society, thereby erecting an ideological barrier that, before Schapiro, was difficult to cross). Schapiro's argument thus hit a sensitive spot. From the realization that abstract art, like all other art, is socially conditioned, it was but a short step to the assertion that the artist's social conditioning and perceptions of the social situation find their way into his artistic work, even if it is abstract. Thus it became possible in theory to use an abstract language to express a critical social consciousness. The use of abstraction as a critical language in fact responded to a pressing need, already formulated by *Partisan Review* and *Marxist Quarterly*, namely, the artist's need to work independently of political parties and totalitarian ideologies.

Because Schapiro's text was "open," it lent itself to such an interpretation, and Delmore Schwartz's comments criticizing Schapiro for attributing too much importance to aesthetics prove that Schapiro was heading in an opposite direction to the Communists and Popular Front strategists and thereby offering assistance to artists anxiously looking for another way.[36] It is of course difficult to judge how important this particular way of reading Schapiro may have been in 1937, but what we can say is that it was the first sign of a breach in the Communist wall that would later be widened (by Breton and Trotsky in 1938, Greenberg in 1939, and Motherwell in 1944) as the concept of a critical art, abstract and avant-garde, was developed. Schapiro's article was the first sign of a thaw in the frozen opposition between idealist formalism and socialist

realism, and it paved the way for a reevaluation of abstraction. The article liberated American painters, tired of their role as propaganda illustrators, and brought Schapiro considerable prestige in anti-Stalinist artistic circles.

Violent though these skirmishes may have been, it should be pointed out that they did not significantly weaken the Popular Front. On the contrary, 1937 saw the triumph of the American Artists' Congress, to which Picasso sent his blessings from the Continent. Nevertheless, it remains true that some artists did begin to take their distance from the Popular Front, and in doing so they were helped by Meyer Schapiro's theoretical contribution.

Picasso, the titan of the art world and the most prestigious of all modern artists, lent his support to the Popular Front. Despite an amusing series of mishaps that in the end prevented the crowd attending the Second American Artists' Congress in December 1937 from hearing the voice of the ailing master via telephone, his message, finally read by a nurse, had a tremendous impact. Transmitted across the ocean, it gave American artists a sense of oneness with their comrades in Europe, an impression of taking part directly and immediately in the battle against fascism, and a feeling of working together with Picasso and other European artists in a united front to rescue culture.[37] Picasso's message is worth citing in full, because it captures in a nutshell the whole ideology of the Popular Front:

I am sorry that I cannot speak to the American Artists' Congress in person, as was my wish, so that I might assure the artists of America, as director of the Prado Museum, that the democratic government of the Spanish Republic has taken all the necessary measures to protect the artistic treasures of Spain during this cruel and unjust war. While the rebel planes have dropped incendiary bombs on our museums, the people and the militia, at the risk of their lives, have rescued the works of art and placed them in security. It is my wish at this time to remind you that I have always believed, and still believe, that artists who live and work with spiritual values cannot and should not remain indifferent to a conflict in which the highest values of humanity and civilization are at stake. No one can deny that this epic people's struggle for democracy will have enormous consequences for the vitality and strength of Spanish art. And this will be one of the greatest conquests of the Spanish people. Convinced of our triumph, I take pleasure in greeting the American Democracy, as well as those present at this congress. Salud—Picasso speaking.[38]

While Paul Vaillant-Couturier spoke in Paris in the abstract of kidnapping art from the bourgeoisie, in Madrid in the midst of the fascist bombardment it was literally happening. Absurd and theatrical as it is, Picasso's

message depicts a fantastic, romantic scene, the people and the militia risking their lives, working by the light of incendiary bombs to save the works in the Prado. Breton might have said that as usual the people were actually rescuing the means of their own domination. The artists in attendance at the congress, galvanized by this vision of salvation and not yet aware of the fate that history had in store for them, were not yet ready to accept the Trotskyite analysis, for reasons we can readily understand. Not until the invasion of Finland brought still further disillusionment was Meyer Schapiro able to find an excuse for quitting the congress.

Although the Franco-Russian treaty signed by Laval in 1936 surprised some intellectuals, it did not bring about a change in attitudes comparable to the one that followed in the wake of the Moscow Trials of 1936–38, in which the Soviet Union astonished much of the left in the West by trying some of its own most prominent intellectuals (Zinoviev, Kamenev, Trotsky, Radek, and Bukharin). By themselves not even the trials were enough to shake the faith in the structure of the Communist party, but they planted the seeds of doubt and suspicion, which quickly sprouted and bore fruit when the Hitler-Stalin pact was signed. Malcolm Cowley's articles in the *New Republic* from 1936 to 1938 give some idea of how difficult it was for American intellectuals to evaluate the trials while holding on to certain illusions in regard to the basic soundness of the Soviet system. Despite certain doubts, Cowley accepted the trials' verdicts and signed a petition in favor of Russia.[39] He was not alone. A hundred and fifty artists (including Philip Evergood, Max Weber, Raphael Soyer, Hugo Gellert, William Gropper, Stuart Davis, and Joe Jones) signed a letter published in *New Masses* in support of "the verdicts in the recent Moscow trials of the trotskyite buckarinite traitors."[40]
The trials permanently divided the left but did not destroy it. The American Committee for the Defense of Leon Trotsky, an alliance of liberals and Trotskyists, was established in 1936. In an editorial published in the *Nation*, the committee offered to hear Trotsky's version of his alleged crimes. An investigative commission headed by the liberal philosopher John Dewey went to Mexico to hear the accused.
At this point the Communist party launched a virulent campaign against the Trotskyists in the pages of *New Masses*. The liberal *New Republic* and *Nation* felt that the accused were guilty but preferred to take a neutral position and to await further information before pronouncing final judgment. It suited the liberals to play the high-minded role of impartial arbiters in the matter of the trials; at the same time they did not hide the fact that they preferred Stalin's flexible and pragmatic politics to Trotsky's dogmatic fanaticism. As far as they were concerned, the USSR had launched the Popular Front and remained the champion

of peace.[41] In the end, however, what began to emerge from the inter-rogations of Trotsky and from analyses of the trials and ruminations on the guilt of the accused was the shamefaced realization, which a few writers began to articulate, that communism could serve as a cover for the same kinds of injustice as fascism. Such at any rate was Selden Rodman's conclusion after interviewing Trotsky in Mexico and coming to believe him innocent. This led him to the judgment that the trials were a direct consequence of the philosophy of Marxism-Leninism. Not only Stalin but the entire Soviet system was guilty: "Trotsky and the opposition, had they been in power, would have acted in the same way."[42] Thus all forms of dictatorship were to be rejected. The idea that communism and fascism were similar had taken root and in 1939 would lead to the formation of the Committee for Cultural Freedom, which spelled the end of the Popular Front.

The whole affair of the Moscow Trials accentuated the pessimism of the editors of *Partisan Review*. Early in 1938 Philip Rahv published an essay entitled "Trials of the Mind," in which he took the part of per-secuted intellectuals in the Soviet Union and lamented the decline of the spirit in the face of the animal brutality and violence rampant in the world. For Rahv the trials laid bare the failure of communism: "The failure of capitalism had long been assumed, but the failure of com-munism was a chilling shock and left the intellectual stripped of hope and belief in progress, with only himself and his own talents to rely upon."[43]

Events in Spain also played a role in the way many intellectuals in-terpreted the trials, for it was possible to draw a parallel between the conduct of the trials in Moscow and the violence against anarchists and Trotskyists in Spain and thus to conclude that the entire Soviet political system was fundamentally flawed. But others saw in the defeat of the Spanish Republic the justification for repression in the Soviet Union, since the government there needed to strengthen its hand in order to carry on the fight against triumphant fascism.

When *Partisan Review* resumed publication in December 1937 under a new group of editors, it took a new political line. Working gradually toward disengagement, the magazine abandoned proletarian literature and tried instead to establish an intellectual community, a community so totally alienated that it could develop into a "revolutionary force in opposition." The editors took the position that modern literature must be free of all political interference. Accordingly, they rejected proletarian literature, which in their eyes was all too often mere Party propaganda disguised as the literature of a class. The lot of the artist, they maintained, was a hard one: the artist must live two lives, that of citizen and that of artist. He must understand the difference between public life and private life. This position introduced a new complexity into the political

image of the left: "The estrangement of the intellectual was the justification for his withdrawal from real politics, but it was also an explanation for his ability to rise above the mundane and reunite art and politics into a vision of a revolutionary culture. The alienated man became the radical man."[44] *Partisan Review* became an arena for serious discussion and analysis of the artist's problems in coming to grips with his social role.

The period 1936–39 was one of intense political analysis, during which many intellectuals reformulated their positions. Between the opening of the Moscow Trials and the signing of the Russo-German pact, the importance of the Trotskyite movement grew, even to the point where it was possible for *Partisan Review* to publish articles in its defense. The magazine's editors asked Trotsky, then in exile in Mexico, to contribute a series of articles on the relations between art and politics, a request that Trotsky was to honor only with the greatest misgivings.[45] But it was these articles that brought the Trotskyite analysis to the attention of American intellectuals and that stimulated interest in an activist avant-garde. The intellectuals associated with *Partisan Review* were cut off on one side from the Communist party and on the other side from the middle class, and so they found themselves in a no-man's-land, an enclave, as members of a sort of intellectual's international and defenders of the idea of an avant-garde culture.

Partisan Review was quick to strike a balance: it was against pro-Soviet writers and against naturalists.[46] As James Burkhart Gilbert has observed, however, there were two distinct tendencies within the magazine's staff, represented by Dwight Macdonald on the one hand and by Philip Rahv and William Phillips on the other.[47] Whereas the latter two men had given up political analysis in favor of formal literary criticism, politics was still of central concern to Macdonald. These differences within the editorial staff stimulated much tense and impassioned debate and proved fruitful for the elaboration of a theoretical framework for avant-garde culture, which was desired by all. At the second writers' congress, the Communists allied themselves even more firmly with liberal writers who were seeking to create a "new Americanism" with roots in the cultural renaissance of the period prior to World War I: back to the patriotism of Randolph Bourne.[48] *Partisan Review* had nothing but scorn for the Communist-supported nationalism of Van Wyck Brooks, Lewis Mumford, and Malcolm Cowley. Faced with a resurgence of patriotism and traditionalism in American literature and with aesthetic bankruptcy in proletarian literature, the editors of *Partisan Review* felt they had no choice but to turn to the European avant-garde for leadership.

In painting the same thing was happening. The position of the American Abstract Artists, a group formed in 1937, was the same as that of

Partisan Review. The group's internationalism did not go beyond making commentaries on European art. American artists associated with the AAA hoped that by following the lead of endangered European artists they might transcend nationalism and regionalism and raise themselves up to the level of international painting. As a result, however, they relinquished whatever was specifically and uniquely American in their work. For this they suffered repeated reproaches from critics and museums and failed to make much of an impact during the Postwar reorganization of American culture.

In August 1938 *Partisan Review* published under the title "Art and Politics" a letter that Trotsky had sent to the magazine at its editors' behest. This letter was both a fierce attack on Stalinism's totalitarian conception of art and a paean to independent art. Pure and true, independent art, Trotsky said, always contains a subversive and critical element. The bourgeoisie, however, never flags in its efforts to reclaim innovative art and turn it into a new form of academicism. In times of crisis bohemian artists are able to escape the control of the bourgeoisie and start a new cycle:

> Generally speaking, art is an expression of man's need for an harmonious and complete life, that is to say, his need for those major benefits of which a society of classes has deprived him. That is why a protest against reality, either conscious or unconscious, active or passive, optimistic or pessimistic, always forms part of a really creative piece of work. Every new tendency in art has begun with rebellion.[49]

Trotsky's analysis was addressed particularly to the American artist, whose cultural and economic situation was disastrous. In circumstances of general crisis, according to Trotsky, the artist has a decisive role to play, indeed a revolutionary role, if he can combine free art with participation in the revolutionary effort:

> The decline of bourgeois society means an intolerable exacerbation of social contradictions, which are transformed inevitably into personal contradictions, calling forth an ever more burning need for a liberating art. Furthermore, a declining capitalism already finds itself completely incapable of offering the minimum conditions for the development of tendencies in art which correspond, however little, to our epoch. It fears superstitiously every new word.[50]

What Trotsky was proposing to American artists was a new line of conduct and a solution, a quite ambiguous solution, to the problem of art's relation to revolution:

Art, which is the most complex part of culture, the most sensitive and at the same time the least protected, suffers most from the decline and decay of bourgeois society. To find a solution to this impasse through art itself is impossible. It is a crisis which concerns all culture, beginning at its economic base and ending in the highest spheres of ideology. Art can neither escape the crisis nor partition itself off. Art cannot save itself. . . . For these reasons the function of art in our epoch is determined by its relation to the revolution.[51]

Trotsky's message was also a warning: too many artists, victims of blind optimism and of the desire for rapid change, had allowed themselves to be duped by the illusion of revolution in Russia, where in fact the blockage of the revolutionary process had given rise to a new privileged class that was once again exploiting the artist, the slave of the dominant ideology. The first battle that the artist must wage was the battle against the false prophets of the Russian Revolution now in power in the Soviet Union. The artist, Trotsky said, must take a stand on this issue. Impartiality in the midst of a pitched battle was reactionary:

Behind the act, so popular now, of impartially keeping aloof from the Stalinist bureaucracy as well as its revolutionary adversaries, is hidden nine times out of ten a wretched prostration before the difficulties and dangers of history. . . . In the face of the era of wars and revolutions which is drawing near, everyone will have to give an answer: philosophers, poets, painters as well as simple mortals.[52]

The way to overcome these problems and ambiguities, in art as in politics, would have to be pointed out by isolated avant-garde groups:

When an artistic tendency has exhausted its creative resources, creative "splinters" separate from it, which are able to look at the world with new eyes. The more daring the pioneers show in their ideas and actions, the more bitterly they oppose themselves to established authority which rests on a conservative "mass base," the more conventional souls, skeptics, and snobs are inclined to see in the pioneers, impotent eccentrics or "anemic splinters." But in the last analysis it is the conventional souls, skeptics and snobs who are wrong—and life passes them by.[53]

The artistic production of the avant-garde is, by definition, rebellion at the moment of conception. To attempt to channel such production is, also by definition, reactionary. It is the duty of art to remain independent:

Art, like science, not only does not seek orders but by its very essence, cannot tolerate them. Artistic creation has its laws—even when it

consciously serves a social movement. Truly intellectual creation is incompatible with lies, hypocrisy and the spirit of conformity. Art can become a strong ally of revolution only in so far as it remains faithful to itself.[54]

In the autumn of 1938 it was again *Partisan Review* that published a manifesto entitled "Towards a Free Revolutionary Art," which was signed by Diego Rivera and André Breton, then in Mexico, and prepared in collaboration with Trotsky.[55] Translated by Dwight Macdonald and published at a time when *Partisan Review* was trying, under the impetus of Farrell, to outflank communism, the manifesto took on a symbolic significance. Recent political events in the Soviet Union and Breton's unhappy experiences with the French Communist party were invoked as proof that the independence of the artist was difficult to maintain but crucial if he hoped to avoid becoming a mere tool of propaganda.

The linking of the names of André Breton, Diego Rivera, and Leon Trotsky had a profound impact on intellectuals who were looking for a way out of the political and artistic labyrinth in which they were trapped: Breton represented the avant-garde art of Europe, Rivera the political art of the fresco, and Trotsky the political avant-garde. In order to fight against the subordination of art to propaganda, what was needed, according to the manifesto, was to set up a unified line of defense. In a civilization as repressive and authoritarian as the present one, however, to do so was to commit an act of aggression. Artists could defend themselves, according to Breton, simply by preserving their freedom to create. But this simple act, this refusal to serve as a cog in the machine, was taken as an attack by both ideological blocs.

The manifesto further defined its political position by making clear that the equation of Russia with Germany did not rule out criticism of liberals who played along with the Popular Front: "It goes without saying that we do not identify ourselves with the currently fashionable catchword: 'Neither fascism nor communism,' a shibboleth which suits the temperament of the philistine, conservative and frightened, clinging to the tattered remnants of the 'democratic' past."[56]

In the politically tense situation of the pre–World War II period, which left no room for subtleties, Breton saw his position as an eminently revolutionary one: "True art is unable *not* to be revolutionary, *not* to aspire to a complete and radical reconstruction of society."[57] By emphasizing the complete freedom of the artist and his art, the authors of the manifesto automatically distinguished themselves from the Communists and Fascists but were ambiguous on the question of their relation to the liberals, in that they did not define what they meant by "pure art" or "true art." Notwithstanding this ambiguity, the manifesto did insist,

albeit abstractly, on the need for political action in concert with artistic creation: "It should be clear by now that in defending freedom of thought we have no intention of justifying political indifference, and that it is far from our wish to revive a so-called 'pure' art which generally serves the extremely impure ends of reaction."[58] The solution proposed by the manifesto was the organization of a third force based on Trotskyism: a Trotskyism for the artist, an alliance of an unspecified nature between a political avant-garde and an artistic avant-garde. Cooptation of the artist by the dominant ideologies of the day was not to be tolerated, but the picture of the artist's role in the socialist society of the future was imprecise and shot through with contradictions, as Herbert S. Gershman has shown in *The Surrealist Revolution in France*.[59]

The credo of complete freedom for the artist—"No authority, no restriction, not the slightest trace of compulsion"—was a laudable one, but devoid of practical consequences and vague in its definition.[60] Underlying Breton's thinking was a hatred of nationalism, which had already been responsible for a world war. The call for an international alliance of revolutionary artists grew out of this hatred. In an issue of the magazine *Clé*, which Breton started upon his return to France from Mexico, he defended foreign artists living in France and insisted on the fact that

art has no more fatherland than the workers. To advocate today a return to "French art," as not only the fascists but even the Stalinists do, is to oppose the maintenance of that close link necessary to art, to work for division and lack of understanding among peoples. It is to produce a premeditated example of historical regression.[61]

This idea would later make headway with American artists after the war, albeit with its significance profoundly altered. Meanwhile, the association of Trotskyism and avant-gardism quickly foundered in the face of internal dissension and the general mobilization of 1939. Debate continued, first in Marseilles and later in New York, but the key issues were now less pressing, less political. A refugee in New York, Breton was hesitant, moreover, to continue his political attacks: "My position as a refugee does not permit me to be more explicit on this—with reference to the causes of the war."[62]

Debate on the importance of the artist's role was renewed, however, by Clement Greenberg, temporarily allied with the Trotskyists, who in the fall 1939 issue of *Partisan Review* published an article entitled "Avant-Garde and Kitsch."[63] For Greenberg, the causes of the crisis of Western culture were similar to the ones listed by Trotsky in "Art and Politics," namely, the crisis of capitalism and the decline of the ruling class:

The masses have always remained more or less indifferent to culture in the process of development. But today such culture is being abandoned by those to whom it actually belongs—our ruling class. For it is to the latter that the avant-garde belongs. No culture can develop without a social basis, without a source of stable income. And in the case of the avant-garde this was provided by an elite among the ruling class of that society from which it assumed itself to be cut off, but to which it has always remained attached by an umbilical cord of gold. The paradox is real. And now this elite is rapidly shrinking. Since the avant-garde forms the only living culture we now have, the survival in the near future of culture in general is thus threatened.[64]

Because of the political and economic crisis, the ruling class had cut off its support of high culture. Greenberg did not see the cultural crisis as it had been seen in the previous decade, as an end in itself, or in other words as the death of bourgeois culture and its replacement by proletarian culture. Rather, he saw it as the beginning of a new era. And why should this new era not be the era of America, since the crisis was centered in Paris.[65] Furthermore, this new era became a possibility only after the failure of proletarian culture, nipped in the bud by the Popular Front as documented in the pages of *Partisan Review.*

Like Greenberg, Trotsky and Breton had also blamed the cultural crisis on the decadence of the aristocracy and the bourgeoisie and had seen in the independent artist the way to overcome the crisis.[66] But Greenberg lacked their revolutionary optimism. Though independent of political parties, the artist, they felt, should not be independent of politics. The revolutionary power of a painter depended precisely on his critical political consciousness. More pessimistic, Greenberg dismissed what Trotsky had referred to as "eclectic action" in favor of a unique solution: the modernist avant-garde. In fact, as Greenberg saw it, only an avant-garde could save culture of quality from the invasion of kitsch and "keep culture moving in the midst of ideological confusion and violence."[67] There was only one answer to the rapidly spreading crisis, the widening abyss that was quickly swallowing up all the aspirations of modern artists. The organization of an avant-garde, said Greenberg, was the only way to slow down the general disintegration of culture.

It is among the hopeful signs in the midst of the decay of our present society that we—some of us—have been unwilling to accept this last phase of our own culture. In seeking to go beyond Alexandrianism, a part of western bourgeois society has produced something unheard of heretofore: Avant Garde culture.[68]

But this avant-garde was one that rejected revolutionary hopes that had still been strong only a few years earlier. What many artists now

saw as the answer, after the disqualification of the Communist party and the impotence of the Trotskyists, was a nonrevolutionary approach. By invoking the avant-garde, of whose history he was well aware, Greenberg was able to pose as the defender of "quality" and the champion of progress against academicism while renouncing political struggle and sanctioning a conservative mission to rescue bourgeois culture:

> Yet it is true that once the avant garde had succeeded in "detaching" itself from society, it proceeded to turn around and repudiate revolutionary politics as well as bourgeois. The revolution was left inside society, as part of that welter of ideological struggle which art and poetry find so unpropitious as soon as it begins to involve those "precious," axiomatic beliefs upon which culture thus far had to rest.[69]

In Greenberg's mind, the greatest threat to culture lay in academicism or Alexandrianism, the essence of kitsch. Kitsch was the result of a mass culture stemming from the industrial revolution:[70]

> Kitsch, using for raw material the debased and academicized simulacra of genuine culture, welcomes and cultivates this insensibility. It is the source of its profits. Kitsch is mechanical and operates by formulas. Kitsch is vicarious experience and faked sensations. Kitsch changes according to style, but remains always the same. Kitsch is the epitome of all that is spurious in the life of our times. Kitsch pretends to demand nothing of its customers except their money— not even their time.[71]

Hence in a period of intensive propaganda-mongering, kitsch could be used easily and directly by the authorities. In Greenberg's view, modern avant-garde art lent itself less easily to propaganda uses, not as Trotsky maintained because it was too critical,[72] but rather because it was more "innocent" and therefore less apt to conceal a hidden message in its draperies. Greenberg carried Trotsky's defense of a critical art that remained "faithful to itself" one step further, maintaining that while the avant garde did indeed do critical work, it was criticism directed within, toward the work of art itself, toward the very medium of art, and intended solely to guarantee the quality of the production.[73] Such criticism was necessary because capitalism does not tolerate quality:

> Capitalism in decline finds that whatever of quality it is still capable of producing becomes almost invariably a threat to its own existence. Advances in culture no less than advances in science and industry corrode the very society under whose aegis they are made possible.[74]

Capitalism's antipathy to quality is then linked to the profits offered by kitsch in order to explain why kitsch has been encouraged by the system and has come to dominate art:

> Because it can be turned out mechanically, Kitsch has become an integral part of our productive system in a way in which true culture could never be except accidentally. It has been capitalized at a tremendous investment which must show commensurate returns; it is compelled to extend as well as to keep its markets.[75]

With the threat of a second world war, Greenberg felt that it was impossible to attempt action in both the political and cultural spheres at the same time. The house might be in danger, but by fighting to protect Western culture, at least the furniture might be saved.

The interest of this article lies in the fact that it was an important element in what might be called "the de-Marxization of the American intelligentsia," a process that began around 1936.[76] The piece was published at just the right moment to help intellectuals see the light at the end of the tunnel. The new *Partisan Review* went through a Trotskyist period during which it stressed the importance of the intellectual rather than of the working class. The concern with creating an "international of intellectuals" was so fundamental that it sometimes led to outright disregard for Marxist politics as such:[77]

> To the editors of the *Partisan Review* the events of 1936 and 1937 cast fundamental doubts on the integrity of communism. This process was first evident in their reassertion of the theoretical purity of Marxism through their temporary identification with Trotskyism. But in the long run it meant the beginning of a piecemeal rejection of Marxism itself.[78]

This was the context in which Greenberg's article appeared and in which it must be understood. The delicate balance between art and politics that Trotsky, Breton, and Schapiro had tried to maintain was generally missing from Greenberg's articles. Although he continued to use certain elements of Marxist analysis and clung to a Marxist vocabulary, Greenberg was in fact laying the theoretical foundations for an "elitist" modernist position, a position that had in fact been taken up by some artists as early as 1936.[79] Among these were artists from the AAA who attempted to create an artists' pressure group by claiming allegiance to modern European abstract art.

It is interesting to note that George L. K. Morris, a member of the association, art critic, and financial backer of *Partisan Review*, had the

following words to say in regard to the artists of the AAA (his remarks were published in the pages of *Partisan Review*):

And you must overlook the opposition that will satirize you as "escapists" who work in a vacuum. They will find in your work no visible connection with the causes of social justice, asserting that illustrative propaganda is a function of art, that much of past culture was essentially propagandist. You qualify as the sole organization in America that is dedicated to having an authentic and appropriate cultural expression.[80]

Thus Morris and the *Partisan Review* encouraged abstract artists to follow the line laid down by Trotsky and distinguished between their work and that of the retrograde Stalinist artists who belonged to the American Artists' Congress:

The slogan of the Congress is "For Peace, For Democracy, For Cultural Progress," and obvious comments upon these phrases echo resoundingly from every wall. The Abstract Artists share these convictions, but they also believe that the aesthetic impulse cannot become a tool for concrete political or philosophic dissemination—at this stage of our cultural metamorphosis at least. The present decade may have publicized at last the crevices in the old social order. The Congress illustrates the crevices. The abstractionists, on the other hand, attempt to reorder their plastic instincts; they attack the established conceptions of art itself.[81]

What "Avant-Garde and Kitsch" did, then, was to formalize, define, and in some sense rationalize an intellectual position that had been adopted in a confused way by many painters. Although extremely pessimistic from the standpoint of anyone who was looking for a revolutionary solution to the crisis, the article restored hope to these artists. In effect, by making kitsch the target and, because it was tied to the totalitarian powers, the symbol of evil, Greenberg gave artists who were at a loss for what to do next the means to act. By fighting through art against mass culture, artists enjoyed the illusion of actively fighting against repugnant regimes, using the weapons of the elite. Rooted in the views of Trotsky, Greenberg's position led to a complete break with the political approach taken during the Depression. He appealed to socialism to save the dying culture so as to be able to carry on the artistic tradition.[82] "Today," wrote Greenberg, "we no longer look towards socialism for a new culture—as inevitably as one will appear, once we do have socialism. Today we look to socialism *simply* for the preservation of whatever living culture we have right now."[83] This transvaluation of values worked wonderfully and for many years Greenberg's article served

as a basic point of reference for the renaissance of American painting: served up with a new sauce, the old recipe of the avant-garde was destined to enjoy a tremendous success.

Greenberg knew what he was talking about when he later wrote that "some day it will have to be told how anti-Stalinism which started out more or less as Trotskyism turned into art for art's sake, and thereby cleared the way, heroically, for what was to come."[84]

Two events that more or less coincided with the publication of "Avant-Garde and Kitsch" had a profound impact on some of Greenberg's writer friends and collaborators at *Partisan Review:* the Russo-German pact and the invasion of Finland by the Soviet Union. The pact signed by Hitler and Stalin at the end of August 1939 destroyed the last illusions of the Communist sympathizers and emptied the ranks of the writers' congress, which at the beginning of the summer had been at a peak of popularity.[85] After the pact many intellectuals looked for a new place on the political spectrum. Even before the pact some writers had tried early in the year and throughout the summer to move away from the Popular Front and set up an independent, anti-Stalinist left-wing organization. This was the purpose of Dwight Macdonald's efforts to establish the League for Cultural Freedom and Socialism. The league attacked not only fascism and communism but also fascist tendencies in America and the American drift toward war.[86]

In reaction to the league, four hundred writers, artists, educators, and intellectuals signed a petition published in the *Nation* just two weeks before the signing of the pact on August 22.[87] This position reaffirmed faith in the Soviet Union as the heroic defender of freedom and proclaimed the belief that political cooperation between the United States and the Soviet Union was inevitable. This document, which Macdonald referred to as a "historical curiosity," might provoke laughter if it did not reflect the utter confusion of much of the American intelligentsia, whose political naiveté precluded a global view of the situation.

In the summer of 1939 a more prestigious group of intellectuals gathered under the aegis of the Committee for Cultural Freedom, headed by Sidney Hook and John Dewey. Unlike Macdonald's group, the committee did not see itself as revolutionary but rather as a force to combat fascism and communism both at home and abroad.[88] Sidney Hook, the group's spokesman and an affiliate of *Partisan Review,* answered Freda Kirchwey's *Nation* article "Red Totalitarianism" by saying that totalitarianism had to be fought wherever it was found, whether in fascist countries or in the Soviet Union. Both the Hook and Macdonald views had support among intellectuals and provoked discussion within the pages of *Partisan Review,* which became the intellectuals' favorite forum for political discussion, the crossroads for all who wished to reevaluate their positions and to reconsider the relations between art and politics. The

magazine became a point of reference for the anti-Stalinist left, many of whose prominent figures appeared in its pages. Two forms of anti-Stalinism were in fact represented: a revolutionary form associated with Macdonald and a nonrevolutionary form associated with Dewey and Hook.[89]

For many intellectuals the fall of 1939, which saw the partition of Poland and the entry of France and England into the war, was a dramatic period, a period of reconsideration and reevaluation of all that the intellectual left had believed in for so long and, some said, so naively and superficially.[90] Although many still saw the Russian-German alliance as unnatural and nothing more than a bit of realpolitik,[91] the Soviet Union lost the advantage it had had when it was seen as the leader of the opposition to fascism. In the eyes of surprised liberals, "the crisis that the Nazi-Soviet Pact represented for the American writers was spiritual, intellectual, and moral."[92] Intellectuals who had placed their faith in the Popular Front were left at a loss when that attractive structure collapsed. The collapse left a void that many writers tried to fill by establishing new left-wing but anti-Stalinist organizations.[93] For the liberals it was Soviet Russia far more than the Communist party that had represented the hope of a way out of the crisis of capitalism. After confidence in the Soviet Union collapsed, the editors of the *New Republic* wrote that "people must have something in which to repose hope and confidence; it is more likely that with the eclipse of Russia's moral prestige they will turn more and more to this country—the last great nation to remain at peace under democratic institutions."[94] On the eve of World War II America was already being seen as the sole champion of democracy.

The few hopes that some people still held out for the Soviet Union evaporated with the news of the Russian attack on Finland. The collapse of the powerful American Artists' Congress is important for what the confused welter of events that led to the final disintegration can tell us about the political forces and ideologies at work within the New York art world at the time war was declared in Europe.

After the attack on Finland, the leadership of the American Artists' Congress, apparently in the hands of the Communist party, kept quiet.[95] Stuart Davis, the national president of the congress, was approached by Ralph Pearson, an influential founding member, who urged that a clear statement of position be put to a vote. Davis preferred to do nothing, owing, he said, to the "ambiguities" surrounding the affair. For the Soviet Union to have been condemned by a Communist-dominated Congress would have been unthinkable. A dissident group characterized as Trotskyist formed around Meyer Schapiro. This group had already been critical of the organization for several months, charging that the congress had followed a Stalinist line and had manipulated the majority of artists for political reasons.[96] On April 4 a petition calling for free discussion

of the position to be adopted by the congress on the Finland question circulated among the members of the group. Among the signers of the petition were Milton Avery, Mark Rothko, Adolph Gottlieb, Lewis Mumford, José de Creeft, and Ilya Bolotowsky.[97]

At the heart of the debate was the question of the political independence of the artist and of the relation of the artist to the Popular Front. The Trotskyists asked, without any illusions as to the answer, if the congress was "a remnant of the cultural front of the communist party or an independent artists' organization." The vote that followed showed that the Communists were still firmly in control of the organization. For Schapiro and his allies, however, it was important to distance themselves from an organization that was linked not only to the Stalinists but also to the social aesthetics of the Popular Front. Despite Lynn Ward's motion in defense of the invasion and in favor of American neutrality approved by an overwhelming majority (125 to 12) Stuart Davis, disappointed by the politicization of the debate, was the first to resign on April 5, 1940. On April 8 Davis sent a notice to several New York City newspapers announcing his resignation. Meyer Schapiro and Ralph Pearson even recruited members to resign in protest. Approximately thirty artists withdrew from the congress. That same week, seventeen of them announced their secession publicly with a letter to the *New York Times* criticizing the congress's approval of the Stalinist "line," which they believed could damage the cause of free art.[98]

On April 17, 1940, following Davis's resignation, the *New York Times* published the text of the Schapiro group's declaration of secession:

The American Artists' Congress which was founded to oppose war and fascism and to advance the professional interests of artists, at its last membership meeting on April 4, endorsed the Russian invasion of Finland and implicitly defended Hitler's position by assigning the responsibility for the war to England and France. The congress has also revised its policy of boycotting Fascist and Nazi exhibitions (e.g. Venice and Berlin 1936). It has failed to react to the Moscow meeting of Soviet and Nazi art officials and official artists, which inaugurated the new esthetic policy of cementing totalitarian relations through exchange exhibitions.

Moreover, congress officials have informed members that participation in a projected fascist show at Venice is a matter of individual taste. The congress no longer deserves the support of free artists.[99]

This declaration was nothing less than a sweeping critique of the Stalinist line, the American Communist party, and its allies in the congress. It asserted that Stalinist policies could only prevent the rebirth of free art and hamper the individual creativity which alone could bring about a renovation of American art. The position of the Schapiro group

was based largely on the Breton-Trotsky position of 1938 and on the analyses published in *Partisan Review*. This shows that, notwithstanding commonly held opinions to the contrary, relations between writers and artists were decisive at a crucial moment when theoretical definitions were being settled.[100]

In order to maintain some degree of independence, the Schapiro group decided to organize the Federation of Modern Painters and Sculptors, whose declared purpose was the nonpolitical one of promoting "the welfare of free progressive art in America."[101] In fact the group's orientation was both political and aesthetic. It rejected the politicization of art, which led to such absurdities as posters advertising the Golden Gate Park exhibition in San Francisco in 1940, which combined Diego Rivera with strippers from the Folies-Bergère (fifty cents entitled the spectator to watch the master paint a fresco).[102] If this was the price of democratization in art, then democratization was unthinkable.

Even though many of the artists belonging to the Schapiro group were affiliated with the Trotskyists, the emphasis was on the apolitical nature of the group, whose purpose was said to be to defend the interests of artists and the "democratic way of life."[103] On November 1, 1940, the group began meeting in the studio of Morris Davidson, and minutes of these meetings show that for the most part the group's efforts were devoted to an active search for buyers to purchase members' works, which were promoted as examplars of artistic "quality." To that end a number of committees were organized. One such committee was the Committee of Sponsors, which was responsible for sending letters— "birth announcements"—to prospective buyers of new works.[104] Another was the Membership Committee, which kept the list of artists approved for membership by a vote of the group. Most important of all was the Exhibition Committee, which organized the group's shows. The Publicity Committee coordinated the activities of fourteen different artists' groups in New York.[105] However, some members of the group did not exhibit their own work but were associated for professional reasons and no doubt also because they were in a position to offer their help to artists in the group (such as members of the executive board of the Museum of Modern Art, professors, writers, museum curators, etc.).

Why was such a group formed, and why did it resort to such aggressive tactics in promoting its members' work? As we have seen, part of the reason had to do with the political situation. But the formation of the group was also in part a reaction to the social situation in which artists found themselves. The WPA had provided assistance to artists for a number of years, but by 1939, after the defeat of the Coffee-Pepper bill (which would have provided continuing funding for the arts), it seemed likely that federal aid would diminish. The aims and aggressivity

of the Federation of Modern Painters and Sculptors (FMPS) seemed to respond well to the fears voiced by several artists' associations, like the Fine Arts Federation.[106]

Federal control will in the long run substitute journeyman standards of art for truly artistic standards, mediocre common standards in place of the highest individual standards, regimentation of art work in place of individual talent, and personal and political pull in the award of art jobs in place of free and open competition.[107]

The FMPS also responded to the worries of traditional critics, who were discouraged by the hostile Parisian reception that met the Three Centuries of American Art show held in the summer of 1938 at the Jeu de Paume. Proposing an open structure as an alternative to the institutionalized mediocrity of American art, the FMPS promoted individual effort in the arts, as opposed to the collective efforts being promoted by the government. The French criticism of the official exhibition of American art is interesting, because it reveals the sorts of attitudes with which the avant-garde would have to contend after the war, when American painting again began to be shown in Paris.

French critics were so hard on "young" America that it took a year for American art circles to prepare a response. In 1939 two books concerned with the state of contemporary art in America appeared: *Have We an American Art?* by Edward Alden Jewell (art critic for the *New York Times*) and *American Painting Today* by Forbes Watson (of the American Federation of Arts). The shock of the French attack was all the more severe, these writers felt, because American museums had been enthusiastic in their preparations for the show. For the first time governmental efforts in the cultural sphere had made it possible for America to venture with some confidence and with a new awareness of its talents to mount a major exposition. Unfortunately the bold plans did not reap the expected rewards. Those French newspapers that bothered to cover the event were amused by the efforts of the Americans to present a "cultivated" image of themselves. Knowing very little about America, French critics used the most hackneyed stereotypes in evaluating cultural life in the United States: the country was "young," they said, young and naive and yet modern and extravagant, lacking European refinement and all sense of proportion. Edward Alden Jewell noted the reactions of the French press in his book with some irritation.

America, according to the French, is Hollywood. Thus, it should come as no surprise that American films were prized and honored in dithyrambic terms: "I would give all the contemporary paintings in the U.S. for a few meters of American films," proclaimed French critic François Fosca in the newspaper *Je suis partout*.[108] America at that time was also

seen as New York and its skyscrapers, so there were laurels for American architecture. Along with cinema and architecture it was industrial art that was said to be representative of this modern civilization, oppressive and brutal of course and yet endlessly fascinating. For the French this was all that America could be. Laudable though its efforts in painting might be, they were not really to be taken seriously. For true painting depended on the aesthetics, the taste, and the standards of a long cultural tradition; at the very heart of culture, painting requires a refinement that takes centuries of work, analysis, and study to acquire. Painting, in short, could only be done in France. Blinded by this prejudice, French critics showed no mercy in their treatment of the American paintings in the show, which they regarded as entirely derivative, based on the work of the Paris school. How could American painting possibly be original when all the keys to painting were in Paris? Even the regional art that American artists saw as a uniquely American product was viewed in Paris as a crude by-product of French realism.

Characteristic of French reaction was André Villeboeuf's article in *Gringoire*. Villeboeuf reported making his way through

huge rooms . . . hung with paintings of the so-called avant-garde, which betray the germ of academic death. Here is painting justly styled "International" without origin, without taste; marked alone by an originality that accentuates the indecency of its arrogance, the puerility of its conceit out of fashion with us in France (This "international" painting never attracted any but a few complacent snobs). It is distinguished by nothing particularly American.[109]

The modernity of American film and architecture was set alongside primitive American painting, the only American painting that found favor in French eyes. Primitive art, said the French critics, embodied the exuberance, the naiveté, the raw, popular force that they took to be the essence of America (mingling reality and myth).

Serious American painting was disparaged because it did not contain the novel way of life that could be detected in the more "naive" paintings. Serious American painting was in thrall to Paris. It imitated Parisian forms and because of its international style was artificial and worthless. It was a decadent style, just as International Gothic was once decadent. These criticisms show how precarious the situation of American painting was. On the one hand it was derided for its cold, dead international style, while on the other hand it was said to be a provincial art that imitated Paris and that could break out of its provincialism only by becoming "international." By shaping critical discourse Paris kept a firm grip on Western culture, as everyone was aware. To move up a rung on

the scale of cultural values was no mean feat. These values were as clearly delineated and as jealously guarded as colonial possessions.

Jewell's book is interesting for its careful analysis of the problems raised by the exhibition. Unlike isolationist critics in America, Jewell was aware of the dangers of over-Americanization of American art at a time when world war threatened to break out at any moment. He chose to replace the ambiguous notion of "internationalism" with the equally abstract idea of "universality." Judged against this latter standard, American art was, he felt, up to Parisian norms. In fact he was suggesting a strategy to American painters, offering them a way to think about their art that reflected a tendency increasingly prevalent in the mind of the public just a few months before the outbreak of World War II as this letter received by Jewell shows:

> While nations war and prepare for war and politically tend to become more nationalistic, the world of art (I hope) travels a different road and tends to become more universal, approaching finally the expression of a common human experience. Here in America, with all the intermingling of nations and races, would seem an unusual opportunity for artists to achieve a universality of expression. Why deliberately aim to make smaller that expression by pinning it down to one locality or nation? It all sounds too much like the egotism of the small boy crying for attention.[110]

The goal of universality had a quite specific meaning: art must be independent. But a considerable obstacle stood in the way of attaining that goal: the Parisian machine.

As Thomas Craven saw it, Parisian dealers had such firm control of the American market and echoes of Parisian ideology were so widespread that Parisian art had a virtual monopoly in the United States. Unless this situation was changed domestic art could not hope to gain recognition. The change was to be brought about by the war. Forbes Watson has this to say:

> The American artist saw that picture buying in New York was dominated by Paris dealer agents, who at every turn discouraged their American clientele from buying the work of the native artist. By the time our period began, America had been treated to a quarter of a century of propaganda so astute and untiring that even minor talents if quoted on the Paris picture bourse, could sell perverse and disingenuous work more easily on the American market than American major talents could sell sincere and able pictures.[111]

The books of Jewell, Craven, and Watson set forth the fundamental issues that were debated by American artists during and after the war.

The artist's political independence was to be matched by his independence of Parisian dominance in the art market.

If this plan was to succeed, a first-rate museum was an absolute necessity. Recently moved to new quarters, the Museum of Modern Art in New York was determined to fill the bill, to be certain that its work was both scholarly and bold and that its standards measured up to those of Europe. This was Paul Sachs's message to the museum trustees in his speech commemorating the opening of the new museum. He emphasized the need for the elite to educate the general public through the museum:

> The need of greater cooperation between museums and universities to the end that we may develop scholarship, combined with connoisseurship plus a greater insistence on standards; that is, our future curators and directors need more time for study in youth, quiet, untroubled study; in order to form scholarly habits. . . . The Museum of Modern Art has a duty to the great public. But in serving an elite it will reach, better than in any other way, the great general public by means of work done to meet the most exacting standards of an elite.[112]

The disintegration of the governmental structure of support for the arts which had been created during the Depression dumbfounded the artists who had to cope with a new atomization of the art world. They organized in small groups, often drawn together by shared political and aesthetic convictions. Now they had to face a new reality: each artist as an individual was up against a very limited private market that was virtually closed to American art.[113] Painters, who were still receiving federal aid from the WPA, were increasingly pressured to give it up, either for political reasons or to hasten preparations for mobilization.[114] These, then, were the circumstances surrounding the creation of the Federation of Modern Painters and Sculptors after the disintegration of the American Artists' Congress. Though less prestigious and more eclectic than the other artists' group, the AAA, the federation is rewarding to study because it tells us about the conditions under which one group of artists worked, and as it happens this group turned out to be potent enough to transform the American art scene during the war years.[115] The federation first came to prominence in the art world thanks to an aggressive publicity campaign modeled on the strategy perfected by the French avant-garde in the nineteenth century. The Cultural Committee, headed by Gottlieb and Rothko, decided that its policy would be "to send protest letters whenever required."[116] Constant invective against the "establishment" turned out to be the perfect way to win recognition in the complex and versatile world of art. To attract further attention the

federation even planned a group exhibition to be held in an enormous tent that would have made Courbet himself blush with pleasure.[117]

In March 1940, as though in response to the dissident federation, a new magazine, *New York Artist*, appeared. It was published by the United American Artists, a Communist-dominated group that followed the new Party line in foreign policy by opposing the entry of the United States into the conflict in Europe and by sanctioning the artist's participation in politics.[118] The third issue of the magazine, which appeared in May 1940, attacked the "imperialist war" and urged all artists to do the same:

Artists are antipodal to those forces which bring about the modern imperialist war, because they begin by a denial of the means of life to others, because of the slaughter of human beings who have no stake in such war, and specially because war brutalizes culture which is the highest product of men's peaceful association.

When the flames of war mount so high the artist himself is apt to look upon his work as ironic and tragic by contrast. It was speculation in just such possible discouragement that might have led a professor of esthetics recently to pronounce in the art pages of the *New York Times* that the war will usher the artist back into his ivory tower. . . . But the situation today is bound to disappoint such hopes and speculations. The ivory tower is an image of a past that will never rise again.[119]

After June 1941, that is, after Nazi Germany launched its attack on Russia, another shift took place on the left. The American Communist party now supported sending the U.S. Army to Europe to defend democracy. This led, as during the period of the Popular Front, to the obliteration of political and social differences and produced a temporary sense of euphoria that covered up basic contradictions in the positions adopted by various groups. The effect of the inevitable rallying around the flag was to produce a mixture of bellicose nationalism and hopeful internationalism that seeped into all the pores of American life and had the most curious consequences on the cultural scene, as we shall explain in the next chapter.

No longer was the interest of the leading painters and intellectuals focused, as it had been during the thirties, on the issue of the artist's relation to the masses. From social concerns the center of attention had shifted to individual concerns owing to the disappearance of any institutional structure for political action. After 1940 artists articulated individualized styles, yes, but styles that were invariably rooted in a simulacrum of the social. The artist's attachment to the public was still a central concern, but that concern had evolved and had changed targets, as it were. Whereas the target had once been the masses, thanks to such

social programs as the WPA, now, with the recent growth of an open private market for art, the target became the elite. In regaining his alienation, the artist abandoned his anonymity: "Toward the late 30's a real fear of anonymity developed and most painters were reluctant to join a group for fear of being labeled or submerged."[120]

2
The Second World War and the Attempt to Establish an Independent American Art

Particularly in our relations with Latin America must we sustain the all too recently begun emphasis on our cultural rather than our economic life, for at this moment the respect and friendship this brings are literally weapons for wartime use. And no less shall we need, when the war is over, to win the same respect from the nations of Europe and Asia.

ALFRED M. FRANKFURTER
ART NEWS, 1943

When the lights went out in Paris, panic reached as far as New York and beyond into the American hinterland. The American press without exception lamented the abandonment of Paris to the Germans. Lost without a battle, Paris now suffered under the jackboots of the Nazis, but at least it had been saved from destruction. The city of light may have been protected by its culture, but this made it no less painful for American editorial writers to see the symbol of Western civilization calmly abandoned to "barbarism."

Paris was occupied by German troops on June 14, 1940. For five years life came to a standstill, or rather it soon took another form, hushed, incomplete, half-hidden. Seen from abroad Paris was a ghost town. Americans saw in the fall of Paris the death of a certain idea of democracy. For them Paris stood for the triumph of individualism, for a free way of life made popular by the artists of Montparnasse.

If the defeat of the Loyalist armies in Spain had previously struck the liberal imagination, the reason was that the fall of the Spanish Republic represented the defeat of democracy in a war against fascism. For Paris to fall without a shot being fired was more serious still, because it represented the symbolic destruction of Western culture, even though the

city's artistic treasures had been saved. American newspaper editorials were in no doubt as to what had occurred: a symbol had been killed, Western culture lay in chains, and freedom of expression was stifled:

It was freedom which made Paris great. Men and women were free to utilize their full talents, without restraint. They came from all corners of the earth and found a place to match their wits with masters in every craft. No small minded politician told them what to say or do or think. This liberty was not a possession of the intellectual elite alone. It was enjoyed by the man on the street and the woman in the kitchen. To live in Paris was to breathe the unaltered air of individualism.[1]

Those responsible for the destruction of this way of life were depicted as satanic savages bent on destroying all civilization and on returning to a time of disorder, of noncivilization. Fascism was said to be a reversion to the Dark Ages, when men, unaccustomed to the civilizing benefits of Christianity, behaved like beasts. It spelled the end of the "democratic way of life."

The fact remains that the alliance against Hitler and Stalin is an alliance to preserve the way of life that Christ brought into the world. In main outline this way of life gives first importance to the worth of the individual and his sacred rights, whereas the Hitler-Stalin formula completely submerges the individual in the state, and repudiates all the chief tenets of the Christian religion. . . . Nothing like it has been seen before and the modern conspiracy against democracy and the Christian way of life is more powerful, ruthless and unscrupulous than those of Genghis Khan or Attila or the Saracens.[2]

This simplistic analysis of the political and ideological situation of Europe in 1940 might be ludicrous if it was the work of an isolated editorial writer without much influence, but it was not. The same tone was taken by most newspapers and even crept into the speeches of Vice-President Henry Wallace:

The people's revolution is on the march, and the devil and all his angels cannot prevail, for on the side of the people is the Lord. . . . Strong is the strength of the Lord, we who fight in the people's cause will not stop until that cause is won. . . . No compromise with Satan [Hitler] is possible. . . . We shall fight for a complete peace as well as a complete victory.[3]

In 1939 it was still possible to believe in an isolationist America as the guardian of Western culture, as Harry Truman did: "The role of this

great Republic is to save civilization; we must keep out of war."[4] But after June 1940 it became increasingly dangerous politically to defend neutrality. After Pearl Harbor (December 7, 1941) it was almost impossible to do so. Dwight Macdonald and Clement Greenberg were the only writers in the pages of *Partisan Review* to hold out for an anticapitalist alliance against the war, a position they maintained until 1943. As they saw it, the conflict was producing strong social pressures that were all too likely to yield a home-grown variety of fascism and that constituted a grave threat to culture.[5]

Harold Rosenberg took up his pen in November 1940 to write a long and heartrending article in *Partisan Review* on the fall of Paris.[6] Rosenberg was not surprised that Paris had fallen without a fight, since in his eyes the French capital had fallen long ago, when its intellectuals surrendered to the Popular Front. The capital that Rosenberg evoked was the unique capital of the world, the capital of modernity. Unfortunately, in using this notion as a way of combating the powerful nationalist undercurrent in American art, the poet chose this dramatic moment to abandon his critical powers and swallowed whole the ideology of the School of Paris that had been forged by centuries of cultural imperialism: "Because Paris was the opposite of the national in art, the art of every nation increased through Paris."[7] The prevalence of this ideology would have been obvious to anyone reading the text that accompanied Parisian works shown at the New York International Exhibition of 1939, a text supplied by the French governor-general Olivier:[8]

The United States has invited the other nations of the world to participate in a show whose theme, as bold as it is engaging, is this: "What will tomorrow's world be like?" In its magnificent past France has experienced periods of storm and stress and yet has risen again to provide new answers both simple and glorious on so many occasions that we are able to smile at the question put by America and answer quite calmly, "Tomorrow's world will be like yesterday's and today's, largely of French inspiration."[9]

In any case, Rosenberg's article defined a certain type of modern culture for which Paris stood as the symbol in Western eyes. Now that the place accepted as the breeding ground of international culture had been snatched away, an enormous void opened up, and unless it was filled there was a new danger of reverting to nationalistic "barbarism" and its associated conflicts. The fault lay not with the Parisians but with civilization in its entirety: by its carelessness the "intellectual international" had allowed Paris to forfeit its privileged position by rejoining the real world:

No one can predict which city or nation will be the center of this new phase. For it is not by its own genius alone that a capital of culture arises. Currents flowing throughout the world lifted Paris above the countryside that surrounds it, and kept it suspended like a magic island. And its decline, too, was the result, not of some inner weakness—not of "sensuality" or "softness," as its former friends and the present enemies of the people declare—but of a general ebb. For a decade, the whole of civilization has been sinking down, lowering Paris steadily towards the soil of France. Until its restoration as the capital of a nation was completed by the tanks of the Germans.[10]

The responsibility of the intellectual for the decadence of Paris was a burning question of the day and for Rosenberg the crucial fact in the French defeat:

One had scarcely questioned the reception—in the city of the Communards, and of Rimbaud, Courbet, and Zola—of the stupid police pageant of Moscow, with its grotesquely staged appeal to the simple-minded of all countries. . . . A few courageous men—Gide, Breton, Serge, a few others—strove to uphold the tradition of French criticism. But what "higher need" had paralyzed the conscience of non-conformist Paris? The higher need was antifascism.[11]

The May 18, 1940, issue of the *Nation* carried an article entitled "The Irresponsibles" by Archibald MacLeish. MacLeish was no revolutionary, though the American Communist party had courted him during the Depression after the publication of his open letter "to the young men of Wall Street." This contained an attack on corruption and inequality and urged that these evils be eliminated in order to save capitalism, according to MacLeish the only system that allowed the artist sufficient freedom to develop his talents to the full. Clearly, then, the poet's position was an ambiguous one; his attacks on fascism were welcomed with respect on the left and used by both Communists and apolitical artists. MacLeish's virulent attack on the silence of American intellectuals in the face of war in Europe triggered a long series of polemics in which the *Nation*, the *New Republic*, and *Partisan Review* attempted to define the role of the artist and intellectual in wartime. The article also launched an anti-isolationist movement that culminated in 1943 in an internationalist policy.

The "irresponsibles" referred to in the title of MacLeish's article were intellectuals who had not thought it necessary to defend culture against fascist attacks. Now there was a new awareness that the intellectual had an important ideological role to play and that in time of crisis he should do so openly.[12] If culture is not defended by its creators, said MacLeish, its future is in peril.

For Dwight Macdonald, on the other hand, culture was in danger when an attempt was made to make it subservient to an official line, to the needs of politics. MacLeish, however, found it incomprehensible and reprehensible that the American intelligentsia could stand by and watch the destruction of culture in Europe:

It is to this direct, explicit, and intentional attack upon the scholar's world and the scholar's life and the scholar's work that American scholarship has been indifferent. Or if not indifferent then inactive; merely watchful—fearful, watchful and inactive. And it is there that history will place its question: How could we sit back as spectators of a war against ourselves?[13]

As defined by the poet, the destruction of culture was a very serious matter, involving the fascist attack on scholarship, research, and the critical spirit. Artists and writers, MacLeish proclaimed, were too preoccupied with their own personal problems to take part in the great battle that was shaping up. What he wanted was for intellectuals to forget their ideological differences and regroup in a united front supporting the war against fascism. In a sense this was a call for a new "popular front," and this time an "apolitical" one. In wartime, according to MacLeish, artists should forget about making art, or rather they should devote their talents to the production of useful art in the service of the war effort:

What matters now is the defense of culture—the defense truly, and in the most literal terms, of civilization as men have known it for the last two thousand years. [The "irresponsible"] has his work to do. He has his book to finish. He hopes the war will not destroy the manuscripts he works with. He is the pure, the perfect type of irresponsibility—the man who acts as though the fire could not burn him because he has no business with fire.[14]

There were many responses to this call, demonstrating how tragically powerless the intelligentsia felt. The previous ten years had disappointed not only those who had preached revolution but also those who had defended democratic and liberal values. Those who had favored direct action and who had enlisted in the Abraham Lincoln Brigade to defend democracy in Spain had lost their illusions as they watched the fighting left disintegrate as a result of political conflicts beyond their control. These experiences had left many of those who responded to MacLeish in a state of deep despondency. Now, on the eve of war, the long hoped for socialist revolution was forgotten. Many intellectuals of the left thought of the war itself as a bad dream to which they could not really respond.

Along with MacLeish's article, Van Wyck Brooks's *Primary Literature and Coterie Literature* raised new challenges to what *Partisan Review* had stood for since its abandonment of proletarian literature: an international avant-garde. This only made Dwight Macdonald that much more virulent in his condemnation of what he called the "Kulturbolshewismus" of the "MacLeish and Brooks thesis."[15] Under the banner of national defense, this thesis attacked international modernism and defended an aggressive nationalistic art. It attacked Nazi nationalism in the name of American nationalism. According to Macdonald and such remaining stalwarts of the independent left as Farrell, the proposed solution was as dangerous as what it attacked.[16] Both versions of nationalism appealed to the artist to give up his critical role entirely and to become a cog in the machinery of politics:

Here we have that *official* approach to culture which has spread far beyond the confines of the Stalinist movement. Brooks' thesis is essentially an amplification of the attack on the "irresponsibles" made a year ago by Archibald MacLeish, Librarian of Congress and intimate of the White House. And would not Goebbels, the foe of "degenerate" modern art, applaud not only the particular cultural tendency attacked but also the very terms of the argument: "Primary literature somehow follows the biological grain; it favors what psychologists call the 'life drive'; it is a force of regeneration that in some way conduces to race survival." "Kulturbolschewismus," "formalism" "coterie writing," "irresponsibles," the terms differ for strategic reasons, but the content—and the Enemy—is the same.[17]

In this climate the work of the *Partisan Review* ironically came to seem more and more that of a "rear guard."[18] Macdonald tried to form a group of writers to fight against this new repression but failed. At the beginning of the war the social forces were too strong to sustain any illusion that the artist might be able to swim against the tide.[19]

The United States was pleased to see that the title of the new capital of Western culture was within its grasp, though it had no clear idea what this title meant. Nevertheless, it was necessary to lay the groundwork for the transfer of the crown. This was not easy, because for years artists interested in modernism had to go and study in Europe: the issue was more subtle than the mere selection of a new geographic location.[20] The debate revolved around changing mental habits and reconstructing an ideology similar to but distinct from the Paris ideology. The irony in this recreation of an ideological environment is that it was based on a misunderstanding of the threat fascism posed to Western culture.

When the political and cultural crisis erupted in Europe in 1940, it became clear that the traditional role of Europe would be passed on to the United States. Within a very short time it was also clear that the economic strength of the United States would be decisive in the battle that was about to begin. By 1940, the historian Robert Divine tells us, it was clear that the United States would not let pass this "second chance" to become the leader of the Western world.[21] With the outbreak of hostilities America began laying the groundwork for the coming peace. Every section of the political world in the United States agreed that art would have an important role to play in the new America, but what kind of art was not yet clear.

Since the outbreak of war the American press had been unanimous in its call for the defense of the West's most precious possession, its culture. The papers were full of caricatures showing the murder of Civilization, who with her torch brings light to the world, by a barbarian in German boots and helmet. Sometimes the image of the destructive barbarian was replaced by a fearsome gorilla—the result, obviously, was the same.[22] These caricatures and the accompanying articles gave currency to the erroneous idea that fascism was destroying all culture. In reality fascism was getting rid of a certain type of culture: modernism. The fascists were in fact making use of culture and the cultural tradition in a thousand ways, using art, cinema, and literature for their own ends, and what is more in a very convincing way.[23]

Rejected by fascism, modernism was in the United States confounded with culture more broadly and abstractly defined.[24] As a result, what the mass media were defending without knowing it was the concept of modernism with all its attendant ambiguities and contradictions. Though modernism had previously not caught on in the United States, now it slipped in through the back door, as it were, and established itself in the national consciousness. As things turned out, the war was to do far more for modern culture in the United States than all the efforts of *Partisan Review* put together.

Before the nation could support a modernist avant-garde, however, it first needed to develop an awareness of art and organizations within which dialogue and controversy could take place. What was needed was a continuation of the efforts timidly begun with the WPA. Just as Paris was falling to the Germans the American government organized a "Buy American Art Week," which was to be held every year. This program to democratize art was to have three major effects: first, it created a broad mass market for the work of American artists at a time when WPA support for the arts was on the wane; second, it resulted in a reorganization of the private art market; and third, it stimulated public discussion of art and so helped to popularize the views of recent immigrants

from Europe. Furthermore, Buy American Art Week, held in 1940 and 1941, was well attuned to the needs of a period during which the United States was not yet a direct participant in the war. The new enthusiasm for the arts not only met the cultural needs of the nation but also satisfied a political need without engaging American forces on the ground. America participated as a defender of the arts in the war effort against fascist obscurantism. To assist American artists and to contribute to the victory of life (artistic creation) over death (Nazi barbarism) was seen as a national duty. This burst of enthusiasm was cut short by the Japanese attack on Pearl Harbor and the United States' entry into the war. The brochure published during the Buy American Art Week of November 25 to December 1, 1940, laid out the objectives of the program. The purpose of the program was similar to that expressed by Archibald MacLeish: it was designed to bring much-needed assistance to American culture in the face of the new world conflict. America needed a cultural identity, and Americans needed to find in American art "something to fight for":

Our country today is turning toward the arts as at no other time in the history of the Republic. A great tide of popular interest in American art has been rising during the past few years. There are strong currents toward an art of native character and native meaning which shall express with clarity and power the interests, the ideals, and the experience of the American people. It is a significant fact that our people in these times of world emergency are turning more and more to their own cultural resources.[25]

The real popular interest in painting,[26] new since the inception of the WPA, was used in this art week but used without discrimination. At this stage of American cultural development the democratization of art meant the purchase by amateurs of original paintings or engravings, rather than the usual reproductions, for use as decoration. The public received its artistic education through government-sponsored shows and through works reproduced in *Life* magazine. The public that assimilated the traditional art sponsored by *Life* was prepared to react against the excesses of the avant-garde. The purpose of government efforts in this period was to stimulate mass consumption of art works by a new audience, thereby creating a private market for art and resolving the marketing problem created by the enormous American output in the arts. It was hoped that the private market would supplant WPA subsidies.[27]

This experiment was quite in keeping with the New Deal and as such was greeted with sarcasm by the conservative press (*Time* for example). Nevertheless, the statistics were impressive: 32,000 artists showed works

in 1,600 exhibitions across the country. American art was finally reaching the broad public, all to the benefit of national feeling:

In front of Portland Oregon's handsome neo-Georgian Museum of Art (its facade draped with red, white and blue bunting) a W.P.A. band trumpeted, God Bless America, while museum attendance jumped from 75 to 400 daily.[28]

In connection with Buy American Art Week a panel discussion was held at the University of Chicago and broadcast over the radio: its title was "Art and Our Warring World."[29] The transcription of the exchanges between Clifton Fadiman, Eleanor Roosevelt, Louis Wirth, and Archibald MacLeish is crucial for understanding the goals of the American government, which hoped to use art and culture generally as a unifying and pacific influence:

FADIMAN: What MacLeish and Mrs. Roosevelt say opens up, first, an enormous perspective and an enormous responsibility for us Americans. It is quite possible that if things continue as they now are in Europe, whether we wish to or not, we shall be forced to be receivers, as it were, of a bankrupt European culture.

WIRTH: Yes, and to carry on that Western civilization if it is to climb to new heights or to survive this crisis.

FADIMAN: We have reached a critical point in the life of our nation. We are through as a pioneer nation; we are now ready to develop as a civilization.

WIRTH: Art is not only something that is pretty, but art is the expression of some human expression.

FADIMAN: What you are saying seems enormously important from the point of view of national defense in this way: Art is a method of unifying people. When the recent election was over, a great cry for unity arose—you, Mrs. Roosevelt, ought to remember that particularly. This business of unity is dandy, but how do you get it? In this country we don't get it, I think, by the kind of regimentation that other countries have adopted. We get it by people agreeing to or trying to agree, more or less honestly, on a few fundamental things and disagreeing on a lot of others. One of the things that makes people agree with each other is the observance or enjoyment of a work of art. . . . I think the enjoyment and appreciation of art is one means of insuring the kind of psychological unity we are after, and that is why it is important in national defense.[30]

This send-off launched the advertising campaign to sell American art and set the new machinery in motion. But this machinery was so new

that it was still plagued by internal friction: in particular, the Museum of Modern Art, more deeply involved in modernism than other American institutions, did not pay as much heed to American artists as to the great Parisian tradition. It should be noted, however, that its activities during the war years were considerable, and no occasion was missed either to galvanize public morale or to aid the government directly in its military programs.[31] This pro-American propaganda was made necessary by the fact that the output of American modern artists was still small and trailed behind French production; Americans were still paralyzed by the image of Paris even though the political situation dictated that they must take up the baton. The situation at times seemed an impossible one.

In spite of the president's efforts, the American art market and "level of taste" were disastrous, as the painter Byron Browne observed in 1940:

At present it no more occurs to the average American householder that he could own an "original" oil than ownership of a car seems possible to the average Haitian peasant. But I do not think that price is the bar in our case, as it is with the Haitian. In any of the numerous independent or W.P.A. shows all over the country you find plenty of oil paintings and stacks of water colors priced at $25 to $50. But who wants them? Most of them are too abstract and mean nothing to anybody except the artist. A considerable number are simply tripe. Others are that tiresome hammer and sickle stuff, third rate Rivera.[32]

By contrast, George Biddle, a New Dealer, felt that such New Deal experiments as the Buy American Art Week bore witness to a remarkable upsurge of democracy on a scale that could only be compared to the ebullience of the Italian Renaissance:

It becomes then of interest to note that the great swing of the pendulum in American art away from art for art's sake—the preoccupation with aesthetics, the école de Paris, abstractions and the other isms— toward a more extroverted, human interest, American scene expression almost exactly coincides with the federal patronage and the more popular reception and wider interest in contemporary painting.[33]

The two positions were not contradictory but complementary. Although there had been a resurgence of interest in art in general in the United States at the beginning of the war, this interest was directed toward traditional art and generated few sales. George Biddle, in his article "Can Artists Make a Living?" questioned a large number of artists (average age: fifty) and came to the conclusion that the average annual income of an artist of renown was on the order of two thousand dollars. American art was not yet able to fly under its own power.

Not everybody had the same idea of what modern American culture was. George Biddle and the officials in charge of the WPA were banking on popular art, on a form of art in which number and diversity counted for more than quality. As for the Museum of Modern Art, though completely caught up in the war effort, it continued to defend an international modern art for which the imperiled art of Paris stood as a symbol. As a result the museum came into conflict not only with American artists who were dedicated either to regionalism or to social realism but also with the painters of the AAA, who were "playing the international card" by copying Paris a bit too assiduously (fig. 1), as well as with the Federation of Modern Painters and Sculptors, whose fault was the opposite: it had no definite tendency.

Politically, the years 1941–43 saw the United States abandon its isolation. This was a period during which very gradually Roosevelt involved the nation directly in world affairs and overcame its traditional isolationism. During these few years two major concerns were influential, though at first sight contradictory: nationalism and internationalism. Nationalism, in the guise of patriotism, had to be promoted in order to create an ideologically unified public prepared to wage a world war (and the promotion of nationalism was already under way well before Pearl Harbor). At the same time, the nation had to be prepared mentally to assume the leadership role that America would be called upon to play after the war in all areas. The longer the war went on in Europe, the more the notion of internationalism took hold in the minds of the general public. Day by day support grew stronger for a U.S. role in peacekeeping once the war was over.

Shortly after war was declared in Europe, American groups began organizing for the purpose of investigating America's place in the postwar political order, to ensure that the country would not again be caught unaware as it had been in 1918. Once peace was restored, the new order could not be consolidated unless the United States played a central role. A new willingness to consult with other nations was therefore essential. Between 1939 and 1943 we see a fundamental shift taking place in American attitudes toward relations with the rest of the world. Both in the government and in the public we see a move away from fierce isolationism and toward one form or another of internationalism, varying according to underlying political commitments.

The change was rapid: within the space of a few months all political factions had to take a position on internationalism and differentiate themselves from other groups on the issue. The process began in 1939 when James T. Shotwell invited fifty experts on international relations to discuss the problems that would inevitably come up once the war was over. This group financed a CBS radio series broadcast in January

1940 under the title "Which Way to Lasting Peace?" and aimed at a broad public, for the most part still isolationist. Its proposals were set forth in the book *Union Now* by *New York Times* journalist Clarence Streit, which was a tremendous success, not only because it called for the development of an international organization to police the world but also because this organization was modeled on American democratic politics and its sole beneficiaries would be the English-speaking nations.[34] Another sponsor of this plan was Henry Luce, the influential publisher of *Time*, *Life*, and *Fortune*, who in an article resoundingly entitled "The American Century" unambiguously defined America's future world role: the United States was to become the uncontested leader of the world, provided the country had the will to seize the opportunity.[35] In this highly didactic article, Luce explained that it was naive to believe in American neutrality when in fact the country was already at war. Hence the country must respond to the emergency by accepting its responsibilities and winning the war as quickly as possible. This was America's big chance: "The big important point to be made here, is simply that the complete opportunity of leadership is ours."[36] The coming century could be America's century just as the nineteenth century had been the century of England and France:

> For example, any true conception of our world of the 20th century must surely include a vivid awareness of at least these four propositions. First, our world of 2,000,000,000 human beings is for the first time in history one world, fundamentally indivisible. Second: modern man hates war and feels intuitively that, in its present scale and frequency, it may even be fatal to his species. Third: our world, again for the first time in human history, is capable of producing all the material needs of the entire human family. Fourth: the world of the 20th century, if it is to come to life in any nobility of health and vigor, must be to a significant degree an American century.[37]

The coming American century would undoubtedly be another age of Pericles for the entire world: "The vision of America as the principal guarantor of the freedom of the seas, the vision of America as the dynamic leader of world trade, has within it the possibilities of such enormous human progress as to stagger the imagination."[38] Through his widely circulated magazine Luce not only leapt to the defense of endangered capitalism but also popularized the idea that for America to move away from isolationism was not only not dangerous but a unique opportunity. His friends' comments clearly illustrate the importance of the message and its impact on conservatives suspicious of Taft's isolationism. Dorothy Thompson wrote in the *New York Times* that "to Americanize enough of the world so that we shall have a climate and environment favorable to our growth is indeed a call to destiny."[39] And

Quincy Howe said in a radio broadcast that "Luce has achieved what some of the great British statesmen of the last century achieved, complete identification of his own nation's interests with the interests of humanity and of moral law."[40] But the mass media were not always willing to accept the thinly veiled imperialism contained in these proposals and searched for a less crude alternative to Luce's nationalist internationalism.

On April 8, 1941, the government itself gave internationalism the green light when liberal Vice-President Henry Wallace made a speech supporting the creation of an international peacekeeping force.[41] Responding to Luce's aggressive tone, Wallace delivered a speech in May 1942, "The Price of Free World Victory," in which Luce's "American Century" was replaced by the "Century of the Common Man." Wallace's dream was one of a new world order from which imperialism would be banished and in which rich nations would help poorer ones work toward democracy. Looked at more closely, the system proposed by the vice-president appears to have been an identical twin of the New Deal, a New Deal for the whole world.

In the summer of 1942 Dwight Macdonald responded to both Luce and Wallace with an article ironically entitled "The (American) People's Century," in which he was critical of pan-American visions of a world rebuilt in the image of the United States and for America's greater glory.[42] The similarity of Luce's ideas to those of Wallace, which illustrates the degree to which imperialism had become identified with liberalism, alarmed Macdonald. This aberration, he claimed, was the result of war and its accompanying social pressures:

> Two disturbing elements of American culture were joined: Luce who symbolized the decadent journalism purveyed by conservative capitalism upon the masses and Wallace who was a representative of the optimistic liberalism enthroned in the Roosevelt Administration and encrusted in the artistic tenets of the Brooks-MacLeish thesis.[43]

In March 1943 Senator Joseph H. Ball of Minnesota introduced and secured passage of a bill calling for an international police force to keep the peace. This signal launched a broad movement and led to a meeting of all the internationalist groups, which at the behest of Clark M. Eichelberger met on July 30 under the auspices of a single new association, the United Nations. All the best-known internationalist leaders were represented. By the end of 1943 the United Nations Association was quite active and thanks to its newsletter *Changing World* and to a series of radio broadcasts financed largely by the Carnegie endowment had achieved considerable visibility on the political scene. The association emphasized the leading role that the United States would have to play

in the future: "Democracy is not dead; but it can live only in an organized world. America is the last best hope of earth in building such a world. The time has come when America must keep her momentous rendez-vous with destiny."[44]

From 1941 on the United States became more aware with each passing day of the growing interdependence of all the nations of the world. Both major parties had internationalist left wings, represented by Willkie on the Republican side and Wallace on the Democratic. With Roosevelt's approval Willkie set out in July 1942 on a world tour that took him to Russia and China. Upon his return he published a book that quickly became the best-selling work of the period: *One World*. Willkie's thesis in this book was already quite popular and strengthened those who wished to see the United States take a greater part in world affairs. Correct in its estimate of the desire for independence on the part of colonized countries, *One World* erred on the side of optimism. Techno-logical progress, Willkie thought, would reduce the world to a global village and in the end restore the harmony destroyed by the war.

In 1943 the Gallup poll along with most other surveys indicated that the American public hoped to see national security guaranteed by an international organization of some sort. In September of the same year the Republican party met on Mackinac Island and passed a resolution which, though ambiguous, placed the party in the internationalist camp. The Republicans voiced their approval of "responsible participation by the United States in a postwar cooperative organization among sovereign nations to prevent military aggression and to attain permanent peace with organized justice."[45]

In response to the idealism of *One World*, Walter Lippmann in 1943 published *U.S. Foreign Policy: Shield of the Republic*, in which he expressed his support for a future international nuclear alliance including the United States, Great Britain, and Russia, as a way of settling the world's prob-lems. Clearly, then, 1943 was a crucial year for the new internationalism in America. The change had come about quietly, but as Macdonald pointed out disapprovingly, wartime pressures had imbued all the var-ious internationalist tendencies with a touch of imperialism. America's role was always seen as central, as decisive for the new world order. This debate was to affect every sphere of American society. Art was not exempt, so that it should come as no surprise that artists along with other Americans set a new course for themselves in keeping with Amer-ica's sharply altered self-image. The influx of European refugees, who brought with them a cultural baggage that American artists had always admired without altogether assimilating, suddenly brought home to New Yorkers especially that the United States was indeed at the center of the cultural upheaval provoked by the war.[46] Comparing the flow of refugees due to the war with other great migrations in history, commentators

stressed the profound and beneficial impact that the immigrants would have on America, which, like Italy welcoming refugees from Byzantium, would allow Europe's shipwrecked culture to flourish on its shores.

The crisis of the West—the disintegration of modern Western culture exemplified by book-burnings and by exhibitions of degenerate art— was a profound crisis, to be sure, but one that signified not the death of Western culture but rather its rebirth, reinvigoration, and purification by fire, its starting over again in a new place, America. Indeed, New York seemed the only place in the world cosmopolitan enough to replace Paris.[47] Once American artists and intellectuals realized this, it became imperative for them to reconsider their relation to their own national culture as well as the relation of American culture to international culture and to adjust their actions accordingly, so as not to miss this unique opportunity to join the modern movement.

In the spring of 1941, John Peale Bishop aptly voiced the feelings of many American intellectuals in an article published in *Kenyon Review* in connection with the symposium "The American Culture: Studies in Definition and Prophecy":

> I shall begin with the single conviction that the future of the arts is in America. . . . Without waiting for the outcome [of the war], or even attempting to predict it, it is possible even now to say that the center of western culture is no longer in Europe. It is in America. It is we who are the arbiters of its future and its immense responsibilities are ours. The future of the arts is in America. . . . The presence among us of these European writers, scholars, artists, composers, is a fact. It may be for us as significant a fact as the coming to Italy of the Byzantine scholars, after the capture of their ancient and civilized capital by Turkish hordes. The comparison is worth pondering. As far as I know the Byzantine exiles did little on their own account after coming to Italy. But for the Italians their presence, the knowledge they brought with them, were enormously fecundating.[48]

If one considered the impact of the foreign artists carefully, however, it was clear that while beneficial it cut two ways, as an editorial in *Art News* pointed out:

> We can understand that for American colleagues, their own lives full of struggles, it is not the most natural thing in the world to welcome enthusiastically rivals who, in a way, are going to make life still more difficult. We might add, for the solace of countrymen, that these new immigrants are only a drop in the bucketful of problems of living art in America.[49]

In a similar vein, art critic and internationalist James Thrall Soby published the following words in the catalog of the Artists in Exile exhibition held at the Pierre Matisse Gallery from March 3 to March 28, 1942:

Their presence can mean much or little. It can mean the beginning of a period during which the American traditions of freedom and generosity may implement a new internationalism, centered in this country; it can mean that American artists and patrons may form a xenophobic circle and wait for such men to go away leaving our art as it was before. The choice is of a final gravity, yet no one with vision will hesitate long over it. . . . Our enemies themselves have defined the disaster of which I speak—by declaring that art is national or that it does not exist, they have established what may well be their most absolute perversion of truth. Fortunately, numbers of American artists and interested laymen are aware that a sympathetic relationship with refugee painters and sculptors can have a broadening effect on native tradition, while helping to preserve the cultural impetus of Europe. These Americans reject the isolationist viewpoint which 10 years ago sought refuge, and an excuse, in regionalism and the American scene movement. They know that art transcends geography. . . . These men know if the world is not lost, its borders must narrow, its lines of communication quicken and extend, until ideas achieve an almost immediate parlance around the earth. They want American art to have equal voice with that of Europe in the new world, but they check their ambition at this point, knowing that beyond lies the dread bait of imperialism which all men of heart must suspect. Meanwhile, the arts are the only currency left which cannot be counterfeited and which may be passed from nation to nation and from people to people. It is true that this currency must now be smuggled part of the way by men for whom beauty stifles the pulse of terror. But it will some day return openly to the captive lands, and in America—let us make sure—it will never be refused or unjustly deflated. These . . . artists have brought us art in high denomination. Let us therefore say to them, for their sakes but also for ours: Welcome, and welcome again.[50]

This somewhat overemphatic "welcome" betrays Soby's anxiety as to native reactions. Soon to be employed by the Museum of Modern Art, the critic viewed the presence of painters from the Paris school as a magnificent stimulus to a generation of young American artists, but like *Art News* he could not quite see how the mixing of the two groups was to be effected. Nevertheless, he was sure that the beneficial influence of the Europeans would ultimately produce a strong, original, and modern American school of painting.

In some respects Soby's article may have been a response to a letter sent to the *New York Times* in 1941 by Samuel Kootz, who challenged

the New York art community to react to the death of Paris by creating something new, strong, and original. This was the moment for New York to gain its freedom from both Paris and reactionary nationalistic art. In this important letter, never before analyzed in its social context, Kootz looked forward to a new era and a new technique in answer to the bankruptcy of the "subject," exhausted by ten years of pictorial propaganda. It was up to the American painter, alone left standing amid the ruins of the School of Paris, to create a new and different world for an audience prepared to pay for innovation. Kootz was a businessman who knew his marketing and saw a wonderful new market in the offing, a market for a new kind of painting symbolic of the new America:[51]

Under present circumstances the probability is that the future of painting lies in America. The pitiful fact is, however, that we offer little better than a geographical title to the position of world's headquarters for art. We can expect no help from abroad today to guide our painters into new paths, fresh ideas. We have them hermetically sealed by war against Parisian sponsorship—that leadership we have followed so readily in the past—we are on our own. . . . I probably have haunted the galleries during the last decade as much as have the critics, because of my anxiety to see new talent, intelligent inventions. My report is sad. I have not discovered one bright white hope. I have not seen one painter veer from his established course. I have not seen one attempt to experiment, to realize a new method of painting. Subject matter, that's the only thing the galleries are showing. Poor Cézanne fought a losing battle, didn't he? to give birth to this pleasant, harmless, dispirited series of anecdotes. True, some years ago, we had a rash of class-struggle painting, but the boys didn't have their ideas straight, and they killed what they had by shamelessly putting those ideas in the same old frames—they made no effort to invent new techniques to express their thoughts. And the old timers, those who were at the top 10 years ago, what do they report? They are still there, resting on their laurels. Rigor mortis has set in and they don't know it. Yet no new talent has come forward to challenge them. And the old boys are not good enough for us to rest our hopes upon. The spirit isn't there— the questing has gone. Practice has made our old boys perfect—notice the uniform envelope of staled style, the placid thinking, the courteous suave lack of imagination. . . . Anyhow, now is the time to experiment. You've complained for years about the Frenchmen's stealing the American market—well, things are on the up and up. Galleries need fresh talent, new ideas. Money can be heard crinkling throughout the land. And all you have to do, boys and girls, is get a new approach, do some delving for a change—God knows you've have time to rest.[52]

Interested in painting since his student days, Samuel Kootz was not unknown to either Edward Alden Jewell or the American public, since in 1930 he had published *Modern American Painters*.[53] With the Depression and the concomitant turn toward regionalist and social realist painting in the United States, Kootz had devoted himself entirely to his work in public relations.[54] In 1941, when the debate over the importance of Western culture was at a height, he resurfaced with the publication of the letter from which we have quoted, which the *New York Times* described as a "bombshell."[55] What a very strange place the American art world was during the period of wartime reorganization: a public relations man working in the film industry sends a letter/broadside to a newspaper and somehow manages to turn the art scene upside down, lands a contract to mount an exhibition, writes a book on American art, and is invited to join the "advisory board" of the Museum of Modern Art before going on to open his own painting gallery and making a fortune.

Kootz's letter proposed no way out of the crisis that was daily becoming more and more obvious in New York. He merely put his finger on a number of sore points that artists had been trying to conceal by means of technical artifice. The letter articulated the criticisms and aspirations of a whole group of young painters and young collectors, to say nothing of a whole political class. In fact the letter was nothing short of a résumé of what was being discussed throughout the United States. It touched on the question of New York's future world leadership and on the rejection of the Popular Front and its imagery, it evoked internationalism as an essential ingredient in the American renewal, and it predicted the development of a new market for art. It even offered artists some pieces of advice, pointed the way to possible solutions, and made clear which paths would henceforth be closed.

This denunciation of the painting then being done in America was in keeping with the tradition of the modernist avant-garde. The essential thing was to be modern, to find something "new." Suspicion was voiced as to the tricks of the trade that enabled artists to package a lifeless but polished product ready for consumption. There was a new energy smoldering in the country, and no work done according to the sterile, lifeless old rules could hope to capture it. The new art, it was said, would therefore have to look askance at the ease and know-how that came with acquired skills, with the backward techniques of the old world. Imperfection was a guarantee of authenticity, sincerity, and personal expression. It bore witness to experimentation and painstaking research. The clear target in this enunciation of a new scale of values was Paris, whose trademark was technical perfection. What Kootz was attacking was the old, rigid prewar world in which Paris figured as the arbiter of taste. Paris—Paris in exile—was laid low a second time. From now on Paris was to be the enemy of this "new" young America. In some ways

Kootz's letter became the theoretical rallying point of the new avant-garde.

According to the artists, original, living art did exist in America, but it existed outside the museums, blinded as they were either by Europe or by regionalist prejudices.[56] The responses to Kootz's letter showed that he had indeed put his finger on a sore spot. Apparently a fairly large number of artists, frustrated by their experiences with the WPA and rejected by the museums,[57] were lurking in the shadows where they were busily creating, in spite of their alienation, an original style ready to burst forth at the slightest appeal. In subsequent months they formed what was known as the "Bombshell Group," whose aim was the "furthering of vital contemporary art and the interest of the living artists." This group mounted a show in 1942, but it was not particularly successful.[58]

More significant was the invitation that Kootz received after the publication of his letter, asking him to mount a show in Macy's department store featuring contemporary American art. This alone is enough to suggest the growing interest that American painting was capable of engendering, as well as its advertising potential. Although the results were disappointing (as Jewell noted in the *New York Times*, no new talent was discovered),[59] the experiment was an important one: not only did it represent an attempt to open up a vast new private market for art works, it also revealed the vitality of a new segment of the New York art world, exposed the work of certain modern artists who were then neglected by the museums, and gave new hope to the avant-garde by suggesting an alternative to the traditional institutions.

It was also with the "outsiders" in American art that Peggy Guggenheim became involved when she opened her curious gallery-museum, Art of This Century, in 1942. The history of this gallery as well as its importance in the development of contemporary American art is too well known to bear retelling here.[60] What interests us is the way the gallery and its owner were seen by the New York art world. Peggy Guggenheim symbolized the rescue of Parisian avant-garde culture, and the story of how her collection was saved from the fascists, fantastic and almost ludicrous as it was, was living proof of what she represented.[61] She also stood for the "search for the extreme" in contemporary art: "Miss Guggenheim hopes that Art of This Century will become a center where artists will be welcome and where they can feel that they are cooperating in establishing a research lab for new ideas."[62] At the heart of Peggy Guggenheim's quest were the values of inventiveness, novelty, and "research"—just as we saw was the case with Samuel Kootz. In a time of cultural disarray Art of This Century seemed a haven not only to European artists but also to young American artists in search of a liberal setting to show their work. Peggy Guggenheim had this to say:

Opening this gallery and its collection to the public during a time when people are fighting for their lives and freedom is a responsibility of which I am fully conscious. This undertaking will serve its purpose only if it succeeds in serving the future instead of recording the past.[63]

There was virtually no one else with prestige or money enough to support such an undertaking during the war. Guggenheim's aesthetic choices were therefore of some importance, since many of them were destined to become our choices as well. By placing her selections in the institutional setting of a museum-gallery, she forced the market to pay attention and thus brought commercial recognition to her protégés for the first time.[64] Clement Greenberg said of her that "her taste was often erratic and unsure. But she had a flair for life, a sort of smell for life that made her recognize vitality and conviction in a picture. It was surer ground in selecting the new than taste."[65] As though to protect herself against what was "erratic" in her "taste," she surrounded herself with a battalion of experts including Herbert Read and Marcel Duchamp, a majority of whom (such as Sweeney, Barr, and Soby) were affiliated with the Museum of Modern Art. Whatever she may have lacked in taste, Peggy Guggenheim apparently made up for it with a flair for business.

With the closure of European borders and the return to America of collectors, dilettantes, and expatriates who normally spent their time touring Europe, a potential audience of connoisseurs was at hand. The period 1941–43 saw the real beginnings of an independent New York art scene without ties to Paris. It was an aggressive scene organized around new internationalist principles directly related to the new political climate. What happened after the publication of Kootz's famous letter was that the many artists' groups within the New York art world reorganized. In the jockeying for position that followed, the most vocal groups were made up of artists influenced by Trotskyism who either had been part of Meyer Schapiro's group in 1940 or had at least been attracted by the Breton-Rivera alternative, set forth in their 1938 letter, of an art that would be independent of politics. To be independent in 1943 was to refuse regimentation in art organizations aiding the war effort such as Artists for Victory. It was to develop an international style, rejecting the nationalism of Brooks and MacLeish. And finally it was to forge a new image of art in America, a "different" image, an art with a difference capable of representing the new America. In short, to be independent was to give an affirmative response to Samuel Kootz's letter to the *New York Times*.

All of this was forcefully expressed in the catalog written by Barnett Newman for the American Modern Artists show at the Riverside Museum in New York, which was held in January 1943.[66] As though to delineate the position of the exposition, the catalog attacked the huge

Artists for Victory show (1,418 works) held at the Metropolitan Museum. The attack was launched on several fronts. In the first place the "democratic" selection procedures were said to bear obvious signs of manipulation by the Communist party. In addition the aesthetic standards of the show were attacked, even though prizes had been awarded to such well-known artists as John Stuart Curry, Peter Blume, John Atherton, Lyonel Feininger, Mark Tobey, Marsden Hartley, and Charles Howard. Unrest in art circles was at its height, since as many artists had been rejected as accepted.

The press reported rumors that a *salon des refusés* was in the works.[67] This was the American Modern Artists show, which gathered together a fair proportion of artists belonging to the Federation of Modern Painters and Sculptors. The idea of holding a *salon des refusés*, typical of the avant-garde and modeled on the great French tradition, gave vent to a frustration that had been building for years and that finally burst out into the open following the exclusion of many artists from the "biggest show of modern American art in U.S. history."[68]

We have come together as American modern artists because we feel the need to present to the public a body of art that will adequately reflect the new America that is taking place today and the kind of America that will, it is hoped, become the cultural center of the world. This exhibition is a first step to free the artist from the stifling control of an outmoded politics. For art in America is still the plaything of politicians. Isolationist art still dominates the American scene. Regionalism still holds the reins of America's artistic future. It is high time we cleared the cultural atmosphere of America. We artists, therefore, conscious of the dangers that beset our country and our art can no longer remain silent. For the crisis that is here hangs on our very walls. We who dedicated our lives to art—to modern art—to modern art in America, at a time when men found easy success crying "to hell with art, let's have pictures of the old oaken bucket"—we mean to make manifest by our work, in our studios and in our galleries the requirement for a culture in a new America.[69]

Barnett Newman's catalog was not only a critique of the socialist realist academicism supported by the Metropolitan Museum but also an urgent appeal for the creation of an art more representative of the new world that was being born before the old world's very eyes in the midst of World War II's devastation.

Newman's text was also a sign that a major change had taken place in Trotskyism, which had been so popular in 1940. It is true that the majority of artists in the rebel group as well as the federation had been loosely allied with Trotskyism, but certain basic ideas had been lost along the way. The accent was still placed on the artist's independence, but

now, if the artist wished to represent the new America, he must cast aside his "outmoded politics." The new culture would be apolitical. In the case in point this apoliticism may seem rather strange, since the show about which Newman was writing was intended as a protest against the Artists for Victory show, which according to Newman was infiltrated by the Communists.[70] In Newman's mind the artist had to reject politics before he could move on to modernism. Using some of Trotsky's ideas but eliminating the political commitment associated with them, Newman depicted the revolutionary as the ally of formalism. Furthermore, by insisting on internationalism, Newman was now aligning himself with the majority of the public as well as with the government, for as we saw a moment ago there was now substantial support for a vaguely international line. Thus in 1943, the rebel artists became, in spite of themselves perhaps, the spokesmen for the new, liberal America. As a result, their criticisms of society, constantly repeated in letter after letter and pamphlet after pamphlet, lost their bite and became one part of a strategy typical of avant-garde movements.

Edward Alden Jewell failed to see the relation between art and politics in the new world situation and admitted that he had a hard time understanding the complaints put forward by the new group, which in his eyes had no special distinguishing characteristics:

> What crisis? That the organizers of this group do not explain, nor do they name, otherwise than in a most vague and generalizing way, the evil forces to do away with which they have taken up arms. . . . So explosive a manifesto, as applied to this particular exhibition, is not likely to sweep many of us off our feet.[71]

What must be understood is that at this point the battle was being waged on the ideological level; artistic production was to follow, but at some distance.

Indefatigable in his search for a genuinely American form of cultural expression, Samuel Kootz in March 1943 wrote the text for the catalog of a show put on in January of that year at the Pinacotheca by the painter Byron Browne.[72] Already well known, Browne was rediscovered by Kootz to meet the needs of the international cause and was promoted to a leadership role:[73]

> America's more important artists are consistently shying away from regionalism and exploring the virtues of internationalism. This is the painting equivalent of our newly found political and social internationalism. Byron Browne is making a personal contribution in this field through energetic inventions, brilliant color dissonances and athletic rightness in space divisions. His balanced designs and rhythms

are highly rewarding and repay continuous investigation. In an area not yet familiar to most of the American public, Byron Browne is rapidly succeeding in creating a fine place for himself. His aggressive grasp of our more advanced ideologies pays off in canvases that evidence constant growth.[74]

What Kootz saw in Browne's painting was a marvelous parallelism between art and politics. His text is particularly interesting because it hits the nail squarely on the head when it comes to describing the embryonic new American ideology. All the elements are in place: individualism ("personal contribution"), the newfound strength of the United States ("energetic, athletic, aggressive"), constant inventive power ("inventions, investigations"). Never mind the confusion and abstractness of the text: the choice of words is revealing in itself. So is the fact that Kootz has not a word to say about Picasso's influence on Browne (at times carried to the point of pastiche), nor does he describe any of the works: this shows how hard Kootz was trying to take bits and pieces from the plastic vocabulary and reassemble them into something that corresponded to his idea of what the new American painting should be (fig. 2).

In the forefront of the battle for modernism, Browne's work stood for the aggressive and optimistic expansionism of the United States ("advanced, constant growth"). Aggressive, energetic, violent in its "brilliant color dissonances," this type of painting matched the virile youth of America. For Kootz, Browne was the perfect representative of internationalism (Picasso) tinged with Americanism (violence). In 1948, when the market required an Americanism tinged with internationalism, Kootz made an about turn: as quickly as he had propelled Browne to the forefront of the art scene, he now relegated him to the scrap heap, Gimbel's basement.[75]

Internationalism was treated again in Kootz's 1943 book, *New Frontiers in American Painting*, dedicated to the glories of American art, now in the thick of "revolution":

Though for many years it has been the custom of Americans to be humble about our contribution (new nation and all-that-really aggressive humility), the time is here to discuss what we are doing in positive terms. We have advanced. There has been a revolution—but one would not suspect it from even so recent a show as the hippopotamus at the Metropolitan in January 1943. . . . An artist must preserve his balance, be unaffected by hasty propaganda, and always seek the eternal truths which are his business and personal vision.[76]

The very title of Kootz's book suggested two different and at first sight contradictory approaches. The metaphor of the "new frontier," with its

nationalist overtones of westward expansion, was used in a way that suggested that national boundaries might be transcended. Beyond the nation's traditional borders lay access to the international art scene. In attempting to cross those boundaries American artists harked back to their own history, to the American tradition. They sought to become "pioneers," to join the advance guard. Stuart Davis was the typical modern American artist in Kootz's eyes, even though he saw the future of painting in the combination of Cézanne's two great discoveries, abstraction and expressionism:

> Davis' style is one of the most American expressions we have. It has an American intensity, aggression and positiveness that is thoroughly symbolical of the spirit of our most imaginative political, social and economical leaders. It is healthy and constructive.[77]

On June 5, 1943, Jewell followed his custom of the past several years and submitted to the *New York Times* his criticism of the season's last shows. This was a signal of the impending vacation, of a well-deserved rest after a year full of insipid openings and futile polemics in the letters columns of various art journals and newspapers. Jewell's last contribution to the newspaper therefore included a critique of the Wildenstein Gallery opening held to commemorate the third anniversary of the Federation of Modern Painters and Sculptors. Jewell's usual innocent and superficial analyses had for years been good enough to assure him a comfortable niche in the columns of the *Times*, but this time his article blew up in his face. For three weeks after its appearance controversy raged, often placing the critic in an uncomfortable position despite his cold, detached air, altogether appropriate to a *Times* personality. What sort of monkey wrench had been thrown into the well-oiled critical machinery of the New York art world? What accounts for the furious reaction to the Jewell article, which shook the calm assurance of the critics and thrust the guilty parties into the limelight?

The "guilty parties" were in fact none other than Adolph Gottlieb and Mark Rothko, two "Federation" painters. Remember, first of all, that the Federation of Modern Painters and Sculptors had been established in 1940 after the Trotskyists seceded from the American Artists' Congress, and that it was made up of several committees, the most important of which was the Cultural Committee, responsible for sending protest letters to newspapers, museums, and critics whenever necessary and as often as possible, so as to keep the artists of the group before the eye of the public as well as of potential buyers. For three years nothing very important came of this activity.[78] But this time Jewell's direct attack on two paintings by Gottlieb and Rothko (cochairmen of the Cultural Committee) provided the long hoped-for occasion to attack an art world and

a critical establishment lulled to sleep by several years of tedious "war" exhibitions. After three years of waiting the powder was dry, and a bombshell exploded in the decorous pages of the *New York Times* on June 13, 1943. This was the opportunity the federation had dreamed of, a chance finally to issue a manifesto, to define the identity of a group that hitherto, despite references to the nineteenth-century avant-garde in Paris, had not got beyond a few rather naive and commonplace statements of faith such as, "We believe in freedom of expression, we believe in quality of work, we believe in cultural activity."[79]

It is worth pausing a moment to consider Rothko and Gottlieb's letter in the light, first of all, of their work and, second, of their respective positions in the art world. This will help us to gain a better understanding of the usefulness of their action.

By 1943 the surrealists had already been in New York for two years, and the public had become used to their extravagances which, if Salvador Dali's exhibitions in the windows of large New York department stores are any indication, were by now familiar to the man in the street.[80] Max Ernst was the darling of museums and society matrons alike. Matta was the young eccentric whom other artists took seriously. Masson was doing automatic drawings. The unconscious was on everybody's mind. Yet it was in the midst of this broad understanding accorded the surrealists that the *New York Times* critic declared his surprise and embarrassment before three paintings that he found impossible to understand: Gottlieb's *Rape of Persephone*, Rothko's *Syrian Bull*, and a very Daliesque canvas by Theodore E. Schewe. Jewell wrote that he failed to see how these particular paintings, inspired by Paris and surrealism, fitted in with the call for a "globalization" of painting put forward by the federation (bear in mind that Willkie's *One World* was at this time breaking all sales records). Nor could he see how these works would help to place American art at the center of world attention. With cynical amusement, therefore, Jewell rejected the federation's aims as proclaimed in the show's catalog:

The current 3rd annual exhibition of the Federation . . . prompts us to state again our position on art, and the new spirit demanded of artists and the public today. At our inception three years ago we stated "We condemn artistic nationalism which negates the world tradition of art at the base of modern art movements." Historic events which have since taken place have eminently confirmed this. Today America is faced with the responsibility either to salvage and develop, or to frustrate western creative capacity. This responsibility may be largely ours for a good part of the century to come. This country has been greatly enriched, both by the recent influx of many great European artists, some of whom we are proud to have as members of the Fed-

eration, and by the growing vitality of our native talent. In years to come the world will ask how this nation met its opportunity. Did it nourish or starve this concentration of talent? It may be asked whether people at large should by their active interest participate in the development of art, or stand aside indifferent until the art of their time is ripened, ready for historic deposit. . . . Since no one can remain untouched by the impact of the present world upheaval, it is inevitable that values in every field of human endeavour will be affected. As a nation we are being forced to outgrow our narrow political isolationism. Now that America is recognized as the center where art and artists of all the world must meet, it is time for us to accept cultural values on a truly global plane.[81]

Although Jewell judged the aesthetic standards of the exhibition to be quite high, he failed to find the least concrete expression of the hopes so vehemently expressed in this manifesto. On the contrary, he had this to say: "I left with just the old uneasy feeling that reverence for the école de Paris had failed to produce over here many miracles worth speaking of."[82] He also acknowledged that the paintings of Gottlieb and Rothko had left him in a state of "befuddlement." He was not alone. An unsigned article in the *New York World Telegram* of March 15 had some fun at the expense of one of these paintings:

The third annual exhibition—for so large and mixed pickle an affair, it's rather good. The pity is that the few lemons on hand are so sour as to spoil the flavor of the whole presentation. If one could remove such items as Adolph Gottlieb's "Rape of Persephone" . . . you'd have a nice pleasantly rewarding show left.[83]

The importance of Jewell's reaction lay in the fact that, while he recognized the Parisian influence on the American painters, he nevertheless avowed his inability to understand two paintings which, albeit abstract, were quite traditional and which should have been readily comprehensible to a "connoisseur" of surrealism. Apparently this reaction was typical. Liberal critics had never disparaged the works of the French surrealists (even Greenberg and Kootz attacked only the realistic paintings of Dali and the neoromantics). The prestige of these works seems to have given them a sacred "aura" that was difficult to penetrate,[84] an "aura" that did not surround the American paintings. In courteous but mocking language Jewell was quite comfortable suggesting that the latter works were hermetic.

The violent response of Rothko and Gottlieb, assisted by Barnett Newman, is equally revealing, for it is out of all proportion to Jewell's criticism. For the painters concerned this was a unique opportunity to declare their independence. In a polemical style quite in keeping with avant-

garde tradition they made a series of points that clearly spelled out the ideology of the nascent avant-garde. The strategy worked wonderfully: a full page of the *New York Times* was devoted to a reproduction of the paintings and to the response of the artists to their critics. "Globalism Pops into View" was the headline in bold type on the *New York Times* art page for June 13, 1943 (fig. 3).[85] For the first time in American art history the mass media were creating an artistic event. Adolph Gottlieb, Mark Rothko, and Barnett Newman took advantage of the opportunity to give an authoritative declaration of what the new American painting ought to be. They cast aside the vague rhetoric of earlier statements and published instead a strict program that showed the influence, with some modifications, of surrealist ideas.[86]

The new artists were men who had worked on developing their styles for the past three years (since their departure from the American Artists' Congress) and who had gained enough confidence to assert their independence.[87] Standing the problem of the thirties on its head, as it were, they asserted themselves with unprecedented vigor. During the Popular Front period artists had tried to develop styles that expressed the aspirations of the masses (or at the very least tried to foster good relations with the public). But by 1943 political disappointments (e.g., the collapse of the social base for a revolution) and changed social conditions (e.g., the growth of the private art market and of a knowledgeable audience for the arts) had caused some artists to assert their own individuality with strength and confidence.[88] These artists found some people willing to listen to what they had to say. To be sure the number of such people was limited in 1943, but the audience made up in enthusiasm what it lacked in numbers.

After Jewell published his attack, Gottlieb, Rothko, and Newman set forth a five-point aesthetic program that was well attuned to the concerns of the new public:

1. To us art is an adventure into an unknown world, which can be explored only by those willing to take risks.

2. This world of the imagination is fancy-free and violently opposed to common sense.

3. It is our function as artists to make the spectator see the world our way—not his way.

4. We favor the simple expression of the complex thought. We are for the larger shape because it has the impact of the unequivocal. We wish to reassert the picture plane. We are for flat forms because they destroy illusion and reveal truth.

5. It is a widely accepted notion among painters that it does not matter what one paints as long as it is well painted. This is the essence of academism. There is no such thing as good painting about nothing. We assert that the subject is crucial and only that subject matter is

valid which is tragic and timeless. That is why we profess spiritual kinship with primitives and archaic art.

Consequently if our work embodies those beliefs it must insult anyone who is spiritually attuned to interior decoration; pictures of the home; pictures over the mantle; pictures of the American scene; social pictures; purity in art; prize-winning potboilers; the National Academy; the Whitney Academy; the Corn Belt Academy; buckeyes, trite tripe, etc.[89]

This text clearly marks out the position of the group within the American art world. It was modernist but accorded a crucial place to the "subject." It was anti-isolationist, anti–social realist, anti-AAA, anti–Artists for Victory, antiacademic, and antipopulist. This "anti" philosophy was a way to stake out a position and to clear away the dead wood left behind by the rapid social changes of the war.

The group defined its position in terms that were not merely stylistic but social as well. The federation, largely Trotskyist, continued its unrelenting battle against the Communists, who by this point had entered into alliance with populist artists' groups inspired by the New Deal (and represented by the Metropolitan's Artists for Victory show and *Art News*). It also joined forces with the internationalist elite associated with the Museum of Modern Art, though this alliance was as yet tenuous and ambiguous, since the entire art world was in turmoil at this point. The MOMA, it should be noted, was itself involved in ongoing conflict with the Metropolitan Museum and its nationalist propensities. The tenuous link between the MOMA and the federation was made possible by two intermediaries, Robert Motherwell and Barnett Newman. Having written notices for the federation and for certain of its member artists, Newman had contacts with such apolitical avant-garde galleries as Peggy Guggenheim's and Betty Parsons's.[90] Motherwell had connections to high society through his father, a director of the Wells Fargo Bank, and to Trotskyism through Meyer Schapiro, his professor at Columbia. Newman and Motherwell introduced the Trotskyist group to Guggenheim's Art of This Century Gallery. Thus Peggy Guggenheim and her protégés played an important role in launching the new avant-garde. The relationship not only brought the Americans into contact with Parisian artists, thereby influencing their styles, but also led to certain political realignments.

Through Motherwell and because of the connection with Guggenheim, the Trotskyists of the federation came to align themselves unknowingly with the Museum of Modern Art.[91] What happened, in fact, was that the painters and their works were caught up in the battle between the two museums, MOMA and Metropolitan, for cultural supremacy in New York. The trustees of the Met represented old wealth

in America, and the museum consequently stood for a tame, prudent, and academic culture oriented toward the past.[92] Young, liberal, and dynamic, the Museum of Modern Art represented new wealth, the "enlightened rich," the future of American culture.[93] As Stuart Davis wrote in *Harper's Magazine* of December 1943 in response to George Biddle, the battle was actually between isolationists and internationalists:

Isolationist culture is reactionary and undemocratic in character in that it seeks to suppress that free exchange of ideas which alone can develop an authentic modern American art. It exercises a censorship in our channels of art communication which Mr. Biddle apparently does not detect. . . . The American Scene philosophy parallels political isolationism in its desire to preserve the status quo of the American Way of Life.[94]

As in Barnett Newman's first article, a new note of apolitical thinking could be detected in the new ideology. In the Gottlieb-Rothko manifesto this took the form of a rejection of "history," which could already be detected in surrealist and modernist practice if taken out of context.[95] The American avant-garde painters had no polemical tradition of their own to draw on and so made use of ideological elements drawn from Trotskyism, surrealism, and other movements. They used these elements to establish a theoretical justification of their own position, with which they could respond to the new social situation. If they deformed the texts from which they borrowed, the reason was not that they failed to understand them, but rather that they were sick of politics and therefore thought they were sick of history as well. By using primitive imagery and myths to cut themselves off from the historical reality of their own time, they hoped to protect themselves from the manipulation and disillusionment they had suffered previously. What remained of their old leftist ideas was the desire and the need to communicate with the public. But now the public was redefined to encompass all mankind. In this way the artists of the avant-garde hoped to transcend the barriers of language and class. Again, the ideology was similar to that expressed by Wendell Willkie in *One World*. The archetypal image was seen as the perfect vehicle for the new ideology: "Since art is timeless, the significant retention of a symbol, no matter how archaic, has as full a validity today as the archaic symbol had then. Or is the one 3,000 years old truer?"[96]

Faced with an incomprehensible and corrupt world, painting must commune directly with the fundamental forces. The artist-as-shaman uncovers these forces by delving into his own imagination and then transcribes them as simply as possible, and with the maximum possible

impact, using archaic symbols which, it was claimed, possess universal significance.

On the one hand Gottlieb and Rothko's letter was pessimistic: "Those who think that the world of today is more gentle and graceful than the primeval and predatory passions from which these myths spring are either not aware of reality or do not wish to see it in art."[97] But on the other hand it also struck an optimistic note: in spite of everything, it is still possible to communicate. That the attempt to connect with the public was not always successful was of no consequence. The important thing was that the public see and understand the theoretical principles involved. Once a universal symbol was found, it could not fail to "speak," or so the artists believed. As far as they were concerned, this was enough. For the modernist movement to progress further, a certain blindness to reality had become necessary and would become increasingly so (indeed, it would become compulsory during the McCarthy era): "The point at issue, it seems to us, is not an 'explanation' of the paintings but whether the intrinsic ideas carried within the frames of these pictures have significance."[98]

The "truly global plane" referred to by Gottlieb and Rothko was the ideology of *One World*, a vision for all mankind that had been forged in downtown New York.

Those still caught in the old ways of thinking, like Jewell, those who were still defending the old values symbolized by the cultural programs of the New Deal, failed to understand the significance of the manifesto. Indeed, they had no hope of understanding it. For the text made explicit political views that had not yet been captured on canvas or embodied in images. What had been produced was an unattached "signified," not yet coupled to any "signifier."

Jewell wanted to see an art engaged with its historical period, an art that stood for the values being defended by the allied armies. In their detachment Gottlieb and Rothko were laying the groundwork for the art of peacetime. Like many artists of their generation, they had never been directly concerned by the war or directly involved with the war machine. For them what was abstruse was the reality of war, not the abstract concept of a general apocalypse that the conflict represented. What Jewell was asking of artists was a pedestrian awareness of reality which the members of the federation hoped to transcend. From this point on there were to be two distinct camps within the art world, with little hope of reconciliation between them. The federation shibboleth of individualism was rejected by the *Times* critic and by many of his readers as antidemocratic or at any rate anti–New Deal:

But the "globalists"—do they start with anything as plain and profound as a cat? No, they start and end with what we call "private

symbols": with invisible Persephones and esoteric soi-disant Syrian Bulls and trijugated tragedies in syzygy brustalk. That is probably why, at this rate, they will never get anywhere with a public that hasn't been provided with a glossary.[99]

Not without humor, the well-known New York artist Hananiah Harari added:

The "globalism" of the artists whose manifesto was quoted in your columns is clearly limited to the respective globes of their individual craniums. Such windmill jousting, morbid individualism, heroic gestures belong to remote romantic ages and not to our own. . . . We cannot live nor paint as simple primitives, nor as Rubens or Daumier, nor as Fauves because we are not of the same time. We must learn to use our past to pull ourselves forward . . . not freeze ourselves in hypnotic stares backward. . . . Very certainly, with victory, artists will have to keep pace in every sense with world progress. If they don't they will indeed have become "archaic symbols."[100]

The war years are crucial to our story because it was then that artists and critics were busy revising their positions and redefining their relations with institutions, social groups, political parties, the tradition of painting, and the city of Paris. It was in this context that Robert Motherwell turned back to the analyses put forward by Schapiro and Greenberg some years earlier. Significant shifts are apparent in his commentary on their views. He asked himself what the artist's role was in an environment of all-pervading pessimism: Is the contemporary artist important, and is he necessary? In two articles published in 1944, "The Modern Painter's World," which appeared in *Dyn*, and "Painter's Objects," which appeared in *Partisan Review,* Motherwell laid the foundations on which the avant-garde was to base its ideology. In essence these articles amounted to an artistic depoliticization of one kind of political analysis. And the important thing was that this was a depoliticization that retained the imprint of politics. For us, Motherwell's writings are an important key to understanding the development of the New York avant-garde. Without these texts it would be impossible to grasp the fundamental difference between the work of the avant-garde and other contemporary American art.

Consider first the article published in *Dyn* in 1944. Motherwell's argument is based on earlier articles by Meyer Schapiro, who also stressed the importance of the individual.[101] He attempts to define the position of the modern painter in contemporary society in the wake of the intellectual and political crisis of the thirties. The article certainly reflects the aspirations of a segment of the new generation of painters, with

whom Motherwell was in close contact.[102] More subtle than the Rothko-Gottlieb polemic, Motherwell's argument was at the same time more pessimistic, emphasizing the artist's need for freedom and considering in the light of recent history what had become of that freedom. As Motherwell saw it, the future of modern painting in the United States was not very promising, for painters were caught between two periods: federal support from the WPA was coming to an end, but the growth of the private market and the economic boom that would begin in 1945 still lay in the future. From where he stood Motherwell could see nothing but devastation. Isolated in the United States, American artists could no longer even hope for an alliance with the intelligentsia of Europe, which for several years had been restrained and unable to operate effectively in exile. This was the gist of the message he sent to his friend William Baziotes:

> I was at Mt. Holyoke College with Goldwater [who wrote "Primitivism in Modern Art"], Zadkine, Hayter, Masson, where I gave a socialist analysis of the response of ten abstract artists and surrealist ones to a property losing society and which was something of a success. I think the gaullists are going to publish it in French abroad and Paalen will in the next issue of Dyn. . . . The future in America is hopeless. *For you as for me there are only two possible courses, to go to France forever (which is what I am going to do), or remain here to be psychoanalyzed* [Motherwell's italics].[103]

The artist regained his importance as an individual, Motherwell wrote, precisely because progressive and revolutionary socialist forces had failed in the thirties. This failure cut the artist off from the proletariat, and since he was already cut off from his own class (the bourgeoisie), the creator found himself, alienated, in no-man's-land. Nevertheless, drawing on his Marxist experience as well as on Schapiro's work, Motherwell articulated a rejection of bourgeois egocentrism. He argued in favor of the individual, but without individualism.

> The function of the artist is to express reality as *felt*. In saying this, we must remember that ideas modify feelings. The anti-intellectualism of English and American artists has led them to the error of not perceiving the connection between the feeling of modern forms and modern ideas. By feeling is meant the response of the "body and mind" *as a whole* to the events of reality.[104]

Because art is always socially determined, Motherwell continued, those of its elements that are not eternal must be changed to meet new social needs.[105] In this way art adjusts itself to new situations, to new relations between the individual and the social whole, by giving them form. Thus

the "new," the "modern," plays an important role in the organization of society. The artist does not reproduce old codes but rather becomes the person responsible for giving form to imperiled freedom, the protector of liberty:

> Now artists especially value personal liberty because they do not find positive liberties in the concrete character of the modern state. It is the values of our own epoch which we cannot find in past art. This is the origin of our desire for new art. In our case, for modern art.[106]

The battle for freedom brings the painter into sharp opposition to the decadent bourgeoisie and forces him to resort to a kind of cultural underground prepared to wage unrelenting guerrilla warfare against old values, now linked to the forces of oppression. The point to be made about Motherwell's class analysis, however, is that it enables the artist to go on playing the role of the sole creator of art and to continue working in a traditional institutional setting, the traditional institutions having emerged from the failure of socialism in the Depression with their importance intact or even enhanced. In the final analysis, Motherwell recognized that with socialist revolution deferred indefinitely the avant-garde had become a viable setting for artists to do their work, a temporary accommodation affording the artist certain positive benefits, without which Motherwell would have found himself unable to operate.[107]

The kind of freedom that Motherwell was after could not accommodate the surrealist experiments then fashionable in New York. One has only to read his attacks on surrealism in the same article to get an idea of the true nature of what some writers have seen as the influence of surrealism on American painting (an influence that consisted mainly of misunderstanding). Motherwell in effect rejected what he saw as destructive forces in surrealist art. These included "animal" tendencies and total surrender to the unconscious. Motherwell saw these forces as a nullification of his freedom. Resorting to the unconscious might entail loss of the artist's freedom of choice: "To give oneself over completely to the unconscious is to become a slave."[108]

But this was one of the main ingredients of surrealist subversive tactics. The automatic technique was, with the devastating force of the unconscious, one of the most crucial components of surrealism, its political "revolutionary" edge. What Motherwell accepted from surrealism was its less virulent aspect, the artistic part, what he called "plastic automaticism" which sidestepped any political or psychic involvement. Motherwell did not tolerate the danger of self-destruction of art that was embodied in the most extreme experiments of surrealist practice. He made this very clear further in the same article: "What we love best in

the Surrealist artists is not their programme . . . , but their formalist innovations."[109] It should by now be clear that misunderstandings, sleight-of-hand, and a selective reading of the past all played a part in the establishment of the American avant-garde, but it should also be clear that with the refusal of surrealism's destructiveness and ambivalence this establishment sounded an optimistic note.

Motherwell's views were not destined to be contradicted by Clement Greenberg, by this time art critic for the *Nation:* not only did Greenberg agree with Motherwell, he was even more violently opposed to the experiments of the surrealists, essentially for aesthetic reasons. In a two-part article entitled "Surrealist Painting," he compared surrealism to the perverse and decadent games played by the *haute bourgeoisie,* not even mentioning the work of artists less given to exhibitionism than those he discussed, such as Breton, Masson, or Miró, whose names came up only in passing:

> The anti-institutional, anti-formal, anti-aesthetic nihilism of the sur-realists—inherited from Dada with all the artificial nonsense entailed—has in the end proved a blessing to the restless rich, the expatriates, and aesthete-flâneurs in general who were repelled by the asceticism of modern art. Surrealist subversiveness justifies their way of life, sanctioning the peace of conscience and the sense of chic with which they reject arduous disciplines.[110]

For Greenberg modernism was more serious, more difficult, more aus-tere—it was something new. What he saw in surrealism was the aca-demic surface, the cliché, the form. For him surrealist painting was Meissonier, it was kitsch. He would not even go so far as to allow that the surrealists were plastically inventive, as Motherwell did. In Moth-erwell's view, formalism would inevitably be successful in a society that relegated the modern artist to the lower ranks:

> The argument of this lecture is that the materialism of the middle class and the inertness of the working class leave the modern artist without any vital connection to society, save that of the *opposition* [Motherwell's italics]; and that modern artists have had, from the broadest point, to replace other social values with the strictly aesthetic. Even where the surrealists have succeeded, it has been on technical grounds. This formalism has led to an intolerable weakening of the artist's ego; but so long as modern society is dominated by the love of property—and it will be, so long as property is the only source of freedom—the artist has no alternative to formalism.[111]

In an article published a few months later in *Partisan Review* entitled "Painter's Objects," Motherwell defined the goal of the "new painter"

and the nature of his work.[112] Abstract painting, he said, had made important discoveries. Citing a poem of Wallace Stevens,[113] he argued, however, that as important as these discoveries were, by themselves they were not enough. He insisted that the painter must go beyond the mere depiction of objects. The history of painting already offered a good example of this development: Mondrian's incorporation of emotion into painting. "Mondrian," wrote Motherwell, "has assembled all his remarkable resources for purely expressive ends."[114] Though still fully abstract, Mondrian's *Boogie-Woogie* captured the impressions and emotions of the painter at the sight of the modern city. This altogether remarkable work showed the way to other artists. It indicated a new-found openness in the style of abstraction, which for a while had seemed to have fallen into self-absorbed sterility. For Motherwell this work of Mondrian's was a sign that there was a way out of the ivory tower in which the modern artist was trapped. It showed that it was possible to make contact with the public, always at the center of Motherwell's concerns:

> For the first time a subject is present, not by virtue of its absence, but actually present, though its appearance is torn away, and only the structure bared. The modern city, precise, rectangular, squared, whether seen from above, below, or on the side; bright lights and sterilized life; Broadway, whites and blacks; and boogie-woogie, the underground music of the at once resigned and rebellious; the betrayed . . . Mondrian has left his white paradise, and entered the world.[115]

Motherwell's two articles laid the groundwork for the new avant-garde. Motherwell himself provided only part of the scaffolding for the new movement. By publishing his articles in the avant-garde press, he was aiming particularly at an audience that already knew something about European innovations in the plastic arts and literature. The *Partisan Review* piece included a few lines of praise for Motherwell's friend Jackson Pollock, who also exhibited at Peggy Guggenheim's Art of This Century Gallery.

Partisan Review's art critic James Johnson Sweeney also worked for the Guggenheim gallery.[116] Sweeney occasionally wrote articles for *Harper's Bazaar*, which tried to keep its readers abreast of the latest developments in aesthetics, fashion, painting, and interior decoration. In April 1944 *Harper's Bazaar* printed his article "Five American Painters," in which he discussed Pollock's work and included along with the text a color photograph of the painting *She-Wolf*, which would be purchased one month later by the Museum of Modern Art at the behest of Alfred Barr, recently named to the post of advisory director.

The MOMA's interest in American surrealist art was not firmly established, to say the least. In fact, it was the attempt to "Americanize" the surrealist taste for the bizarre, the primitive, and the art of madmen that had been responsible for Barr's ouster as director of the MOMA in 1943. Following a series of shows (Morris Hirshfield, Joe Milone) that had failed to win the approval of either the public or the museum's president Stephen Clark, Barr had been removed, or rather, as the administration preferred to put it, he had been offered a "shift in responsibilities."[117] This episode shows the differences that existed between the museum's administration (trustees, director), the historian Barr, and the living world of the arts.

The critics were vehement in their condemnation of the show of paintings by slipper manufacturer Morris Hirshfield as well as of the exhibition of Joe Milone's decorated shoeshine stand, which they considered iconoclastic expositions. Barr and Soby, who had helped him discover these American artists whose work was, they felt, akin to that of "Douanier" Rousseau and "Facteur" Cheval, couldn't understand the press's hostility. Their aim was to establish an American tradition modeled on that of the Paris school by presenting the work of "naive" American artists.

The Parisian avant-garde had made a practice of incorporating such marginal mannerists as a way of revitalizing academicized Western culture, as Apollinaire and the cubists, Breton and the surrealists were fond of proclaiming. The two Americans were merely attempting to do the same thing in New York. Since the French *naïfs* had already been canonized by American connoisseurs, it seemed a good strategy to find naive artists in the New World who might serve as a basis for the discussion of the new moderns such as Pollock and Rothko. But the public, which had forgotten the history of modern art, failed to see the strategy behind the museum's maneuvering. What the critics expected from the Museum of Modern Art was a consistent aesthetic line, a guide to good taste. A shoeshine stand apparently did not fill the bill in 1943. In such an uncertain time what was needed was a positive aesthetic choice capable of responding to contemporary needs, a direction that the American public could follow without grumbling. What was needed above all was a sense of unbroken continuity. Only continuity could assure the stability of a culture that stood in such urgent need of protection against chaos. This was the will of the majority.

When the "inner circle" (Guggenheim, Barr, Soby, Sweeney, and Greenberg) finally discovered the "consistent" image they were after, what they chose to represent the new American taste seemed to be chaos itself, unfortunately for those who were after a well-defined aesthetic line. To this chaos was attached a name: Jackson Pollock. Indeed, it is astonishing to see how quickly Pollock's work was discovered in

1943–44, and how uniform the critical celebration was, to the great sur-
prise of Pollock himself. As B. H. Friedman explains in his book on
Pollock:

> By mid-1944 Pollock's career was off to a good "start": a first one-man
> show in probably the most chic gallery in town, a contract with that
> gallery, a mural commission from its owner, generally good notices,
> the questionnaire in a prestigious West Coast magazine, the color
> reproduction in *Bazaar*, the Modern Art purchase, and at least one bite
> and some nibbles by other institutional and private collectors, not
> including small purchases by Herbert Matter and the artist Jeanne
> Reynal.[118]

From the moment of his first show Pollock became a symbol for all those
who had formed an idea, still rather imprecise, of the "new America,"
battling to rescue imperiled culture and the Western world. Theirs was
a young America, strong, adventurous, exuberant, and open to the
world. Pollock's work fitted in with the image that enlightened liberals
had formed of their country.

Still to be persuaded were the critics attached to a populist vision of
America. This was done by adopting a critical style whose aim was to
strip the image of all content or meaning, a style that emphasized the
technique and individuality of the painter, much as Kootz had wished
in his famous 1941 letter. The jubilation with which all the critics greeted
Pollock's work shows that the questions raised by Kootz's letter were
central to the definition of the "new look" that everyone was after. The
first analysis of Pollock's work, James Sweeney's article in the catalog
for the show at Peggy Guggenheim's gallery, already serves up all the
ingredients that history was to make famous:

> "Talent, will, genius," as George Sand wrote Flaubert, "are natural
> phenomena like the lake, the volcano, the mountain, the wind, the
> star, the cloud." Pollock's talent is volcanic. It has fire. It is unpre-
> dictable. It is undisciplined. It spills itself out in a mineral prodigality
> not yet crystallized. It is lavish, explosive, untidy.
> But young painters, particularly Americans, tend to be too careful
> of opinion. Too often the dish is allowed to chill in the serving. What
> we need is more young men who paint from inner impulsion without
> an ear to what the critic or spectator may feel—painters who will risk
> spoiling a canvas to say something in their own way. Pollock is one.
> It is true that Pollock needs self-discipline. But to profit from pruning,
> a plant must have vitality. In art we are only too familiar with the
> application of self-discipline where liberation would have been more
> profitable. Pollock can stand it. In his early work as a student of
> Thomas Benton he showed a conventional academic competence. To-

day his creed is evidently that of Hugo, "Ballast yourself with reality and throw yourself into the sea. The sea is inspiration."

Among young painters, Jackson Pollock offers unusual promise in his exuberance, independence, and native sensibility. If he continues to exploit these qualities with the courage and conscience he has shown so far, he will fulfill that promise.[119]

Pollock's work was seen as an American version of surrealism: it was "unpredictable, undisciplined, explosive." Here, of course, these characteristics are viewed positively.

Sweeney's catalog article advised other artists to follow Pollock's example in drawing their works out of their unconscious. This was the way of the future. Relying on the unconscious was a way to permit the explosion of individuality, the development of the painter's unique style. To be sure, there was a danger of error, of going wrong. But the painter's errors were taken as signs of sincerity, tokens of his willingness to experiment and to seek after the modern truth. The breaking of the rules offered proof that the artist was free and that his works were frank and authentic.

Clement Greenberg also emphasized the same standards of quality. He attacked the formal copy. In a discussion of the work of Eugene Berman, he explained the nature of what he called "aristocratic painting," painting destined for an audience in search of a thrill at the cocktail hour. "Decadent" was the word he used to describe a painting interested more in "effect" than invention, more in the slavish copy than in the bold experiment:

Berman's pictures, crowded as they are into a relatively small space, are too overpowering, too decadent, too spurious, and really too well done to be dealt with in measured words. If this is art, the age is doomed.[120]

The same argument recurs in his discussion of Motherwell:

There his constant quality is an ungainliness, an insecurity of placing and drawing, which I prefer to the gracefulness of his water colors because it is through this very awkwardness that Motherwell makes his specific contribution.[121]

The perfect symbol of the modern painter, Pollock was able to win everyone's approval. Thanks to his long academic apprenticeship with Benton he claimed the support of the nationalists, who were pleased by what Sweeney called his "native sensibility." But he also gained the favor of the internationalists, since after 1940 he "dropped the Benton nonsense" and made his work into a surrealistic commentary on modern

art.[122] Mingling both tendencies in this way, Pollock became the perfect commodity, and even Jewell found it hard to reject his work out of hand.

Still, it was difficult for Pollock's art to be assimilated in its complexities since in order to woo both sides the artist had to sell his image to a public whose interests were profoundly at odds with his own. Consider, for example, the case of Sweeney's article in *Harper's Bazaar*, "Five American Painters." The article included a color reproduction of a Pollock canvas in company with works by Roberto Matta, Morris Graves, Arshile Gorky, and Milton Avery. The painting reproduced, *She-Wolf*, was featured on the same page and printed in the same size as the reproduction of a work by Matta, a well-known surrealist of the *école de Paris* who had become an American citizen and who was the international artist par excellence. Sharing the honors with Matta, Pollock was truly the sole international American. As though to underscore this point, three other American works were reproduced on the facing page in smaller format. These were not considered worthy of the place of honor, either because they were too American (Graves, Avery) or too influenced by Paris (Gorky).

Unfortunately, the place that Pollock came unwittingly to occupy was in fundamental contradiction to his own aspirations. Indeed, the *She-Wolf* image was somewhat emasculated by being reproduced in the sumptuous pages of an upper-middle-class magazine: its point and content were lost.[123] The reproduction reduced the painter's creative power to the level of fashion and placed it on the same footing as Avery's cellist on the facing page. When asked about the painting of *She-Wolf* by Sidney Janis, who was then writing a book on abstract art and surrealism in the United States, Pollock, in November of the same year, gave this answer: "She-Wolf came into existence because I had to paint it. Any attempt on my part to say something about it, to attempt explanation of the inexplicable, could only destroy it."[124] If explanation risked killing the image, printing it on the glossy pages of *Harper's Bazaar* could only mutilate it and wring the last ounce of meaning out of it. This castration affected not only the mythological image reproduced but also the painter himself, who was domesticated by the system of fashion. The she-wolf was transformed into a lamb. The domestication of the artist was necessitated by his own desire to be included in the new "system of signifiers" then being established.

Gottlieb's and Rothko's efforts to win recognition of their individuality should come as no surprise once the pressure on artists to find a place for their work in the art market is recognized. The competition for sales that developed slowly with the demise of the WPA left painters faced with a serious problem. Encouraged by government support during the Depression, they were producing more art but had not correspondingly

increased their sales despite the attempts to do so in the two national "art weeks." The social survival of the artist became the crucial issue for American critics: "The problem used to be: could the U.S. produce art? The current problem is what are we going to do with the prodigious amount of art that we are capable of producing?"[125] Of equal concern was the other side of the same problem, that of the nature and quality of the artistic output. This was stressed by Milton W. Brown in his article "American Art a Year after Pearl Harbor," published in *Art News* in December 1942. Brown's view was that the image of American art as presented by Juliana R. Force of the Whitney Museum reflected the apathy of both American artists and American museums. He questioned the integrity of American painters who in wartime continued to paint personal fantasies and insipid nudes. The message of the Whitney show was that of a divorce between art and reality, art and social life. Clearly, for some painters the act of painting, the act of creation, was a sufficient response to the devastation of Europe. To paint had become the aim of painting and the subject was of little or no importance.

It was this sense of impending doom for Western culture that impelled a large audience to go to museums and buy contemporary art. Museum attendance did indeed increase at a surprisingly rapid rate, as the following figures show. In the crucial year of 1943 the number of visitors to the Metropolitan Museum increased by fifteen percent over 1942, to 1,384,207. The number of members of the Museum of Modern Art had doubled by April 1940 from 3,000 to 6,846 and by July of 1940 had reached 7,309.[126] Furthermore, the growth of national consciousness in the United States since the country's entry into the war had led the museums to take decisive steps to integrate themselves into the social and political life of the nation, as a result of which they worked their way into the awareness of growing numbers of people. The museums placed their facilities at the disposal of the nation, often for use as a propaganda weapon. The Metropolitan lent its support to the Artists for Victory group, and the Museum of Modern Art served as a recreation center for soldiers, a symbol of free expression and a place to mount military exhibitions for propaganda purposes:

> The museum collection is a symbol of one of the four freedoms for which we are fighting—the freedom of expression. . . . It is art that Hitler hates because it is modern—progressive—challenging. Because it is international, because it is free.[127]

In late June of 1942 the MOMA mounted a major show under the title "Road to Victory," which featured enlargements of Edward J. Steichen photographs accompanied by poems and other writings of Carl Sandburg. Herbert Bayer was responsible for the exhibition, a fact that by

itself is an indication of the impressive proportions of the project. The overall layout emphasized the military might and the potential political power of America (fig. 4). Immediately upon entering the visitor was confronted by photos of the American people. He then proceeded along corridors festooned with gigantic enlargements and, breathing the atmosphere created by these images, felt himself marching in step with the proud troops, smiling farmers, and laughing workers, volunteers all (fig. 5). The depressing images of the American countryside produced by social realist painters during the Depression were completely forgotten. The show was a tremendous success that left 98,000 visitors proud and happy to be Americans. All the reviews were exultant, without exception, and agreed on the importance and truth of the statement in the introduction to the catalog: "By showing how greatly the war effort depends upon the human element, the exhibition will enable every citizen to recognize his position in the nation's effort."[128] Even the left-wing press hailed the event. *PM* remarked that "your heart will be warmed by a fullscale picture of the great country and its people," and the *Daily Worker* reported that the show was "the most sensational exhibit of photography that ever was shown in these parts. What a country to fight for."[129] (A similar show was held in 1943. See fig. 6.)

The viewer's euphoria carried beyond the walls of the museum. On his way home he would have stopped in front of the "world's biggest billboard" at the corner of Forty-second Street and Fifth Avenue to gape at the poster that had won the Support America Contest organized by the MOMA: "Buy a Share in America" was the theme. Nor did the pressure to "buy American" to support the war effort let up once he returned home: the message was repeated ad nauseam in the pages of popular magazines such as *Life*, where an ad featured a pair of glasses whose lenses had been replaced by American flags, with the caption, "Look through these glasses at everything you buy" (fig. 7).

In all this paraphernalia what interests us is the way in which a public once cut off from the products of culture was shown an image of itself, an image of fighting America, and thereby persuaded ideologically and intellectually that the defense of culture, of its culture, had become crucial to the survival of civilization in general. Inevitably imbued with nationalism, this selling job involved the use of art by the advertising industry.

The enthusiasm of businessmen for art and its use in advertising began around 1940 and grew rapidly, finally becoming a key factor in the art explosion of the late forties. At a time when the industrial might of the nation was oriented entirely toward war production, so that nothing was left over for sale on the traditional marketplace, companies made use of art and advertising as a way of keeping their trademarks alive and before the public eye (fig. 8) Support for the arts in a time of cultural

crisis seemed to be a brilliant idea, a way of associating businessmen with Renaissance art patrons in the minds of many. Despite the efforts of IBM, Coca-Cola, Container Corporation of America, De Beer, and others, the program apparently did not satisfy the most ambitious artists. Once the initial euphoria was past, many saw their art more severely limited than it had been under the WPA.[130]

The year 1944 was the moment when artists with too much ambition or too vivid a memory of their left-wing involvement in the thirties refused to take advantage of what seemed to be American art's only chance. If it was true that New York was about to become the world capital of art, a choice had to be made or artists would risk falling into the rut prepared for them by the free market, for all its openness and competition. "Applied art" was a trap to be avoided. A stand had to be taken in favor of great painting and the great tradition. After a series of disappointments from the WPA to the army—painting war pictures for *Life* (fig. 9) or camouflage for the troops—to industry, some artists began to see a glimmer of hope with the beginnings of the economic boom: the position taken by the Federation of American Painters and Sculptors might be a viable one. More than that, it might be the only way for artists really to define themselves in the new art market then taking shape. To many young painters, the picture that appeared on the cover of *Life* in 1944, showing an artist in uniform in the midst of debris, sketch book in hand, attempting to capture what was eternal in war, seemed ridiculous. With the end of the war and the growth of the private market, industry lost its prestige.

We must turn now to an examination of the rebirth of the private market. In this way we may hope to gain some understanding of the possibilities that now began to open up for young American artists. It was in 1943 that the skies began to clear, just when everything seemed finished, as Motherwell had written in his letter to Baziotes.

To give an idea of the war's enormous impact on the economy, it is worth noting that during the first six months of 1942 the government placed $100 billion worth of orders with the private sector (compared with $12 billion over the preceding six months) and that seventeen million new jobs were created.[131] The demand was such that it was frequently necessary to resort to overtime work and to hire women. Unemployment hit bottom in October 1944, with only 630,000 people out of work.

For the last two years of the war, citizens socked away about 25% of their take-home pay, and by mid-summer 1945 their liquid assets to-taled an astounding $140 billion in savings accounts and war bonds— three times the entire national income in 1932. Add in the individual incomes of $120-plus billion for 1945, and Americans had a quarter of

a trillion dollars to spend during the first year of peace. . . . And by the estimate of the Federal Reserve Board, the savings were spread fairly evenly across the populace.[132]

Thus an enormous quantity of money stood idle, awaiting the advent of the consumers' paradise that businesses and industries were promising in their advertising. As a hedge against inflation and for relief from the thirst caused by ten years of scarcity, many Americans began to invest in diamonds and painting. In 1942 jewelry sales increased by twenty to one hundred percent, depending on the area. A few months prior to the passage of a new law on luxury consumption, which went into effect in the spring of 1944, Macy's was selling jewelry, furs, and cosmetics at an unprecedented rate.[133] In 1944 American industrial investment was at its highest level in history, as business made ready, and made the public ready, for the anticipated flourishing of a postwar market in consumer goods. Newspapers of the period tell us of a time of euphoria when prospects for profit seemed unlimited. Clearly, the situation of the New York artist was critical, for he found himself in the midst of a wave of furious spending, an orgy of accumulation, from which he was all but cut off.

But the art world also experienced a sharp upturn. Beginning in 1944, at a time when French art was no longer being exported and European sources of art had dried up, at a time when inflation, despite the government's best efforts to control it, was on the rise,[134] at a time when consumer goods were becoming more and more scarce and when the battle for position among various artists' groups was heating up, we find a number of articles reporting that the art market is bustling and that a golden age is about to begin for the artist. The "art boom" followed the "economic boom." All of a sudden the country seemed to have developed an insatiable appetite for the arts. All the sources agree: the art scene was ebullient and the art market was going full steam. The number of art galleries in New York grew from 40 at the beginning of the war to 150 by 1946. Parke-Bernet's public sales (private sales are not recorded) increased from $2,500,000 in 1939 to $4,000,000 in 1942 and by 1945 stood at a record $6,500,000. Private gallery sales for 1945 were up forty to three hundred percent compared with sales for 1944.[135]

In order to attract a broader clientele, art dealers developed new sales methods, emphasizing simplified transactions, advertising, democratization of the market, direct sales, sales through artists' cooperatives, and even buy-by-mail arrangements. The character of the clientele did indeed change. Gone were the "aristocratic" collectors who bought art to enhance their prestige or to decorate their "palaces." The change in clientele necessitated changes in the way art was sold. Direct relations between buyer and dealer were encouraged in order to move away from

the intimidating pomposity and symbolism of a bygone era. As Eugenia
Lea Whitridge has observed, these changes helped to desanctify the art
object by displaying it as an ordinary consumer good:

Original paintings and signed etchings have been sold, to be sure,
but seldom have the names of the artists meant anything. For the most
part, *clerks*, not art experts, have sold pictures, not paintings, to *cus-
tomers*, not to clients or collectors. There has been little, if any, con-
nection with the real art market.[136]

Writing in the *College Art Journal,* Whitridge lamented this disruption
of the market, which she said had resulted in a lowering of standards,
a decline of expertise, and a loss of status. The coming of the masses
and of anonymity was dangerous, Whitridge argued, because it might
quickly lead the market to lose sight of the traditional masterpieces and
traditional values without which hierarchy is impossible. Confusion
would then reign supreme. The old image of the connoisseur or collector
as someone who spent hours examining a canvas and appreciating the
artist's work gave way to a new image of the harried businessman drop-
ping in to buy a painting at a gallery where the selling was impersonal,
efficient, and rapid. Art became a commodity and the gallery a super-
market. A new relationship came to exist between the buyers and sellers
of art. But art still made it possible for the harried buyer to gain in status
by being seen as a "cultivated man." Large numbers of people now
began to buy paintings, unique objects of art produced by the artist's
hand, which made the canvas different from the illustrations that had
previously been popular. The change marks the passage into a society
of luxury and excess, where high culture takes its place in a consumer
society. At the same time, the expenditure of money on art indicates a
desire on the part of the buyer to identify himself with the classical
image of the collector and thereby to establish his difference from other
people, to establish his "social meaning" in Baudrillard's sense.[137]

As a result of the new opulence there was, for the first time since the
Depression, a reorganization of social groups, a rearrangement of the
social hierarchy that made individuals wish to differentiate themselves
from other individuals in a number of different ways. Art was to play
a central role in this process, and the art market mirrored the change.

Americans enthusiastically invested in painting, just as they had done
after the First World War. But now the buyers were patriotic; they pre-
ferred to buy American works. The reasons for this are explained in
Aline B. Louchheim's important article, "Who Buys What in the Picture
Boom?" published in 1944 in *Art News.* Carried out with the cooperation
of New York's largest art galleries, this study documents the considerable
growth of the American art market. The 1943–44 season beat all previous

sales records. Louchheim gives a profile of the new art lover, who accounted for one-third of the season's sales:

> The new collector almost always buys American. American paintings are cheaper, they are more plentiful, it is easier to find good ones, it is considered "patriotic" to help by supporting American artists.[138]

Her characterization should come as no surprise, since we have already seen the intensity of the ideological bombardment to which the public was subjected during the war. There had been changes in the sort of art bought by the new collectors (typically under forty-five and upper middle class), but no particular style held sway:

> 1944 collectors want painting which seems alive to them, surcharged with energy, or excitement, or emotional connotations. . . . They don't want work which is stylized. . . . People seem to be seeking paintings which are close to them with a clear emotional meaning. . . . Familiarity with abstract painting has brought about acceptance according to dealers. "The label no longer shocks or frightens."[139]

From this account one very clear tendency emerges: buyers were looking for an expressionist art, for an art that was at once abstract and emotive.

In 1945 Louchheim repeated her study and in "Second Season of the Picture Boom" reported that sales were thirty-seven percent higher than in 1944, establishing yet another new record. Young collectors were buying paintings to decorate their apartments (62% of all purchases were made by businessmen, 28% by professionals, 2% by students, and 7% by soldiers).[140]

The new importance of the middle class in the art market was demonstrated by the sale of art objects from the William Randolph Hearst collection at Gimbel's Department Store in 1942. This spectacular sale brought in $4,225,000, to say nothing of the prestige it brought to Gimbel's. Members of the middle class were given the chance to acquire a bit of Hearst's prestige at their favorite department store. The sale symbolizes the replacement of one world by another. A year later, Macy's, not wanting to be left out, placed the following ad in the *New York Times:*

> Macy's offers for sale authenticated paintings by Rembrandt, Rubens, etc. . . . A $130,000 collection of paintings at our lowest possible prices. . . . Pay only one-third down on Macy's cash time, take months to pay, plus the service charge.[141]

The "war of the Rembrandts" was under way. Gimbel's responded to Macy's sale of a tiny Rembrandt, *Portrait of an Old Man* ($6,894), by

putting the master's *Portrait of a Child* on sale at the typical department store price of $9,999. The acquisition of an old master was thus no longer the prerogative of the millionaire alone. With the installment plan one could have the illusion of power equal to that of a Hearst or a Mellon—and the illusion sufficed. Differences of value were totally effaced, and the old watertight compartments between the classes were broken down. The disruption caused by the war opened a breach in the citadels of power through which the middle class found its way.

Heretofore, ritual expenditure for nonproductive purposes had been limited to a small minority and contributed to maintaining the power and prestige of the few who could afford to make such purchases. Now, however, with the arrival of the middle class on the art scene, the amount of money available for art was multiplied considerably. It was just as this change began, in 1943, that the two department stores began selling Rembrandts:

> Both stores admitted that there is plenty of room for the two of them. The art buying field has radically changed. No longer is art amassed by the multimillionaire Mellons, Fricks, Baches, and Wideners. It is bought in small quantity for their homes, by the Smiths, the Kellys, and the Joneses. And many of these people, according to the Macy-Gimbels school of thought, would rather buy art in stores where they are accustomed to trade than in the elegant atmosphere of a traditional dealer where some fear they might be outsmarted.[142]

So new was the phenomenon, however, that middle-class art buyers found themselves somewhat at a loss. For the first time in history art became a part of everyday life, a part of the environment, a decoration in middle-class homes. This was all so new that the buyers of art had to turn to home-decoration magazines and to *Life* for advice (see fig. 10). The magazines defined taste; *Life* became the buyers' *arbiter elegantiae*. By the war's end millions of families were turning to these sources for advice on "original" ways to decorate their new homes, products of the unprecedented postwar boom in housing construction.

June 1945 found ninety-eight percent of American cities facing a severe housing shortage.[143] This was resolved in part by putting up partially prefabricated homes and enlarging existing suburbs. By 1946 William J. Levitt was selling three-bedroom houses with fireplace, yard, and gas heating for the price of a Gimbel's Rembrandt. The money Levitt made from this successful design enabled him to start building 150 houses a week near Hempstead, Long Island (Levittown), where his bungalows sold for $6,900.[144] It was in places like this that much of the audience for the new art dealerships resided.

People of somewhat higher status were eager to maintain a cultural distinction between themselves and this new middle class and so were ready to turn to a more advanced, audacious, and modern art.[145] Their choice fell upon the newly organized American avant-garde and was guided by the sophisticated analyses of modern art presented in the pages of *Partisan Review* and by Clement Greenberg in the *Nation*. Whereas *Life* and the home-decoration magazines promoted traditional art,[146] the sumptuous pages of the more fashionable reviews favored modern art.

In 1944 *Harper's Bazaar* presented a collection of new dresses against a background of paintings by the left-wing painter Léger and the mystic Mondrian. The art was used to set off the high fashion, thus glossing over the ideological differences between the two painters. At the same time the fashion distinguished the work of these two artists, setting them apart from the mass of unrecognized painters. As we saw earlier, Pollock was similarly set apart in the pages of the same review.[147] The most advanced modern paintings were presented as objects of desire, as the ultimate in consumer goods,[148] their qualities emphasized by careful framing, through which the photographer succeeded in associating the round shape of the model's black and white hat with a similar form on the left side of Léger's composition. Similarly, the photograph implied a parallel between the geometrical pose of the female model and the geometry in Mondrian's painting in the background. Models and canvases were both eroticized. The attempt to insert the model into the canvas is strikingly successful: the two blend into one. The desire to own the dress is coupled with the desire to own the canvas. The two are inextricably intertwined. *Haute couture* and *haute peinture* are identified. The art of the avant-garde, modern art—represented here by Mondrian and Léger but in other issues by Picasso, Matta, and Pollock—became a shibboleth of class differentiation, a minimal but nonetheless essential sign of distinction. Ritualized, fetishized, and abstract, the art, like the female model, stood not only for luxury but also for knowledge.

At a time when the middle class was striving to incorporate into its own vocabulary the type of painting formerly appropriated by the wealthy, the wealthy were beginning to distinguish themselves by buying abstract expressionist art, hesitantly at first (1943–45) but later with ever increasing confidence (after 1946). But even though the middle class, as Loucheim's 1945 article points out, was enthusiastic for expressionistic, abstract, and energetic forms, abstract expressionism did not catch its fancy. It rejected abstract expressionism as a joke or, worse still, a subversive threat:

Created in an instant, the most beautiful stylized modern objects are not intended to be understood by the majority, at any rate not right away. Their social function is in the first place to serve as distinctive

signs, as objects to set apart those who set them apart. Other people don't even see them.[149]

The readers of *Fortune* and *Harper's Bazaar* were kept abreast of the latest experiments in abstract art. In 1946 *Fortune* published an article, coldly detached and therefore troubling, on the atomic explosion at Bikini. The piece featured two abstract paintings by Ralston Crawford (see fig. 11).[150] Addressed to a privileged audience, the article explained that the discovery of atomic energy had made the world so difficult to understand in its totality that traditional languages, including the languages of maps and graphics, were no longer capable of giving full expression to the realities of a nuclear world. Only abstract art could communicate the new meaning of human experience, the incredible feeling of total disintegration:

> Ralston Crawford here depicts the impact of twisted ships and metal wreckage upon an abstract painter. He makes no attempt to reproduce nature. Through a synthesis of the awful shapes and colors born of man's destructiveness, he expresses his sense of that "compulsion to disintegration" which for him is the central metaphysical fact of war. For this painting he went to the heart of chaos, the target ship, U.S.S. Nevada.[151]

The same public that was reading about the importance of abstract art and modern art in magazines like *Fortune,* the same people who were being told of the new art's attempts to represent the unrepresentable and to illustrate the unthinkable and who were thereby made ready to accept the unthinkable in their everyday lives, were also prepared to accept Pollock's "drippings" without undue astonishment, particularly since Pollock's work at this time (late 1946) was rather close to depictions of fragmentation and disintegration.

At this point it is worth pausing to consider two Pollock paintings with revealing titles: *Sounds in the Grass: Shimmering Substance* and *Eyes in the Heat.* Although these first "all-over" paintings were hard for a majority of the public to accept, because of their uniformity and chaotic composition, informed readers of magazines like *Fortune* could see that they actually represented the modern age, the Atomic Age. Pollock's new style was at once a commentary on the "modern" notion of integrity of the paint surface and a discourse on modern fantasies and anxieties (other paintings shown by Pollock in the same year can also be fitted into an attempt to record modern fears and myths: *Magic Light, Gray Center, The Key, Constellation*). This combination of commentary and discourse in Pollock distinguishes his work from that of a naive painter whose work he particularly admired, Janet Sobel. Sobel, too, used the

whimsical "all-over" style but introduced into the interstices of her composition grimacing human figures, a hangover from anxious surrealist efforts that Pollock cast aside in favor of a more plastic modernism while holding on to the mythic content of those earlier works.

In *Shimmering Substance* (fig. 12), the commas of color in the center of the canvas are placed on a dazzling surface created by a grid of thick white strokes and form a luminous yellow circle, a center of energy that can be understood as a sun. The effect recorded by Pollock is one of bedazzlement, such as can be caused by staring too long at the sun, leading to complete perceptual disintegration. The shredding of objects and forms by light is more complete and radical than anything accomplished by the Impressionists. Things disintegrate not only on the surface, as seen, but also in their very essence, owing to the deeply searing quality of the light. What Pollock depicts is a source of energy that is not merely powerful but also destructive. What is shown, in short, is not the sun but its equivalent, the atomic bomb, transformed into myth.

One has only to read *Fortune*'s calm and detached account of the bomb's explosion to understand the public's wonderment and guilty fascination in the face of this event:

If the atomic bomb detonated over Bikini on July 1 had burst over New York City on the same day, its radioactive cloud would have taken the approximate pattern shown on the map above. A direct hit over the city would have subjected its crowded streets to the full brunt of the blast, flash fires, and radioactive saturation. But a hit anywhere in the black area would have sent a lethal cloud of radioactivity over the city. . . . Moreover, there is no reason why only one bomb should be dropped at a time. Some bombs might be detonated mainly for blast effects, others under water to contaminate the whole harbor area. Some military men even foresee the release of clouds of radioactivity without bombs to act as an invisible poison gas.[152]

Pollock's paintings, with their references to a vibrant, iridescent, brilliant source of light and to a heat so intense that it destroys all objects, reducing each thing to a complex, convoluted web of thick, sticky, undifferentiated fibers, gave expression to the popular fascination with the myth of the thief of fire. Full of power, energy, and strength, these canvases seemed to trap their own energy within their deliquescing linear forms. It should come as no surprise, then, that connoisseurs began to take an increasing interest in a style of modern art that represented what for them was the essence of modernity.

Betty Parsons's sales records tell us that by 1945 most American collectors of modern and contemporary art had begun to buy the works of the American avant-garde.[153] The few critical articles published in 1946

tell us that the avant-garde was seen as a symbol of the new age. Consider the following commentary on Gottlieb, which appeared in *Art News:* "The primitive, elemental symbolism that Gottlieb wants to achieve does not appear to be incompatible with the present psyche."[154]

The new interest in art that was contemporary, modern, avant-garde, and American was reflected in the pages of the *College Art Journal,* which published a long series of articles emphasizing the growing importance of courses in the history of modern American art at both the graduate and undergraduate level.[155] In 1945 the *Journal* published a special issue edited by Alfred Barr, which focused on the teaching of the history of modern art in the United States.

> This issue of the *College Art Journal* is propaganda. It is intended to persuade the scholars in American Universities—undergraduates, graduates, instructors, professors—to interest themselves more deeply in studying the history of the arts in the U.S.[156]

Strong, victorious, and confident, America in 1945 could boast of increasing public interest in art, of media support for the new enthusiasm, and of many willing artists, who had profited from working alongside their European colleagues and who were now liberated by the return of those colleagues to Europe, as well as any number of art historians and museums ready and willing to turn their attention to the nation's own art. All that remained was to establish a network of galleries to promote the new art and profit from the growing public awareness.

It seems clear that the movement was under way as early as 1943. In March of that year, the Mortimer Brandt Gallery, which specialized in old masters, opened an experimental wing devoted to contemporary art and directed by Betty Parsons. The purpose of opening the new wing was to serve the needs of a market avid for modern works.[157] In April of 1945 Kootz opened a gallery of his own. In February of 1946, Charles Egan, who had previously worked at Ferargil, opened a modern art gallery, followed in September of that year by the opening of Betty Parsons's own gallery, which showed artists who Peggy Guggenheim, now in Europe, was no longer able to represent (Rothko, Hofmann, Pollock, Reinhardt, Stamos, Still, and Newman). Thus the groundwork had been laid for the peacetime art market, and dealers looked confidently to the future.

These facts stand in sharp contrast to the traditonal image of America, so dear to aging bohemians like Henry Miller, who in 1945 was still vituperating against philistine America and dreaming of Montparnasse and art students wearing berets:

I could have escaped that war in America. I could have become a citizen and made a good living. But I'd rather take my chances here. Even if there's only a few years left, those few years are worth more here than a lifetime in America. There's no real life for an artist in America—only a living death. . . . If he is a painter, the surest way for him to survive is to make stupid portraits of even more stupid people, or sell his services to the advertising monarchs, who, in my opinion, have done more to ruin art than any other single factor I know of.[158]

3
The Creation of an American Avant-Garde, 1945—1947

During the forties and fifties Europeans, and particularly French-
men, did not take a particularly favorable view of America. Poor Eu-
ropeans hated America because it was rich. Rich Europeans,
themselves little given to things spiritual, hated America because it
was materialistic. Petty bourgeois Europeans, themselves unculti-
vated and crude, hated America because it was not intelligent. Euro-
peans on the left hated America because it was imperialistic.
Europeans on the right hated America because it believed in progress,
morality, and man's inherent goodness. Europeans in the center
hated America because it was more in the center than anyone else,
and to begin with in the center of the world. All Europeans hated
America because Americans were Europeans who had gotten lucky,
except for those who had had the misfortune to be the earliest victims
of American colonialism (blacks and Indians). Europeans hated
America because they hated one another. And the few Europeans who
defended America usually succeeded instead in providing further rea-
son to hate it.

CLAUDE ROY, NOUS, 1972

For most Americans the end of the war brought with it the realization of the prophecy made by Henry Luce in his 1941 article "The American Century."[1] Made wealthy by the conflict, America had achieved both economic and military independence. Add to that the persuasive power of its nuclear arsenal and it becomes clear that America was ready to lead the newly liberated world into the "American century." Enticing though this prospect was, there were major problems and obstacles, as various planning agencies and commissions responsible for postwar development projects were not remiss in pointing out (among these were the National Planning Association, the Twentieth Century Fund, and

the Committee for Economic Development).[2] The new world would have to be built from the ground up. Bright promise often met with failure and contradiction, which gave rise to a mood of anxious pessimism that within a few years had permeated through all the strata of the society.

At the time Europe was liberated, the American left was still powerful, united under the banner of the Popular Front. But there were soon disappointments, owing to the ineffectiveness of international conferences, the lame performance of President Truman, and the behavior of the Soviet Union. The optimism that had held sway immediately after the liberation quickly evaporated. The hope that many people had harbored during the long years of struggle, of finally being able to create "One World," vanished with the breakup of the Popular Front and the growing specter of a third world war. Nowhere was the disappointment greater than among liberals, who had hoped that the terrible war would give rise to a more perfect world, and among supporters of the extreme left, who saw all too clearly that their earlier pessimistic analyses were now becoming a reality.[3]

Our next order of business will be to take a closer look at the disillusionment of liberals and radicals that followed the end of World War II. This pessimism on the left plays a key role in our analysis of the postwar scene. By looking at the sequence of events in the political realm and then examining intellectual reaction to those events we hope to gain some understanding of the attitudes of painters and writers as they watched their illusions being dispelled and their morale being destroyed. What positions did they take, and what ideology did they elaborate in response? For left-wing intellectuals, peace had been restored, but it was so tenuous and so absurd a peace that in some ways the situation was even more intolerable than the war had been. For the hapless left it was a Pyrrhic victory. The postwar world was a powder keg awaiting a spark.

The seeds of dissension were sown at the Yalta Conference, which ratified the victory of the two superpowers and divided the world between them. For the Western nations Yalta meant that free elections would be held in Eastern Europe and parliamentary democracies established there. For the Soviet Union, however, Yalta meant that a ring of friendly nations was to be established along its borders—and "friendly" meant that the political systems in these countries would be modeled on the Soviet political system. This was the first point of friction between the two superpowers, and the result was a heated and rather confused debate that culminated in March of 1946 with Winston Churchill's speech at Fulton, Missouri (see below).

The partition of Europe was made explicit by Truman's "policy of containment." This policy ran counter to the internationalist principles of the New Deal, which as we have seen had won it the support of various liberal groups. Utopian in its outlook, New Deal internationalism had envisioned extending freedom and democracy to the entire world.

Liberals continued to support the postwar New Deal, but the problems of reconstruction had begun to produce splits in the liberal ranks.[4] Writing in the *Nation*, Freda Kirchwey maintained that peacetime policy must be based on a new international order. The principles of this new order were to be cooperation, democracy, prosperity, and stability.

In many respects the system was modeled on that of American democracy: "Only a New Deal for the world, more far reaching and consistent than our faltering New Deal can prevent the coming of World War III."[5] This new world order, liberals hoped, would somehow deliver the colonial peoples from the grip of imperialism. As a step toward that goal, as well as to maintain American economic supremacy, they favored free trade for all nations.[6] Thus, from the traditional American position of total isolationism characteristic of the thirties, the United States moved first, during the war, to an interventionist policy, and then, at the war's end, to a utopian internationalism in which we find the first seeds of the imperialist internationalism that was to blossom forth later during the period of the Cold War. But the liberal program was never implemented despite the continued strength of liberals within the government. Liberal disappointment crystallized in 1944, when by the end of the Dumbarton Oaks Conference it became clear that none of the nations present were ready to give up national sovereignty in favor of a world government, as Wendell Willkie had suggested. The liberals envisioned a world delivered from the anarchy that had hitherto reigned among nations. If the idea of world government had to be given up, then they favored the creation of an international organization equipped with a police force strong enough to discourage any abuse of power by the great nations.

With all the optimism they were still capable of mustering, liberals put the best possible face on the ground rules limiting in advance the scope of the San Francisco conference that resulted in the creation of the United Nations. But despite their optimism the conference was no victory for liberalism. In fact it marked the beginning of the end for their view, for what was supposed to have been a peace conference quickly turned into an undeclared battle between the United States and the Soviet Union, a battle in which, morally speaking, the Soviets seemed to have the upper hand. Indeed, the Communists put themselves forward as the champions of the liberals' favorite planks (opposition to the admission of fascist Argentina to the United Nations, independence for colonized nations, right to work and to receive an education) against the American delegation, which was led by Senator Arthur H. Vandenberg, who it was said "seemed bent on wrecking Soviet-American relations."[7]

It was impossible for liberals and radical leftists to support imperialist and reactionary governments (whereas the American government wanted to support the Dutch in Indonesia, the French in Indochina, and the

Franco government in Spain). The political choices made by the American government seemed to run counter to everything that the liberals had fought for during the war. This disillusionment came to the surface on December 4, 1945, at a "crisis meeting" held in Madison Square Garden and organized by the Independent Citizens Committee of the Arts, Sciences, and Professions. Henry Wallace attended the meeting and supported its goals.[8]

Harry Truman's accession to the presidency on April 12, 1945, dashed whatever remaining hopes the liberals had after Yalta and San Francisco. Despite Truman's reputation as a "New Dealer," many saw him as a traditional machine politician. The liberal magazine *Common Sense*, for example, described the new president as "a representative of a small town middle-class viewpoint, a racist and a non-ideological broker who lacked a grasp of the fundamental issues facing America and the world."[9]

There was one alternative for those who rejected Harry Truman: Henry Wallace. Still popular, Wallace enhanced his public image with the publication of his book *Sixty Million Jobs* in September of 1945. A clear, natural successor to Roosevelt, Wallace thereby became Truman's leading potential opponent for the presidency.

American isolationism reached a nadir in 1945: "By 1945, the number, as well as the influence, of public spokesmen for American isolationism had dwindled. The internationalists were in the lead. They had acquired a near monopoly in the representation and propaganda of certain ideas about the world."[10] As moribund as isolationism may have seemed, however, one of its constituent elements, nationalism, enjoyed a period of rapid growth. The radical left, equally disappointed but more cynical than the liberals, took an increasingly ironic attitude toward all this political maneuvering. The radical analysis was not changed by the intervention of Wallace, the left-wing hero, in the debate:

> Wallaceland is the mental habitat of Henry Wallace plus a few hundred thousand regular readers of *The New Republic*, *The Nation*, and *P.M.* It is a region of perpetual fogs caused by the warm winds of the liberal Gulf Stream coming in contact with the Soviet glacier. Its natives speak "Wallese," a debased provincial dialect.[11]

Radicals, burned first by lost battles and then by battles never fought, no longer knew which saint to worship. Their bewilderment was equalled only by their pessimism, by their inability to believe in any public cause or to envision any valid kind of political action. Dwight Macdonald gave clear voice to this feeling when he wrote, in 1946 following the Declaration of the United Nations, that:

> The U.N. shows why it is difficult for a radical today to place himself in relation to international affairs, or to any kind of thought or action

which goes beyond his own personal experience, whether as an intellectual living in New York City or a member of a cooperative group farming some acres in Georgia. Speaking as the former, I cannot see that the U.N. is either a hope or a menace, just a bore.[12]

Yet in fact the period 1946–48 was a rare moment in modern American history, a time when there was again diversity in political debate, a brief interval sandwiched between the left-wing uniformity of the New Deal in the thirties and the right-wing uniformity of the fifties. From 1946 to 1948 political debate held center stage. Not only political but also artistic commitments were being questioned: there were battles, splits, shifts, reorganizations, and redefinitions, even as new positions began to solidify. The reason was that the right emerged from the 1946 elections with new strength. The middle class was satisfied with its new wealth and uninterested in prolonging the political ferment that had brought it to power during the war. It wanted to put an end to demands for further change and to maintain the comfortable status quo. The war had brought the middle class enough that it now had "something to fight for." Hence the Popular Front slowly began to unravel and finally came apart at the seams. Suspicion of a former ally, the Soviet Union, also played a part. As Truman said on January 5, 1946, "The Russians will soon be put in their places. The U.S. will take the lead in running the world in the way that the world ought to be run."[13] And the American Communist party, which defended Soviet policy, fell under the same cloud. The willingness to reject communism became a crucial litmus test for politicians.

The big change in politics after 1946 was in the position of the Communist party. Whereas during the Popular Front period it had been considered normal and even essential for the Communists to be included within the liberal coalition, their presence was now viewed as divisive, even if they remained an important political force until Wallace's defeat in the 1948 elections. The American government's suspicion of the Soviet Union, already apparent in the President's message of October 27, 1945,[14] was made even more explicit in Truman's memo of January 5, 1946, attacking Soviet expansionism. World peace, Truman said, required a strong stand against this Soviet policy: "Unless Russia is faced with an iron fist and strong language, another war is in the making."[15] The president referred to this memo as a "point of departure." It was followed in February by George F. Kennan's famous telegram from Moscow to the Department of State, in which Kennan explained in detail why the Soviets refused to join the International Monetary Fund and the World Bank.[16] Kennan's telegram contained a clear warning: be suspicious of Soviet expansionism and of left-wing parties that support Soviet policy.

As if this were not enough to excite public opinion, Winston Churchill, responding to increasing Soviet belligerence, delivered a speech at Ful-

ton, Missouri, on March 5, 1946. Speaking in his own name but with obvious encouragement from Truman, who had invited him, he made remarks that liberals considered excessive and dangerous, to say nothing of the reaction of the English government, which was taken by surprise. Churchill's remarks are too well known to warrant treatment here, but they stand as a historical milestone because of their enormous impact on the press and the popular mind. It was here that an ideological divide was created between East and West and an Iron Curtain rung down across Europe along with an ominous call for an anti-Soviet alliance. The reaction among the liberals was panic. Only a few months after the end of the war it seemed once again that a fresh outbreak of hostilities was inevitable. "Lots of people seem to have gone completely mad."[17] The Communists also used the "war scare tactic" to emphasize the seriousness of the situation, thus adding to the popular paranoia.[18]

Always ready to capitalize on topical issues, *Life* in July of 1946 published an article by Arthur Schlesinger, Jr., attacking the American Communist party's subservience to the Soviet Union. The historian emphasized the danger of the Communist party's attitude for the unity of the left. This was the beginning of the attempt to turn the traditional fascist/antifascist oppposition into an opposition between democracy and communism. Communists were soon to replace fascists in the witch hunt.

The split in the liberal ranks was consummated by the foundation of Progressive Citizens of America (PCA), with Henry Wallace as leader.[19] The PCA favored alliance with Communists. A large number of former New Dealers founded their own group, Americans for Democratic Action (ADA), which differed from the PCA mainly in rejecting Communists from membership.[20] The breakup of the Popular Front thus culminated in the establishment of two hostile liberal organizations. Add to that the confusion in which left-wing intellectuals found themselves at the end of the war and it becomes clear how divided and uncertain liberals were as to their future political direction in the wake of Republican gains in the 1946 elections. The president was isolated and unpopular in the eyes of both left and right.

All the illusions harbored by liberals during the war vanished in the space of a few months, giving way to a deep-seated confusion that led many to withdraw from politics altogether. In this connection it is interesting to look at the position of Dwight Macdonald, who was one of the few writers at the time to analyze the defection from the liberal ranks and the withdrawal of many liberals from politics in terms that reflect the sentiments of the artists we shall be looking at. Macdonald and others who rejected the alternative of the moment, that of a false choice between Truman's America and Stalin's Russia, were excluded from political debate: "In terms of 'practical' politics, we are living in an age

which constantly presents us with impossible alternatives."[21] From the standpoint of the radical, the current quarrel was foolish and unimportant. There was no choice but to stand on the sidelines and create a world apart, aloof from the meaningless debate. The disaster was that the new "war scare" afforded the radical left no room to maneuver within the traditional political system. Since 1939 radicals had been drifting farther and farther outside the normal channels of political discussion and found themselves isolated and therefore bitter. Even worse than their political isolation was the absurdity of their position, their incapacity to respond to the threat of nuclear annihilation.

In the September 1945 issue of *Politics* Macdonald analyzed the nature of the despair into which the Hiroshima explosion had plunged the radical intellectual, painter, or writer. It was not so much the horror of the event as the atmosphere of normality that surrounded it that provoked Macdonald, who noted the radical consequences of the blast for every man, woman, and child on earth:

The Authorities have made valiant attempts to reduce the thing to a human context, where such concepts as Justice, Reason, Progress could be employed. . . . The flimsiness of these justifications is apparent; any atrocious action, absolutely any one, could be excused on such grounds. For there is really only one possible answer to the problem posed by Dostoievski's Grand Inquisitor: if all mankind could realize eternal and complete happiness by torturing to death a single child, would this act be morally justified? . . . From President Truman down, they emphasized that the Bomb has been produced in the normal, orderly course of scientific experiment, that it is thus simply the latest step in man's long struggle to control the forces of nature, in a word that it is Progress.[22]

It was this attempt to rationalize and normalize the bomb that disconcerted the radical mind: Macdonald could not accept the scientists' explanation that "the weapon [had] been created not by the devilish inspiration of some warped genius but by the arduous labor of thousands of normal men and women working for the safety of their country."

Again, the effort to "humanize" the Bomb by showing how it fits into our normal, everyday life also cuts the other way: it reveals how inhuman our normal life has become.[23]

For Macdonald, the dehumanization of society that made it possible to produce a weapon as sophisticated as the atom bomb, that made it possible for 125,000 workers to participate in a project without knowing the purpose of what they were doing, was incomprehensible. Under such conditions, he maintained, the words "democracy," "freedom,"

"progress," and "science" no longer meant anything. The atomic age revealed the powerlessness of the individual; the new situation implied that responsibility and irresponsibility could not be disentangled:

The Bomb is the natural product of the kind of society we have created. It is as easy, normal and unforced an expression of the American Way of Life as electric ice-boxes, banana splits, and hydromatic-drive automobiles.[24]

In commenting on a *New Yorker* article by John Hersey on the Hiroshima bombing, Macdonald said what we have already said about Pollock's art and about the impact of atomic energy on such younger painters as Rothko, Newman, and Gottlieb, products of the thirties and forties.[25] Quite realistic, *The New Yorker* gave a meticulously objective description of the horror and carnage. For Macdonald this bourgeoisified, clinical, and detached account of atomic horror said nothing. The critic rejected the calm recital of the facts, ready for consumption and for absorption by the mind. This was a way of reducing the atomic outrage to the level of an anecdote, a way of placing it beyond criticism. The monotonous objectivity of the description was the most frightening thing about it. Macdonald agreed with the modern painters that "naturalism is no longer adequate, either esthetically or morally, to cope with the modern horrors."[26]

In order to speak of horror without accepting it, some artists experimented with an abstract idiom. Motherwell, for instance, said that premonition of disaster "seems to me a very natural feeling for someone in the 40's to be dealing with."[27] And Gottlieb explained that he started "with arbitrary forms or shapes and [tried] to come from that to something that relates to life and evokes and expresses some of the feelings we are concerned with today such as the disintegration of the world."[28] As Macdonald said, the radical, excluded from the debate concerning important national and international decisions, could only turn in on himself and try to pin his radical illusions to the tail of history. For the intellectual left that had participated with high hopes in the discussions of the thirties, the explosion of the bomb and the postwar climate destroyed whatever hopes they may have placed in science and democracy. By the same token they rejected Marxism, which for many of them had offered the only way out of the crisis.

The new world required a new kind of radicalism. Macdonald, in a 1946 article entitled "The Root Is Man," explained why Marxism had failed and suggested instead a kind of anarchist individualism that attracted the attention of many intellectuals.[29] However few in number they may have been, radicals were particularly interested in Macdonald's proposals now that they had to confront the government's new anti-

Soviet policy and accommodate to the split in the liberal ranks, as James B. Gilbert explains:

The society that fought and won the war was not the regimented, fascist-like state that Macdonald had feared, nor was it a society cleansed by a great and successful world crusade for democracy. What emerged was a mediocre society whose senses were dulled to the issues of culture and politics but which was able, nevertheless, to convey an overwhelming sense of permanence.[30]

As a result, the radical community developed what Arthur Koestler called an "active fraternity of pessimists."[31]

Looking back at the thirties, radical intellectuals saw nothing but a series of disasters and failures: the Moscow Trials, the Spanish Civil War, the failure of proletarian literature, the Hitler-Stalin pact, the atom bomb. Everything had been sadly bungled. The postwar artist was a down-trodden figure, a "portrait of the artist as a middle-aged man," as William Phillips put it.[32] No longer was the artist seen as one of the voices of revolution, as he had been in 1936. Rather, he had become the guardian of the liberal democratic ideal (even though some progressive artists did continue to fight against nationalistic and isolationist conceptions of art and literature).[33]

The summer 1946 issue of *Partisan Review* clarified the position of the magazine and of the avant-garde in regard to relations with communism.[34] "The Liberal Fifth Column" was an attack on liberals who associated with communists and who, like the *New Republic*, the *Nation*, and *PM*, favored cooperation with the Soviet Union. *Partisan Review* chose capitalist democracy over Stalinism. Its position was that the overriding necessity was to attack Stalin before the right did, because the attack from the right would make no distinction between Communists and the anti-Stalinist left. The magazine had no desire to be caught in the cross-fire.[35] *Partisan Review* saw no radical alternative. The logic of realpolitik would have to be accepted: a choice had to be made between the two ideologies without regard to the prospects for revolutionary change, which only two years earlier had still seemed within the realm of possibility. Ironically, it is clear that *Partisan Review*'s attitude toward liberalism was still one of mistrust:

One powerful element of continuity was the editor's distaste for liberalism: once they had disliked it because it was nonrevolutionary; later they disliked it because it became nationalistic at the approach of war. Now they rejected it because they were convinced that many liberals were pro-Stalinist.[36]

Dwight Macdonald serves as a standard against which we may measure the radical artist. He moved first from conventional Marxism to Trotskyism and then, immediately after the war's end, set aside both Science and Marxism and took up the anarchist cause.[37] Painters such as Rothko and Gottlieb, Pollock and Motherwell—members of what has been called the New York school—followed the same course. Newman had been an anarchist since the twenties. The works and writings of these painters shed further light on the parallel between their path and Macdonald's, despite the lack of letters and other documents that might show a direct influence. One point should be made right away. It is a point that has been made before.[38] Specifically, between 1945 and 1946 the intellectual elite of New York turned to the analysis and use of myth as a way to move beyond the aesthetics of the Popular Front:

> These days the word "myth" is thrown about as cavalierly as is any word which the cultural climate envelops with glamor and charges with an emotional voltage. It is a powerful word, but not precise.[39]

Of course there was nothing new in this. Breton, for his second surrealist manifesto, had called for the creation of a modern myth. Thomas Mann envisioned a mythology that would be capable of taking the place of science, completely discredited after Hiroshima, and thus enable the modern artist to overcome his inability to create:

> We need a new myth to replace the narrow and now harmful nineteenth-century world view of science and progress; especially as a method of criticizing and creating, literature is far superior to science.[40]

It was through surrealism that American avant-garde artists developed an interest in myth. Most painters combined myth with personal obsessions in creating biomorphic canvases that ranged from the strident and densely erotic compositions of Gorky to the rough, simple paintings of Clyfford Still:

> Thus biomorphic art emerged in New York as the result of a cluster of ideas about nature, automatism, mythology, and the unconscious. These elements fed one another to make a loop out of which this evocative art developed.[41]

But some artists in the biomorphic group sought to distinguish their work from that of the many other painters in New York then working in the same vein. There was a resurgence of primitivism in the city, as can be seen by looking at the interesting work done by a group of painters affiliated with the gallery Neuf. Led by Oscar Collier and Kenneth Law-

rence Beaudoin, these painters used American Indian symbolism and myth but in a manner close to that of the surrealists (Collier, Busa, and Barrer were very close to Masson and Miró).

In New York this spring, Wheeler, Barrell, Busa, Collier, Barrer, De Mott, Sekula, Lewis, Orloff, Daum, Smith are painting a new magic out of old stardriven symbols rooted in an understanding of pre-co-lumbian American Indian Art, using it (not historically) but as a com-petent vehicle for current representational art. I have referred to this group of painters as semeiologists/semeioly (*sic*) connoting the roots of the method to be in ancient runic American Indian art, connoting two dimensional rather than three dimensional representation.[42]

Although it was still hard at this point to detect any formal differences between a surrealist work and a painting of the American avant-garde (Gottlieb, Rothko, and Newman), there was a clear difference in what the painters wrote about their work, in the image they projected of themselves. What the artists who formed a group around Barnett New-man rejected was salon surrealism, the black humor and lack of seri-ousness they found in the work of certain surrealists. They rejected attitudes like those of Alfred Russell, who published in *Iconograph* an article that combined a bit of sex, a bit of confusion, and a touch of violence with a good dose of mystery designed to send shivers of plea-sure up the backbones of those who gathered at fashionable art openings:

I believe in power, activity, reflection, destruction and creation in art. I believe in confusion and above all, unevenness, in those who never find themselves. A painter is lost once he has found himself. Quantity is much more important than quality. Paint large pictures, crowded pictures. Scribbles, scrawl errantly reflect only terrifiedly about a past that is nightmarish. Eroticism in all forms is the pervading magnetism of the picture, the sun must bicker with an incessant madness.[43]

A rather similar figure was cut by an artist working in the same tradition, a young painter of the Art of This Century group who was considered by many to be the latest of the modish young prodigies, Charles Seliger:

The art of Charles Seliger is a contemporary extension of the modern morphological tradition. . . . To this observer [Seliger's forms] suggest more than anything else the viscera. Indeed at this stage of its de-velopment, Seliger's art might be defined as an apotheosis of viscera, contrapuntally punctuated with the image of the phallus.[44]

This says it all: Seliger was mired in the surrealist tradition, he played with and enjoyed his personal fantasies, and he contented himself with

an eroticism (viscera, phallus, blood) having no direct connection with history, too close to Pavel Tchelitchew (fig. 13), whom Greenberg had called a "neoromantic," to be taken seriously.

In contrast, the painters whom Rothko referred to as "a band of myth-makers" did attempt to connect their work to history and to contemporary events, though in an indirect way. To be modern in New York in 1946, to wish to live or rather to survive in one's own time, meant, as we have seen, to be pessimistic, somber, and incapable of painting the visual reality of the atomic age. It was also to be incapable of painting viscera, such a statement or description of reality having become frivolous, superfluous, hollow. This kind of representation stripped the object represented of its meaning, making art into artifice. In order to avoid using modern horror to amuse oneself, what was needed, according to the group of painters affiliated with Art of This Century, was the development of a style capable of conveying the world's absurdity. To be modern, finally, meant to respond to the alarming reports of preparations for a third world war, to pay heed to the fate of the individual faced with the surrounding chaos.

A radio interview given by Rothko and Gottlieb in 1943 gives us a clear idea of the early ideology of the American avant-garde. It illustrates the artists' interest in the violent and frightening content of primitive art. This turn to an archaic form of art was a way for avant-garde artists to establish an indirect link with a part of modern history from which they were aware of being cut off:

> For us it is not enough to illustrate dreams. While modern art got its first impetus through discovering the forms of primitive art, we feel that its true significance lies not merely in formal arrangement, but in the spiritual meaning underlying all archaic works. . . . That these demonic and brutal images fascinate us today is not because they are exotic, nor do they make us nostalgic for a past which seems enchanting because of its remoteness. On the contrary, it is the immediacy of their images that draws us irresistibly to the fancies and superstitions, the fables of savages and the strange beliefs that were so vividly articulated by primitive man.

For Rothko myths

> are the eternal symbols upon which we must fall back to express basic psychological ideas. They are the symbols of man's primitive fears and motivations, no matter in which land or what time, changing only in detail but never in substance, be they Greek, Aztec, Icelandic or Egyptian.[45]

Gottlieb and Rothko believed that myth and primitive art could be used to express contemporary anxieties (though only as a conceptual point of departure, there being little direct formal influence): in 1943 the source of anxiety was the war, in 1946 it was the atomic menace. Their attitude was in itself a myth, the myth of the noble savage, of the return to the womb. They held fast to the notion that with a tabula rasa they could save Western culture, purify it, and rebuild it on new foundations. For them, as we have seen, the political situation had become hopeless in its complexity and absurdity (many who rejected the Marxist left ended up embracing what they had once detested and rallying to the liberal cause). The avant-garde retained traces of political consciousness, but devoid of direction. The political content of their art had been emptied out by the use of myth. Pollock, Rothko, Gottlieb, Newman—the avant-garde painters who talked about their art—did not reject history, because it was there in all its hideous features, snapping at their throats. They did not reject the idea of some kind of action, of some reaction to the social situation. They did not avoid the problems of the age but transformed them into something else: they transformed history into nature. As Roland Barthes has put it, "By moving from history to nature, myth gets rid of something. It does away with the complexity of human actions and bestows upon them the simplicity of essences."[46]

While using automatism, myth, and surrealistic biomorphism, the modern American painter kept intact one aspect of his political experience from the thirties and held on to one cherished notion: the idea that the artist can communicate with the masses, though now through a universal rather than a class-based style. Political analysis was replaced by "a fuzzy world whose sole inhabitant is eternal man, who is neither proletarian nor bourgeois."[47]

In the introduction to the catalog of the show held by Polish artist Teresa Zarnover in April 1946 at the Art of This Century Gallery, Barnett Newman explained what he thought the new art ought to be.[48] In the first place it should be related to the contemporary world. Political and social history, he argued, had shown that the world of the "purists" was an abstract world cut off from reality. Under the present circumstances personal obsessions no longer mattered. As Dwight Macdonald had done in writing about the bomb, Newman here emphasized that the horror of modern conditions could not be represented or described. To do so was unworthy of the artist; it was to descend to the level of *Life* or *The New Yorker*, to wallow in the filth of everyday life. To depict the horror, to describe it, was tantamount to accepting it:[49]

[Zarnover] now, in her first exhibition of work done here, feels that purist constructions in a world that she has seen collapse around her

into shambles and personal tragedy is not enough, that an insistence on absolute purity may be total illusion. Art must say something. In this she is close to many American painters, who have been no less sensitive to the tragedy of our times. It is this transition from abstract language to abstract thought, it is this concern with abstract subject matter rather than abstract disciplines that gives her work its strength and its dignity. The truth here is mutually inclusive, for the defense of human dignity is the ultimate subject matter of art. And it is only in its defense that any of us will ever find strength.[50]

Whenever Barnett Newman expressed himself, he, like other members of the group around him, had one eye always on the place of the avant-garde on the contemporary scene, which he was interested in redefining. This explains why he attacked abstract art ("purist constructions") and surrealism ("personal tragedy"). For Newman, the representation, the sign, was nothing unless it conveyed an abstract thought as its subject matter. His head was not in the sand: his text speaks of what is going on in the world, of quite real anxieties, colored by the politics of the present moment. Recall that it was on March 5 (one month before the Zarnover show at the time when Newman was writing the catalog) that Churchill made his speech in Fulton, in which he spoke of the abyss between the two camps in Europe and proposed an anti-Soviet alliance of the nations on the western side of the Iron Curtain. In this situation the work of the Polish artist took on a new significance, which Barnett Newman recognized. The nervousness of the period emerges clearly from the pages of the catalog. For Newman, purist abstract art was an illusion, a kind of totalitarianism. In contrast to geometric abstraction, expressionist fluidity was freedom: the freedom to speak and to act. In Zarnover's rejection of the purist style Newman saw proof that his theories were in step with the march of history.

The art practiced by Newman and the avant-garde was one of a range of possible painting styles then being discussed in the press. In 1946 the art world was in ferment. It was a moment of euphoria when everything seemed possible. If people were right that New York was going to take the place of Paris, then it was important to find the right image for America and its culture. This image would have to allow for the ideological requirements of both New York and the United States as well as take account of the international situation.

In the ebullience of the early postwar period there were many different styles corresponding to various political options, but all defined themselves in relation to Paris. Some rejected Parisian modernism in favor of isolationist Americanism (these were on the decline). Others copied Parisian styles with modifications (Stuart Davis). Still others copied the art of Picasso or of the Abstraction-Creation group (created in Paris in

1932 by Antoine Pevsner and Gabo). And finally there were some artists who rejected Parisian influences without accepting nationalist art in their stead (these were the painters of the liberal and radical avant-garde).

For the New York avant-garde, tradition meant the Parisian tradition: Paris was the target, the standard of comparison. We must be sure to keep this in mind if we wish to understand the strategy adopted by the avant-garde. For the time being, however, nobody was sure what direction to go.

At the great national exhibitions of 1946 (Iowa, Carnegie, Whitney, and even MOMA) a vast and eclectic array of contemporary art was presented and no one was satisfied.[51] Efforts were made, however, to sum up the current situation in the arts. One such was the Whitney Museum's annual show, which according to Hilda Loveman attempted to give a broad overview of works by living American painters.[52] Loveman stresses the growing importance of the abstract movement, which had already received the name "abstract expressionism" and which, it is interesting to note, had almost completely supplanted the social art of the thirties.

The ferment in the art world worked in favor of American art in the postwar years. The "picture boom" that began in 1944 continued up to 1947, when there was a slight downturn. In the absence of French art, American art was selling well. An *Art News* editorial of July 1946 describes the situation succinctly:

> Going into the 4th year of the picture boom, the still increasing contingent of the new as well as the old collectors are virtually yanking them off the walls of the galleries. Even the work of living Americans is beginning to grow as scarce as the long shut-off supply of the modern French and the ever diminishing stock of old masters.[53]

The art scene had been so loosened up and diversified by European artists who spent the war years in New York that New York artists were now producing modern art. But their work had not yet been accepted by the general public. Nevertheless, Lester Longman, who began showing contemporary art at the University of Iowa in 1945, was optimistic:

> Artists now interpret the American environment with no fear of foreign influence, and seek with honesty and self-confidence to shape new forms which ritualize our spiritual concerns. American painting has never been more vigorous, more prolific or more impressive.[54]

Prolific it certainly was, but American art was not as impressive or as liberated from academic, nationalist, and social realist traditions as Longman was pleased to think. But there was nevertheless an element of

truth in this advertising circular (remember that the show was also a sale and that the buying public was not always very well informed): abstract art was now in the forefront, thanks to the influence of the Europeans in New York.

Artists returning from the front after three years' absence were astonished to find all the gallery places gone and all the walls covered with abstract art.[55] This is the tale told by Milton Brown in an article published in *Magazine of Art* in April of 1946.[56] When Brown left for the war social realism had been battling with nationalistic art for supremacy in the American market. When he came back both had been banished from the arena in which the fate of Western culture was being decided. In their place was abstract art, the art which, as Ad Reinhardt intimated in a famous drawing published in *Newsweek*, was going to save art in general from banality, prejudice, sentimentality, and so on (fig. 14).[57] "I have returned," Brown wrote, "to find with some surprise that in the interim the dark horse of abstraction has swept into the lead."[58] Abstract art dominated the New York scene: "All along the street are evidences that the vogue today is for abstraction. Three years ago this tendency was evident, today it is swarming all over the stage. The galleries are now exhibiting many abstractionists of whom I had scarcely heard—Baziotes, Schanker, Gasparo, Motherwell, Davidson."[59] For Brown, the vogue for abstract art represented a real danger that the artist would lose contact with visible reality. He viewed the change as a sign that artists had abandoned their social responsibilities. His reaction is typical of artists and intellectuals who still adhered to the ideology of the Popular Front and the New Deal, an ideology that by 1946 was already on the decline:

> Certainly the artist has become, just as all people have, more conscious of the world—the atom bomb must have done that, if the war did not—but faced with the complexities of postwar life, its uncertainties and its problems, he has retired even further into the clear and untroubled limitations of his craft. There he can deal with tangibles, with the basic ingredients of his profession. It is as if, unable to resolve his conflicts and problems as a human being and a citizen, he keeps at least his individual artistic capacities limber by practice.[60]

More perceptive than Brown, Lester Longman had a fairly clear idea of the change that had taken place and by 1946 was willing to accept the use of devices taken over from surrealism to represent the morbidity of the modern age:

> Young painters are boldly experimental in conjuring up a host of unfamiliar shivers, and the MOMA is increasingly persuasive in cap-

turing their imaginations and certifying their achievements. The more adventurous critics are preparing mentally for the time when an art that seems disloyal to the generation of Picasso will, at first, appear intolerable. . . . Both abstract and semi-representational artists are fusing formal and surrealistic values, resolving anew the ageless polarity of the classic and romantic. . . . So many new names have been enrolled in the ranks of the abstract painters that they constitute our newest "academy." After time has separated the grain from the chaff, there will be much to commend. But now slight and often elementary patterns of precious ambiguity are taken seriously, though they exhibit little knowledge of the complicated problems of pictorial design of form in space.[61]

At the heart of this all-out experimentation, Longman already glimpsed not merely the growth of a new academicism but also the catastrophic abandonment of the formal tradition. Modernist experimentation was moving too fast, he said, and thus turning out works that were inarticulate and unacceptable. Longman was already setting limits on what modern plastic styles he was willing to accept, limits that would later cause him to reject abstract expressionist style.

The large exhibitions that attempted to sample the full range of the nation's artistic output were interesting for their attempt to reveal the magnitude and complexity of the aesthetic choices confronting America in the postwar years.[62] Most artists were trying either to accept modern art or to "modernize" old formulas (Robert Gwathmey, Paul Burlin, Joseph deMartini). In any case it was clear that the interest in covering old styles with a modernist veneer was so widespread that modernism was in danger of becoming a new kind of academicism. As Clement Greenberg put it in 1945:

We are in danger of having a new kind of official art foisted on us— official "modern" art. It is being done by well-intentioned people like the Pepsi-Cola Company who fail to realize that to be for something uncritically does more harm in the end than being against it. For while official art, when it was thoroughly academic, furnished at least a sort of challenge, official "modern" art of this type will confuse, discourage and dissuade the true creator.[63]

Greenberg was afraid of seeing the entire avant-garde coopted. He complained that academicism was no longer playing its role of opposition. Without this opposition the avant-garde was effectively disarmed. The art spectrum became homogeneous, mediocre. In this period of renewal what American art and American society needed was vitality, aggressiveness, and optimism. For Greenberg, writing in April of 1947, "academism" stood for pessimism:

It is in the very nature of academism to be pessimistic, for it believes history to be a repetitious and monotonous decline from a former golden age. The avant-garde on the other hand believes that history is creative, always evolving novelty out of itself. And where there is novelty there is hope.[64]

Novelty was supposed to come to the rescue of American works that were in effect pale copies of modernist styles. But the rescue was not easy to effect, because the avant-garde was caught in the toils of the eclectic approach favored by the large national exhibitions: "living" art was not visible.

We must now examine how that "visibility" was acquired and how the avant-garde became a mirror image of America and dazzled the free world. The process got under way in 1946 when the Advancing American Art exhibition was sent abroad. There were disappointments connected with this show, whose preparations were halted in midcourse for domestic political reasons.[65] Nevertheless, the exhibition demonstrated that the American government was willing to involve itself in the international art scene.

By 1946 the success of abstract art made it necessary for the popular press to educate its readers about the major change that had taken place in American culture. The press tried to help the middle class move from a traditional provincial culture to a modern urban culture. But what did the middle class really want, and what was it ready to accept? Still defending the art of the New Deal period, George Biddle attempted to give new life to the dying Popular Front (the Artists for Victory group closed at the end of 1945):

I personally want an American art that deeply moves me. We are perhaps the most powerful nation in the world today. We are passing through one of the great crises in human history. Can we ask less of American art than something worthy of our destiny? The American artist today, however, is apt to be caught on the horns of a dilemma. I think that much of modernism is far more concerned with artistry than with life; that it is often exotic and derivative; that its roots are not fed from passion or love or tears; that it will never sweep us to any great heights. On the other hand, it is urbane, cultured, sophisticated. It is an art bred of good taste rather than from the bowels.[66]

Biddle's opposition was clear. Still, it is curious to observe that what he was asking for was exactly what some avant-garde artists (Rothko, Gottlieb, and Newman) thought they were offering: a painting with subject matter, a painting that was profound, important, linked to man's fate, moving, neither too aesthetic nor too functional:

The dilemma which confronts the artist and public today: or more accurately, these are the two reefs, the Scylla and Charybdis, which he must avoid in that narrow channel between functioning vulgarity and sterile estheticism. He will need courage and discipline to create a vital expression in the grand manner. Whether his chosen style is traditional or modernist is vastly unimportant.[67]

We find the same idea in an article by Howard Devree in the *New York Times*.[68] Since America was the most powerful country in the world, Devree argued, there was a pressing need to create an art that was strong and virile to replace the art of Paris, a city that no longer had the strength to serve as the beacon of Western culture. Like Biddle, Devree insisted that the new art must be situated in the center, equidistant from both right ("the outworn formulas of academism") and left ("stereotypes of the new academism of the left"). In the *Times* of July 21 he repeated that the new American painter must be a man of the center:

Further progress depends on our post war artists taking stock of the situation and finding that true balance between reactionary formulas on one side and excesses on the other. The road is uphill all the way and the task is endless.[69]

In September 1946 Edward Alden Jewell had a more pragmatic formula to recommend in a *New York Times* article telling artists what direction to take.[70] Jewell distinguished between "international" and "universal" art. The former (sponsored by Gottlieb and Rothko as early as 1943) he said was fatally flawed by being derived from foreign influences. The words "national" and "international" had political connotations which the critic felt must be avoided. "International," he said, "refers to politically separated groups rather than to humanity, whereas 'universal' art roots in individual experience and for that reason may have a profound appeal for individuals anywhere."[71] At the same time "universal" art would be profoundly American, since the artist would have taken his inspiration from his own personal experience, which was of course American. Now let us forget Jewell and his naive analysis and recall what the "myth-makers" of the avant-garde were saying. Art, they believed, should be rooted in desire for the absolute and should aim to reach universal man. Ideologically, they were closer to their enemy Jewell than they suspected.

In October of 1946 the Betty Parsons Gallery took the symbolic step of staging a show of Northwest Coast Indian painting.[72] The significance of this show derived from the fact that Parsons's gallery had taken on many of Peggy Guggenheim's artists and was now attempting indirectly to define what living American art was. Barnett Newman, who spoke

for the gallery and its painters, had no doubt whatever that the position taken by the "myth-makers" during the war was the right one for defining the atomic age.

What distinguished the 1946 announcement from earlier declarations was the novel attempt to reject Western culture and to assert in its place a truly American culture. American artists were going back to their roots. They were seeking and finding an alternative to the European and hence the Parisian tradition:

> It is becoming more and more apparent that to understand modern art, one must have an appreciation of the primitive arts, for just as modern art stands as an island of revolt in the stream of western European aesthetics, the many primitive art traditions stand apart as authentic aesthetic accomplishments that flourished without benefit of European history.[73]

With this complex cultural baggage the American artist might now dare to venture onto unexplored pathways of plastic creation. Newman took the occasion to attack in passing purist, nonobjective abstract art, which he compared to primitive decorative art. In primitive societies decorative art was the province of women, whereas men were responsible for creating the art of ritual. The art of circles and squares was too feminine and hence had no serious value. Along with its practitioners it was relegated to an insignificant, effeminate role of entertainment in a world where history was shaped by men:

> It is our hope that these great works of art, whether on house walls, ceremonial shaman frocks and aprons, or as ceremonial blankets, will be enjoyed for their own sake, but it is not inappropriate to emphasize that it would be a mistake to consider these paintings as mere decorative devices; that they constitute a kind of heightened design. Design was a separate function carried on by women and took the form of geometric, non-objective pattern. These paintings are ritualistic. They are an expression of the mythological beliefs of these peoples and take place on ceremonial objects only because these people did not practice a formal art of easel painting on canvas.[74]

Defending the work of his group from populist attacks in an effort to reestablish communication with the masses, Newman invoked the example of Indian art:

> There is an answer in these works to all those who assume that modern abstract art is the esoteric exercise of a snobbish elite, for among these simple peoples, abstract art was the normal, well-understood domi-

nant tradition. Shall we say that modern man has lost the ability to think on so high a level?[75]

Thus the avant-garde artists took on both a prestigious past and an image of gravity and seriousness as well as a coherent native tradition, all the things that the new age required. The group thereby forged an "American" image for itself, something that was becoming increasingly necessary for selling art in the United States. Elsa Maxwell, discussing the Parsons gallery 1946 Christmas show in her "Party Line" column, did not fail to make this last observation, her treacly style striking a rather cruel blow at an art conceived by its authors in such serious terms:

Now I am not an authority on painting and don't profess to be, particularly on American painting. But anyone who wants to spend $100 or $150 for a picture by one of the younger American Abstractionists may eventually own a masterpiece. Who can tell? Don't turn down our own artists, no matter how silly or funny you think them. Their dreams are real and their aspirations pure. Miss Parsons's "Christmas Show" should attract a much larger audience (in number) than your old roving reporter, who just happened to pass 15 East 57th and noted that there is a little show really worth looking at, particularly because it is American. Some dissenters scream "Hang the abstractionists." I echo "Certainly, but why not on your walls?"[76]

Enthusiasm for painting by young Americans grew rapidly and did not go unnoticed by Samuel Kootz, who was still interested in modern art but now as a member of the Museum of Modern Art's advisory board. As early as 1945 he had signed contracts with Motherwell and Stamos. Kootz was an art dealer of a new kind. He was dynamic, decisive, sometimes audacious: he had, in short, all the qualities that the critics wanted to see in painters. In keeping with Parisian tradition he bought up all the work that an artist did until he was established and then took the usual percentage. This left him free to speculate on his stores of early works after they became "rare finds."

From the first, Kootz championed internationalism, fashionable in the years when he was starting out (1945–46). He represented not only artists like Motherwell, Gottlieb, Baziotes, Holty, Browne, and Bearden but also painters from the Paris school such as Léger, Picasso, Arp, Braque, Miró, and Mondrian, thereby hedging his bets while enhancing the prestige of both his gallery and the American artists he had under contract. In order to reap the maximum possible profit from the vogue for modern art and the economic boom, Kootz staged a series of shows to attract a new audience of collectors, including an exhibition of broker Roy Neuberger's collection of modern American art.[77] Devoted to domestic works, this exhibition was a resounding success. In addition to

canvases by painters affiliated with the Kootz gallery, there were works by Alexander Calder, George L. K. Morris, Jacob Lawrence, Horace Pippin, Abraham Ratner, and Jack Levine. The press was unanimous in its praise for Kootz:

> The Samuel Kootz Gallery has persuaded Mr. and Mrs. Roy Neuberger to lend their private collection to a three-week exhibition, now in progress. This is a generous idea on the part of these collectors, and the more so since their tastes run toward modernity, for one of the problems in establishing standards in contemporary production is that the prize items are so quickly swept into private collections and their educational possibilities restricted.[78]

The gallery was thus portrayed as an instrument of cultural education, at once disinterested, patriotic, and international. But the ostensible disinterestedness was merely a tactical ploy, since what Kootz was after was a public of avid collectors.

Shortly after the Neuberger exhibition, Kootz staged another sale-show and did not beat around the bush about its purpose: "Modern Painting for A Country Estate: Important Painting for Spacious Living" was the title of this June 1946 extravaganza. Celebrating the gallery's first anniversary in May and June of 1946, Kootz went after young collectors. Posters advertised the theme of "Building a Modern Collection." The paintings sold on this occasion were of somewhat smaller format than those in the Country Estate show. Thus Kootz went after customers of every category. Within a short period of time both Kootz and his artists were highly visible, recognizable names. Kootz became something like the *metteur en scène* of modern taste.

We can get an idea of how Kootz looked at his profession by examining the catalog he prepared to accompany one of his shows. His aggressiveness opened up a whole new market: the upper middle class, all of whom became potential buyers. Accordingly, in his catalog Kootz cast himself as a modern, optimistic, and aggressive American. This was to become his trademark:

> This gallery has confined itself to a specific direction in American painting, having made that positive choice with the same deliberation and inevitability that prompts a painter to determine his personal course. We enjoy the painting we exhibit; we believe its direction has expanded the plastic possibilities in modern American art, and we have witnessed with great pride the acceptance of the artists we represent—by museums, well known collectors and young enthusiasts, who feel that these artists are speaking to them in a new idiom (possible only in this day, continuously exploring, as it does, the emotions and thought of this day). . . . We have titled the exhibition "building

a modern collection" for these paintings express superlatively the accomplishment and directions of the artists, and should, we believe, become important sources for enjoyment to discriminating collectors.[79]

In order to impress his own name and the names of his artists on the public mind, Kootz used a "saturation" technique derived from radio advertising. Bimonthly shows organized around specific themes were staged one after another, always showing works by the same group of artists affiliated with the gallery. Thus the names of these artists would appear in the press every two weeks, affording them repeated exposure. For themes Kootz chose historical topics with which he was familiar as an art historian and which typified the Parisian modernism he knew so well, such as Picasso's "circus theme" or Matisse's "joy of jazz." Garish posters were sometimes used: one advertising a show on the theme of "The Big Top," proclaimed

GAYEST SHOW OF THE YEAR—COLOSSAL, TERRIFIC
PAINTINGS OF THE CIRCUS.
HURRY, HURRY, HURRY
SEE CLOWNS, TUMBLERS, ACROBATS—
Admission absolutely free.[80]

The painters were left to adjust to this hoopla and to more like it, such as the following advertisement for a show held in 1949:[81]

Strange and wonderful,
THE BIRDS AND THE BEASTS*
The like of which
have never been seen
on land, in the air, under the sea.

by world renowned artists
(with a dubious bow to nature)
Grand opening.
Picasso, Braque, Arp, Miro, Dubuffet, Calder,
Baziotes, Browne, Gottlieb, Motherwell, Hare,
Holty, Hofmann.

*with, occasionally, a few ladies thrown in.

As is clear from the foregoing samples, Kootz's advertising continued to give prominence to the Parisian connection, which no artist at this time even dreamed of rejecting. In 1946 the free and rather vague relationship with Paris and its tradition was still a token of prestige. With the help of this first-rate promoter the avant-garde gained each day in visibility and acceptance. Kootz's trademark certainly made use of an

image of Paris, but it was a passé image, a Paris of operettas, circuses, and bohemian memories.

Some critics, however, were beginning to reevaluate American art and to ask themselves if Paris was really still Paris. In an article on painting published in late 1946 in the *Encyclopaedia Britannica*, Frederic Taubes celebrated New York's newfound independence, admittedly with a bit more confidence than the facts warranted:

> During the year 1946 more than ever before, a significant realization was experienced by many who are interested in, and observant of, art trends: U.S. art has become independent, self reliant, a true expression of the national will, spirit and character. It seems that, in aesthetic character, U.S. art is no longer a repository of European influences, that it is not a mere amalgamate of foreign "isms," assembled, compiled, and assimilated with lesser or greater intelligence.[82]

The optimism is somewhat excessive, but it nevertheless shows the impatience for recognition that existed in American art circles at a time when Paris was still the standard of reference.

Between France and the United States there was almost no exchange of living art. Nothing made it across the Atlantic. Nineteen forty-six was a year of questioning, a year when the two art capitals both reassured themselves that they were going strong. As we already noted in speaking of Kootz, the Parisian influence was still strong in New York, and it is this influence that explains Clement Greenberg's position in a brilliant article published in Sartre's journal *Les Temps Modernes* under the title "L'art américain au XXe siècle," an article that pulled out all the stops to reassure the French:

> Our results are in the end rather thin. No matter what our optimism, we cannot fail to take note of this. We are still following in the wake of Europe, and none of the American artists who have achieved some renown since the Armory Show counts for much on the world scene. . . . At the present time only a positive attitude, free of both Freudian interpretations and religion and mysticism, can bring life into art without betraying one or the other.[83]

What Greenberg wanted to see was a positive, materialist art, though he believed that, all things considered, such art had little likelihood of coming into being in the United States:

> Whereas in France strong-minded materialists and skeptics have expressed themselves mainly in art, in the United States they have limited their efforts to business, politics, philosophy, and science, leaving

art to the half-educated, the credulous, spinsters, and old-fashioned visionaries.[84]

For many people who thought as Greenberg did, the hoped-for renewal of American art could only come from Paris. But in Paris people were looking enviously toward New York, as can be seen by looking at articles published in the French press on the United States.[85]

The French were dazzled by the wealth and power of the victors. Although there was criticism of the United States from Marxist groups and from the champions of traditional humanism, American civilization exercised a power of fascination over the French mind:

The sudden growth of American power has made it impossible for any single person to grasp the United States as a whole. The rumbling of the cars on Broadway seems to encapsulate all the worries of the Western world, and delicate skyscrapers seem to spring up from curbside like new pillars of Hercules supporting half the universe.[86]

New York was an enticing city, a place of tremendous wealth and tremendous wastefulness.[87]

Meanwhile, France was struggling with apparently insurmountable political and economic problems. In Paris there was agreement on only one thing: art. Parisian art must be the best in the world. Only one thing was left to France after the horrifying disaster of surrender, collaboration, destruction, exhaustion, and ruin: French culture, the art of Paris. Cultural revival was therefore a national duty. But how could it be accomplished? While New York, which found itself in a position of strength, was artistically timid because of doubts about the American tradition, Paris, though exhausted, nevertheless attempted to relight the flame of art that had gone out during the war. The only similarity between the two cases was that neither New York nor Paris had a recipe for renewing artistic production.

Whereas in New York political differences between the supporters of various kinds of art were not very pronounced, in Paris a battle was raging between the Communist party, which in 1945–46 acted as the champion of realistic art, and the "establishment," which was busy promoting the old modern academics that had served so well in the past. Art became a political issue in France, so that it was impossible for the French to present a united front abroad, impossible to paint a serene portrait of the Parisian cultural scene, notwithstanding the way political disagreements were toned down in the articles that René Huyghe sent to *Magazine of Art*.[88]

On June 18, 1945, the Union Nationale des Intellectuels held a meeting in Paris, the purpose of which was to reorganize French cultural life by

uniting all French intellectuals in behalf of "the greatness and renown of the fatherland."[89] The intention was to create a sort of cultural front, and the illusion that this could be done lasted about as long as the government in place. The membership of the union included all the leading artists and writers recognized by the center and left, who were brought together to polish up the national escutcheon. Insisting on national unity, the union's goals closely reflected the national mood:

> The aim of the Union Nationale des Intellectuels is to establish a federation of intellectual organizations, without distinction as to political, philosophical, or religious opinion, in order to:
> 1. Preserve, promote, and defend the free expression of ideas and culture against oppression of all kinds.
> 2. Place its resources at the service of the French nation so as to assure France's renewal and continued grandeur wherever French thought has penetrated.[90]

This alliance fell apart as soon as political difficulties were encountered, first in 1946 and then finally in 1947 when the Communists were dismissed from the government, in which they had served since 1945.

At the end of 1945 Paris did not know which way to turn to find an art movement likely to bring about a renewal of French art. In the second issue of L'Amour de l'Art, a special number devoted to the School of Paris in New York, Germain Bazin expressed satisfaction with the purity of the avant-garde, which had steadfastly resisted collaboration during the dark years of the war.[91] The avant-garde stood for freedom:

> Who can say why it was only fauves and realists who became collaborators? In avant-garde circles there was no one who "made the journey," unless it was the journey into exile. Perhaps the reason is that abstraction is freedom, a total commitment that precludes any pact with the powers-that-be.[92]

Abstract artists preferred expatriation to compromise.

In New York the French avant-garde had struck roots with somewhat frightening ease, to judge by Bazin's account:

> At a time when despicable propaganda was daily trying to convince us that we were decadent, a group of artists in which Frenchmen and foreigners who had adopted our culture mingled easily preserved the faith of the new world in France's creative powers. To this modern nation our painters and sculptors brought a modern vision of form and color, which seems to have attracted a wider audience in the

United States than in France. These artists were addressing themselves to virgin minds, which unlike European minds had not been subjected to a thousand-year iconographic tradition and which had been spared the influence of the naturalistic and anthropomorphic dogma inherited from ancient Greece and Rome and spread throughout Europe by the Rome of the Renaissance.[93]

In the end Bazin tried to put the New York episode into some sort of perspective. The threat of out-and-out competition was a frightening one, but Bazin took the sting out of it by rationalizing the new vitality of American modern art and turning it into an ideological message. In so doing, he not only reinvigorated the Parisian muse but changed her sex with a surprising touch of phallic imagery:

"New York is now the artistic and intellectual center of the world," the magazine *View* has proudly declared. Will the Paris School become the New York School? Will the exiled artists adopt the country that offered them refuge? Even if things turn out that way, France will be no worse off as a result. She will not have failed in her mission, which is to fertilize the world with a flow of seminal ideas.[94]

After five years of torment, silence, and exile, the Parisian critic had no doubt that French art was still the beacon of the West and would long remain so. The poster artist Carlu, who returned from New York in 1945, was asked by the review *Arts* if "a school of abstract art was being formed by young American painters (aided by museums, lectures, nonobjective art shows, and so forth)." He answered that the American abstract school's development was "still quite limited. American painters seem to be interested mainly in folklore, particularly from the west and south."[95] The question of New York's importance came up again and again in interviews. Parisians were obsessed with the possibility that a New York school would come into being, and it is clear that many people were not satisfied with the reassurances being trumpeted loudly in every quarter. Fernand Léger was one who spoke lucidly about what was going on in New York. In a 1946 interview with Léon Degand in *Lettres françaises*, he said:

Does American painting exist? Yes, and it is developing rapidly. Young painters are throwing themselves into their work with such intensity that it is impossible that a nation which has given itself the best professors and the finest art collections in the world will not one day achieve an original style of its own. . . . I am convinced that the Americans are on the way toward a period of greatness in art. The first signs are already here.[96]

Clear, accurate, and well informed, Léger's observations were forgotten as soon as violent internal battles erupted on the Parisian art scene. The warfare was too intense to leave room for study of the problem posed by the United States.

Had the French paid attention, they might have heard what the prophetic voice of Walter Lippmann, echoing Winston Churchill, had to say in the first issue of Les études américaines, a magazine published in Paris. Lippmann felt that it was the destiny of the United States to put an end to the schism between East and West, whose origins could be traced back to the Middle Ages. The naive self-assurance of Lippmann's comments is frightening:

> Fate has willed it that America is from now on to be at the center of Western civilization rather than on the periphery. . . . The American idea is based on a certain image of man and his place in the Universe, his reason and his will, his knowledge of good and evil, his faith in a law above all particular laws. This tradition has come down to Americans and to all citizens of the West from the Mediterranean world of the ancient Greeks, Jews, and Romans. The Atlantic is now the Mediterranean of this culture and this faith. This is no accident. It is in fact the consequence of an historic and providential act that the formation of the first world order since classical times has been linked from the outset to the reunion of the scattered fragments of Western Christendom. The prospect before us is grand: the schism between east and west that began in the Middle Ages between the fifth and the eleventh century of our era is about to come to an end.[97]

The French capital and thus the School of Paris, had very few arguments to offer in response to such an acclamation of the new shift of the center of Western Civilization to the shores of the American Atlantic coast. Those put forward by the establishment through its spokesman Waldemar George were so frayed around the edges that they seemed laughable in comparison to the fierce determination of the Americans. The art critic of Le Littéraire (Figaro) reaffirmed his confidence in French art but worried about the rise of abstraction, in which he saw a kind of antihumanism. In the avant-garde he detected a snobism that he equated with destructive left-wing tendencies. Indiscriminately, he attacked Americans, Orientals, Slavs, Germans—anyone who lacked the "balance" of the French:

> If it ventures onto this terrain, French art risks both sacrificing its originality and losing control of Western art. If the world wants erector sets, monsters, or colossi, it does not need us. The mission of French art is to defend the individual rights of man, his dignity, his charm, and his value, against the enemy forces: the "made in U.S.A." spirit

and the herd spirit of the Slavic East. French art can carry out this mission only if it returns to concrete realities and recovers its original virtues: a love of things and of well crafted work, a spirit of observation, and a critical spirit.[98]

There was a powerful desire in France for a return to tradition as a token of reconstruction and postwar stability, a response to the chaos that abstract art seemed to represent. In a small volume published in 1946 and entitled *Opinion d'un peintre d'aujourd'hui*, Aramov explained this view, which went hand in hand with the resurgence of religious art and of simple, primitive art:

Perhaps the only difference between [the realists] and [the abstractionists] is that the latter have not yet received the same treatment. From the moral point of view, however, they are more dangerous. Their efforts result only in manifesting and engendering a bitter pessimism. They bring us back to our eternal position of impotence in the face of the unknown and constantly remind us, at inconvenient moments, how miserable and insignificant the created being is compared with the grandeur and mystery of nature. The effect of art should—normally—be to make us happy. The effect of abstract art is merely to make us anxious, afraid, unhappy, desperate. Is this not enough to classify it as a negative art?[99]

In a sumptuous but superficial book on French painting Jacques Baschet is even more categorical:

As for the young who are just starting on their careers, the task that lies ahead is clear. Since it is customary to summarize the program of a new regime in three words, we propose posting the following words at the threshold of every artist's studio: consciousness, labor, tradition. These sum up the work of today that will lay the groundwork for the renaissance of tomorrow.[100]

This trinity is curiously reminiscent of "labor, family, fatherland," the slogan of the Vichy government.

It was inevitable that postwar French art would be not only modern but above all positive and constructive. As the prominent Communist intellectual Jean Kanapa saw it, what was needed was "human painting." Things were less simple than they may appear at first sight, however: in 1946 the French Communist party, in the person of Léon Degand, was still willing to entertain the possibility that abstract art is valid art. As long as the Communists shared power with the bourgeoisie they were willing to tolerate abstraction. This tolerance was not without dif-

ficulties, however, as the diatribe carried on in the pages of the Communist art reviews *Lettres françaises* and *Art de France* between Roger Garaudy and Louis Aragon attests.

In "Artistes sans uniformes" Garaudy attacked sectarianism and party-controlled art, maintaining that there is no such thing as a purely Communist aesthetic:

> The issue is the right of artists to express themselves as they choose, even if they are Communists. Anyone who says that we ought to force our painters and musicians to wear a uniform is either an enemy or a fool. What is Marxist? Avant-garde experimentation or the subject? Neither. Both.[101]

Aragon's reaction was quick and categorical:

> I am sad to see that Garaudy has given his approval, in a way that those people are immediately going to regard as the approval of the party itself, of such things as escape into art, the intangibility of art, and the culture of the ruling class with all its poisons and ideologies, under the guise of eclecticism. The fear of being thought to wear a uniform makes some people, who dress in every color of the rainbow, blind to the fact that they are in fact all wearing the same livery, that of the harlequin, and that they are actually using their slapstick not to strike the enemies of freedom but rather to lash out at the only freedom worth having, the freedom to speak the truth. . . . The Communist Party has an aesthetic, and it is called realism.[102]

In the face of the poet's flamboyant reaction, Garaudy began with a polite recantation:

> To say that there is still room for experimentation and discovery in this domain is not the same as saying that "every aesthetic is valid." We are opposed, for example, to any aesthetic based on a belief in some sort of "beauty in itself," which is closely related to an idealist metaphysic and diametrically opposed to our concept of man.[103]

He then went on to discuss the dangers of formalism:

> Formalism is reactionary in the full sense of the word. It expresses a desire to swim against the current of history. It is the aesthetic of decadence.[104]

He concluded with a complete about-face, which intellectually is not very serious but which must have been quite pleasing to one faction

within the politburo of the French Communist party and to the supporters of realism:

Our realism establishes the totality of the human context. It places man in the context of his time and its needs, his class and its interests, his ideal and its historic mission. . . . An answer to the false prophets of skepticism, anguish, and despair, our realism is a realism of affirmation, construction, and joy.[105]

This confrontation was a precursor of the major battles that subsequently shook the Parisian art world, pitting realists against abstractionists.

A defender of a kind of eclecticism, Léon Degand was a victim of the change in the political climate. By the summer of 1947 the Communists had been thrown out of the Ramadier government and the country was on the verge of civil war, so the Party had no further reason to beat around the bush with bourgeois ideology. Degand was sacked from his position with the Party journal and replaced by Georges Pillement, who adhered to the traditional realist line of the French Communists (PCF).[106] The optimistic realism of the Communists was a long way indeed from the pessimistic abstractionism of the American avant-garde as well as from the work of the French avant-garde, to say nothing of the pessimistic realism ("miserabilisme") recently discovered by the bourgeoisie in the work of the young painter Bernard Buffet, who though not yet twenty declared that "I prevent myself from thinking in order to be able to live."[107]

The situation in France in 1946 was tense in both politics and art. With great difficulty the country was attempting to pick up the scattered bits of its culture and restore the coherent image of Paris that had existed before. The question on everyone's mind was whether the old pattern was still valid. In particular, there was some doubt about the perception of the "Parisian renaissance" in New York, which many people thought of as being in a position to upset or alter the established order in the world of art.[108] This was the subject of one of Léon Degand's articles in Lettres françaises:

Recently I echoed certain complaints heard abroad concerning the excessive cautiousness evident in some recent shows of paintings by young French artists. . . . But for a few noteworthy exceptions, the world of the plastic arts is currently afraid of its own shadow and inordinately attached to proven values. Not so long ago people recklessly went after every novelty so as to be sure not to miss the good ones. Today people are suspicious of innovation for fear that one day they might pick a bad one. They question the past, calculate the future, invoke tradition, and try everything but consulting their horoscopes.

One exhibition, which advertises itself as presenting a complete over-
view of current French painting, has room for the conventional—so
be it, since the conventional exists—but leaves out the abstract. An-
other exhibition that successfully included all the tendencies among
the younger French painters is viewed as dangerous, by some because
the left was invited, and by others because the right was not excluded.
. . . It is an obvious fact that too many national exhibitions bear witness
to a distressing anemia. Everyone has noticed it. Somebody has to
say it out loud.[109]

Rumors about the decline of the French were in fact circulating, as we
can see from the mention made of them in reviews published by Clement
Greenberg and also by Althea Bradbury in *Critique*.[110] Indeed, the paint-
ings sent abroad were quite timid and traditional, the usual works by
Utrillo, Derain, Vlaminck, Picasso, Bombois, and Vivin. Experimental art
was scarcely visible, and this was enough for American critics to declare
that it did not exist at all. Writing about an exhibition of French art at the
Whitney, "Painting in France, 1939–1946," Greenberg said:

The show itself is shocking. Its general level is, if anything, below
that of the past four or five Whitney annual exhibitions of American
painting—about the lowness of which I have expressed myself rather
strongly in the past, lamenting the sad state of American art in our
day. . . . I now see that we have reason to congratulate ourselves on
being as good as we are.[111]

As Greenberg saw it, then, there was cause for hope in the very
mediocrity of American art. The important point, it should be noted, is
that on both sides of the Atlantic the critics were totally blind to the
artistic realities. Their blindness was ideological: the truth was carefully
filtered out so as to allow both French and American critics to hold on
to their illusions. This filtering process insured that Greenberg would
be ignorant of, and therefore take no interest in, experimental work
being done by members of the Parisian avant-garde, work that was
covered by the French press (including abstract painting by Wols, Ma-
thieu, Hartung, Atlan, and De Staël).[112] Greenberg based his opinion
exclusively on the exhibitions selected by government bodies to be sent
to New York and did not bother to inquire into the complexities of the
Parisian art world.

Parisian critics also wore blinders: both consciously and unconsciously
they refused to see the new realities of American culture. One example
will suffice: a review published in *Le Monde* by René-Jean entitled "Five
Shows Confirm the Universality of Paris," a review which was a little
too sure of itself to be truly natural and convincing.[113] Rather curiously,
this confidence was based on exhibitions of the work of the Russian

Kandinsky, drawings by French and English schoolchildren, and paintings by a Spaniard, a Dutchman, an artist from Franche-Comté, and another from Lyon.[114] The notion of universality had to be forced somewhat to fit the French Procrustean bed.

The universality that Paris hoped to safeguard had in fact already been subjected to wide-ranging attack. In 1946 it was challenged by the Blum-Byrnes accord with the United States. This agreement marked the first time that the importance of culture was recognized and related directly to economic and political concerns, sanctioned by the signatures of ministers and presidents.[115] Its effects were far-reaching. One clause pertaining to culture—an agreement affecting the film industry—was lost amid the terms of American economic aid for France. The treaty was signed in Washington on May 28, 1946.[116] Many French people regarded the film clause, which spelled doom for the French film industry, as a concession offered in exchange for American economic assistance.[117]

Discussions concerning the film industry had been under way between the two governments since the end of the war. These discussions dragged on for a considerable period, stymied by the stubborn persistence of the French to protect their own film industry by limiting importation of American films (the barriers had in fact gone up during the Depression). On January 10, 1946, the *New York Times* reported that the negotiations had been acrimonious and cited Georges Huisman to the effect that cinema was an important means of disseminating French cultural influence.[118] The existing import quota, which reserved seven out of thirteen weeks for French films, was reduced to four out of thirteen weeks when the treaty was signed.

The film agreements were part of a coherent economic and ideological package whose purpose was not only to rebuild the war-torn European economies but also to counter Soviet expansionism. The two aims went hand in hand, the second perhaps being even more important than the first. The Communist menace was an undercurrent throughout the negotiations. With the discussions barely under way, the French minister of foreign affairs, Georges Bidault, leaked the stakes to the press in a maneuver intended to be clever but which was clumsily carried out. In an interview on March 22 he stated that American aid was essential for reconstructing the French economy. Should the Allies refuse, however, it was clear, he said, that France "would be forced to orient its economic policy in other directions," that is, toward the Soviet Union.[119] The blunder was considerable, but it was also a wink in the direction of the French Communist party, which was then sharing power with the Socialists.[120] Bidault's statement was of course quickly repudiated by Léon Blum.[121] The battle was real, but it was waged in secret.

The French negotiators, aware of the delicacy of their position (since a large percentage of the electorate was Communist), insisted that the

discussions with the United States focus mainly on economic issues. Both Léon Blum (in a speech delivered on April 12, 1946) and Georges Bidault (on June 1) insisted vehemently (too vehemently perhaps not to seem a bit suspicious) that the discussions were of a purely technical nature. André Philip, as minister of finance a member of the French negotiating team, reiterated the point that politics and economics were separate issues and tried to explain how important it was for France to be included in the system of international trade, which could not happen unless it pulled down its tariff barriers. In other words, he sided with the Americans in favor of an open economy and against the closed economy favored by the Communists:

> France has no desire to continue the economic policy it adopted along with all other countries in the prewar period. It has no desire to perpetuate commercial rivalries between nations, which invariably lead to war. We want to sell our products on a free world market. We want to become a part of the system of international trade.[122]

France was not alone in joining the new "multilateral" commercial order: Great Britain and Italy also joined the club.[123] Although America did not enter into a recession in 1946 as the Council of Economic Advisors had predicted, fears of a recession remained widespread. The only way to avoid recession seemed to be massive exports. This was the situation when the French ministers arrived in Washington. They brought with them a reconstruction plan (the so-called Monnet Plan), but they lacked the funds needed to make it work.

After negotiations that dragged on from March 15 to May 28, the American government agreed to grant the necessary aid. Although the amount proposed was regarded by many as disappointing (the press had been expecting a loan of $1 billion),[124] it was enough to get the dying French economy moving again and at the same time to halt the disintegration of French society, which had been playing into the hands of the Communist opposition. However, the French economy was not yet out of the woods: the deficit stood at $2,200,000,000.

Unanimously ratified on August 1, 1946, the accords wiped out the war debt contracted by France under the lend-lease program and advanced a further $318 million, to be repaid over a thirty-year period and reserved for the purchase of American war surplus stored in France together with seventy-five Liberty ships.[125] In addition France received $650 million in credit from the Export-Import Bank. For its part, France agreed not to renew its prewar protectionist policies. The door was open for trade. The United States, with its industrial base intact and prosperous, was well placed to take advantage of the situation.

French spokesmen persistently maintained that the agreements contained no political quid pro quo. Nevertheless, *Le Monde* made no secret of its skepticism on this score and reprinted an article from the *New York Times* to show why:

> The United States would be stupid and incredibly shortsighted not to use its power and resources to encourage moderate elements in France and to establish the order on which our future as well as the future of France depends.[126]

Le Monde's skepticism was only enhanced by Léon Blum's sybilline statement upon his return from New York: "While the agreement contains no political conditions, it nevertheless has political consequences."[127]

These consequences did not yet extend to the elimination of the Communists from the government: that did not come until 1947 and the Marshall Plan. For the time being it was only a question of weakening the Communist influence, as certain Socialist deputies told the *New York Times* correspondent:

> We socialists are in disagreement with the communists on foreign policy, and Americans in their own interests should grant the aid Léon Blum asks so that the socialists can win the elections and guide French foreign policy.[128]

But to everyone's surprise the Socialists did not win the June 1946 elections, in which the big winner was the Mouvement Républicain Populaire (MRP, a Christian democratic party) with 28.22 percent of the votes cast. The Communist party lost ground, coming in second with 25.98 percent, while the Socialists slipped to 21.14 percent.[129] Thus the Communist advance had been stopped short. The Blum-Byrnes accords had been signed only a few weeks before the elections. Meanwhile, the *New York Times* was publishing articles that showed what was really at stake. On May 7 the headline read "France Swing toward USSR Noted." On May 15 the treaty was signed. On May 28, the paper reported, "France, No Change, Back to U.S., Away from USSR." On June 1 it was "Officials Deny Charges That U.S. Uses Loan as Diplomatic Weapon."[130] In fact all of this was only preliminary skirmishing prior to the big battle. The real war of diplomacy got under way the following year with the inception of the Marshall Plan.

By 1946 it had become clear that France, Germany, and Italy were key countries that had to be kept in the capitalist orbit if England and thus the United States were to be protected against Soviet attack. Whereas Germany presented no problem, the situation was quite different in France and Italy, both countries in which the Communist parties had

gained power and prestige from their participation in the resistance against fascism.[131] This made it important for the United States to win minds by extolling the civilizing virtues of free enterprise. This was done in two ways. One was through economic aid, as we have already seen, a tactic explained in the following remarks by the special counsel to the president of the United States:

> In addition to maintaining our own strength, the United States should support and assist all democratic countries which are in any way menaced or endangered by the U.S.S.R. Providing military support in case of attack is a last resort; a more effective barrier to communism is strong economic support. Trade agreements, loan and technical missions strengthen our ties with friendly nations and are effective demonstrations that capitalism is at least the equal of communism. The United States can do much to ensure that economic opportunities, personal freedom and social equality are made possible in countries outside the Soviet sphere by generous financial assistance. Our policy on reparations should be directed toward strengthening the areas we are endeavoring to keep outside the Soviet sphere. Our efforts to break down trade barriers, open up rivers and international waterways, and bring about economic unification of countries now divided by armies are also directed toward the re-establishment of vigorous and healthy non-communist economies.[132]

An equally important weapon in this battle was the dissemination of American culture, of the "American way of life." The United States hoped to use American movies to win European public support for its cause.[133] Hollywood had an important role to play, as the head of Paramount Pictures stated unequivocally in discussing the foreign mission of the American film industry:

> We, the industry, recognize the need for informing people in foreign lands about the things that have made America a great country and we think we know how to put across the message of our democracy. We want to do so on a commercial basis and we are prepared to face a loss in revenue if necessary.[134]

The problem was that the Americans, new to this game, lacked finesse in their hasty efforts to out-maneuver the Soviets.

The French press was unanimously favorable to the major elements in the accord with the United States but was often violently critical of the special clause concerning the cinema. The reason for this opposition was that the clause spelled doom for an industry that had been flourishing in the prewar years. It also meant that France would be subjected

to large doses of the American ideal, to an image of the "American way of life" that many people did not hesitate to label propaganda.

The film clause in the treaty stipulated that French theaters would be required for at least two years to show no more than four French films per quarter (rather than the nine per quarter previously allowed). The American film industry thus killed two birds with one stone. It got rid of French competition, and it knocked down the old quotas, thus allowing American films to take over the French market. The European market was now wide open, and Hollywood was in a good position to capitalize on the situation, since it was prospering (between 1939 and 1944 the Americans had made 2,212 films, while the French film industry was practically shut down). Furthermore, Hollywood films were offered at unbeatable prices, since their production costs had already been recouped on the American market.[135] It was not, then, only a question of taste (French public preferring American movies) but a question of market structure which doomed the French film industry.

While American economic aid transfused new blood into the country to help heal damaged social tissue, American films were offered as a supplementary treatment designed to go after the Communist virus wherever it still lurked. As George F. Kennan put it in his famous telegram, communism, like the plague, is spread by corpses. The best defense against it, therefore, was to heal the sick by administering massive doses of dollars in conjunction with pictorial medicine:

World communism is like a malignant parasite which feeds only on diseased tissue. This is the point at which domestic and foreign policies meet. Every courageous and incisive measure to solve internal problems of our own society, to improve the self-confidence, discipline, morale and community spirit of our own people, is a diplomatic victory over Moscow worth a thousand diplomatic notes and joint communiqués.[136]

Fair tactics in a time of war. Oddly enough, however, the French reacted not with relief and satisfaction but rather with outrage at the interference in their private affairs and the threat to their independence. They saw the treaty as a vicious attack on their national and cultural identity.

To allow a flood of American films to inundate French theaters was, as actor Louis Jouvet put it, to abdicate the French tradition, it was to allow the devastation and destruction of the foundation stone of French culture, French authenticity, and French strength. It was French culture destroyed by kitsch:

These accords jeopardize the very existence of dramatic art. The change in French taste may well be irremediable and fatal. Used to the wines

of Burgundy and Bordeaux, our stomachs will now have to adjust to Coca-Cola. For a Frenchman this amounts to renouncing his citizenship.[137]

Writing in Le Monde on June 12, 1946, Etienne Gilson gave a clear-sighted account of the international changes taking place. What he saw and repudiated, not without touches of chauvinism, was the first step toward a shift of cultural hegemony from France to the United States. Gilson was horrified at the prospect. Like Jouvet he realized that the confrontation was between two different worlds and that it marked the end of the world's fascination with the Parisian aesthetic. Hollywood films carried the germs of a fatal disease that would kill off what to Gilson were cherished values. Hence his tirade was ferocious and violent. For us it is valuable as an indication of the size of the problem. The attack cut Paris to the quick. Although the American press had little to say about the significance of this episode, in France there were petitions, demonstrations, and even, in 1948, violence in the streets.

Those who fought against the accords in 1946 saw their fears confirmed in 1947. Throughout that year the crisis in the French film industry grew increasingly severe and many people associated with the movies in France found themselves unemployed (only 898 people were employed in film in 1947, compared with 2,132 in 1946). In 1948 sixty percent of the remaining employees were laid off.[138]

Although by 1947 French culture was losing ground internationally, people were still unwilling to trust the increasing number of signs of decadence.

Pressure from the Americans increased during the spring of 1947 with the announcement of the so-called Truman Doctrine. Truman reminded the world that its division into two camps was an unavoidable fact and therefore a choice had to be made, the sooner the better.

On March 15, 1947, the Nation published an article signed by a French lawyer who was critical of the American attitude toward Europe:

At present I feel there is a danger that the American crusade for "One World" may be deflected from its course. One world must be based on those universally valid civilized ideas which should be common to all humanity. It cannot and should not be an American world; it would be absurd to expect Russians or Moslems to behave like Americans. Yet people in the United States tend to think that the economic system which created their prosperity is an integral part of civilization, as indispensable as guarantees of individual liberty.[139]

It was as though the liberal magazine wanted to respond to the president's speech of March 12. In this context, with both great powers

gearing up their enormous ideological machines, the viewpoint of a moderate Frenchman was all the more striking, a cause for concern but absurdly insignificant in comparison with what was going on all around.

The British withdrawal from Greece and Turkey, confirmed by notes from the British embassy in Washington on February 21 and 24, 1947, was a consequence of Europe's economic problems, which sooner or later the United States would have to confront.[140] The new American responsibility to replace the English presence throughout the world (which many people saw as an imperialist presence) was one of the first tangible consequences of America's rise to a position of supremacy. Because of the threat of Communist revolution in Greece, the situation there was easier to handle, and it was therefore on Greece that Truman focused in his celebrated speech to both houses of Congress on March 12, 1947, a speech that was broadcast to the entire nation. This pomp and circumstance was necessary to "sell" the aid program to a hostile Republican Congress. In order to push back the Soviet thrust into this part of the world Truman asked Congress for an emergency appropriation of $400 million.[141] He said little about Turkey but a great deal about freedom: "The free people of the world look to us for support in maintaining their freedoms."[142]

At the present moment in world history nearly every nation must choose between alternative ways of life. The choice is often not a free one. One way of life is based upon the will of the majority, and is distinguished by free institutions, representative government, free elections, guarantees of individual liberty, freedom of speech and religion, and freedom from political oppression. The second way of life is based upon the will of a minority forcibly imposed upon the majority. It relies upon terror and oppression, a controlled press and radio, fixed elections, and the suppression of personal freedoms. I believe that it must be the policy of the United States to support free peoples who are resisting attempted subjugation by armed minorities or by outside pressures. . . . I believe that our help should be primarily through economic and financial aid which is essential to economic stability and orderly political processes.[143]

The two major themes of the speech were the new American foreign policy, which was clearly laid out, and the proposal to grant large amounts of economic aid to countries threatened by what was seen as Soviet aggression. For tactical reasons the president emphasized that the aid program was one of "self-defense." The speech was carefully prepared and aroused considerable debate. During one preparatory meeting with congressional leaders, Dean Acheson (then undersecretary of state) rejected Marshall's proposal for aid to Greece and Turkey because the aid

was described either as humanitarian or as assistance to English imperialism in the Middle East. Acheson reworked the proposal to emphasize the role of foreign aid in defense against Soviet aggression on three continents, which made it more acceptable to Congress:

> The Soviet pressure on the straits, in Greece, and in Iran, if successful, might open three continents to Soviet penetration. Like apples in a barrel infected by the rotten one, the corruption of Greece would infect Iran and all the east. It would also carry the infection to Africa through Asia Minor and Egypt and to Europe through France and Italy.[144]

It should be noted that this was the first time since the war that the Americans refused to cooperate with the Soviet Union, a refusal that was made in the face of reluctance on the part of European nations, many of which had large Communist parties of their own, and of negative reactions from the American left. The political analysis of the situation in the speech as well as in newspaper articles on the same subject overturned earlier articles of faith in the foreign policy domain, including the optimistic belief in the possibility of peacefully reorganizing the world through United States–Soviet cooperation and faith in the ability of the United Nations to resolve conflicts.[145] Not only would these hopes be dashed after March 1948, but the specter of war between the two superpowers would rise on the horizon.

Within the United States the liberal alliance had begun to come apart over the issue of "containment." Writing in *PM*, Max Lerner accused the president of collusion with the reactionary right, and the American Communist party attacked the move away from the "One World" policy and toward a division of the planet into two hostile camps vulnerable to the threat of nuclear war. The danger of war was further heightened by the fact that Truman in his speech committed the United States to protect and defend any country threatened by a Soviet takeover. Even such figures as George Marshall, George F. Kennan, and Bernard Baruch apprehensively characterized Truman's text as "a declaration of . . . ideological or religious war."[146] For many liberals Truman's "doctrine" concealed imperialist policies. Listen to Robert Lash of the *Chicago Sun*:

> I believe our foreign policy is now dominated by military advisers, by men with big business backgrounds, and by small-bore politicians of the Missouri clique. It appears to be actuated almost entirely by the narrowest considerations of national interest and blind fear of communism. There is no vision or understanding in it, and above all no real interest in working toward a strong United Nations organization based on reconciliation of our interests with Russia's. It is not surprising that such a policy, formulated by such men, should be repugnant to progressives. The Roosevelt policy is dead.[147]

Even the *Progressive*, an anti-Communist magazine, could not bring itself to support Truman and his crude ideological apparatus: "It was only five years ago that we were being implored to help communism stop fascism, now, in effect we are being urged to help fascism stop communism."[148] For those who still believed in a Roosevelt-inspired approach to foreign policy, the President's speech came as a shock. These people understood the corollary of Truman's assertion that "if we falter in our leadership, we may endanger the peace of the world—and we shall surely endanger the welfare of this nation."[149] The corollary was this: "What's good for the United States is good for the world."

The issue of aid to Greece demonstrated the depth of the division in liberal ranks. A vocal group of liberals led by Henry Wallace refused to approve the aid proposal. The day after Truman's speech, Wallace made a broadcast appeal in which he described what he believed was the real crisis at hand. "March 12, 1947," he said, "marked a turning point in American history. It is not a Greek crisis we face, it is an American crisis. It is a crisis in the American spirit."[150] Wallace was joined by Senator Taylor of Idaho, who said that if there was to be aid to Greece, it ought to be administered by the United Nations. Taylor concluded his remarks by criticizing Truman's intentions in Greece: "The objective of the Truman doctrine is not so much food for the Greek people as oil for the American monopolies—the oil that lies in the great lands just east of Greece and Turkey."[151]

Because the undertaking was viewed as being in the national interest, whatever its flaws, some liberals supported the president, in particular such ADA anti-Communists as Arthur Schlesinger, Jr., and Hubert Humphrey.[152] On April 22, 1947, the Senate approved the Truman Doctrine by a wide margin, 67 to 23. Oddly enough, the president's image in the eyes of the liberals regained some of its lost luster when he showed himself to be firm in the face of a danger which, as we have seen, was largely fabricated.[153] The whole pseudo-crisis was an admirable application of Assistant Secretary Clayton's recommendation: "The U.S. will not take world leadership effectively unless the people of the U.S. are shocked into doing so."[154] In the same vein, Senator Vandenberg advised the president during one meeting that it would be necessary to "scare the hell out of the country" to get the public to accept his program.[155] Justified or not, fear and anxiety took hold of the country. It is this phenomenon that interests us here.

The pro-Soviet coup d'état in Hungary on May 30, 1947, did not drastically change the positions of liberal magazines such as the *Nation* and the *New Republic*. Despite the rationalization that a right-wing coup was imminent, doubts began to arise in liberal consciences, along with the suspicion that the Soviet Union was playing a double game. This suspicion quickly became a certainty in the minds of left-wing radicals

like Macdonald. At the risk of repeating ourselves, it is worthwhile to cite Macdonald's analysis of the March 12, 1947, speech. Macdonald repeated some of the arguments he had used in 1946 in discussing the atomic bomb. But now that the subject was politics he was at once more precise, more pessimistic, and more confused. While acknowledging the need to oppose the menace of Soviet imperialism, he rejected the authoritarian way in which the government was proposing to lead the attack:

> In terms of "practical" politics, we are living in an age which constantly presents us with impossible alternatives. . . . The Truman Doctrine poses another such impossible alternative. American or Russian imperialism? If these be the only alternatives—as they are in terms of practical politics—my own choice would be for the former, no doubt partly because I happen to live here, but also because we have not yet reached, by far, the degree of totalitarian horror that Russia has. . . . In the above, I am discussing only the dilemma which big-scale politics (and especially its ultimate, world politics) presents to the radical of today. On this scale, the situation indeed appears desperate. But on a more limited scale—that in which the individual's own thought, action and feelings can "make a difference"—political problems are more tractable, and there is some connection between knowledge and success. There, too, "practical politics" is possible: "effective forces now existing" (both emotional and rational) may be called into play. The slim hope left us is that in this limited, small scale kind of activity some seeds may be planted now which will later produce larger changes. This kind of activity, also, can be rewarding in itself. But on the world scale, politics is a desert without hope.[156]

This passage seemed to me worth citing at length since it sums up all that we have been driving at thus far: namely, that radical intellectuals, unable to situate themselves in relation to contemporary political events or even to interpret those events in a satisfactory way, deserted politics altogether. The individual became the sole focus of interest, a symbolic vestige of days gone by when radicals still had a definite function. These feelings of frustration, powerlessness, and rage were expressed in an arrogant way by the painter Clyfford Still, who sought to express his individuality by eliminating every reminder of the real world, every last vestige of physical reality, even the frame, from his canvases:

> To be stopped by a frame's edge was intolerable, a Euclidean prison, it had to be annihilated, its authoritarian implications repudiated without dissolving one's integrity and idea in material and mannerism.[157]

It is against this background of confusion, feverish maneuvering, and chaos, against a policy of fits and starts dictated by the initial shudderings of the ideological machinery, that the art of the period must be viewed and the consolidation and success of the avant-garde ideology understood. It was during the disorder of a period that many people viewed as a headlong race to war (1947–48) that a yawning abyss opened up between the public and the world of politics, between the painter and the public, between the painter and politics, and between the private and public spheres.

A vast contradiction emerged: self-censorship, silence on political themes, became the norm in the midst of a daily hub-bub of constant controversy. The artist produced a steady commentary, the celebrated "subject of the artist," but it was a commentary several degrees removed from the primordial questions of the day. The artist in a sense disappeared from the scene but not without leaving traces. The silence of the avant-garde artist was in part a response to his alienation in a system that was becoming more and more Kafkaesque, a system in which art and culture served as propaganda weapons. The avant-garde artist who categorically refused to participate in political discourse and tried to isolate himself by accentuating his individuality was coopted by liberalism, which viewed the artist's individualism as an excellent weapon with which to combat Soviet authoritarianism. The depoliticization of the avant-garde was necessary before it could be put to political use, confronting the avant-garde with an inescapable dilemma.

In order to confront America's foreign and domestic problems the anti-Soviet sentiments expressed in Truman's speech had to be turned into anti-Communist sentiments. Every Communist became suspect, blackened by the new image of the Soviet Union. On March 21, 1947, nine days after his celebrated speech, Truman made this suspicion official by announcing a new program designed to protect the government against possible infiltration by subversives. The Employee Loyalty Program was intended to keep Communists out of federal jobs on the grounds that the Communist party represented a threat to the security of the United States. Suspicion of Communists was nothing new, but never before had it assumed the character of a crusade.[158] The government's anti-Communist program was also designed to cut the ground out from under the Republicans, who were constantly trying to link Communist infiltrations to the Democratic administration, which they accused of being "soft on Communism." The president was in fact killing two birds with one stone: he stirred up public fear and suspicion of the Soviet Union and thus helped gain public acceptance for his program of economic assistance to Greece and Turkey, and he also drove a wedge

between Henry Wallace and the Communists. Wallace was in fact forced to keep his distance from the extreme left if he hoped to remain politically viable, but by cutting himself off from Communist votes he lost whatever chance he may have had to challenge Truman in the 1948 elections.

While Congress was debating the appropriation of aid to the Middle East, George C. Marshall disclosed the famous plan that was to bear his name in a speech delivered at Harvard on June 5. Marshall called upon the nations of Europe to cooperate with the United States "in a titanic economic rehabilitation effort for devastated and war-torn nations."[159] Although the plan drew timid criticism from some liberals because it was designed to work outside the framework of the United Nations, it was nevertheless widely accepted as a plan at last intended to unify Europe rather than to divide it. This policy was deemed quite suitable by the Americans for Democratic Action, which through spokesman Samuel Grafton stated its pleasure in the following terms:

> There shines in Marshall's speech the recognition that we are engaged in a struggle for the souls of men, and not for the possession of mountain passes.[160]

Although the plan to aid Europe was part of the same strategy as the Truman Doctrine, it was conceived in far more constructive terms. The popularity of the Marshall Plan with the public and the press shows the broad appeal of the notion that America was now the number one country in the free world and could do without the United Nations.

The Marshall Plan was an elaborate project which envisioned a complex and subtle series of solutions to the problems of rebuilding the free world around the leadership of the United States, a project which we must now analyze in some detail. The choice not to present the Marshall Plan to the United Nations was one of the keys to success of the postwar American economy. Another aspect of the program was its use in the fight against subversion of the French and Italian governments by the powerful Communist parties in those two countries. The economic reconstruction of Europe was to be the key element in this fight. Furthermore, surplus American production and American private investment were to be directed toward Europe. Finally, the Marshall Plan was promoted by President Truman as a defense of the capitalist system itself:

> If we leave these countries of western Europe to shift for themselves and say, "we are sorry, we can't help you any more," I think conditions will quickly ensue there which will, in effect, bring about a substantial blackout of that market for goods and for the goods of the rest of the world for Latin America, for example. If Latin America loses its mar-

kets in western Europe, we lose ours in Latin America. . . . It is highly important that we do what we responsibly can to help these countries to get again to a position where they can stand alone, because if we do not we are going to have to make such radical changes, I am afraid, in our own economy, that it would be very difficult for a democratic free enterprise system to make it.[161]

We have gone into some detail about the nature of the Marshall Plan because it was this plan that determined the course of American foreign policy for nearly a decade and that exerted a broad influence on political and cultural developments in both France and the United States. The Marshall Plan should be understood as a natural extension of the policy underlying the Truman Doctrine and as the cornerstone of anti-Soviet policy in western Europe as well as the basis of American economic supremacy in the postwar period. The plan permanently alienated the Soviet Union from the United States, because Marshall's speech placed responsibility for the division of Europe into two rival blocs squarely on Moscow's shoulders and because the plan was in fact an indirect rejection of Soviet participation in the Western economy.[162] Marshall Plan aid helped to stabilize bourgeois governments in France and Italy, which eliminated Red ministers from coalition cabinets and clamped down on Communist agitation. At the same time Europe was made more dependent on American economic aid.

Henry Wallace expressed concern about the consequences of economic intervention in western Europe: "We are not loved in Europe," he observed, "and the more we use economic pressures to intervene in European affairs, the worse we are hated."[163] In Wallace's view the European assistance program was more a "martial plan" than a "Marshall Plan." As debate on the Marshall Plan dragged on in Congress, the administration used the severe economic crises in France and Italy to extract an emergency aid package from the legislature, which was therefore more inclined to approve the more ambitious overall aid plan.

The years 1946–47 were extremely tense. Americans, though aware of the benefits of their newfound prosperity, worried about the prospect of a third world war, fear of which was encouraged by the government. The image of a devastated and divided Europe ready to fall at any moment into the hands of the Communists was hardly reassuring. At the core of American life in the postwar years was a tension between the desire to lead a calm and prosperous life after years of depression and the need to defend America's newfound prosperity by taking action against communism. Americans found it impossible truly to understand the problems that faced them or to obtain a global view of America's new role in the world. Hence they felt alienated from political realities and often reacted in a schizophrenic manner.

The social and political climate changed dramatically within the space of two years. Fear of subversion became so widespread that the attorney general drew up a list of allegedly subversive organizations. The first such list was made public at the end of 1947, marking the beginning of the so-called witch hunt and the exclusion from American society of various clubs and organizations which had questioned the government's foreign policy in any way whatsoever. Anyone who opposed the policy of "containment" was considered to be suspect and potentially dangerous. It is therefore possible to agree with Richard M. Freeland that the list, combined with other means of coercion (propaganda, press, schools), ushered in a period during which all genuine political debate was suppressed. What we see is nothing less than the intellectual and political castration of the entire nation:

> Since the list also became a test of employability in state and local governments, defense-related industries, and schools, and of eligibility for passports, occupancy of federally financed housing, and tax exemptions, it does not seem excessive or imprudent speculation to suggest that the Attorney General's list had a profoundly suppressing effect upon political dissent in the U.S. In this sense, the impact of the list's publication was to enroll the whole country in a vast loyalty program.[164]

This, together with a policy of extradition, deportation, and imprisonment of suspected foreign nationals, created hostility between true-blue Americans and "others," who were suspected of every imaginable crime. In the end this climate proved more oppressive than one of openly declared war, for while the enemy was clearly defined, the field of battle was not. It was a war without avowed purpose against a menace with no particular target. Psychological warfare on a vast scale was waged in the dark against an intangible enemy.

Patriotism became the rallying point of mobilization. A number of programs were launched to stiffen the nation's patriotic backbone and promote love of democracy. Attorney General Tom Clark stands as a perfect symbol of the reigning mentality:

> What is required is to reawaken in the American people the loyalty we know them to have to the American way of life. . . . In the final analysis, our best defense against subversive elements is to make the ideal of democracy a living fact, a way of life such as to enlist the loyalty of the individual in thought, in feeling, and in behavior.[165]

The best way to accomplish this task in the long run was education. The Office of Education, which operated like a military commission (the

Studebaker commission), put education on the same footing as national security in its propaganda: "The single most important educational frontier of all involved the need to strengthen national security through education."[166] For the purpose of preserving and defending "the American way of life," the so-called Zeal for American Democracy program was designed to "vitalize and improve education in the ideals and benefits of democracy and to reveal the character and tactics of totalitarianism." In August 1947 the American Federation of Teachers chose as the theme for their annual congress "Strengthening Education for National and World Security." The AFT congress selected textbooks that would enable teachers to instill in their students the principles of democracy laid down by the Eightieth Congress.[167] Under the title *Growing into Democracy*, two series of pamphlets were issued. One showed teachers "how the principles of democracy may be inculcated in children through precept and experience." The other was intended for use in high schools as a guide to "the strategy and tactics of world communism." In order to reinforce the notion that democracy had to be defended and to rally a working majority behind the president, Clark and J. Edgar Hoover organized the "Freedom Train" in the spring of 1947. This was a sort of patriotic museum on wheels, which was sent on a tour of the United States. In Clark's own words this train produced an "upsurge of patriotism" just as Congress was debating the issues of special funds for Europe and the Marshall Plan. The train also had another purpose, as Richard Freedland explains:

> Perhaps not incidentally, the train's tour would also coincide with the 1948 presidential campaign; the effort to rally the country behind the Truman Doctrine was related to the need to rally the voters behind the Truman candidacy.[168]

The crisis atmosphere reached a peak when the National Guard conducted a practice bombing raid on the capital on the day that Congress began debate on the temporary aid measure. Psychological pressure could not have been carried any further. This out-and-out manipulation of Congress was denounced by some liberals such as Archibald MacLeish, who since May had been critical of political pressures on educators to indoctrinate the young in certain modes of thought. George Kennan and Harvard president James B. Conant denounced the mass hysteria that had taken hold of the country. The pressure kept building into 1948, however.

The Marshall Plan was adopted by Congress in April of 1948, despite Wallace's proposal of an alternative "Peace and Reconstruction Act of 1948."[169] Thus the period between June of 1947 and April of 1948 is crucial, for it shows us that the administration was running into diffi-

culties in trying to win acceptance of its program and succeeded only by raising the specter of nuclear war.

It was during this period that Pollock, de Kooning, and Rothko began work on a series of paintings in which no form is recognizable. What they produced was work that was totally abstract and yet intended to express a "subject," namely, anxiety. It was during this tumultuous period that the avant-garde gathered strength and established a secure foothold on the art scene. The message was brought home to the public in Barnett Newman's catalog for the Ideographic Picture exhibition held at Betty Parsons's gallery from January 20 to February 8, 1947.

Spontaneous, and emerging from several points, there has arisen during the war years a new force in American painting that is the modern counterpart of the primitive art impulse. . . . It is now time for the artist himself, by showing the dictionary, to make clear the community of intention that motivates him and his colleagues. For here is a group of artists who are not abstract painters, although working in what is known as the abstract style.[170]

There was in fact a certain group spirit. To see this one has only to read the catalog for Gottlieb's show at the Kootz Gallery in January 1947. The text was similar to Newman's:

Gottlieb does not work in the popular mode of the day, the so-called International Style [the allusion is to Paul Burlin and Romare Bearden]. Neither is he an abstract painter, nor a sur-realist. The fragments which he has unearthed in his excavations of our common underworld—an underworld which unites Mayan, Oceanic, Paleolithic and Atomic man—he has synthesized into a powerful and unmistakable signature.[171]

Eager to gain recognition on the domestic art market, the avant-garde sought to acquire approval from Paris, for Paris, as we have seen, still commanded a certain prestige, though the precise nature of this prestige was unclear. It was for this reason that Kootz sent his "promising" young painters off to Paris to capture the market there, without realizing that he was in fact sending them off to slaughter.

French critics, as it turned out, were nearly unanimous in turning thumbs down on the works of the Americans. In order to understand the forces that held sway in the art world of the day, it is essential to study the critical reaction in France to the Introduction to Modern American Painting exhibition. For our present purposes, however, it is enough to note that Kootz's risks in the venture were minimal. If the reaction was negative, it would not be mentioned in New York and Kootz could

attack the arrogance of the Parisians. If the reaction was positive, he could only gain. Even if the experiment failed, Kootz could make a publicity coup. If Paris recognized his artists, New York would heap glory upon them. A glance at the gallery's advertisements in the New York papers is enough to reveal the avant-garde's strategy: "Now showing in PARIS at the Galerie Maeght," read one ad, "Bearden, Baziotes, Browne, Gottlieb, Holty, Motherwell: the American members of the KOOTZ Gallery." The capital letters indicate the message that Kootz wanted to convey to the American public. His artists were international; they showed their work in Paris. This was the dealer's primary concern, and to emphasize his artists' international stature he saw no better place to exhibit their work than Paris:

> April represents the beginning of our third year as a gallery devoted to "International" art. With our first show—the oils and gouaches of Léger—we emphasized our intention not to be nationalistic. We selected artists in America who interested us, with no regard to their being "American," but with large insistence upon their creative abilities.[172]

Harold Rosenberg's introduction to the catalog attempted to portray modern American painting in a classical, that is to say, an international light. According to Rosenberg, the artists he was writing about had rejected their American past so as to become virginal, fit to wed the international cause. They painted in the international style, which was the style of Paris. Rosenberg attempted to draw a parallel between their work and that of Chagall and Miró and thus to bolster his contention that the American painters were stamped from the Parisian mold. His remarks exhibit a brilliant strategic instinct:

> On the western shore of the Atlantic, then, these men have sought out, made their own, and applied to the needs of their special passions the international idiom of twentieth century painting—an idiom that belongs to no one country, race or cultural temperament (though it is associated above all with Paris), but that in fact achieves much of its energy, inventiveness and glory in negating what is local and folkloristic through assimilating all national vestiges into a transcendental world-style. Such is the modernism of a Chagall or Miró, insofar as the echoes of the East European ghetto or the Spanish village sound in their images. And only to this extent, and in this subjective sense of a creative transformation, is American present in this exhibition.[173]

The artistic avant-garde followed the same course as American government policy. With the announcement of the Marshall Plan and the policy of "containment," the American government became aware of

the importance of closer ties with France. The United States indirectly patronized the show at the Maeght Gallery. For a government to patronize a private gallery may not seem quite legitimate, but after the failure of the traveling show "Advancing American Art" in 1946, the administration preferred to bypass Congress by using such government agencies as the United States Information Service (USIS) to finance private cultural ventures abroad.[174] In this case the cooperation of the France–U.S.A. Association was also enlisted. As a result, the painters from the Kootz Gallery were taken to be representative of American modern art in general: a real coup for Kootz.[175]

The Maeght show was part of a broad American attack on the cultural front. The assault was intended to dispel the notion that the American people were interested only in money, science, and crass materialism.[176]

The American Institute was established on April 11 for the purpose of facilitating student travel to France. During a dinner given in New York by Georges Wildenstein, managing editor of the magazine *Arts*, the French ambassador Henri Bonnet stressed the importance of the work being done by the institute in these troubled times:

The exchange of students between our two countries is the best guarantee that our young people will learn to understand and to like one another, thereby laying the best possible foundation for international and cultural cooperation.[177]

To this, Howard Wilson, assistant director for foreign relations of the Carnegie Foundation for International Peace, replied that "at the present time the number one item on the agenda is to strengthen the cultural ties between France and the United States."[178] In the context of the period, these remarks take on a clear political significance, because the words "cooperation," "ties," "comprehension," and "guarantee" denoted the side taken in the intense ideological battle then being waged in France between the supporters of the United States and the partisans of the Soviet Union. For the same reasons the exhibition at the Maeght Gallery was also politically explosive.

Once the Marshall Plan was unveiled, at a time when Communist participation in the French government was being reconsidered, the reaction of the Communist left took a violent turn:

Carriers of an alien ideology, American films are invading our theaters, American books are inundating our book stores, and foreign film producers and publishing houses are setting up shop within our very borders for the purpose of degrading our national spirit, aided by various economic and cultural agreements. All of these carefully planned undertakings aimed at regimenting the French mind in keep-

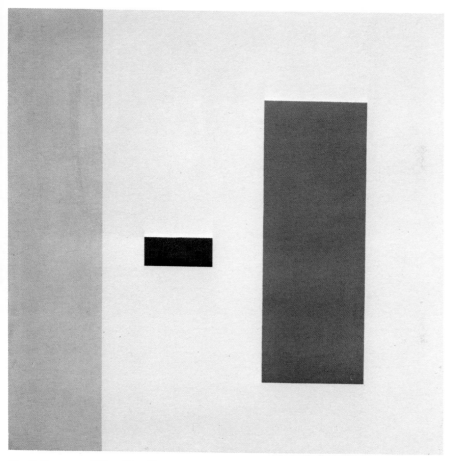

Fig. 1. Burgoyne Diller, *First Theme* (1942). Oil on canvas, 42 × 42" (106.6 × 106.6 cm). Collection, The Museum of Modern Art, New York. Gift of Silvia Pizitz.

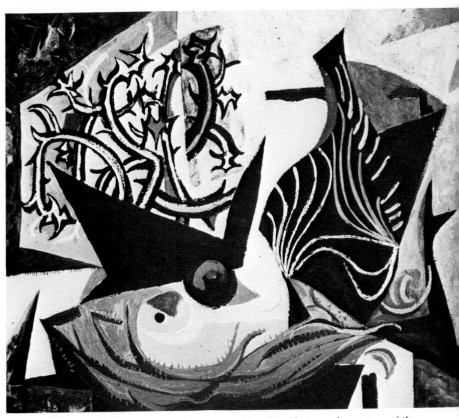

Fig. 2. Byron Browne, *The Basket of Leaves* (1943). 24 × 28″. Photograph courtesy of the estate of Byron Browne.

Fig. 3. "The Realm of Art," *New York Times*, June 13, 1943. © 1943 by The New York Times Company. Reprinted by permission.

THE REALM OF ART: A NEW PLATFORM AND OTHER MATTERS

'GLOBALISM' POPS INTO VIEW

Puzzling Pictures in the Show by the Federation of Modern Painters and Sculptors Exemplify the Artists' Approach

By EDWARD ALDEN JEWELL

FROM A REVIEWER'S NOTEBOOK

Brief Comment on Some Recently Opened Group and One-Man Exhibitions, Chiefly of Work by Our Contemporaries

By HOWARD DEVREE

IS THIS THE ART OF THE FUTURE?
"Triangulated Tragedy," by Theodore E. Scherer. This and the other two paintings reproduced are included in the current exhibition by members of the Federation of Modern Painters and Sculptors at Wildenstein's.

"The Rape of Persephone," by Adolph Gottlieb.

LOCAL SHOWS

"Peter," by Henry Varnum Poor, at the Bohn Gallery.

"The Syrian Bull," by Mark Rothko.

ON THE LOCAL CALENDAR

Fig. 5. Installation view of the exhibition "Road to Victory," May 21 through October 4, 1942. Collection, The Museum of Modern Art, New York.

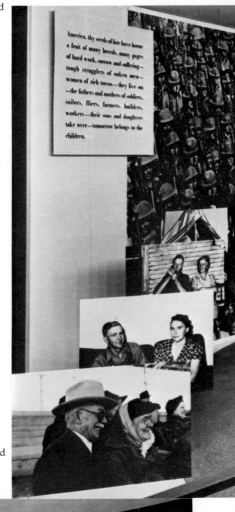

Fig. 4. Installation view of the exhibition "Road to Victory," May 21 through October 4, 1942. Collection, The Museum of Modern Art, New York.

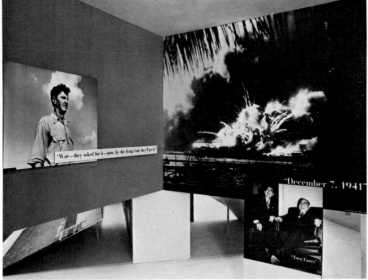

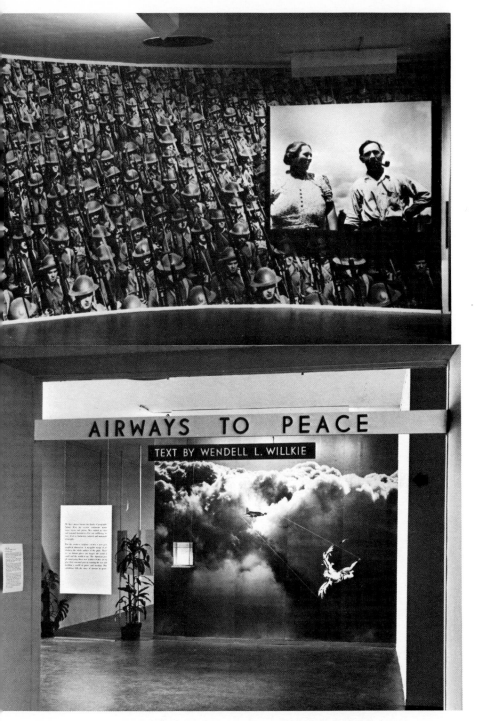

g. 6. Installation view of the exhibition "Airways to Peace," July 2 through October 31,
943. Collection, The Museum of Modern Art, New York.

U. S. supplies, packed in paper, speed the liberation of The Netherlands and colonies **CONTAINER CORPORATION OF AMERICA**

Fig. 8. Advertisement, *Fortune,* January 1945. Courtesy Contai Corporation of America, "United Nations Series," 1945. Artist Willem de Kooning.

Look through these glasses at everything you buy

From now 'til victory comes, patriotic buying must be the rule.

It will help mightily toward winning the war if, for instance, we all buy *longer-lasting* things—when we must buy at all.

Here's one little example of how quality buying helps in an all-out war: Take razor blades. There's as much steel in a poor blade as in a good one. If the good blade gives you, say, twice as many shaves, it means you'll use only half as much steel. Sounds insignificant; but, multiplied by millions, the saving adds up to a lot of steel-jacketed shells.

Whether it's blades or batteries or any other thing, whenever you buy . . . buy *longer-lasting* quality. So doing you get better value, better service for yourself—and you conserve for Uncle Sam.

It happens to be a sound, economic truth that the wiser we buy the quicker we'll win.

THE ELECTRIC STORAGE BATTERY CO., Philadelphia
The World's Largest Manufacturers of Storage Batteries for Every Purpose
Exide Batteries of Canada, Limited, Toronto

CONSERVE YOUR PRESENT BATTERY!
One way to help your country and yourself is to take care of your present battery. Your Exide dealer wants to help you get from it all the service it is capable of. Why not see him soon?

◄ Fig. 7. Advertisement, Electric Storage Battery Co., February 1942. Courtesy Exide Corporation, Horsham, Pennsylvania.

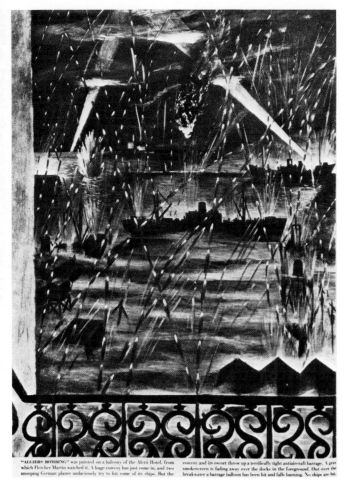

"ALGIERS BOMBING" was painted on a balcony of the Aletti Hotel, from which Fletcher Martin watched it. A huge convoy has just come in, and two snooping German planes audaciously try to hit some of its ships. But the convoy and its escort throw up a terrifically tight antiaircraft barrage. A gray smokescreen is fading away over the docks in the foreground. Out over the breakwater a barrage balloon has been hit and falls burning. No ships are hit.

Fig. 9. Fletcher Martin, *Algiers Bombing*, in *Life*, April 30, 1945.
Courtesy Jean S. Martin.

Colonial-type living room is attractively furnished but without pictures the walls look bleak and bare. Even one good-sized painting hung over the mantelpiece would give the room character. How four paintings change appearance of room is shown at right.

Contemporary paintings fit into rooms of any period. In this colonial setting, a modern circus water color by Kruckman, a gouache by Spivak and two landscapes—an oil by Eaton (*in color, page opposite*) and a water color by Taskey—all look equally at home.

DEPARTMENT STORES POPULARIZE ART

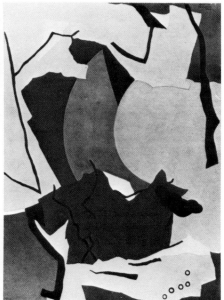

BIKINI

WITH DOCUMENTARY PHOTOGRAPHS, ABSTRACT PAINTINGS, AND METEOROLOGICAL CHARTS RALSTON CRAWFORD HERE DEPICTS THE NEW SCALE OF DESTRUCTION

Photographs: Joint Army-Navy Task Force One

The two atomic bombs touched off by Joint Task Force One at Bikini on July 1 and 25—Test Able above water, Test Baker below—sank twelve ships, wreaked major damage on twenty-four other craft, and spread varying degrees of disaster throughout the target fleet. These were the immediate and visible effects of the blasts. More terrible by far were the invisible radioactive effects stirred up by the titanic releases of energy, which caused sea water and ships to radiate as dangerously as radium and made the blast area uninhabitable for days. Two months after the second blast some ships were still too radioactive for repairs.

There is more than meets the camera's eye in atomic bombing. The intangibles allowed some blast correspondents, far from the blasts, to pooh-pooh the bomb's power. But the great clouds that have become so familiar a symbol of atomic explosions cloak the lethal streams of neutrons and gamma rays. To track these streams, an elaborate meteorological apparatus was set up on four islands within an 890-mile radius of Bikini and on three ships nearby. Atomic bombs can spread lingering death over a vast area. If the bomb is detonated in air in fair weather, its radioactivity may be quite rapidly dispersed by wind currents. But if detonated under water or in moist atmosphere, its poisonous radioelements are concentrated in water droplets and held in the area for days. Meteorological bureaus will undoubtedly be the most important part of any future bombing teams. Two new radar and elec-

tronic devices, called rawin and raonsde, now aid in the accurate prediction of weather conditions up to the stratosphere. For, by accurate use of wind and weather, the bomb might literally be made to rain death upon a sizable portion of any country.

The accompanying portfolio is an attempt to bring home this macabre warfare. Ralston Crawford, in civil life an abstract painter, was Chief of the Visual Presentation Unit, Weather Division, Headquarters A.A.F., during the war. He developed a notably successful application of principles of abstraction to meteorological maps and charts. Both in Washington and in the C.B.I. theatre his total experience of war convinced him that the meaning of war lies not in individual battles or even in the sum of human tragedy but far deeper—in the all-encompassing force of destruction itself. For Crawford, Bikini was the supreme challenge. It combined destruction in terms of the ultimate energy sources of the universe itself, and the charitable consequences if man should lose the battle of good and evil.

The extraordinary photograph above was taken almost at the instant of the bomb explosion. In Crawford's even more extraordinary painting (right), similar circular forms can be identified. "But," says the artist, "my forms and colors are not direct transcription; they refer to paint symbols to the blinding light of the blast, to its colors, and to its devastating character as I experienced them in Bikini Lagoon."

g. 12. Jackson Pollock, *Sounds in the Grass:
immering Substance* (1946). Oil on canvas, 30⅛
24¼" (76.3 × 61.6 cm). Collection, The Mu-
um of Modern Art, New York. Mr. and Mrs.
bert Lewin and Mrs. Sam A. Lewisohn Fund.

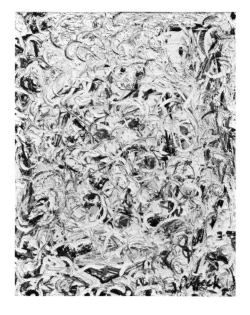

g. 10. "Department Stores Popularize Art,"
e, January 3, 1944. Courtesy Elizabeth Timber-
an.

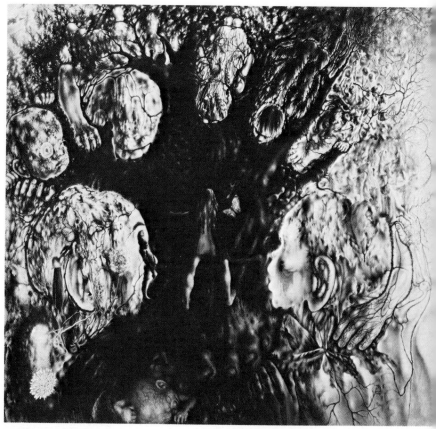

TIMELESS POLITICAL CARTOON

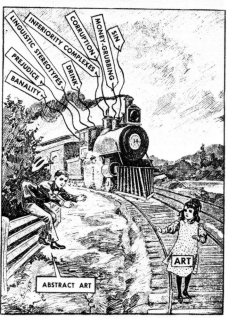

Fig. 13. Pavel Tchelitchew, *Hide-and-Seek* (1940–42). Oil on canvas, 6′ 6½″ × 7′ ¾″ (199.3 × 215.3 cm). Collection, The Museum of Modern Art, New York. Mrs. Simon Guggenheim Fund.

Fig. 14. Ad Reinhardt, *The Rescue of Art*. Collage drawing published in *Newsweek*, August 12, 1946. Courtesy The Pace Gallery, New York.

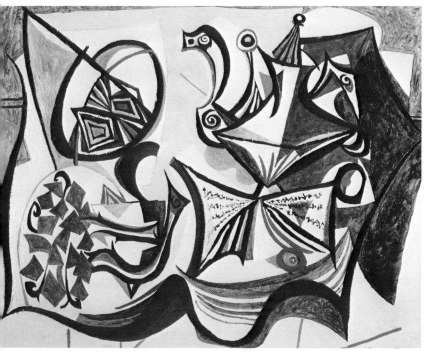

Fig. 15. Byron Browne, *Still Life in Primary Colors* (1945). Oil on canvas, 30 × 38″. Private Collection, Florida. Photograph courtesy of Stephen B. Browne.

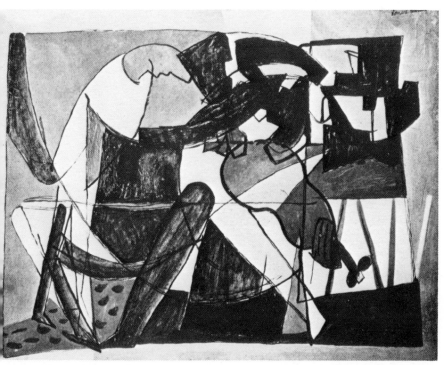

Fig. 16. Romare Bearden, *Note bleue.* Published in *Cahiers d'Art,* 1947. Courtesy Samuel Kootz Gallery and Romare Bearden.

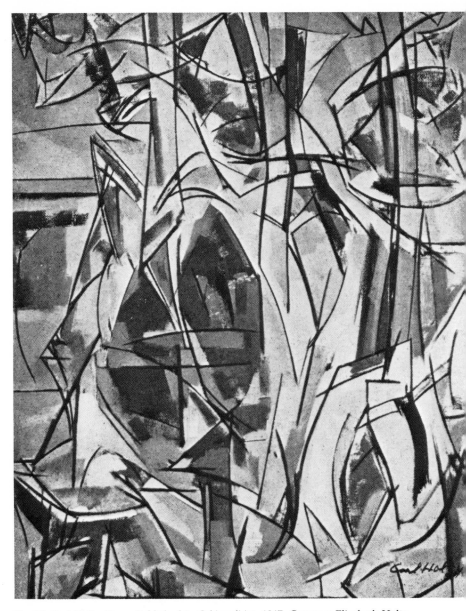

Fig. 17. Carl Holty, *Trees*. Published in *Cahiers d'Art*, 1947. Courtesy Elizabeth Holty.

Fig. 19. Byron Browne and Samuel Kootz standing in front of *The Four Horsemen of the Apocalypse* (1946). Photograph courtesy of the estate of Byron Browne.

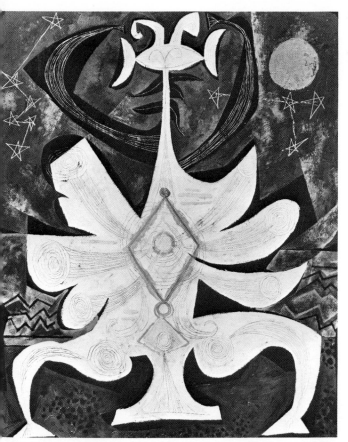

Fig. 18. Byron Browne, *Queen of the Crustaceans* (1948). Oil on canvas, 38 × 30″. Photograph courtesy of the estate of Byron Browne.

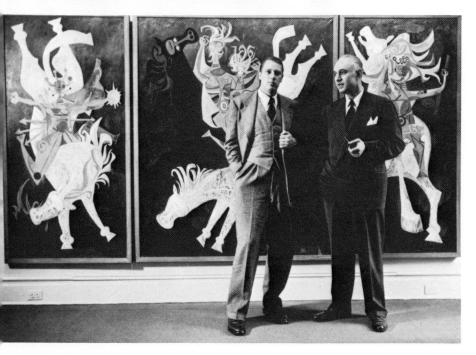

Fig. 20. Drawing by Jackson Pollock in advertisement for County Homes, Inc., in *Partisan Review* 15, no. 9 (September 1948). © Partisan Review 1948. Courtesy of David Swope.

Drawing (1948), by Jackson Pollock Courtesy of County Homes, Inc.

WE ASKED Jackson Pollock to draw this picture to help tell PR readers what County Homes is doing about housing. This is the second of a series by contemporary artists, all of whom find it unusual to illustrate a real estate advertisement.

THE UNUSUAL, however, is our business. We sell land and build houses; the results are extraordinary in that they fit both their surroundings and the ideas of their owners to such a satisfactory degree. You may buy our land and use your own architect and builders, or County Homes will handle all the elements involved in building or reconverting, from the first plan to the intricacies of home financing. Anyone who can afford $150 rent for a New York apartment can buy or build on the banks of the Hudson, where windows stay clean for months. Land is available from ¼-acre up. Commuting time: 35 minutes.

RIGHT NOW we are putting nine large estates, ghosts of a past era, back into use—dividing them into sites of more reasonable size but avoiding, like a plague, the too-familiar horrors suggested by the word "development." We are preserving the individuality, the magnificent, natural landscaping, and the privacy the original owners enjoyed. We want you to see this work. We should like to show you some of the remarkable houses already complete, and suggest the possibilities in property still available. Our Tappan Hill office is a pleasant 40 minute drive up the Sawmill River Parkway, or we shall be glad to meet you at the Tarrytown Station.

COUNTY HOMES, Inc.
Tappan Hill
Tarrytown, N. Y.

DAVID SWOPE, President
Tarrytown 4-3034

Fig. 21. "Not Left, Not Right, But a Vital Center," *New York Times Magazine*, April 4, 1948. © 1948 by The New York Times Company. Reprinted by permission.

Drawing by Bertrand Zadig

Not Left, Not Right, But a Vital Center

THE nobles, walking into the French Assembly of 1789, took their traditional place of honor on the president's right. The Third Estate grouped itself defiantly on the left. Thus arose the division which, at first a question of protocol, was soon converted into a question of politics and emotion. As parliamentarianism reached its height in the

The hope of the future lies in the widening and deepening of the democratic middle ground.

By ARTHUR M. SCHLESINGER JR.

simplicities of the nineteenth century, when the Right meant those who wished to preserve the existing order and the Left

At the same time, new complexities were overtaking the Left. The declarations of the Rights of Man, the spirit of

certain basic respects—a totalitarian state structure, a single party, a leader, a secret police, a hatred of political, cultural and intellectual freedom—fascism and communism are clearly more like each other than they are like anything in between. This dilemma drove Prof. De Witt C. Poole to an inspired suggestion. Right and Left, he said, should be con-

Fig. 22. Philip Evergood, *Renunciation* (1946). Oil on canvas, 49¼ × 35½″. Private collection.

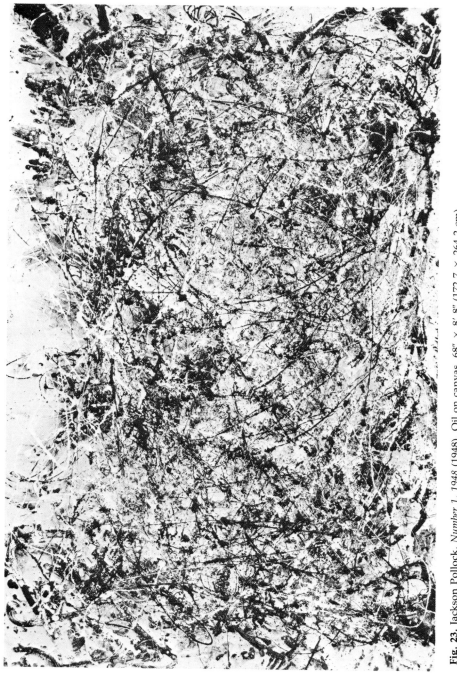

Fig. 23. Jackson Pollock. *Number 1, 1948* (1948). Oil on canvas, 68″ × 8′ 8″ (172.7 × 264.2 cm). Collection, The Museum of Modern Art, New York. Purchase.

ing with the needs of a new global expansionism have been approved in the name of artistic freedom.[179]

The arrival of American art on the banks of the Seine was greeted with the same suspicion as the tidal wave of American films and American efforts to chip away at the market for high fashion:

Paris has once again won the war for elegance. As if in response to certain couturiers on the other side of the Atlantic, who have been acting as though they had nothing more to learn from Paris and the old world, [this season's] collections are more sumptuous and delicately refined than ever they were in happier times.[180]

What seemed to be happening early in 1947 was the orchestration of a wide-ranging and all but unstoppable cultural offensive against France. French art critics were nearly unanimous in trying to turn back the American tide with haughty sneers. In one letter Samuel Kootz described the French reaction in the following terms:

The show confused most people, since they have never seen your work before. Then having suddenly to appraise six different personalities was a bit too much for them. . . . Many artists liked the show, and each had his favorites.[181]

This was an optimistic and soothing view of reality. The critics had in fact been devastating.

The April 4, 1947, issue of *Arts* described the general feeling. The Parisian art world wished to make it clear that, as far as it was concerned, there was no further room for avant-gardes, for the shock of novelty. Paris was blasé and tired of the kind of art that New York had sent:

Is the purpose of this show to demonstrate to us that abstract art no longer holds any secrets for American artists? Or is it perhaps that they know no other aesthetic? Or is it merely that someone wanted to prove to us that the Yankees, always eager for novelty, are now at the cutting edge of modern art? We have no way of knowing, but the fact is that all the works shown are nonfigurative, except for Browne's. This kind of audacity has long been familiar in the art of western Europe. For us it could not cause either surprise or scandal. The only thing that can still attract us in a work is therefore its quality. This is not conspicuous in the painting of Baziotes, Bearden, Browne, Gottlieb, Holty, and Motherwell.[182]

Once the naive nature of the American works was established, debate could get under way. The attack focused on the banality of the works

in the show and on the pastiche of works by Parisian painters. The anonymous critic writing in *France au Combat* described the show as consisting of paintings in an unoriginal international style using Picasso's style of drawing in conjunction with Matisse's cloisonné decorative colors. The *Figaro* dismissed the show in a few lines: "In no case is any comparison with French painting possible."[183] By contrast, *Combat* of April 9, 1947, published a major article on the show, spread over five columns and including a reproduction of Holty's *Hockey Player*. While congratulating the Maeght Gallery for having brought together these samples of modern American painting, Jean-José Marchand complained about the rather disappointing overall level of the work:

> Maeght should be thanked for putting on this show despite the terrible difficulties imposed by the Customs Service, which demanded an enormous bond. The Service was mistaken, however, because the works shown do not have the immense value it imagines. And we are troubled to learn that these painters are considered the bright hopes of the Samuel Kootz Gallery.[184]

Marchand attacked Gottlieb for leaving out the forceful expression of Indian painting and degenerating into pleasant decoration. Byron Browne's work was considered too much like Picasso's and received brief mention: it "strives for effect," the critic said, "and does not hesitate to sacrifice the essential in doing so."[185] Romare Bearden was described as "the worst of the lot, with a careless and facile brush stroke and colors laid down at random in a sort of jigsaw puzzle done in the loudest possible shades. A painter of this sort in France would be regarded as quite mediocre."[186] Marchand's favorite was Baziotes, whom he saved for last:

> Baziotes has much more talent and goes infinitely further in the direction of audacity. His titles—"Green Doll," "Nocturnal Form," "Sphinx," etc.—indicate a somewhat overly symbolistic "literary" tendency, but he is courageous enough to go so far with his style that he approaches some recent French experiments in abstract painting. His work remains minor, however, and frequently gives the impression that Baziotes does not really know where he is headed.[187]

The press was fierce in its attacks on Holty, Bearden, and Browne, who were said to be totally subservient to French painting. But the dice seem to have been loaded in this Paris–New York exchange: French critics, who, it bears repeating, were shown a one-sided view of American production, rejected works that were too influenced by Paris but at the same time found redeeming merit in the work of Motherwell, pre-

cisely because it could be compared with the work of certain young Parisian abstract artists. On the whole Paris emerged from this skirmish calmer than it had been. The size of the economic and cultural stakes made the rejection all the more reassuring:

The art trade along with the other luxury trades is of the utmost importance to France. Foreign sales of both plastic and decorative arts contribute in large measure to our balance of payments and extend our influence and renown.[188]

The critical unanimity was broken by Mauriac's *Carrefour* (a journal with Gaullist leanings), which on August 6, 1947, published a review by Frank Elgar of the "salon des réalités nouvelles." Earlier, on April 9, *Carrefour* had happily denounced the works in the Maeght show as copies of Parisian originals:

Clumsy compositions, clashing colors, gratuitous aggression, absence of style, and above all a frightening spiritual dryness—must the art of a young and powerful nation pass through such a barren phase before setting foot on the shores of a new world?[189]

But in August, after discovering the regenerative boons to be expected from the Marshall Plan, Elgar and *Carrefour* found signs of genius in the works of painters they had raked over the coals just a few months before, namely, Motherwell and Baziotes:

For the time being I can only observe that the "foreign abstractionists" are superior to their French colleagues. This, I think, is the first time in a hundred years that a new school of art has arisen outside our influence. A visit to the American section of the *salon des réalités nouvelles* leaves no doubt as to the scope and vigor of a movement that, one day perhaps, will emerge here as well, a movement that has nothing more to learn from Europe and that surpasses similar work being attempted in our aging countries in number, fantasy, and simplicity.[190]

Lurking behind the encouragement of the new abstract art in which American painters excelled was a touch of anxious resignation in the face of a future which might well yield a new style of painting to replace an old and moribund one but which nevertheless left something to be desired. If it seemed certain that European humanism would be replaced by American technology, there was also no doubt that the price to be paid was the end of a world centered on human relations. The conflict between humanism and technology was a fine metaphor for discussing the Marshall Plan and its consequences:

Without speaking ill of our American friends we may note the degree to which they generally lack poetic sensibility and plastic sense. So quickly have the Americans domesticated the forces of nature, developed mechanical technology, and rationally organized the labor process, and so avidly have they devoured the real world and adjusted to its pace, that today nature refuses to give herself to them and the things around them live only for themselves, so that man feels a stranger in the world he has dominated. Hence it is easy to understand why American artists have been so quick to accept an aesthetic which, by eliminating the dialogue between man and nature, by eliminating the very thought of nature, has given them their opportunity and raised their hopes. . . . A number of painters have gained an enviable notoriety: Morris, Coale, Reichman, Lewis, Redman, Tobey, Rebay, Graves, Bauer, Scarlett, Kantor, Pearl Fine, and others too numerous to mention. Make no mistake about it: These artists are better than our own at working the same vein. If true painting were to reap the benefit, there would be no cause for regret. But will it? That is the question.[191]

Samuel Kootz made a calculated effort to create a niche for his artists on the Parisian international scene. After failing to interest Cassou, the director of the Musée d'Art Moderne of Paris, who was unable to purchase American art for his collections, Kootz persuaded Zervos to devote three pages of the 1947 issue of *Cahiers d'Art* to American artists, including an illustration of the work of each artist mentioned (figs. 15–17). This was a master stroke. Not only were the artists covered introduced to Paris in a serious and sumptuous review, where they were surrounded by the stars of modern art (such as Picasso and Miró), but they also took on considerable importance in the United States, where the magazine was still highly respected and quite popular in the studios. They could no longer be ignored in the United States.

The period from the autumn of 1947 to the end of 1948 proved crucial for the American avant-garde. It was during this time that the avant-garde really emerged from obscurity and organized in a sufficiently cohesive and aggressive manner to seriously trouble the public, the critics, and some museums. Thus it was precisely at the time when the country was divided, worried, and unconvinced of the urgent need for a European Recovery Program, when a strong and forceful image of the United States had to be promoted both domestically and abroad, and when fears of the nuclear menace were once again exacerbated, that the avant-garde began to command attention. A sort of parallel art world came into being, outside the regular art scene but in constant dialogue with those inside. This new art world revolved around certain reviews, critics, schools, and exhibition spaces, all held together by a common

ideology. A number of new reviews were first published in 1947: *Iconograph, Instead,* and the two most important of all, *Tiger's Eye* (October 1947) and *Possibilities* (Winter 1947), which came after the announcement of the Marshall Plan.

Articles favorable to the creation of an avant-garde appeared in the nonspecialist press as well as in the writings of critics who were influential but peripheral to the art world such as Rosenberg and Greenberg. It was as though scattered elements of American culture had coalesced, brought together by suspicion of the establishment and by an aggressive, polemical criticism. In order for art to function in a modern way and to meet contemporary needs, what was needed, as Macdonald, Greenberg, and to some extent *Partisan Review* had been saying for some time, was a parallel organization, hostile to the establishment and ready to replace it sooner or later. To replace it: that is, to seize the market.

The years 1947 and 1948 saw the formation of such an organization and the establishment by the avant-garde of a new standard of reference based on alienation and on the notion of the freedom of the artist as individual, together with all the anxiety and contradiction inherent in such an approach. For the establishment of the avant-garde was a contradiction in terms: the forces that brought the avant-garde to power ceased to operate once it became in turn a new "establishment," causing problems for artists who believed they could still behave in the old way. Such artists failed to understand why their image of the avant-garde no longer corresponded to society's desires. They became part of art history, that is to say, a dead letter. They fell out of fashion since they no longer represented what was new and active. As soon as the avant-garde became successful, whatever artists did helped to embalm their work. They produced signs that could no longer be incorporated into the new code.

The mood expressed in *New Iconograph* is one of forced euphoria:

The American artist has come of age. A more tolerant and encouraging public has freed him from the moral and economic restrictions that so limited his endeavors and his audience twenty years ago. Moreover he is no longer obliged to indulge in the incoherent polemics and esoteric experiments of his predecessors. For his position today is quite similar to that of the artists of Florence and Rome in the first decade of the sixteenth century who were able to achieve a synthesis of the philosophic and technical experiments of the quattrocento. . . . It is therefore our firm belief that we are hesitating on the edge of a renascent period of the American arts and it is our desire as the editors of the New Iconograph to assist and promote in every way possible within our limited means those whom we believe capable of fulfilling the cultural potentialities of our time.[192]

This gave way to a more temperate and disillusioned tone in the editorial published in the sole issue of the magazine *Possibilities*. The first page of the magazine set forth a new working code, a platform for action which took the importance of politics into account.[193] How could it have been otherwise, given the fact that the editorial was written in September and came out just after the announcement of the Marshall Plan and the establishment of the Attorney General's List. The importance of politics and the impossibility of fully understanding the political situation were among the main concerns of the group of artists that gathered around Rosenberg and Motherwell. Recognition of the political dimension was a novelty for avant-garde artists, but in this case the recognition came by default: it was the recognition of an absence, as it were. The artists worked around politics and responded to it, but in such a way as to work in the interstices between art and politics. Put differently, their work took account of both art and politics but did not particularly concentrate on either. Instead, man was the central focus: the artist himself embodied both art and politics and through his work resolved the contradictions between them:

> Naturally the deadly political situation exerts an enormous pressure. The temptation is to conclude that organized social thinking is "more serious" than the act that set free in contemporary existence forms which that experience has made possible. One who yields to this temptation makes a choice among various theories of manipulating the known elements of the so-called objective state of affairs. Once the political choice has been made, art and literature ought of course to be given up.[194]

Hope won out, however:

> Political commitment in our times means logically no art, no literature. A great many people, however, find it possible to hang around in the space between art and political action.[195]

As the name indicates, *Possibilities* attempted to define ways in which artists might put this program into practice. In the stifling climate of modernity, the artist must seek to develop a new kind of art in order to breathe, in order to gain some freedom of maneuver, however minimal, in the area between art and political action, where the former could no longer represent the tragedy of the age and the latter had become impossible as far as radicals were concerned. Motherwell and Rosenberg were struck with amazement by the discovery that there was indeed room for maneuver. Art, they believed, might still be action, because it served the goal of personal liberation.

Another important article in *Possibilities* by Andrea Caffi shed light on the goals and desires of the new group of artists. For them, myth was the way to reestablish communication with the public. Myth was supposed to enable the artist to escape the ideological regimentation against which the radical left was battling in the early days of the Cold War.

The myth is peculiarly at work when the pressures of rigorous rationalism, of strictly revealed or demonstrated "truth," of political, moral and aesthetic conformism come into conflict with the need to communicate with one's fellows. From the very beginning the myth has been a representation and, above all, a communication of things that do not exist but *are*.[196]

Myth was the only way to enter into dialogue with "man," to overcome his alienation. This was what Mark Rothko hoped to achieve with his abstract paintings: "It really is a matter of ending this silence and solitude," Rothko wrote, "of breathing and stretching one's arms again."[197] According to the artists of the avant-garde, there was a possibility of reestablishing a connection between art and political action without submerging art in a sea of propaganda. Art could again be liberating as it was in times past, when it thrived on myth. Myth enabled art to rise above the commonplace and to take leave of the contemporary. Modernism, in its abstract phase, and modernity, in its alienation, were the solutions, the only solutions, to the problems of the incomprehensible present with which the modern painter found himself confronted.

If one is to continue to paint or write as the political trap seems to close upon him he must perhaps have the extremest faith in sheer possibility. In his extremism he shows that he has recognized how drastic the political presence is.[198]

Because it was impossible to act, to transform social life or the world itself, the painter was obliged to project himself into the future, to think about "possibilities," to fulfill his potential by escaping the confines of the present moment.

Motherwell and Rosenberg knew their Marx and followed his description of alienation step by step up to a certain point. But then they took a shortcut, departing from the Marxist analysis at a crucial moment in the argument. Pessimistic because they had given up hope of changing the situation or of taking a hand in the "socialization of society," they were at the same time optimistic because they believed that individualistic internalization offered the possibility of immediate access to what Marx foresaw, dimly, as a prospect for the future socialist society:

Alienation makes species-life into a means of individual life. In the first place it alienates species-life and individual life, and secondly, it turns the latter, as an abstraction, into the purpose of the former, also in its abstract and alienated form.[199]

For the avant-garde the important thing was that it now became possible to perpetuate the practice of painting without losing face, that is, without abandoning the vocabulary of radical politics. The alienation of the artist, the avant-garde believed, was necessary to his liberation. All avant-garde artists agreed on this point, for them characteristic of modernity. Greenberg and Rosenberg, moreover, based their hopes for a renewal of American art on this belief.

Alienation was viewed as a preparation for rebellion and liberation:

The unfriendliness of society to his activity is difficult for the artist to accept. Yet this very hostility can act as a lever for true liberation. Freed from a false sense of security and community, the artist can abandon his plastic bank-book, just as he has abandoned other forms of security.[200]

As Pierre Dommergues explains in his book *L'aliénation dans le roman américain contemporain*, after World War II alienation ceased to be seen in the United States as a deviant condition and began to be viewed as a way of being. The period saw a reevaluation of madness and, more generally, of alienation:

Alienated man acquired a new prestige: there was talk of "cultural revolution." Alienation became a mode of knowledge. It allowed a resumption of the dialogue with the forces of darkness. It gave rise to a new dynamic. Connected to the emergence of minorities in civic life as well as literature, alienation became an object of praise.[201]

Painters were no longer interested in covering their canvases with signs linked to the visible world, because, Rothko said, society always succeeded in twisting the work's original meaning. If the artist wanted to be truly free, then according to the avant-garde he had to be completely alienated. This was the price of genuine communication.

The familiar identity of things has to be pulverized in order to destroy the finite associations with which our society increasingly enshrouds every aspect of our environment.[202]

Recall that in 1947 the federation of which Rothko was a member was falling apart. Last bastion of one of the thirties ideologies, the group was succumbing to social pressures. With the return of prosperity artists

found themselves alone on the marketplace, in competition with other artists. Groups, associations, federations lost their meaning. Cooperation gave way to "every man for himself."[203] Alienation, which led to rebellion, was still seen in a positive light, because it was aggressive and enabled the artist once again to find his place in the bosom of "mankind." Alienation was therefore seen as a privilege:

> The privilege of alienation is to offer a new mode of communication: alienation is not a kind of isolation but a way of being in the world which engages the individual, the society, and the public. . . . Alienation is a way of communicating on a symbolic plane. In reality the alienated person is not indifferent to the world; if he isolates himself, the reason is that he is too sensitive to the environment.[204]

Alienation was thus a token of liberty. The corollary of this was that only the alienated man could be truly free: this was a central dogma of avant-garde criticism.

Rosenberg, in his preface to the catalog prepared for the show in Paris of works by artists from the Kootz Gallery, accordingly depicted the American painters as heroes. In this sort of group show it was customary to look for similarities in the work of the various painters shown in order to establish a common theme. But this catalog took the opposite tack: the intention was to destroy the concept of a common character and replace it with the idea of fragmentation, individuality. Each painter was shown as an individual alienated from the others:

> The paintings stand for a peculiar truth—or, more precisely, truths; since they are, above all, the work of individuals—of the creative process in the United States.[205]

The state of isolation in which the American artist found himself was beneficial because it allowed for individual analysis and introspection and preserved some "personal essence" through which it was possible to envisage the creation of another world, a world without alienation:

> Attached neither to a community nor to one another, these painters experience a unique loneliness of a depth that is reached perhaps nowhere else in the world. From the four corners of their vast land they have come to plunge themselves into the anonymity of New York, annihilation of their past being not the least compelling project of these aesthetic Legionnaires. . . . The very extremity of their isolation forces upon them a kind of optimism, an impulse to believe in their ability to dissociate some personal essence of their experience and rescue it as the beginning of a new world.[206]

In an article published in the English magazine *Horizon*, Clement Greenberg saw hope of salvation in the depressed quarters of the avant-garde, in artists who fought against wind and tide to paint as they wished, to express their desire to create without illusions a new modern art. In its expression of faith in the ultimate victory of the avant-garde, this article resembled Greenberg's 1939 piece, "Avant-Garde and Kitsch":

The fate of American art does not depend on the encouragement bestowed or withheld by 57th Street and the Museum of Modern Art. The morale of that section of New York's bohemia which is inhabited by striving young artists has declined in the last twenty years, but the level of its intelligence has risen, and it is still downtown, below 34th Street, that the fate of American art is being decided by young people, few of them over forty, who live in cold-water flats and exist from hand to mouth. Now they all paint in the abstract vein, show rarely on 57th Street, and have no reputations that extend beyond a small circle of fanatics, art-fixated misfits who are as isolated in the United States as if they were living in Paleolithic Europe.[207]

Like the show at the Maeght Gallery, the publication of a special issue of *Horizon* devoted to American society and art is a sign of the effort to create an intellectual image of the United States in Europe, an effort that began in 1946 but was stepped up after the announcement of the "policy of containment." But the new image was still not very sharply defined, although the articles published by American intellectuals did succeed in making certain needs quite clear. In an article on literature, for example, a disappointed William Phillips deplored the gap between America's world power and its cultural poverty:

In the past, our own creative energy has been nourished by new literary movements in Europe. Today, however, an impoverished and politically tottering Europe is not only dependent on the economic resources of the United States but also, apparently, more receptive than ever before to its cultural advances. . . . On the one hand, our economic power and the democratic myths behind our institutions are all that stand in the path of a Stalinist enslavement of Europe. On the other hand, the United States might well become the greatest exporter of kitsch the world has ever seen. Not being art fetishists, most of us are willing to accept the cultural risks involved in preserving European political freedom. If, however, America is to be looked to, as do some of our European friends, as a source of literary salvation, then all I can say is—God Save the King.[208]

In "The Present Prospects of American Painting and Sculpture," Clement Greenberg was a good deal more positive than Phillips, because as

we saw a moment ago Greenberg saw hope for avant-garde culture in the emergence of a group of alienated American artists. Returning to the arguments developed in "Avant-Garde and Kitsch," he again asserted that the problem with contemporary American society was that the rise of the middle class had produced a mediocre culture:

> Art has become another way of educating the new middle class that springs up in industrial America in the wake of every important war and whose cash demands enforce a general levelling out of culture that, in raising the lowest standards of consumption, brings the highest down to meet them. For education always means a certain number of concessions. In any case the very improvement of general middle-brow taste constitutes in itself a danger. . . . It was to be expected that sooner or later the American "common man" would aspire to self-cultivation as something that belonged inevitably to a high standard of living as a personal hygiene. . . . Cultivation not only makes one's life more interesting but—even more important in a society that is becoming more and more closed—defines social position.[209]

For Greenberg, the art of his time and his civilization could only be a city art, an art of urban experience.[210] He pointed out how American artists could develop a style appropriate to this kind of art:

> In painting today such an urban art can be derived only from Cubism. Significantly and peculiarly, the most powerful painter in contemporary America and the only one who promises to be a major one is a Gothic, morbid, and extreme disciple of Picasso's cubism and Miró's post-cubism, tinctured also with Kandinsky and Surrealist inspiration. His name is Jackson Pollock. . . . For all its Gothic quality, Pollock's art is still an attempt to cope with urban life; it dwells entirely in the lonely jungle of immediate sensations, impulses and notions, therefore is positivist, concrete.[211]

In some respects Pollock and David Smith met the requirements of modernism, but they still had work to do to fully perfect the new urban art envisioned by the critic. For Greenberg the solution to the problem of contemporary art lay in balance, in an art that was rational but not rationalized. Pure expressionism was to be avoided; paroxysm and romanticism were very grave dangers that threatened the development of avant-garde painting:

> The task facing culture in America is to create a milieu that will produce such an art—and literature—and free us (at last) from the obsession with extreme situations and states of mind. We have had enough of

the wild artist—he has by now been converted into one of the standard self-protective myths of our society: if art is wild it must be irrelevant.[212]

Although Greenberg was hopeful in the case of Pollock, he was less optimistic than Rosenberg. For Greenberg alienation held another danger, because it kept the art work from being seen:

Their isolation is inconceivable, crushing, unbroken, damning. That anyone can produce art on a respectable level in this situation is highly improbable. What can fifty do against a hundred and forty million?[213]

It should be noted that, a few pages after these analyses of American culture and its modest hopes of achieving international status, *Horizon* published a long article by Joe Alsop on American foreign policy, describing and supporting the Marshall Plan's policy of containment.

Greenberg's article, which emphasized the continuation of the modernist tradition in a balanced, antiexpressionistic art, cited Nietzsche in calling for an art that was full of "balance, largeness, precision, enlightenment, contempt for nature in all its particularity."[214] By working toward this end American art would in fact be linking up with European tradition. Hence America was not necessarily as barbarous as the European left suggested. American art was the logical consequence and extension of Parisian art, which had lost its sharp edge. The United States stood ready to pick up the sword. Greenberg repeated the same arguments on March 8 in the *Nation*. He carefully specified what the new modern painting should be like. It must be blasé and detached in order to be controlled and composed, fully developed on the canvas while maintaining the "integrity of the picture plane":

The error consists in pursuing expressiveness and emotional emphasis beyond the coherence of style. It has led Tamayo and the younger French into an academic trap: emotion is not only expressed, it is illustrated. That is, it is denoted, instead of being embodied.[215]

What Greenberg was rejecting was distortion and exaggeration. Expressionist artists (like Picasso and Tamayo) were unable to unify and order their emotions:

This amounts in the last analysis to an attempt to avoid the problems of plastic unity by appealing directly, in a different language from that of painting, to the spectator's susceptibility to literature, which includes stage effects.[216]

Traditionally a sign of academicism, theatrical effects were to be rejected. At the end of the article Greenberg touched on the problem of contemporary painting, which he thought bogged down in the desire to respond in one way or another to daily life:

> In the face of current events painting feels, apparently, that it must be epic poetry, it must be theatre, it must be an atomic bomb, it must be the rights of Man. But the greatest painter of our time, Matisse, preeminently demonstrated the sincerity and penetration that go with the kind of greatness particular to twentieth-century painting by saying that he wanted his art to be an armchair for the tired business man.[217]

For Greenberg, then, painting could not be important unless it returned to the same ivory tower that artists in the previous decade had been so intent on destroying. The "detachment" of modern art had to be recovered. This, however, was a program that would obviously be difficult for artists of this generation, so cruelly integrated into the social fabric, to put into practice.

4
Success:
How New York Stole the
Notion of Modernism from
the Parisians, 1948

> The Man in the Cage. *Again it was Gide who gave us this image when, during the occupation of France by the Germans, he confided to his diary that he "could live happily even in a cage. The secret is to establish oneself equi-distant from the four walls."*
> MILTON HOWARD, MAINSTREAM, WINTER 1947

Nineteen forty-eight began as turbulently as the preceding year. Henry Wallace announced his candidacy for the presidency. The campaign revolved around the issue of the European Recovery Program. Political realignments continued. Liberal disillusionment with President Truman increased. The rightward drift of former radicals accelerated as the volume of Soviet propaganda rose.

Partisan Review, which hitherto had served as a barometer of the political climate among radical intellectuals, underwent a strange mutation. With an influx of new funds early in 1948, a new and much more conservative panel of editors took over the magazine.[1] Among the new editors were Allan Dowling, James Burnham, Lionel Trilling, Sidney Hook, and James Johnson Sweeney. The radicalism that had once been central to the magazine's interests gave way to liberalism. There was also an important shift from critical studies of the artist's alienation (a radical notion connected with society) to studies of neurosis (connected with the individual). Marxism gave way to psychiatry.[2] The individual moved into the place of history and social relations.

The rightward drift was marked in 1952 by a symposium on the theme "Our Country, Our Culture," which commemorated the tragic end of the oppositional vitality that had characterized the magazine. Exhausted by its many battles and no doubt also its many disappointments, and

perhaps, too, done in by internal subversion, *Partisan Review* declared that writers henceforth wished to be integrated into American society as it was. This marked the end of the illusions of the avant-garde, which lost its driving force and raison d'être, namely, its oppositional stance.[3]

Not only at *Partisan Review* but elsewhere as well the deradicalization of the artist continued. The pace even picked up as the political climate worsened. Modern artists seemed unable to make up their minds: they were frozen, suspended midway between art and politics. Once alienated, said William Phillips, man was now "suspended between tradition and revolt, nationalism and internationalism, the aesthetic and the civic, and between belonging and alienation."[4] As the article published by Rosenberg and Motherwell in *Possibilities* illustrates, avant-garde painters and critics supported this assertion. *Tiger's Eye* stressed the total rejection of politics and devoted itself completely to the individual, to art, and to the separation of art from criticism: "A work of art, being a phenomenon of vision, is primarily within itself evident and complete." In 1949 the magazine added that it had "presented art with the viewpoint that it is an aesthetic creation, apart from political or commercial considerations, that arises and is formed by the imaginative disposition of the artist, whether painter or poet."[5]

The separation of art and politics came at an opportune moment, just as politics, or rather the side effects of politics, were beginning to take on a more important and more bewildering and threatening role in the life of each American citizen. It was in fact becoming clear that, despite the admonitions of the administration, Congress and the public were not ready to accept the European aid program as the only way to get European economies moving again while damping down Communist agitation and rebuilding world trade.

To its proponents, the European Recovery Program seemed to be the only way to rebuild a stable world, a world safe for business. Marshall tried to make the public understand this:

Why should the people of the United States accept European burdens in this manner? European economic recovery, we feel sure, is essential to the preservation of basic freedom in the most critical area of the world today. European economic recovery is essential to the return of normal trade and commerce throughout the world.[6]

Marshall's statement shows how important the question was and how much the authorities were worried by the apathy of the public. A Gallup poll conducted in February showed that fifty-six percent of the public viewed the program as one of charity, while eight percent saw it as a

weapon against the Soviets and the remaining thirty-six percent were divided or had no opinion.[7] Ways of correcting these erroneous views were being considered in high places when European events took a turn that helped matters considerably.[8] Just two weeks before the House Foreign Affairs Committee was to consider the European Recovery Program, on February 25, Czechoslovakia went over to the Soviet bloc after the Communists succeeded in outmaneuvering the divided and disorganized democrats.

The Czechoslovak Communist party since the "November crisis" of 1947 had worked hard to divide the Social Democrats and to organize workers and peasants to put pressure on the helpless government of president Edvard Beneš. On February 25, Beneš accepted the resignation of the Social Democratic ministers and appointed a new cabinet hand picked by the Communist Klement Gottwald. As Radomír Luža explains, the Social Democrats were not forced out of the government by the Communists, they walked out of it. The Czechoslovak crisis came to symbolize the aggressive intentions of the Soviet Union, but also the weakness and division of some of the Social Democratic parties in Europe.[9]

A few weeks later it was learned that Finland had entered into a mutual defense pact with Russia. On March 10, Jan Masaryk, the symbol of Czech democracy, was killed in suspicious circumstances. The international situation immediately took a turn for the worse, becoming so grave that Marshall and Truman made it clear in a number of speeches that they considered the Soviet moves to be a threat to world peace.[10] The exacerbation of tensions came at just the right moment, particularly since, as Secretary of State Byrnes pointed out, the Soviet advance might mean victory for the Communists in the impending French and Italian elections. The image of a Red tide engulfing Western Europe was impressed on the national consciousness by a press eager for sensational headlines. The *Washington Times Herald* proclaimed that "Byrnes Sees World Crisis within Five Weeks," while the *New York Times* depicted a "Marshall Stirred by World Crisis."[11]

On March 17, Truman made a long-awaited broadcast speech to the nation in which he lashed out violently at Soviet foreign policy, announced in no uncertain terms that the peace of the world was threatened, and urged Congress to hasten passage of the European Recovery Program in order to thwart the Soviet advance. To drive home his point Truman announced his support for universal military training, which made every American alive to the danger of war. Although many liberals were apparently uneasy with the new rhetoric, it galvanized Congress and the public, which awoke at last from its lethargy. The *New York Times* announced that "Truman Asks Temporary Draft Immediately and Uni-

versal Training as the Price of Peace."[12] This was reinforced by reports
of two speeches delivered in California by Marshall, who compared
Soviet policy with the expansionist policies of the Nazis in 1939.[13]

The army itself showed signs of hysteria: on March 25, the Senate
Armed Services Committee discussed various Department of Defense
plans for increasing the number of troops and mobilizing the reserves.
Once again, the press relayed the news to the public: "Top Military Men
Urge U.S. to Arm to Show We Would Fight for Freedom," read the
headline in the *New York Times*, while the *Times Herald* revealed that
"Russian Subs Prowl West Coast Waters."

Clearly, the climate in which the New York avant-garde developed
was pessimistic, ambiguous, uncertain, and full of disillusionment. It
should not be forgotten, moreover, that the presidential election cam-
paign was already under way, and that Wallace, supported by the Com-
munists, was attempting to maneuver his way through a political
minefield laid down by Truman. It became increasingly dangerous to
have anything to do with communism, and though the dream of the
Popular Front was not yet dead, thanks to the Progressives, it seemed
a long way off indeed.

The atmosphere in Washington was apocalyptic, and the *New York
Times* reported that "the mood of the capital this week is exceedingly
somber. For the moment the sweep of great events seems to overwhelm
the men trying to deal with them. . . . Even the president has mentioned
that awful three letter word, war."[14] The *Washington Post* was even more
straightforward: "The atmosphere in Washington is no longer a postwar
atmosphere. It is to put it bluntly, a prewar atmosphere."[15] The public
did not misread the signs, either: a poll conducted in March by the
National Opinion Research Center indicated that seventy-three percent
of those questioned believed that there would be a world war within
twenty-five years, compared with forty-one percent in 1946.[16] A kind of
collective hysteria had gripped the nation, even though the panic was
not, as Freeland points out, fully justified, since Russia was merely
fortifying the bastion it had been given under the Yalta accords. The
situation was tense but certainly not catastrophic. What interests us in
this state of affairs is the popular reaction to the administration's colorful
rhetoric, the perception of the international situation, or rather the im-
possibility of telling reality from propaganda and political strategem.

March 1948. A crucial moment, for it was then that Greenberg chose
to announce that American art was the foremost in the world. The roots
of this pronouncement go back to January of the same year, when Green-
berg began publishing a series of articles in *Partisan Review* and the
Nation, in which he examined American art and found it fit for service,
though he did not yet pin any medals on its chest. In "Situation at the

Moment," Greenberg repeated the commonplace judgment that American art, like Western art in general, was in crisis, but for the first time he shows a certain optimism:

> One has the impression—but only the impression—that the immediate future of Western art, if it is to have any immediate future, depends on what is done in this country. As dark as the situation still is for us, American painting in its most advanced aspects—that is, American abstract painting—has in the last several years shown here and there a capacity for fresh content that does not seem to be matched either in France or Great Britain.[17]

In general, however, American culture was still opposed to the culture of the avant-garde, and as far as modern art was concerned this, according to Greenberg, was all to the good.

Despite the political and economic advantages to be found in the United States, the time had not yet come for the victory of modern art. But it was only a matter of time: aided by the new supremacy of the United States, and protected against the pitfalls of kitsch, American modern artists were busy creating the long-awaited new art. Despite his perception of alienation as something potentially "damning," Greenberg agreed with Rosenberg and Rothko that it was a necessary condition for ambitious art:

> The situation still opposes itself to the individual artist with an unfriendliness that makes art life in Paris or even London idyllic by comparison. With all our present relative advantages, much more is still required of us in the way of exertion, tenacity, and independence in order to make an important contribution. The American artist has to embrace and content himself, almost, with isolation, if he is to give the most of honesty, seriousness, and ambition to his work. Isolation is, so to speak, the natural condition of high art in America. Yet it is precisely our more intimate and habitual acquaintance with isolation that gives us our advantage at this moment. Isolation, or rather the alienation that is its cause, is the truth—isolation, alienation, naked and revealed unto itself, is the condition under which the true reality of our age is experienced. And the experience of this true reality is indispensable to any ambitious art.[18]

The key to Greenberg's thought is the word "independence," for it was on autonomy that the fate of the avant-garde depended. Independence meant independence of Paris. In these troubled times it was crucial—the need was perhaps even more imperative than during the war— to create a unique form of art, an art that would be strong, international,

and capable of effectively combating totalitarianism, which came from the east and threatened Paris from within as well as without.

Alienation, Greenberg argued, made the American artist the "most modern" of all artists and enabled him to express the modern age. Like Picasso, who worked alone in his studio and developed a modern style based on objects in his immediate vicinity, the American artist, who was cut off and isolated from the decadent culture of the United States and its offshoot, kitsch, and who was in rebellion against his formal and political attitudes of the recent past, but in contact with the modernist code of Parisian painting, concentrated on himself and worked at elaborating bit by bit an art capable of expressing the reality of our time, alienation, in all its facets.

Independence of Paris became the crucial factor. Success had spoiled Parisian art. The Parisian avant-garde was paralyzed by the applause it received and lulled to sleep by the steady drone of praise from a blasé public. It had gone soft from so much pleasure. Like an overripe fruit it needed only the slightest breeze to be dislodged and fall back to earth. Seen in this way, Parisian art seemed effeminate and altogether unsuited to confront the violent dangers in store for Western culture.[19] Virile New York art came to the rescue. The fashionable private shows that were commonplace in Europe did not exist in the United States. Paris was a dream machine. Compared with the decadence of Paris, Pollock's sincerity became a symbol of regeneration, just as David's painting had once, by its simplicity and coarseness, seemed to personify the rising bourgeoisie against the corrupt monarchy.[20] Pollock, with his brutality, revealed the truth and cast artifice aside.

Thus in Greenberg's view New York was the appropriate place for the avant-garde renaissance. At the same time he glimpsed the form that the new painting would take: it would be an intimate diary writ large for no particular audience, the result of the rejection of easel painting in favor of the mural. It would be an art of contradictions, tending toward the dimensions of architecture while remaining profoundly personal:

There is a persistent urge, as persistent as it is largely unconscious, to go beyond the cabinet picture, which is destined to occupy only a spot on the wall, to a kind of picture that, without actually becoming identified with the wall like a mural, would *spread* over it and acknowledge its physical reality. . . . Thus, while the painter's relation to his art has become more private than ever before because of a shrinking appreciation of the public's part, the architectural and, presumably, social location for which he destines his product has become, in inverse ratio, more public. This is the paradox, the contradiction, in the master-current of painting.[21]

The text reads like a notice of Jackson Pollock without naming him.[22] Writing on January 10, Greenberg, for the first time in his career as a critic, declared himself satisfied with the Whitney Museum exhibition:

It shows an enormous improvement over the annuals of the past seven years, and this improvement is apparent even among the routinists of the American scene—especially among the young ones—Pellew, Stern, Scheuch, Thon, Wyeth.[23]

The fact that Greenberg now deigned to speak positively of a group of painters and type of painting that he had ridiculed only a few months earlier shows how eager he was to find signs that heralded a bright future and bolstered his early 1948 dream image of American art.

He took the opportunity in the same article to congratulate Gorky on his work:

Arshile Gorky's large "The Calendars" is the best painting in the exhibition and one of the best pictures ever done by an American. . . . I would hold Gorky the only artist in America to have completely assimilated French art—an assimilation that reveals itself in the fact that, whatever else his painting may be, it is never dim or dull, and never unfeeling in touch or texture. . . . What we have here is a synthesis of a kind rare in modern painting—"mannerist" in the best sense of the term.[24]

Behind the compliment, however, critical claws were hidden. Gorky might well be the American painter best able to assimilate the work of the Paris school, but this only made him a "mannerist in the best sense of the word": put differently, his work was a dead end, a high point beyond which there was only free fall. It was not to Gorky that one should look for the long-awaited renewal. His allegiance to French painting was too clear, and this did not fit in with the new needs of American culture. In this regard Greenberg was content merely to mention how much American art had progressed.

On the whole, American art has reason to congratulate itself on this year's Whitney. It is far from being satisfying and plenty of trash is still present; but something does seem to be fermenting and for once I look forward with curiosity to next year's annual.[25]

As things turned out, he did not have to wait that long.

Nothing shown in New York prepared the way for the conclusions that Greenberg published without warning in March 1948. In "The De-

cline of Cubism," published in *Partisan Review*, the critic declared that American art had broken with Paris once and for all and that it had at last taken on vital importance for Western culture. This profession of faith was based on an analysis of Parisian cubism, which according to Greenberg was on the decline because the forces that had brought it into being had abandoned Paris and emigrated to the United States. The fact that Greenberg chose the month of March to drop this bombshell was not unrelated to political events and to the climate that had prevailed in New York since January.[26]

For the first time in the history of American art, an important critic showed himself to be sufficiently aggressive, confident, and devoted to American art to openly challenge the supremacy of Parisian art and to claim that the art of New York and Jackson Pollock had taken its place on the international art scene. In the war against communism, America now held all the trumps: the atom bomb, a strong economy, a powerful army, and now artistic supremacy, cultural superiority:

> If artists as great as Picasso, Braque, and Léger have declined so grievously, it can only be because the general social premises that used to guarantee their functioning have disappeared in Europe. And when one sees, on the other hand, how much the level of American art has risen in the last five years, with the emergence of new talents so full of energy and content as Arshile Gorky, Jackson Pollock, David Smith— then the conclusion forces itself, much to our own surprise, that the main premises of Western art have at last migrated to the United States, along with the center of gravity of industrial production and political power.[27]

In May of 1948, pressures from the outside world, political pressures, until then mentioned in Greenberg's articles only in veiled references, burst into the limelight in an article entitled "Irrelevance versus Irresponsibility," again published in *Partisan Review*. Remembering his Trotskyist years, Greenberg, under pressure, lashed out violently at communism and Stalinism on behalf of modern art (the article was accompanied by drawings by Gottlieb and Baziotes). The article contained an attack on a piece published by Geoffrey Grigson in the March issue of *Horizon*. Greenberg used this article as a starting point for a harsh attack on the Soviet conception of art, on the Party line as laid down by Vladimir Kemenov in the Soviet magazine *Volks Bulletin*. The Soviets, of course, favored realistic art and rejected modernism. Greenberg did not hide his contempt:

> The truly new horror of our times is not, perhaps, totalitarianism as such, but the vulgarity it is able to install in places of power—the official vulgarity, the certified vulgarity.[28]

Why did an art critic normally as detached from political polemic as Greenberg enter into this dispute? Because the battle against communism promised to be a long and difficult one, and one which for want of traditional weapons would require the full arsenal of propaganda. The war may have been a "cold war" but it was nonetheless a total war. Accordingly, art, too, was called upon to play its part.

This was the message contained in an article by Stephen Spender published in the *New Yorks Times Magazine* on April 25 under the title "We Can Win the Battle for the Mind of Europe," and subtitled "The Europeans, Even Those Behind the Iron Curtain, Can Still Be Swung to Western Culture."[29] As the English poet saw the problem the situation in Europe was far more complex than it seemed in the United States. Indeed, the battle between the United States and the Soviet Union was being fought over the heads of Europeans to determine whether Europe would fall into the American or the Soviet camp. This, according to Spender, made no sense to Europeans, who wished to be Europeanized rather than Sovietized or Americanized. Spender took his distance from the Soviet Union but was critical of some American tactics and offered the United States a bit of advice. An American presence on the continent was indeed necessary, he said, but the United States must not alienate the citizens of Europe. For Spender, Europe's Achilles' heel was its attachment to spiritual freedom. This was where American liberal ideology should aim its shafts if it wished to overcome European resistance:

It is important to remember that there is a cause in which Europeans do not lose passionate interest cutting right across the present political alignment between West and East. This cause is spiritual freedom. It is here that a struggle continues even within the communist parties themselves, it is here that Russia is in the least favorable position; but it is unfortunately here that American points of view are least in evidence. . . . Cultural freedom and the freedom of the individual within an externally influenced political system are among the realest issues in Europe today, when Europeans are prepared to resign themselves to the loss of internal political sovereignty if they can continue to enjoy such freedoms.[30]

American cultural influence might, Spender said, prove crucial. Already, in literature, the influence of Hemingway, Dos Passos, and Faulkner had been felt by French, Russian, and Italian writers. This, wrote Spender, "demonstrates that where American policy finds dubious allies and half-hearted friends, American freedom of expression in its greatest achievements has an authenticity which can win the most vital European thought today."[31] The impact of Spender's article, published as it was

in a mass-circulation national magazine, is easy to imagine. The text went on to offer the following advice:

> For what is realistic today is to expect nothing of propaganda and political bludgeoning, but to take part in showing Europeans the greatest contemporary achievements of American civilization in education and culture. The advertising, propagandist way of doing things always seems the easiest, but it is almost useless in a continent which has been saturated for many years with diabolically clever propaganda from Germany and Russia. Propaganda does not respond to any real needs, but there are real needs which only the West can satisfy: above all the need for education among a generation which has received very little teaching, the need for teachers, books, orchestras.[32]

And, Spender might have added, along with Greenberg, the need for painting.

The absence of painting from the list of weapons in the cultural arsenal reminds us that up to this point the United States lacked the most prestigious of these weapons, the painted canvas. This was the weapon that the avant-garde had been working to forge since 1943 and that Greenberg announced in his 1948 article was now at hand. His article stated clearly what the majority of intellectuals wanted to hear, namely, that America was at last ready to put forward its own "high culture." In other words, America was now on the point of making the transition from colonized nation to colonizer. This is a good time to explain how the transition was made, so that we will be in a position to understand how American art was used and how it ultimately achieved international success.

The transition occurred in two steps: American art moved first from nationalism to internationalism and then from internationalism to universalism. The first important item on the agenda was to get rid of the idea of national art, which was associated with provincial art and with the political and figurative art of the thirties. This kind of art no longer corresponded to reality, much less to the needs of the Cold War. During the first phase of the transition, therefore, American art recognized its international character. In a gesture of egalitarianism, it broke down the barriers separating different national schools and thereby raised itself up to the level of modern art, which prior to World War II had been represented by Paris.

As early as 1940, the Federation of Modern Painters and Sculptors rejected both provincial and social art. "We condemn artistic nationalism," the federation announced, "which negates the world tradition of art at the base of modern movements."[33] The New York avant-garde was

obliged to attack the academies, the public, the critics, and above all tradition. The tradition that mattered to American artists was that of French painting. The key to the avant-garde's strategy was the notion of internationalism, which at the time was associated with the "One World" movement of the postwar period. If "internationalism" was the watchword, then it was misguided to follow the lead of the preeminent school of Paris, as Jackson Pollock hinted:

The idea of an isolated American painting, so popular in this country during the thirties, seems absurd to me, just as the idea of creating a purely American mathematics or physics would seem absurd. . . . The basic problems of contemporary painting are independent of any one country.[34]

Following Pollock, Motherwell declared in 1946 that "art is not national, that to be merely an American or French artist is to be nothing; to fail to overcome one's initial environment is never to reach the human."[35] This, then, was the intellectual setting in which the idea of national schools of painting—in particular the Parisian school—was rejected in favor of a universalist humanism.

Young American artists stirred by the heroic image of America at war against fascism and emboldened by the economic boom and by the presence of European artists in the United States could envision at last a place for their art on the international scene and a standard of painting equal to that of Paris. They needed a unique image and new blood so that they might identify with the soldiers shipped off to Europe to defend civilization against barbarism. They were aesthetic soldiers who stayed home in order to fight for the same cause on the cultural front.

The situation was somewhat paradoxical. In order to be international and to distinguish their work from work done in the Parisian tradition and forge a viable new aesthetic, the younger painters were forced to emphasize the specfically American character of their work. We see signs of this in the art histories written in 1943 by Kootz and Janis:

Davis' style is one of the most American expressions we have. It has an American intensity, aggression and positiveness that is thoroughly symbolical of the spirit of our most imaginative social, political and economical leaders. It is healthy and constructive.[36]

To Greenberg, Pollock was the perfect representative of American art. Writing in *Horizon* in 1947, the critic had this to say:

His name is Jackson Pollock, and if the aspect of his art is not as originally and uniquely local as that of Graves' and Tobey's, the feeling

it contains is perhaps even more radically American. Faulkner and Melville can be called in as witness to the nativeness of such violence, exasperation and stridency.[37]

This was logically followed by disparagement of Parisian painting in the name of new standards of quality, "purely American" standards of violence, force, greatness, spontaneity, and nonfiniteness.

Imitating Barnett Newman and Mark Rothko, who had rejected, at least in theory, European teaching, Clement Greenberg had attacked painters like Holty and Gorky for being overly subservient to Paris. He developed this line of argument in a 1947 *Nation* article in which he compared Dubuffet to Pollock, an article in which an authoritarian tone took the place of serious and careful analysis of the works discussed, only the formal aspects of which were treated. Pollock, Greenberg maintained, was more interesting than Dubuffet because he was more rugged, violent, and brutal:

Pollock, like Dubuffet, tends to handle his canvas with an over-all evenness; but at this moment he seems capable of more variety than the French artist, and able to work with riskier elements. . . . Dubuffet's sophistication enables him to "package" his canvases more skilfully and pleasingly and achieve greater instantaneous unity, but Pollock, I feel, has more to say in the end and is, fundamentally, and almost because he lacks equal charm, the more original. Pollock has gone beyond the stage where he needs to make his poetry explicit in ideographs.[38]

If Pollock had more to say, Greenberg does not tell us what it was he may have been saying. Instead, he emphasized the characteristics of Pollock's work that he regarded as specifically American. Brutality, crudeness, virility—these were crucial elements in such uncertain times, more impressive than Parisian charm. What the Western world needed was a powerful and vigorous art:

[Pollock] is American and rougher and more brutal, but he is also completer. In any case he is certainly less conservative, less of an easel painter in the traditional sense than Dubuffet.[39]

This distinction between the School of Paris and the New York painters was, as we mentioned earlier, fundamental. By 1950 it had become the war horse of an entire generation, but it was still a difficult notion to manipulate. During a symposium held at Studio 35, for example, much of the discussion revolved in a confused way around the idea of "finish." It was said that in Paris paintings were finished, but not in New York. In that case how was it possible to tell when a New York painting was

complete? The problem was to tell when a painting was "done" without looking "finished." Motherwell explained the American position:

I dislike a picture that is too suave or too skilfully done. But contrary-wise, I also dislike a picture that looks too inept or blundering. I noticed in looking at the Carré exhibition of young French painters who are supposed to be close to this group, that in "finishing" a picture they assume traditional criteria to a much greater degree than we do. They have a real "finish" in that the picture is a real object, a beautifully made object. We are involved in "process" and what is a "finished" object is not so certain.[40]

Gottlieb interrupted the interminable debate to explain how he knew when one of his paintings was finished:

I usually ask my wife. . . . I think a more interesting question would be, "Why does anyone start a painting instead of finishing it?"[41]

He pursued another line of thought, central to the debate, which had to do with tradition and with the anti-Parisian reaction of the avant-garde:

There is a general assumption that European—specifically French—painters have a heritage which enables them to have the benefits of tradition, and therefore they can produce a certain type of painting. It seems to me that in the last fifty years the whole meaning of painting has been made international. I think Americans share that heritage just as much, and that if they deviate from tradition it is just as difficult for an American as for a Frenchman. . . . I think we have this famil-iarity, and if we depart from tradition, it is out of knowledge, not innocence.[42]

American art was described as the logical culmination of a long-stand-ing and inexorable tendency toward abstraction. Once American culture was raised to the status of an international model, the significance of what was specifically American had to change: what had been charac-teristically American now became representative of "Western culture" as a whole. In this way American art was transformed from regional to international art and then to universal art. French "taste" and "finish" gave way to American "force" and "violence" as universal cultural val-ues: "Pollock is one of the most important painters of our age."[43] In this respect, postwar American culture was placed on the same footing as American economic and military strength: in other words, it was made responsible for the survival of democratic liberties in the "free" world. The differentiation of French from American art became crucial for the

Western avant-garde, its absolute standard. With this in mind it is not hard to understand why certain American painters, who until 1948 had stood for all that was most advanced in American art, were now swept aside, not because their work was of inferior quality but because it was too closely related to the work of the Paris school.

With Greenberg's assistance, an authoritarian strain began to emerge in the avant-garde at this time. Beyond Seliger's failure to impose his brand of surrealism, a typical example of this authoritarianism is the Kootz Gallery's rejection of three of its artists, Carl Holty, Romare Bearden, and Byron Browne, when it reopened in 1949. The first group show after the reopening defined what the avant-garde was and spelled out the signs by which its work could be recognized:

> The intrasubjective artist invents from personal experience, creates from an internal world rather than an external one. He makes no attempt to chronicle the American scene, exploit momentary political struggles, or stimulate nostalgia through familiar objects. He deals, instead, with inward emotions and experiences. . . . Intrasubjectivism is a point of view in painting rather than an identical painting style.[44]

While selling Picassos to big collectors throughout the 1948–49 season, Kootz had ample leisure to reflect that it had become both desirable and possible to define a typically American art (as suggested by Greenberg's articles). It was at this moment that Bearden, Holty, and Browne unwittingly put themselves out of the running because their work remained too close to what had been done in Paris (figs. 18–19).

Though surprising to many people in the art community, the rejection of these three famous artists from the best avant-garde gallery was nevertheless read as a signal: after 1948, to be an ambitious painter meant to be an "abstract expressionist." The style became tyrannical. The elegant cubist painter and excellent modernist Byron Browne was therefore committing "suicide" by defending Parisian modernism. A great admirer of Picasso, Browne reiterated in 1952 the principles that had guided his life as an artist:

> I have always been interested in the mainstream of the classical direction in painting that began with Ingres, continued into Cézanne, and was brought up to our times by the so-called "cubist." It is the art of deliberation and meditation . . . rather than an art of swift expression.[45]

Browne later expressed his bitterness over the final victory of his former colleagues from the Kootz Gallery:

I like that kind of art best which shows the consideration of planes and the integration of planes, the movement of planes and the integration of planes. That, for me, is true painting. I do not care for the over-emphasis on texture through dribbling, smudging, etc., which constitutes so much of the half-realized type of picture that so many artists do today.[46]

An admirer of Picasso and Ingres and a follower of Gorky and Graham, Browne had no place in the new American art, which was intended to be independent of Paris, without roots, and free.

By 1946 there was considerable tension within the Kootz Gallery between painters working in the European tradition and younger painters like Motherwell, to judge by the correspondence between Carl Holty and Hilaire Hiler. Complaining about his shows' lack of success, Holty wrote:

I am having the same experience now in the gallery. I don't believe that I exaggerate if I say that there is no comparison whatsoever between my work and that of all the other artists exhibiting there. As a matter of fact, given the commission and the stomach for it, I could do all their work alongside of mine too. I will guarantee you that I could produce Mr. Motherwell's annual opus within three weeks and in a dimly lighted room besides. All this doesn't alter the fact that Mr. Motherwell, Mr. Baziotes, and Mr. Bearden (a nice young colored chap) sell three to my one consistently.[47]

Unfortunately for Holty, rapidity and lack of "finish" were to be the distinctive features of the new art. For the rejected artists, accomplished craftsmen of established reputation, what happened was hard to understand. Even harder to take was the way Kootz humiliated Browne and Holty in 1951 by "dumping" their paintings as a symbol of the death of a genre.

While Browne ceased "to exist," the avant-garde organized the Ninth Street Show to symbolize the victory of the "Club."[48] Also symbolic was the manner in which the sale of out-of-favor works was conducted. One sale was held in Gimbel's department store.[49] Canvases were stacked against the walls and sold at a fifty percent discount (322 works in all, including 100 oil paintings). The signal was clear: the bottom had fallen out of the market for a certain kind of painting, painting that did not correspond to the American image of the avant-garde, as defined by Greenberg and represented by the "Club." The sale touched off panic selling in shares of Browne and Holty, as collectors who saw these artists disgraced hastened to sell of their works to other galleries. Byron Browne never fully recovered from the shock. He suffered a heart attack on February 19, 1952.

The consequences of the avant-garde's new prominence were complex. An animosity against modernism unheard of since the halcyon days of Parisian cubism reared its head. Paradoxically this animosity was one key to the avant-garde's victory. If, as Greenberg maintained, only the avant-garde could save art from mass mediocrity, then it would have to play a dialectical game on two different chessboards. In order to win on the international board, it would first have to defeat its domestic opposition, traditional art and the neophyte public. The strength of the avant-garde position was proportional to the strength of the reaction against it: a violent reaction by a part of the middle class worked in favor of the avant-garde, which used this opposition to promote its works in more "enlightened" sectors of the bourgeoisie. As we noted earlier, the new middle class that emerged triumphant from the war was, unlike the Parisian bourgeoisie, not blasé and was still easily shocked, quite capable of reacting vehemently to the new art.

To those in the know, however, it was clear that the avant-garde had won. Not only was it well organized, but its victory had been celebrated in the pages of the *Nation*. Among the early signs of triumph were the showing of works by de Kooning, Pollock, and Gorky at the biennial Venice show, increasing sales at Betty Parsons Gallery, and above all the award of coveted prizes to members of the avant-garde.[50] The one-thousand dollar Campana Prize of the Chicago Art Institute was awarded to Baziotes in November for his painting *Cyclops*. This brought recognition and prestige to the avant-garde and triggered a fierce reaction from the "establishment," which ranged from traditionalist critics to liberals who favored a moderate version of modernism tinged with a bit of Picasso. At every opportunity the new abstract painting was attacked as incoherent and simplistic. Typical of this kind of reaction was the following comment by Peyton Boswell, which appeared in *Art Digest* of November 15, 1947:

> The rich Campana prize, $1000, perhaps through compromise or default, went to *Cyclops* by William Baziotes, a picture bilious in color, sloppy in craftsmanship and ignorant in design.[51]

As though in approval of the protests from Boswell and others in the press, Boston's Institute of Modern Art announced on February 16 that it was changing the "modern" in its name to "contemporary" as a sign of dissatisfaction with the hermeticism of recent avant-garde work. The spokesman for the Boston institute rehearsed Jewell's argument of 1943 to criticize the position of the Museum of Modern Art. Modern art, he said, was "a cult of bewilderment that rested on the hazardous foundations of obscurity and negation, and utilized a private, often secret, language which required the aid of an interpreter."[52] Emily Genauer, the

critic for the *World Telegram*, applauded this decision, to the great disappointment of the avant-garde: "This is the first victory," she wrote, "in the fight against irresponsibility in art."[53] *Life* also entered the fray with a small article that made fun of works by Paul Burlin, William Baziotes, and George L. K. Morris, which ran in an issue that devoted several pages to color reproductions of works typical of the sort of painting favored by the conservative middle class. The magazine attempted to use the episode to promote the victory of a national art rooted in the realistic or romantic traditions.

Seeing a chance to regroup, the modern artists, aided by the Museum of Modern Art, which saw a threat to its authority, wasted no time in formulating a reply. A forum was held at the museum on March 5, 1948, in response to the press attacks: "The Modern Artist Speaks" was its announced title. Among the five papers presented was one by Burlin, for whom modern art was a symbol of freedom. His argument was similar to Peggy Guggenheim's in 1944, when she defended modernism against the reductionist culture of fascism. The middle-class attack was more serious this time, since it came from within; it permeated the social fabric, had soaked into its fibers. The antimodernist attitude seemed to lurk in the mind of every American. Thus all the speakers tried to argue that modern art was identical with individual creation and in harmony with liberal American values. The artists, the speakers claimed, were defending values similar to those held dear by the middle class:

> Modern painting is the bulwark of the individual creative expression, aloof from the political left and its blood brother, the right. Their common dictators, if effective, would destroy the artist. And as we have witnessed today, he would be the servile creature accepting on bended knee the accolade of the dictator.[54]

Burlin also claimed that modern artists accepted the separation between art and politics. The artist was supposed to be and in fact was a pure individualist confronting a complex and dangerous world.

> The modern artist is aware of the speculative thoughts of man, for this is not the age of tranquility. Titillating, kiss-mummy pictures are no longer acceptable. The prissy decor of the mantelpiece is finished.[55]

He then issued an appeal to liberals to enter into a much-wanted alliance with modern artists:

> Would it be too much to hope that what we are witnessing tonight with this forum could be the germ of a permanent idea for a unity of

liberal forces where the modern artist might find his home—a home that would be a clearing house of cultural ideas.[56]

Stuart Davis believed that the association, or at least the close connection, of art with politics was clear. Opposition to modern art signified censorship and cultural terrorism and was identified with the House Unamerican Activities Committee. The statement issued by the Boston institute was intended, Davis said,

> to find ways and means to censor the artist, freedom of expression. In this way they have affinity with the Un-American Committee and the Moscow art purges, which from different motives seek to control creative ideas for ulterior purposes.[57]

Once again the political use of art was evoked, and the specter was said to be all the more dangerous because the people waging the campaign against modern art did not realize the seriousness of their de facto alliance with Moscow. Moscow had by this time replaced Berlin as the favored target:

> I do not impute political motives to these recent attackers in any sense, but their campaign lends support to all attacks against the artist's integrity. In fact, their arguments are identical in substance with those used against the artists by Moscow.[58]

Recall that the same argument had been used by Greenberg in "Irrelevance versus Irresponsibility," published that very same month. If the whole episode was useful for having triggered a debate over the role of criticism (about which there was growing confusion, as Loucheim has shown),[59] it resolved nothing, unless it was to mark more clearly than before the boundary between the two camps.

In an article published in *Commonweal* on October 7, 1949, Jerome Mellquist analyzed the art scene in terms of both artistic and political tendencies. What had hardly been veiled in the verbal battles of 1948 emerged even more clearly in 1949 after the administration came out of the elections stronger than ever, able to take a longer-range view of the future and ready to throw itself fully into the ideological and cultural struggle with the Soviet Union. Mellquist pointed out that liberals were rejecting isolationist art, linked to an old image of America, in favor of a new image, which, though specifically American, had ties to international art. They were doing so, he said, in the name of modernity and on account of the role that history had bestowed upon the United States. Caught up in the Cold War, America must not refuse to fight or withdraw proudly into itself as some right-wingers advocated. Rather, it must

embrace the opportunity that was being offered. The primary goal of the United States should be to take the lead on the international scene. Those who refused to accept this challenge were swimming against the tide of history:

These new isolationists are too sleek and skillful to promote any flag-waving expeditions, yet they would have us retire from the living currents nevertheless. They stick, as a matter of fact, to academic generalities, and their tone and above all their traditional allegiances show clearly enough that they would segregate us from the challenge of the hour.[60]

This was a challenge that must be met. Going back was out of the question:

Western art then once again surpassed local limitations. Bracing currents already have started to bear us beyond the stagnant drifts and eddies of the New Isolationists toward a better international prospect. Is it too much to hope that these also are the currents that will dominate the political period to come? If so the belated Arcadians are doubly men of the past and no less dead than their counterparts, the back-country isolationists in politics.[61]

In the new political situation that accompanied the Cold War, America was coming more and more to be seen as the symbol of Western culture. Henry Luce's dream seemed to be coming true. In the final analysis, what the art of this period was supposed to articulate was a style associated with the modernist tradition (as defined by Greenberg) allied with an art that responded to the modern anxieties emphasized by Rosenberg and Newman.

As late as early 1948 most art critics still favored a moderate form of modern art influenced by Paris, in spite of the progress the avant-garde had made in winning over museums and private collectors. In that year Emily Genauer published a book, *Best of Art*, which selected favorite works from among 50,000 paintings surveyed in art shows and openings. Not one work by any of the "extremists" (Rothko, Pollock, Newman) was chosen, even though the critic knew them personally. Works by such traditional artists as Guston, Evergood, Davis, Rattner, Burlin, and Prestoppino, to name a few, were selected instead.

The value of this book lies in the fact that it was the last-ditch effort to stop the rising tide of abstract expressionism. It features an apologia for eclecticism and represents an all-out reaction, a willful blindness to the growing power of abstraction. Whereas Greenberg in 1947 was describing the increasing importance of abstract painting, Genauer saw

only what she wanted to see. Averting her eyes, she could make out nothing on the horizon but a pessimistic humanism, a well-balanced art wholly in keeping with the sensibility of the New Deal era which was by now completely outmoded. She dismissed the new abstract painters with irritation:

> The major part of it, however, was the work of young artists—students still, in many cases—who have opportunistically chosen to paint in a bold and dramatic idiom which more quickly draws attention to them in a highly competitive field than more reticent styles.[62]

In a similar tone she also rejected the "chauvinist, isolationist, provincial" regionalist movement.

During the course of the year 1948 the situation in New York became clearer. Things began to settle down so that it became possible to see what the contending forces were. In painting as in politics the spectrum of possibilities was still broad. But by the end of 1948 a battle was shaping up between the middle class and an aggressive, internationalist, liberal elite. By 1949, after the Democratic victory in the 1948 elections and the announcement of the Fair Deal and the Four Point Program and the publication of Schlesinger's *The Vital Center*, traditional liberal democratic pluralism was on its way out.

Defeat removed Henry Wallace from the political scene. The Communist party collapsed and during certain periods was declared illegal. Victorious liberalism, reworked by the ideologue Schlesinger, barricaded itself behind a wall of fierce anticommunism and emphasized the theme of liberty in its rhetoric. Similarly, in art, eclecticism was rejected in favor of an art that was powerful, abstract, modernist, and American.

By comparing middle-class publications such as *Life, Look,* and the *New York Times* with an avant-garde magazine, *Partisan Review*, we can analyze how avant-garde art was received by the American public, and this in turn will enable us to understand the symbolic significance of modern art in attempts to propagate American culture during the postwar years. As we saw in chapter 2, a group of enlightened liberals began to take an interest in avant-garde art after the war in order to distinguish itself from other groups within the society. In this it was aided by the increasingly clamorous opposition of the middle class to modern art, an opposition that poured its vitriol into the pages of *Life* magazine.

Rather than multiply examples of published articles that took the opposite position and favored avant-garde art, I prefer to turn to *Partisan Review* for a typical example of the appeal addressed to intellectuals and to the enlightened left wing of the bourgeoisie. The example I have in

mind consists of a series of advertisements printed on the inside cover
of the magazine. Engravings by Pollock and Gottlieb typified the work
of the avant-garde and served to attract interested readers to the accom-
panying text.

The advertising was paid for by County Homes of Tarrytown, New
York (fig. 20).[63] The text was directed at wealthy, modern-minded clients
interested in luxury living and hence in the work of the avant-garde, in
what was unusual and out of the ordinary. The avant-garde was used
in this case as a marketing asset, a mark of difference. In the eyes of
the public and the company that paid for the ads, the unusual stood for
escape, for access to a higher rung of the social hierarchy. For example,
the Pollock engraving became identified with the social position of the
people for whom the homes being advertised were intended. These were
exclusive homes for those who sought to dissociate themselves from the
mass of "housing developments" (a part of an ambitious, if not always
effective program designed by the Truman administration) then bur-
geoning in the suburbs to accommodate the new growing middle class.[64]

The advertising in *Partisan Review* was therefore aimed at wealthy
prospective buyers who did not wish to be included in the middle-class
"masses." This fate could be avoided if they bought a Pollock and a
piece of the life-style of a nineteenth-century bourgeois. They could then
share with other selected buyers some of the luxury of a by-gone aris-
tocratic way of life:

RIGHT NOW we are putting nine large estates, ghosts of a past era,
back into use—dividing them into sites of more reasonable size but
avoiding, like a plague, the too-familiar horrors suggested by the word
"development." We are preserving the individuality, the magnificent
natural landscaping, and the privacy the original owners enjoyed. We
want you to see this work.[65]

The profile of the client this advertising aimed at goes like this: well
off, active, jealous of his individuality (signified by the avant-garde paint-
ing), bold and modern, keen on the "unusual" ("The unusual, however,
is our business," reads the text),[66] and unafraid of controversy, indeed
eager to make use of controversy as a badge of distinction. Avant-garde
painting here becomes synonymous with modern housing and a so-
phisticated way of life.[67]

By contrast, the resident of the new suburbs found in the pages of
Life the opportunity to laugh at Pollock's expense and to rage against
his art. The famous 1949 article ridiculed him, all right, but it also
gave him tremendous publicity. Betty Parsons was able to sell nearly
all the Pollocks she showed at the end of that year. *Life* introduced
Pollock in the usual way: fraud or genius? Particular prominence was

given to his "dripping" technique as well as to the anti-art side of his work:

Sometimes he dribbles the paint on with a brush. Sometimes he scrawls it on with a stick, scoops it with a trowel or even pours it on straight out of the can. In with it all he mixes sand, broken glass, nails, screws or other foreign matter lying around. Cigaret ashes and an occasional dead bee sometimes get in the picture inadvertently.[68]

The description consecrated Pollock's position as the most advanced and most controversial of painters. This was success, particularly since the article also mentioned that his work had been bought by several American museums. The article heaped ridicule on Pollock but also expressed utter consternation. How, the public wanted to know, could the Museum of Modern Art show a dead bee stuck to canvas and mixed in with sand, nails, and screws, without losing its credibility?

By 1948, thanks to a panel discussion on modern art organized by *Life* magazine, Pollock and Greenberg became the focus of public attention. The magazine published an article on the panel: "Fifteen Distinguished Critics and Connoisseurs Undertake to Clarify the Strange Art of To-day."[69] The specialists agreed on the value of works by Picasso and Miró but got into violent arguments over the quality and correctness of works by the young American "extremists." Greenberg, who had always insisted on the violent and virile content of Pollock's work as a key ingredient for distinguishing New York painting from Parisian painting, was rather astonished to hear European specialists refer to *Cathedral* as an agreeable and "pretty" painting:

Pollock's Cathedral was championed by Mr. Greenberg who thought it a first class example of Pollock's work, and one of the best paintings recently produced in this country. Mr. Duthui said, "I find it quite lovely. It is new to me. I would never think of Beethoven, rather of a contemporary composer playing on his sensations." Sir Leigh Ashton said, "It seems to me exquisite in tone and quality. It would make a most enchanting printed silk. But I cannot see why it is called the Cathedral. It is exquisitely painted and the color is ravishing, but I do not think it has structural design." Mr. Taylor found it "very lovely."[70]

Having demonstrated the confusion of the critics in the face of these contemporary works, *Life* insisted that it was hard to take such work seriously and answered the original question under discussion in the negative:

Is modern art, considered as a whole, a good or a bad development? That is to say, is it something that responsible people can support or may they neglect it as a minor and impermanent phase of culture?[71]

The extremist branch of American modern art, the dripping school, was now a subject of scandal. Hence it was a winner. As Bernard Harper Friedman has shown, Pollock became one commodity among others: Pollock paintings took their place alongside Bendix automatic washers, Ritz crackers, and Pall Mall cigarettes.[72]

In the August 1948 issue of *Partisan Review*, Greenberg and Leslie Fiedler described the literary avant-garde, which in many ways resembled the painting avant-garde, as a bearer of hope and an important cultural asset for the atomic age and its dangers. Fiedler emphasized the importance of the individual, his aloofness, his independence of ideology, and his new vocabulary of "freedom, responsibility, and guilt."[73] He attacked writers such as James T. Farrell, the proletarian novel of the thirties, and the omnipotence of the "subject-matter." Fiedler's article is interesting for its analysis of the road traveled since the Depression, when, in order to be "modern" and up-to-the-minute, artists had to be Marxists. But when writers saw that the works that came out of this school left "art" in an abject position, they abandoned it, though not without anguish and uneasiness over the break. Their anxiety and guilt were social. But under the present circumstances the divorce between art and politics was in itself a kind of action (this was hardly a new ideology):

> But the absolute claim to freedom in the creative act, in *going on writing* as we understand it, challenges many political systems and is challenged by them, most spectacularly these days by the Soviet Communist world-view. An honest devotion to writing *hypothetically* (is it a giant or a windmill?) attacks Stalinism, tests its pretensions and our own analysis at once. What cannot endure the practice of the most human of activities is the Enemy.[74]

Just as Guggenheim had argued in 1944, when the world was fighting fascism, that merely to do modern painting was to take political action against Hitler, so now in 1948 Fiedler argued that modern artistic expression served to defy communism. In the same article Greenberg complained that the literary avant-garde was too well accepted.[75] He therefore had more faith in the painting avant-garde, which, owing to its long tradition of isolation, was capable of arousing greater hostility. But the

avant-garde was in danger, Greenberg said, because it was constantly under attack from two sides:

> On the one side it is faced with political crisis, on the other hand with the increasing aggressiveness and the expansion of middlebrow culture.[76]

In fact, the avant-garde had to stay close to the center, precariously balanced on a razor's edge, if it wanted to survive. This was what gave it its vitality, creative tension, and quality and what made certain things clear to artists. But all this was a myth, as we have seen: success and recognition would have been impossible for the avant-garde to achieve had the "avant-garde code" not been accepted. In other words, this code must in some ways have contained values that corresponded to the dominant ideology. Thus it was clear to Greenberg, for example, that in order to save "high culture" artists must be fiercely anti-Communist:

> As a person the writer ought indeed to involve himself in the struggle against Stalinism to the "point of commitment." Why should we ask less of him than of any other adult interested in the survival of the common decencies and authentic culture? However, he is under no moral or aesthetic obligation whatsoever to involve himself in this struggle as a writer. That he is interested in the struggle as a person does not mean that he is necessarily interested in it *qua* writer. *Qua* writer he is only interested necessarily in what he can write about successfully. I do not mean, however, that the writer does not invest his whole personality in his writing. What I do mean is that his whole personality may not be invested in his interest in the struggle against Stalinism, or, for that matter, in any sort of politics. It must be obvious to anyone that the volume and social weight of middlebrow culture, borne along as it has been by the great recent increase of the American middle class, have multiplied at least tenfold in the past three decades.[77]

In the second part of his article, Greenberg explained why "high culture" was imperiled by the "increase of the middle class" and its impact on all areas of social life. The middle class threatened art and yet was its only hope, for "high culture" exists, Greenberg argued, only when the middle class is powerful. The avant-garde was "culture with a difference": the growth of the middle class tended to diminish differences while making their perpetuation crucial for the survival of "culture."

The same concern and the same hope shine through in a talk given by René d'Harnoncourt to the annual meeting of the American Federation of Arts in May of 1948 and published in *Art News* in November of

that year under the title "Challenge and Promise: Modern Art and So-
ciety." Harnoncourt's analysis focused on the notion of individuality.
Choosing his words carefully, he tried to explain why there was no
collective art in keeping with the temper of the times. Individual freedom
of expression, independent of all other considerations, was the basis of
our culture and, Harnoncourt maintained, must be protected and en-
couraged in opposition to alien collectivist and authoritarian cultures:

Freed from the restriction of collective style, the artist discovered he
could create a style in the image of his own personality. The art of the
twentieth century has no collective style, not because it has divorced
itself from contemporary society but because it is part of it. And here
we are with our hard-earned new freedom. Walls are crumbling all
around us and we are terrified by the endless vistas and the respon-
sibility of an infinite choice. It is this terror of the new freedom which
removed the familiar signposts from the roads that makes many of us
wish to turn the clock back and recover the security of yesterday's
dogma. The totalitarian state established in the image of the dogmatic
orders of the past is one reflection of this terror of the new freedom.[78]

For Harnoncourt, the way to solve the problem of alienation was to
establish an abstract fit between society and the individual:

[The problem of alienation] can be solved only by an order which
reconciles the freedom of the individual with the welfare of society
and replaces yesterday's image of one unified civilization by a pattern
in which many elements, while retaining their own individual qual-
ities, join to form a new entity. . . . The perfecting of this new order
would unquestionably tax our abilities to the very limit, but would
give us a society enriched beyond belief by the full development of
the individual for the sake of the whole. I believe a good name for
such a society is democracy, and I also believe that modern art in its
infinite variety and ceaseless exploration is its foremost symbol.[79]

What we have here is perhaps the first reconciliation of avant-garde
ideology with the ideology of postwar liberalism, the reconciliation of
the ideology of individuality, risk, and the new frontier as forged by
Rothko and Newman, Greenberg and Rosenberg, with the advanced
liberal ideology set forth by Schlesinger in *The Vital Center: the politics
of freedom.*

In order to gain a better understanding of the relations between avant-
garde art and the sophisticated ideology of the Cold War, we must now
turn, therefore, to an examination of what Schlesinger had to say on
the subject of the new liberalism that developed in the wake of the
liberal victory in the November 1948 elections and the defeat of Wallace

and the Communists. Schlesinger's book serves as a key that will enable us to distinguish between the various kinds of "liberalism" on the scene in 1949. The accentuation of anti-Communist attitudes must also be kept in mind. Once we have discussed all of this, we shall be in a position to explain how the work of avant-garde painters came to be accepted and used, without their being aware of it, to represent liberal American values, first at home, in the museums, and then abroad at the biennial Venice show and, in 1951, as anti-Soviet propaganda in Berlin. In short, the question is how an art that saw itself as stubbornly apolitical came to be used as a powerful political instrument. And the short answer is that in 1951 art could be politicized only if it was apolitical.

The events of 1948, particularly the crushing defeat of Wallace's Progressive party and the Communists, destroyed the last vestiges of the Popular Front idea. The old alliance gave way to a (not always very unified) coalition of liberals around what Truman was to call the "Fair Deal" and what Schlesinger called the "vital center": the new liberalism, powerfully situated midway between fascism and communism (fig. 21). The triumph of the vital center did not mean that liberal policies were adopted in toto but rather that a new political climate developed around the rejection of communism. The Americans for Democratic Action, though not formally a part of the Democratic party, became the linchpin of its politics. The new liberals agreed in rejecting communism but in their rightward drift were divided on most other issues. Some were aggressively anti-Communist while others were merely non-Communist. This split is important for understanding the way liberals reacted to political developments and why they looked askance on dissidence of any kind.

In his inaugural address Truman attempted to depict himself as following in Roosevelt's footsteps, in order to win support from liberals on his left who still had doubts about his past performance. But at the same time he wanted to manifest his own personal touch and so unveiled a program that he dubbed "The Fair Deal." This was a polished version of an ideology that had formed over the course of the postwar period: it was a conservative version of the New Deal shaped to fit the analysis set forth in *The Vital Center*.[80] Truman's speech outlined a new offensive against Russia. The president stated, in four points, his agenda for strengthening Western influence in Europe. The Marshall Plan was still the centerpiece of American foreign policy, but it was now to be supplemented by a North Atlantic treaty, shifting the primary focus from economic aid to military aid. Military aid was seen as necessary for the continuation and development of the initial program. Most ambitious and for many most worrisome of all was the fourth point, which attracted the most attention:

A bold new program for making the benefits of our scientific advances and industrial progress available for the improvement and growth of underdeveloped areas.[81]

"By raising living standards," Alonzo L. Hamby explains, "the program would advance freedom and establish America's moral leadership."[82] Though there were some negative reactions to the speech from the non-Communist liberal left (Freda Kirchwey, for example, called the speech a second declaration of Cold War, for beneath its humanitarian phraseology she divined the mailed fist of imperialism), in general the liberal community rallied in support of the president. The *New York Post* went anti-Communist and rejected articles by Progressive writers.[83] The *New Republic*, which had been aligned with Wallace, changed course and allied itself with the Americans for Democratic Action. Max Ascoli founded *Reporter*, a liberal anti-Communist paper.[84]

All this shows how representative *The Vital Center* was of liberalism in 1949. Whereas early forties liberalism was tinged with left-wing philosophy, now liberal attitudes veered toward the right. *The Vital Center* repudiated all totalitarian systems and defended individual liberties while recommending a small dose of mixed economy. But its central thesis ran counter to the New Deal's distrust of large monopolies. The business world was now seen as a constructive force, as in "Saving American Capitalism," a study done in 1948 at the behest of the new liberals. Economic expansion had made it unnecessary for the Fair Deal to concern itself with reapportioning the slices of the economic pie. The aim now was to make the whole pie bigger, so that everyone could enjoy larger shares. This was a return to the traditional economic policy of the pre–New Deal era.

The "vital center" was itself sharply divided between non-Communists, who worried that administration rhetoric was too violent, and others who believed that the Soviet Union was bent on aggression and understood nothing but force. All agreed, however, that the stakes in the ideological battle were enormous and that hostilities were likely on many fronts, including culture as well as politics.

Liberals saw themselves as equally hostile to fascism and communism, both totalitarian systems that sought to destroy freedom. Freedom, moreover, was thought to be inextricably intertwined with individualism. The concept of freedom is the central thread of Schlesinger's book, which ends with a chapter entitled "Freedom: A Fighting Faith." Schlesinger wrote that "the essential strength of democracy as against totalitarianism lies in its startling insight into the value of the individual."[85] The book makes fun of the naive and simplistic analyses on which the left had relied in the thirties. It sees man in the context of an industrial environment, beset by existential anguish. Anxiety (solitude, alienation)

was in fact quite fashionable after the war. It provided a central theme for avant-garde painting. Schlesinger even attempts to show that without anxiety, freedom is impossible:

The final triumph of totalitarianism has been the creation of man without anxiety—of "totalitarian man." Totalitarianism sets out to liquidate the tragic insights which gave man a sense of his limitations. In their place it has spawned a new man, ruthless, determined, extroverted, free from doubts or humility, capable of infallibility, and on the higher echelons of the party, infallible. Against totalitarian certitude, free society can only offer modern man devoured by alienation and fallibility.[86]

Isolation, passivity, a wait-and-see attitude were no longer possible, and Schlesinger, who considered the Truman Doctrine and the Marshall Plan to be complementary, looked forward to an activist liberalism. The United States developed a cultural program that was geared to Europe and that emphasized the intellectual potential of America. Art accordingly became a key element of American foreign policy.

As early as 1945 a major cultural program had been launched as a clever apologia for the "American way of life":

Congressman John Davis Lodge said that the program should seek vigorously to advance American foreign policy. The American point of view should be presented with dynamic enthusiasm, passionate conviction, and a burning faith in the American way of life. Was not propaganda, therefore, essential, although it should be more subtle and adroit than that of the totalitarian communists?[87]

In 1946 and 1947 certain members of Congress traveled to Europe and came back quite surprised by their reception and by the bad press the United States received overseas. To counter what American observers took to be the results of an adroit Communist propaganda campaign, the Senate passed the Smith-Mundt Act in January 1948, reorganizing and expanding the Information and Cultural Program. The act directed attention to the problem of presenting a clear and accurate image of the United States: "If other people understood us, they would like us, and if they liked us, they would do what we wanted them to do."[88]

Encouraged by Truman, who launched his "Campaign of Truth" in April 1950, twelve senators, in March, proposed a resolution calling for "a world-wide Marshall plan in the field of ideas." The year 1950 saw the intensification of the Cold War under the effects of the first Soviet atomic bomb, the fall of the Chinese Nationalists, and increased domestic pressure against the Communist party. The propaganda and ideological war heated up, and the merger of two previously separate agencies

responsible for cultural activities and information testifies to the impor-
tance that was attached to achieving greater effectiveness in this area.
By 1949 propaganda had begun to influence all aspects of social life and
filtered down even to local communities.

Improving the cultural image of the United States was identified in
1948 as the most important goal for American propaganda. But what
sort of image was appropriate? This was the main issue on the cultural
agenda at the time the avant-garde came to the fore.

Avant-garde art could be called American; it was cultivated and in-
dependent, yet linked to the modernist tradition. What is more, it could
be used as a symbol of the ideology of freedom that held sway in the
administration and among the new liberals. The domestic triumph of
the avant-garde was important because it paved the way for conquest
of the European elites.

"Is there an American art?" was the question asked by the *Magazine
of Art* in 1949, and the critics canvassed responded timidly but in the
affirmative. Most critics, however, continued to believe that in some
mysterious way the School of Paris still reigned supreme. Greenberg
alone maintained that the American avant-garde had taken the lead.
What everybody wanted was a commanding personality to lead the
troops, as James T. Soby wrote in *Saturday Review:*

We have produced in painting and sculpture no figure big enough to
hold the eyes of the world on himself and also inevitably, on those
of lesser stature around him. Even so, we can take hope from a curious
fact about giants in the arts: when you get one, the rest come easily.
We await our first in painting and sculpture, certain that he will appear
and others after him.[89]

Soby must have been reassured when, two days later, the famous article
on Pollock appeared in *Life*, transforming the alienated avant-garde artist
into a culture hero.

But a knotty problem of economics stood in the way of American art's
gaining recognition abroad. According to Soby, only the federal gov-
ernment could cut through the knot:

The prices of American paintings and sculptures are naturally related
to the standards and costs of living in this country; they are on average
between two and four times higher than the prices of comparable
works anywhere in Europe except England. Hence the dilemma of
American artists: the only way in which most of them can have their
art shown abroad is through dealers. And dealers are not interested
in exporting works for which there is no likely market, though in a
few prosperous cases we might expect them to be. The only possible

solution to the problem of better international recognition for our painters and sculptors is federal intervention.[90]

In these tense times the absence of American artists from the European scene was, Soby added, politically catastrophic:

Today we are engaged in a vital struggle to help the peoples of Europe regain their strength, to persuade them that we and they are committed to the same basic ideals. One of the most effective propaganda charges used against us in this struggle is that we are a rich, vast, powerful nation, but a nation not deeply concerned with the arts or with related spiritual values. On the political front, we are accused of "dollar diplomacy," on the cultural front, the American movie is cited in its worst examples as an indication of our materialism. In refuting propaganda of this kind, we need every means of communication we can get.[91]

In 1949 Pollock became the looked-for culture hero big enough to gather something like a school around him. He was the catalyst, the "ice-breaker" of the new American avant-garde.[92]

5
Conclusion

On the occasion of the Bicentennial of the United States of America, the Akademie der Kunste and the Berliner Festwochen jointly present the documentation "New York–Downtown Manhattan: Soho" as an analysis of an especially stimulating example of the latest history of civilization.
ULRICH ECKHARDT AND WERNER DUTTMANN,
FROM THE EXHIBITION CATALOG, SEPTEMBER, OCTOBER 1976

The preceding chapters are clearly intended to serve as the basis for a reinterpretation of avant-garde works produced in the years 1947 and 1948, a reinterpretation that would supplement the recent studies by William Rubin, E. A. Carmean, Jr., and Michael Fried. These are all excellent analytical studies of the major works of the avant-garde, but none of them is concerned with the particular reasons (apart from questions of influence) abstraction achieved a special status in American art around 1948.

The present study not only helps, I think, to answer this question but also enables us to understand why it was that this kind of abstraction, at this particular time—a time of public dispute about the value of abstract art and public controversy centered on the person of Jackson Pollock—superseded other forms of art and took upon itself the positive role of representing liberal American culture, which emerged victorious from the 1948 presidential elections.

It was in fact during the period 1947–49 that anticommunism struck deep and permanent roots in the soil of American culture. It was a period when communism seemed about to destabilize Europe, to say nothing of its apparent infiltration of the machinery of American government and social life. These were years of political readjustment. It was a dark

time for the American left, which was attempting, in some disarray, to take its distance from Marxism and communism, in the wake of the serious disillusionments discussed earlier.

The artists who concern us here had political roots in the Marxism of the thirties, and their analysis of the new political situation and of their own position in it bore the imprint of the Marxist tradition. This was what made their art unique, setting it apart from the mainstream for a brief period.

What mattered to these artists was communication with an audience; they wanted to articulate the disarray and anxiety of the postwar period and thus establish a dialogue with the public. Inspired by their work with the WPA, they tried to mobilize the communicative power of the fresco, but with a difference. To be sure, they used very large canvases for their works, eschewing the mural fresco and thus setting their art apart from the propaganda works and decorative art fostered by the WPA. But they also rejected the idea of the easel painting as a precious object, a consumable commodity. They found for their essentially private painting a niche in which it might, so they hoped, become a public statement.[1]

The increasingly reactionary climate did not tolerate criticism of the "American Way of Life," no matter how mild. Any criticism was viewed as playing into the hands of the Soviets. Political criticism, which had been fundamental to the fresco tradition, became impossible. If Lenin's portrait had to be removed from a Diego Rivera fresco in New York in 1935, in 1947 it was the head of Franklin D. Roosevelt that had to be eliminated from an Anton Refreiger fresco in San Francisco.

This generation of politicized artists had to adapt to the new climate of distrust and suspicion, and yet they remained fascinated by mural art. They found a way to get around the difficulties raised by the painted message by making the content of the message private and by treating the private material as a public declaration. Though the giant canvases of the abstract expressionists no longer had the social content of mural art, they retained the impact of the mural, its power and visibility.[2]

But what was the nature of this private content, this "subjectivity" that the avant-garde artist wanted to get across at all costs?[3] The first thing to understand is this: the avant-garde artists were attentive to what was being said by the remnants of the left in magazines like *Partisan Review*, the *Nation*, or Dwight Macdonald's *Politics*. Unlike modern artists of humanist orientation still affiliated with the Popular Front, they were familiar with and accepted the idea that modernity could no longer be expressed in the same terms as had been used by the two previous generations: not after the atom bomb. In particular, it had become impossible to represent the diffuse anxiety and fear that defined modernity without falling into the grotesque or the facile, without, in a word,

making kitsch. Dwight Macdonald said it well: to describe was to accept the unacceptable. It was to incorporate an object into an expressive system by means of a code that sapped all critical force and revolutionary significance.

Abstraction, thought the avant-garde, made it possible to avoid these pitfalls and to enter into an active dialogue with the age. It allowed a militant, committed art that was neither propagandistic nor condescending to its audience. The baroque humanism of a Rico Lebrun, then very popular (Lebrun won the Chicago Art Institute's Harris Prize in 1947), struck avant-garde artists as ridiculous because of its emphasis and its flirtation with depth psychology.[4]

The search for a new style that would avoid the trap of illustration was therefore at the heart of the avant-garde's concerns.[5] The new manner of painting emphasized the individual aspect of creation but at the same time laid bare the process, the mechanics of painting, and the difficulty, not to say impossibility, of describing the world. It is against this background, I think, that the works of the period 1947–49 should be analyzed, particularly the black-and-white canvases of de Kooning, in which bodies and objects are dismembered as though cut apart and scattered over the surface of the canvas, tightly interlaced, and the works of Rothko, who was at this time moving away from explicit erotic imagery toward an abstract sensualism.

In attempting to avoid the dangers discussed above, avant-garde art became an art of obliteration, an art of erasure. It was in some respects close to certain forms of surrealism, in which the work pretended to tell a story, but no sooner had the telling begun than it began ingeniously to undo itself, to cover its tracks, to cover itself up and disappear. The freedom of expression and existential violence that leap to the eye in the works of the abstract expressionists were in fact products of fear and of the impossibility of representation, of the need to avoid the literary expression characterized by the work of Philip Evergood (fig. 22).

Perhaps the clearest statement of this system is found in the works of Jackson Pollock, particularly in his classic painting *Number 1, 1948* (fig. 23), which to my mind embodies the dialectic just described: embedded in the "all-over" mesh of lines, half swallowed by it, pieces of objects and parts of bodies are still visible. While these shapes can still be made out, they are almost completely obliterated, like the totemic form with raised arm at the extreme left of the composition, a guardian figure fairly common in Pollock's work from 1942 to 1945.[6]

This is not the place to enter into the long diatribe concerning the so-called camouflaged representation in Pollock's work that raged in the pages of the specialist magazines during the 1970s. The problem, to my way of thinking, is a false one. There is no camouflage, no secret lurking behind Pollock's mesh. Rather, the artist emphasizes the obliteration. He shows us the object, the representation, as a part of the creation. It

leaps to the eye but in a controlled or domesticated way, as is shown by two 1948 Pollock drawings: *Number 22A* and *Number 4.* The dialogue with the figure is a constant presence in Pollock's work, even when it is by default, present by dint of its absence.[7]

Abstraction, then, was a characteristic feature of avant-garde painting. But what kind of abstraction was it? There were of course already many painters in New York working in the abstract tradition, but the avant-garde painters were aggressive in their individuality. They each wanted to be different, wanted no part of a school or group. This is a crucial characteristic of the group, for it runs counter to the avant-garde tradition; it has a parallel, however, in the line taken by left-wing intellectuals after the end of the war.

Faced with the annihilation of the individual in the totalitarian regimes and with the absorption of the individual into the mass of consumers in the capitalist regimes, the American left tried to stake out a middle ground from which the individual painter or artist could assert his independence of both left and right.

The same thing happened in Europe. Between 1945 and 1950 Sartre's emphasis on an intentional consciousness tied to a certain kind of subjectivism was cutting an original path between idealism and orthodox Marxism. It is worth noting that *Partisan Review* published Sartre in translation as early as 1946, giving a theoretical basis, or at least a working alternative, to those who were caught between Stalinism and Americanism. But in the United States, the complexity of Sartre's position, his uneasy relationship with communism, and his often violent anti-Americanism were ignored.

Partisan Review once again provides documentation of this last episode in the saga of the American left. I say "last" because a majority of the participants in the 1947 symposium "The Future of Socialism" rejected Marxism, and some, like Sidney Hook, went so far as to call for the purge of what Hook called "totalitarian liberals" from American culture.[8] In protecting its flanks against totalitarian assault, the avant-garde lost its critical cutting edge. This fate had earlier befallen even so outspoken a radical as Dwight Macdonald, who after suffering one disillusionment too many took refuge in lofty detachment. In "The Root Is Man" Macdonald explained that the failure of socialism demonstrated that the time had come to invent another system. A system that would put the individual first, that would "start off from one's own personal interests and feelings, working from the individual to society rather than the other way around. Above all, its historical dynamic [would come] from absolute and nonhistorical values such as truth and justice, rather than from the course of history."[9] No doubt the need to make room in left-wing thought for the subjective and intuitive sides of life was felt by

many intellectuals to be primordial, but that did not necessarily mean that history had to be thrown out altogether.

Meyer Schapiro attempted to navigate between the two shoals by emphasizing the importance of individuality in his historical writings. In a 1939 article on the sculptures of Santo Domingo of Silos, Schapiro emphasized the subversive role of the medieval artist, who, he argued, upset the original plans of the religious authorities by introducing secular figures with no apparent connection to the church. For Schapiro, the artist—and here he comes fairly close to positions held by contemporary artists—is a person who transforms his social and political independence into a critical weapon. Unfortunately for Schapiro's argument, it has since been shown that the medieval artist's critical independence did not in fact exist, since the marginal, secular figures (dancers, acrobats, and so forth) that are central to Schapiro's case had a very specific place in religious iconography.[10] Schapiro's unconscious and persistent need to find an independent place for the artist in a society as structured as feudal society shows how much he was in fact a creature of his own time, and how narrow and stifling the space within which he himself was free to move.[11]

Schapiro's 1947 article "On the Aesthetic in Romanesque Art" was even more specific and topical, since it brought out with even greater clarity the critical impact of the medieval artist on the modern artist:

One could easily show that contemporary art . . . is bound up with modern experiences and ideals no less actively than the old art with the life of its time. This does not mean that if you admire modern works, you must also accept modern social institutions as good—much of the best art of our day is, on the contrary, strongly critical of contemporary life.[12]

By defending the avant-garde in these terms in 1947, Schapiro was indirectly setting it in opposition to its enemies: the right wing, religion, fascism, and communism, all of which despised avant-garde art. His essays were a sort of last refuge for leftist intellectuals who refused to reject Marxism completely; they develop a theory of the artist in opposition, expressing his freedom within the social system.

I mention the essays of Schapiro and Macdonald because their positions were still the ones adopted by avant-garde artists. Avant-garde painters also defended individualism in their own terms. But this is where matters get complicated: among the painters we find tendencies associated with each of the two intellectuals just mentioned—a critical individualism on the one hand, an individualism that was fairly close to anarchism on the other hand. Everyone was antiauthoritarian and

critical of the status quo, but dead set as they were against authority, they did not see that individualism as a combative stance could easily combine with individualism as a form of quietism or withdrawal, old-fashioned bourgeois individualism that did not trouble itself with avant-garde subtleties.[13]

Avant-garde individualism, for all its critical and acerbic character and all the pains it took to define and defend itself against cooptation by bourgeois humanism,[14] all but disappeared from the scene as it was painted by *The Vital Center*. For Schlesinger too insisted on the urgency of staking out a middle ground between the left and the right, shrouding the notion of individual freedom in a heavy cloak of ideology. The whole picture was shifted toward the right. At just about the same time, abstract expressionism gained its first successes. This was no accident. Avant-garde culture in general and Pollock's painting in particular infused into the liberal revival the vitality that it needed.

Avant-garde artists, now politically "neutral" individualists, articulated in their works values that were subsequently assimilated, utilized, and coopted by politicians, with the result that artistic rebellion was transformed into aggressive liberal ideology. The new painting was made in the image of the new America, powerful and internationalist but anxious about the Communist threat. By the end of 1948 this new America was able to recognize itself in avant-garde painting because it had been indirectly responsible for the elaboration of the new style.[15]

The new liberalism identified with this art not only because it embodied characteristics of international modern painting (perceived as purely American) but also because the values expressed through the works were especially important to liberals during the Cold War period. Among these values were individualism and the willingness to take risks, central elements in the creative system of the avant-garde and warrants of its complete freedom of expression. Risk also played a key role in the ideology of *The Vital Center*. Risk was said to be a necessary condition of freedom, the shibboleth of a free society:

> The eternal awareness of choice can drive the weak to the point where the simplest decision becomes a nightmare. Most men prefer to flee choice, to flee anxiety, to flee freedom.[16]

The brutality of the modern world can wear down the individual. Against this brutality the artist was supposed to be a shining example of the individual will to set against the dull uniformity of totalitarian society.

The individualism evident in abstract expressionist painting enabled avant-garde painters to stake out a unique stronghold on the artistic front. The avant-garde tailored for itself a coherent, recognizable, and salable image that fairly accurately reflected the aims and aspirations of

the new liberal America, a powerful force on the international scene. It was possible to combine political and artistic images because both artists and politicians were willing, consciously or unconsciously, to overlook large chunks of their respective ideologies in order to enlist the other group as an ally. The contradictions were passed over in silence, though artists, who had to face the situation every day, sometimes erupted in violent outbursts against what was happening. Clyfford Still, who refused to be coopted by the museums and the critical establishment but still wished to be perceived as a spiritual leader of the movement, is perhaps the best example of such an artist. In 1948 he wrote the following letter to Betty Parsons:

Please—and this is important, show [canvases] only to those who may have some insight into the values involved, and allow no one to write about them. NO ONE. My contempt for the intelligence of the scribblers I have read is so complete that I cannot tolerate their imbecilities, particularly when they attempt to deal with my canvases. Men like Soby, Greenberg, Barr, etc. . . . are to be categorically rejected. And I no longer want them shown to the public at large, either singly or in group.[17]

It is ironic but not contradictory that in a society politically stuck in a position to the right of center, in which political repression weighed as heavily as it did in the United States, abstract expressionism was for many the expression of freedom: the freedom to create controversial works of art, the freedom symbolized by action painting, by the unbridled expressionism of artists completely without fetters.[18] It was this freedom, existential as well as essential, that the moderns (Barr, Soby, and Greenberg) defended against the conservatives (Dondero and Taylor). Abroad, this domestic battle was presented as a token of the freedom inherent in the American system and contrasted with the restrictions placed on the artist by the Soviet system.

Freedom was the symbol most actively and vigorously promoted by the new liberalism in the Cold War period. Expressionism stood for the difference between a free society and a totalitarian one. Art was able to package the virtues of liberal society and lay down a challenge to its enemies: it aroused polemic without courting danger. And so Pollock too was transformed into a symbol, a symbol of man, free but frail; his work came to stand for modern anxiety. Alienation was intrinsic to both abstract expressionist art and to the ideology of *The Vital Center*. Freedom, Schlesinger maintained, was impossible without alienation and anxiety:

This freedom has brought with it frustration rather than fulfillment, isolation rather than integration. "Anxiety," writes Kierkegaard, "is

the dizziness of freedom"; and anxiety is the official emotion of our time.[19]

True freedom, according to Schlesinger, can be recognized by the anxiety and frustration that the individual feels when faced with a choice. Authoritarian regimes like Russia make the choice for the individual, who thus trades his freedom for tranquility. "Totalitarian man," to borrow Arthur Koestler's phrase, is planned and programmed and so knows nothing of the anxiety and alienation intrinsic to democratic man. There were of course political overtones to the notion of risk, a term much discussed in avant-garde circles. "Against totalitarian certitude, free society can only offer modern man devoured by alienation and fallibility."[20] Totalitarian man, Schlesinger went on to say, is "tight-lipped, cold eyed, unfeeling, uncommunicative . . . as if badly carved from wood, without humor, without tenderness, without spontaneity, without nerves."[21] In contrast to this the free world offered the exuberant Jackson Pollock, the very image of exaltation and spontaneity. His psychological problems were but cruel tokens of the hardships of freedom. In his "extremism" and violence Pollock represented the man possessed, the rebel, transformed for the sake of the cause into nothing less than a liberal warrior in the Cold War.

Without really wanting to, the avant-garde lined up behind the ideology that had only recently become dominant. What the avant-garde did not realize was that the postwar world had caught up with their radical wartime political stance. By 1948 their once disturbing vision could be integrated into the new anti-Communist rhetoric. Avant-garde radicalism did not really "sell out," it was borrowed for the anti-Communist cause. Indeed, the avant-garde even became a protégé of the new liberalism, a symbol of the fragility of freedom in the battle waged by the liberals to protect the vital center from the authoritarianism of the left and the right:

A free society must dedicate itself to the protection of the unpopular view. It is threatening to turn us all into frightened conformists; and conformity can lead only to stagnation. We need courageous men to help us recapture a sense of the indispensability of dissent; and we need dissent if we are to make up our minds equably and intelligently. . . . And there is a "clear and present danger" that anti-Communist feeling will boil over into a vicious and unconstitutional attack on nonconformists in general and thereby endanger the sources of our democratic strength.[22]

Abstract expressionism had successfully transformed anxiety and alienation into creativity and was thus the perfect answer to Arthur Schlesinger's preoccupation:

The new radicalism derives its power from an acceptance of conflict—
an acceptance combined with a determination to create a social frame-
work where conflict issues, not in excessive anxiety, but in creativity.[23]

The wind from the center was blowing in the direction of the avant-
garde. It should be clear from the foregoing that the artists who in the
January 1951 issue of *Life* were still being called the "Irascibles" were in
fact cozily installed at the center of the new system as early as 1948.

In 1948 a new "style" swept the American art scene, a style that
represented a political tendency equivalent to what was known in France
as the "third force," a tendency that was then trying to carve out a niche
for itself in Paris between the Gaullists and the Communists.[24] But in
Paris the weight of tradition was too great to allow an avant-garde to
achieve victory overnight. Various traditions in art were deeply rooted
and many had direct ties to the political parties. The once unified image
of the Ecole de Paris had been shattered at the time of the Liberation
and gave way to extreme fragmentation in the world of art. Reflecting
this division, Parisian art was fragile by comparison with American art,
unified under the banner of abstract expressionism.

In France politics and art were closely related and left no room for
neutrality. Each political party and its associated newspapers and re-
views championed a style of painting. The vehemence of political conflict
was reflected in art exhibits, magazines, and museums, particularly after
the Communist ministers were dismissed from the Ramadier govern-
ment in 1948. The French art scene was too complex to permit a full
treatment here of all its tendencies. It is worth pausing a moment, though,
to look at the reaction of American critics to French art, to show how
wide the gulf of incomprehension was between New York and Paris.

The fact that Parisian art was now fragmented, where once it had
drawn power from its coherent image, bolstered the confidence and
certainty of American observers, who felt that New York and its new
"school" had nothing more to learn from Paris. The reaction of the liberal
critic James Thrall Soby when he visited Paris in 1949 was typical. His
articles reveal the panic he felt in the face of the extreme politicization
of artistic discourse in France, which could not be accommodated within
the terms of his critical vocabulary:

Today in Paris, the political atmosphere among artists is so tense, that
values have become raucous and distorted. I find it hard to believe
that the new generation will discover its own identifying style until
the current political crisis has abated somewhat. After the polemics
of the salon, it is a relief to visit the calm galleries of the Petit Palais,
where the French masterpieces of the Louvre, up to the Impression-
ists, are now installed.[25]

The absence of a recognizable and accepted style of the sort then so clearly in evidence in the United States, together with the tense political reality, was something the critic simply could not assimilate:

After the complexities of the continental art scene, the conflicts of aim among American artists seem refreshingly pertinent to the creative problem. In this country since the war, the dominant trend has been toward abstraction, with revived emphasis on the physical limitations and character of a given medium.[26]

Such comments show the sort of incomprehension on which the success of abstract expressionism depended. But America did recognize a part of itself, drawn from the complex discourse of the avant-garde, in the work of de Kooning, Pollock, and Gorky, who represented the United States at the 1950 Venice biennial exposition.[27] Americans bought the works of these artists in large numbers.[28]

In 1951 certain members of the "Club," assisted financially by Leo Castelli, staged a show in a rented building on Ninth Street in New York.[29] The so-called Ninth Street Show included the work of sixty-one artists, mostly abstract expressionists. It was well received by the press. In the same year Robert Motherwell, writing in the catalog of an avant-garde art show held in Los Angeles, tried to characterize the New York school and to distinguish it from the School of Paris:

The recent "School of New York"—a term not geographical but denoting a direction—is an aspect of the culture of modern painting. The works of its artists are "abstracts," but not necessarily "non-objective." They are always lyrical, often anguished, brutal, austere, and "unfinished," in comparison with our young contemporaries of Paris; spontaneity and a lack of self-consciousness is emphasized; the pictures stare back as one stares at them; the process of painting them is conceived of as an adventure, without preconceived ideas on the part of persons of intelligence, sensibility, and passion.[30]

While Motherwell was busy defining the ideology of the avant-garde in such clear terms, it was also becoming evident that abstract expressionism had become the American "style" par excellence. In the process, of course, the art suffered tremendously—to the point that paintings by Mark Rothko lost their intended mystical quality to become colorful pieces of decoration in the modern home as shown in *Vogue*.[31]

It is worth pausing to point out that the use of culture as a propaganda weapon became blatant and aggressive after 1951. The Cold War was being waged furiously, its weapons had been chosen and honed. Cultural magazines published in Europe with CIA funds mushroomed.[32] The American liberal spotlight now focused on art and intellectuals.

They became the storm troopers in what president Dwight D. Eisenhower liked to call "psychological warfare."[33] The glamorized and popularized art of abstract expressionism became the avant-garde wedge used to pierce the European suspicion that Americans were only capable of producing kitsch.

To take one typical example, the first issue of *Profils* (Perspectives) contained articles designed to attract left-leaning French intellectuals, including one in which Selden Rodman tried to connect Ben Shahn with the European tradition and another about the well-known humanist artist Van Gogh by Meyer Schapiro.

The magazine editorial makes edifying reading, as does the list of consulting editors, particularly when one understands the powerful manipulation to which American intellectuals, lulled to sleep by the beneficent purring of academicism, were subjected at the time.

Profils has set itself the task of providing the reader with a choice of materials intended to provide a fairly comprehensive view of American culture. . . . Abroad, many erroneous ideas about American culture are current and many American values have been distorted, not only by the shortcomings of certain domestic products (such as Hollywood films) but also by adverse political propaganda. One of the tasks of *Profils* will be to show that in the intellectual and artistic sphere the United States has not been sterile.[34]

It was after 1951—when the Communist threat loomed ever larger in the United States (Hiss, Chambers, the Korean War), when Truman, outflanked on the right and unable to slow the anti-Communist machine that he himself had set in motion, was forced to leave the political initiative to McCarthy—that the American avant-garde was most forcefully presented through independent organizations all over Europe.[35]

Abstract expressionism established such a hold on the European mind that rebellious French students used a form of the style to express their alienation and their desire for freedom on the walls of Nanterre in 1968. Painting as ejaculation was the way one poem scrawled in chalk on a wall put it:

The porridge you forced down my throat as a kid: I've come with it all over your wall.

Was this finally "action painting" in action? Was this at last popular art, the true mural art of Jackson Pollock's dreams?

Notes

Introduction

1. This is shown by the introduction to the catalog of the 1982 Jackson Pollock exhibit at the Centre Pompidou in Paris, in which Dominique Bozo, the museum's director, rehearses Clement Greenberg's old clichés, according to which the American artist follows naturally in the formalist wake of Picasso, Matisse, and Mondrian. The artist joins the gods in the pantheon, and the historian is left with nothing to do but burn incense in his honor: "[Pollock] is one of the great milestones or way stations in the progress of universal creation. With a figure of this scale notions of identity become meaningless" (see Dominique Bozo, *Jackson Pollock* [Paris: Centre Georges Pompidou, 1982], p. 7). Although the catalog is a gold mine of biographical information, it carefully avoids examining the painter's work in relation to American history. The critical essays it contains are the work either of writers and poets (Alain Robbe-Grillet, Maurice Roche, Michel Butor, for example), who confine themselves to impressionistic interpretation, or of formalist historians of art.

2. To be convinced of the truth of this assertation, one has only to note the violent reaction of the American press to the modern art presented at the Armory Show of 1913 and, later, to the modern art shows organized by Alfred Stieglitz at his "291" Gallery. Remember that abstract expressionism represents the first American attempt to create an organized avant-garde around a group of artists and critics sharing a common ideology and bent on acquiring an international reputation. During the twenties Stieglitz and his modern artists did of course defend modern art but they never dreamed of replacing Paris. Disappointment in the League of Nations coupled with the feeling that the American war effort had been in vain led to a general retrenchment and to the growth of nationalist feeling that was hardly favorable to the birth of an avant-garde. This nationalism turned into internationalism around 1939, as the first signs of World War II loomed on the horizon. This war, unlike the previous one, unleashed an aggressive American internationalism in which modern art played a leading role.

3. For example, Jackson Pollock worked with the Mexican fresco painter Siqueiros in New York. He experimented with the techniques of the propaganda fresco. There is a photograph showing Pollock posing in front of a float used in a May Day parade in the thirties. Mark Rothko painted realistic scenes such as cityscapes, subways, etc. Mark Tobey painted apocalyptic scenes of modern cities during this period. Franz Kline, Philip Guston, and Bradley W. Tomlin did not turn to abstraction until after 1948.

4. Harry S. Truman, "To the Congress on the Threat to the Freedom of Europe," *Public Papers of the President of the United States* (Washington, D.C.: United States Government Printing Office, 1964).

5. Harry S. Truman, *Off the Record: The Private Papers of Harry S. Truman*, edited by Robert H. Ferrell (New York: Harper and Row, 1980), p. 129.

6. Pierre Cabanne, "Pourquoi Paris n'est plus le fer de lance de l'art," *Arts et Loisirs* 87 (1967): 9.

7. Baziotes, Gottlieb, Newman, Rothko, and Still were not included in the show.

8. See Serge Guilbaut, "Création et développement d'une avant-garde: New York, 1946–1951," *Histoire et Critique des Arts*, July 1978, pp. 29–48.

9. Irving Sandler, *The Triumph of American Painting* (New York: Praeger, 1970), p. 1.

10. Georges Duby and Guy Lardreau, *Dialogues* (Paris: Flammarion, 1980), pp. 101–2.

11. See the article by Carol Duncan and Alan Wallach, "MOMA: Ordeal and Triumph on 53rd Street," *Studio International* 194, no. 1 (1978): 48–57.

12. Sandler treats the period of the fifties similarly in another work, *The New York School* (New York: Praeger, 1978).

13. Kurt W. Forster, "Critical History of Art, or Transfiguration of Values?" *New Literary History* 3, no. 3 (1972): 467.

14. Dore Ashton, *The New York School: A Cultural Reckoning* (New York: Viking, 1973); David and Cecile Shapiro, "Abstract Expressionism: The Politics of Apolitical Painting," *Prospects* 3 (1976): 175–214; Jean Laude, "Problèmes de la peinture en Europe et aux Etats-Unis, 1944–51," in *Art et idéologies: l'art en occident 1945–49* (St. Etienne: CIEREC, 1978), pp. 9–69. Also worth mentioning is John Tagg, "American Power and American Painting: The Development of Vanguard Painting in the United States since 1945," *Praxis* 1, no. 2 (1976): 59–79. Though critical of traditional histories, this article takes a point of view too much like that of a conspiracy theory to be really useful.

15. Jane de Hart Mathews, "Art and Politics in Cold War America," *American Historical Review* 81 (1976): 762–87.

16. Marcelin Pleynet has written many articles on the subject, see especially "Pour une politique culturelle préliminaire (Plan Molotov ou Plan Marshall)", in *Art et idéologies*, pp. 89–102, reproduced with some changes in the catalog of the Paris–New York show held at the Musée Pompidou (Beaubourg) in Paris in 1977. There is also a series of articles and interviews on Franco-American relations in his book *Transculture* (Paris: Union Générale d'Éditions, 1979). See also his conversation with William Rubin of MOMA in *Situation de l'art moderne, Paris et New York* (Paris: Editions du Chêne, 1977). Pleynet frequently borrows (and on occasion makes rather free use of) arguments and observations made by American critics largely unknown in France: see, for example, *Art et littérature* (Paris: Seuil, 1977), especially pp. 248, 293–94.

17. Robert Carleton Hobbs and Gail Levine, *Abstract Expressionism: The Formative Years* (New York: Whitney Museum of American Art, 1978).

18. As this hagiographic research has been refined, only one change has been made (owing to a combination of guilt, fashion, and noblesse oblige): the inclusion of Lee Krasner.

19. An interesting discussion of this subject may be found in Russell Jacoby, *Social Amnesia: A Critique of Contemporary Psychology from Adler to Laing* (Boston: Beacon Press, 1975).

20. In this connection recall the change in the attitude of Meyer Schapiro, who during this period became yet another promoter of the "apolitical" avant-garde, as can be seen in the somewhat hesitant introduction to "The Younger American Painters of Today" that he wrote for the *Listener,* January 26, 1956, p. 146:

American artists are very much aware of a change in atmosphere since the war: they feel more self-reliant and often say that the center of art has shifted form Paris to New

York, not simply because New York has become the chief market for modern art, but because they believe that the newest ideas and energies are there and that America shows the way. It is easy to suppose that this new confidence of American artists is merely a reflex of national economic and political strength, but the artists in question are not all chauvinistic or concerned with politics—they would reject any proposal that they use their brushes for a political end.

As early as 1950, Schapiro and Clement Greenberg were introducing the latest recruits of the New York avant-garde to Samuel Kootz's gallery. Printed on red velours paper, the program of Talent 1950 reflected the confidence of the younger generation. Represented were Elaine de Kooning, Robert de Niro, Friedel Dzubas, Manny Ferber, Robert Goodnough, Grace Hartigan, Franz Kline, Al Leslie, Larry Rivers, and Esteban Vincente. The Communist newspaper the *Daily Worker* fulminated against this decadent bourgeois image of the avant-garde. The vocabulary was the same as the Party had used during the forties, but the blows no longer struck home:

These critics [Greenberg and Schapiro] have associated themselves at one time or another with some aspect of Trotskyism—that degenerate and poisonous sore on the body politic. And their show is an ostentatious illustration of the integration, these days (more than in any other historical period), of degenerate and poisonous politics and degenerate and poisonous art. The basic features of the show are a reversion to empty barbarism. A demand for violent sensation and a pretty, personalized expression. (*Daily Worker,* May 22, 1950, p. 10)

Individualism became in fact the center piece of liberalism. Listen to Lloyd Goodrich in 1952:

Today more than ever we should demonstrate the artistic freedom and diversity inherent in a democratic society—the most effective answer to totalitarian thought control and uniformity, and the most convincing proof of the strength of democracy. In the troubled world of today, the artist's absolute freedom of thought, his uncontrolled expression of ideas and emotions, and his disinterested pursuit of perfection, are more needed than ever in our history. (Lloyd Goodrich, "Art in Democracies," *The Contemporary Scene: A Symposium* [New York: Metropolitan Museum of Art, March 28–30, 1952], p. 79)

21. Eva Cockcroft, "Abstract Expressionism: Weapon of the Cold War," *Artforum* 12 (June 1974): 39–41, especially p. 39.
22. Many unpublished writings by artists are preserved in the invaluable Archives of American Art, Washington, D.C.
23. Letter from Andreas Feininger to Mark Rothko, October 12, 1949, in the archives of Mark Tobey. I should like to thank Frederic Gordon Hoffman for conveying this letter to me along with other information on the work of Mark Tobey.
24. Hilton Kramer, "Muddled Marxism Replaces Criticism at *Artforum*," *New York Times,* December 21, 1975, section 2, p. 40; and "The Blacklist and the Cold War," *New York Times,* October 3, 1976, section 2, pp. 1, 16.
25. The Age of Revolution was a major exhibition that traveled through France and the United States from November 1974 to September 1975. The articles were signed by the leading international authorities: Pierre Rosenberg, Frederick J. Cummings, Antoine Schnapper, Robert Rosenblum.
26. Carol Duncan, "Neutralizing the Age of Revolution," *Artforum*, December 1975, p. 50. Rosenblum's response appeared in *Artforum*, March 1976, p. 8.
27. Kramer, "Muddled Marxism," p. 40.

28. Bernice Rose, *Jackson Pollock: Drawing into Painting* (New York: Museum of Modern Art, 1980), p. 23. The same wish was expressed by Peter Fuller in the *Village Voice* and in *Art Monthly* 27 (June 1979): 6–12: "I do not pretend to know who all the excluded artists are; I do know enough of them to say with confidence that the true history of art in post-war America is yet to be written."

29. Cited in *USA: The Permanent Revolution* (New York: Prentice-Hall, 1951), p. 221, by the editors of *Fortune* in collaboration with Russell W. Davenport.

Chapter 1

1. The example of Hollywood is revealing. David Caute recounts that "the [anti-Nazi] league served mainly as a kind of Rotary Club whose four thousand members, many of them earning one or two thousand dollars a week, were able to contribute as much to Party funds as the whole American working class. They were naïve enthusiasts without political experience, and many of them had a cruel fate awaiting them" (*The Fellow-Travellers—A Postscript to the Enlightenment* [New York: Macmillan, 1973], p. 142).

2. Pierre Gaudibert, *Action culturelle: Intégration et/ou subversion* (Paris: Casterman, 1977), p. 75.

3. Maurice Thorez, "L'union de la nation française," report to the Eighth Party Congress at Villeurbanne, 1936. Paul Vaillant-Couturier was later to bring his own panache to this ideological guerrilla warfare.

4. Paul Vaillant-Couturier, *Vers des lendemains qui chantent*, Central Committee of the French Communist Party, October 16, 1936, published in Paris in 1962 by Editions Sociales. For an analysis of the French Communist party's rehabilitation of the concept of culture, see Gaudibert, *Action culturelle*, pp. 68–82.

5. Letter from Joseph Freeman to Daniel Aaron, in Daniel Aaron, *Writers on the Left* (New York: Avon, 1969), p. 445, n. 2. Thus did Earl Browder characterize relations between the Communist party and the United States. He is cited in James Burkhart Gilbert, *Writers and Partisans: A History of Literary Radicalism in America* (New York: Wiley, 1968), p. 147.

6. Aaron, *Writers on the Left*, p. 278. Granville Hicks, in his book *Where We Came Out* (New York: Viking, 1954), described his joining the Communist party as an action taken without serious political analysis. The aims of those who joined, he says, "were primarily resistance to fascism, at home and abroad, the organization of labor unions, and support of New Deal reform measures. Party propaganda lost its Russian coloring and took on a flamboyant nationalist hue. 'Communism is 20th century Americanism' was one of the slogans of the late 30's" (pp. 40–41). The fact that the book came out during the height of the McCarthy period may have something to do with the way the Party is disparaged and the way in which Hicks describes his participation: "It never occurred to me at the time that the new line was really a trick, a device for strengthening Soviet foreign policy."

7. It should be noted, however, that while the radical movement made headway among intellectuals, it never had a chance of having much of an impact on the electorate. In this time of cultural crisis, it was natural for artists and writers to applaud the efforts of the left, and many even worked for it, often because they were attracted by the dynamism of the Communist party. What socialism held out in the years 1933–36 was the prospect of an alternative to a worn-out and decadent capitalist system. The socialist alternative was fully acceptable to those who had never been entirely welcome within the system (and this group included the artists). Sandler's claim (*Triumph of American Painting*, p. 8) that artists were manipulated by the Party and forced to put political propaganda into their art gives the Party an importance it never had and suggests that artists had no political sense. The idea of a Communist conspiracy that runs as an unstated theme throughout Sandler's book and that Sandler regards as an essential part of the explanation of why modern art was slow to catch on in the United States may be a comforting simplification of the real situation but it is entirely erroneous. In fact it became even easier to accept the Popular Front after André Malraux returned from the USSR and published

in *Partisan Review* his opinion that Soviet artists had overcome the alienation from which Western artists were suffering ("Literature in Two Worlds," *Partisan Review*, February 1935, p. 14).

8. Gilbert, *Writers and Partisans*, p. 161.

9. Some people wanted to broaden the congress to include liberal intellectuals, but Alexander Trachtenberg, the cultural commisar of the American Communist party, felt that given the urgency of the situation, "this is the time to count noses." See the discussion between Granville Hicks and Daniel Aaron, cited in Aaron, *Writers on the Left*, pp. 300–303.

10. Four hundred artists and critics of various tendencies signed the appeal. Among them were Peter Blume, Aaron Bohrod, Paul Burlin, Stuart Davis, Hugo Gellert, Karl Knaths, Yasuo Kuniyoshi, Isonu Noguchi, Anton Refregier, Ben Shahn and David Smith.

11. A 1937 press release (New York Public Library, 3-MAA) reads as follows: "The national membership exhibition comes after a little over a year of active life. The artists' congress was brought into being in the winter of 1935–36 to deal with the problems of which artists had newly become conscious: the economic pressure brought about by depression; the destruction of democratic liberties and free art expression—carried far in Europe, latent in America; the failure of private patronage-museums and dealers to support the artists; and the threat of discontinuance of the Federal Art projects, when private sources had proved hopelessly insufficient to support the nation's artists."

12. Lewis Mumford, "Opening Address" *First American Artists' Congress* (New York, 1936), p. 2.

13. Max Weber, "The Artist, His Audience, and Outlook," *First American Artists' Congress*, p. 3.

14. Stuart Davis, "Why an Artists' Congress," *First American Artists' Congress*, p. 3.

15. Stuart Davis, "Arshile Gorky in the 1930's: A Personal Recollection," *Magazine of Art* 44, no. 2 (1951): 58.

16. Text prepared in collaboration with Meyer Schapiro, "Race, Nationality and Art," *First American Artists' Congress*, pp. 38–41. Republished with some changes in *Art Front* 2, no. 4 (1936).

17. Ibid., p. 41.

18. This article contradicted the cultural policy of the French Communist party, which was based on the idea that French art was the best in the world and, because of its universality, should reign supreme the world over. For the statements of Maurice Thorez and Paul Vaillant-Couturier on this subject, see above notes 2, 3, 4.

19. Mike Gold, *New Masses* 16 (July 30, 1935): 9–11; (August 6, 1935): 13–15; August 13, 1935): 18–21.

20. Incidents affecting their decision included a violent encounter between André Breton and Ilya Ehrenburg in the streets of Paris and the suicide of René Crevel shortly before the beginning of the congress. See Maurice Nadeau, *The History of Surrealism* (New York: Collier Books, 1965), pp. 193–94.

21. Ibid., p. 194.

22. See the August 1935 note entitled "Du temps que les surréalistes avaient raison," in André Breton, *Position politique du surréalisme* (Paris: Denoël, Gonthier Mediation, 1972), p. 98.

23. Ibid., p. 101.

24. This association was repudiated by Breton and the surrealists in no uncertain terms: see *Position politique*, p. 102.

25. In the fall of 1935 the editors of *Partisan Review* were working with Alexander Trachtenberg of the Communist party to lay the groundwork for the merger of their magazine with Jack Conroy's *Anvil*. The merger took place in February 1936 and lasted until October of that year, as documented in Gilbert, *Writers and Partisans*, pp. 142–45.

26. "The failure of the cultural revolution cut a fundamental tie between the *Partisan Review* and the majority of the radical movement; the belief in a renaissance was shattered. The communists had apparently shed their revolutionary ideas and were moving toward middle-class respectability and political compromise. To the *Partisan*, the death of proletarian literature left the problems of the modern writer and intellectual with no adequate Marxian solution." Gilbert, *Writers and Partisans*, p. 154.

27. George Novack, "The Intellectuals and the Crisis," *New International* 3 (June 1936): 83.

28. James T. Farrell, cited in Alan M. Wald, *James T. Farrell: The Revolutionary Socialist Years* (New York: Gotham, 1978), p. 83.

29. William Troy and William Carlos Williams, "What Is Americanism?" *Partisan Review and Anvil* 3 (April 1936): 13–14.

30. William Phillips and Philip Rahv, "Literature in a Political Decade," in *New Letters in America,* ed. Horace Gregory (New York: Norton, 1937), p. 178.

31. Farrell was acerbic in his criticism of the proletarian novel so dear to the Communists. In 1933 he attacked Conroy's novel *The Disinherited,* and in 1935 he attacked the cultural policies of the Party in his speech to the American Writers' Congress. See Wald, *Farrell,* p. 34.

32. Ibid., p. 39.

33. Since Farrell's book appeared to be an orthodox Marxist attack, many tried to minimize the book's importance after the Catholic Book Club itself had recommended *A Note on Literary Criticism.*

34. For a discussion of this controversy see Daniel Aaron, *Writers on the Left,* pp. 318, 499 n. 28.

35. Alfred H. Barr, Jr., *Cubism and Abstract Art* (New York: Museum of Modern Art, 1936).

36. Delmore Schwartz, "A Note on the Nature of Art," *Marxist Quarterly,* April/June 1937, pp. 305–10. See Meyer Schapiro's response, ibid., pp. 310–14.

37. Paul Vaillant-Couturier, "La lutte des classes aujourd'hui du côté du prolétariat comme la lutte pour la culture," cited in "La défense de la culture," *Commune* 23 (July 1935): 1262.

38. Pablo Picasso, "Press Release," American Artists' Congress, December 23, 1937, New York Public Library.

39. For details see Aaron, *Writers on the Left,* pp. 350–54.

40. *New Masses,* April 28, 1938.

41. Frank A. Warren III, *Liberals and Communism: The "Red Decade" Revisited* (Bloomington: Indiana University Press, 1966), p. 188.

42. Ibid., p. 180.

43. Gilbert, *Writers and Partisans*, p. 205.

44. Ibid., p. 186.

45. Ibid., p. 201.

46. For the Communist reaction to *Partisan Review*'s new line and William Carlos Williams's refusal to publish in the magazine, see Gilbert, *Writers and Partisans,* p. 193. See also Dwight Macdonald, *Memoirs of a Revolutionist* (Cleveland: Meridian Books, 1963), p. 12.

47. Gilbert, *Writers and Partisans*, p. 203.

48. Ibid., p. 161.

49. Leon Trotsky, "Art and Politics," a letter to the editors of *Partisan Review,* August–September 1938, p. 3.

50. Ibid., pp. 3–4.

51. Ibid., p. 4.

52. Ibid., pp. 8–9

53. Ibid., p. 9.

54. Ibid., p. 10.

55. See André Breton, *Entretiens* (Paris: Gallimard, 1969), p. 182, where we are told that the manifesto signed by Breton and Rivera on July 25, 1938, was actually the work of Trotsky, whose name was omitted for tactical reasons. It is amusing to note in this connection that Trotsky's letter to Breton, transmitted via *Partisan Review* and thanking Breton for his initiative, was in fact rather narcissistic. Concerning this problem see also Arturo Schwartz, *Breton/Trotsky* (Paris: Union Générale d'Editions, 1977). For Trotsky's letter to Breton, see *Partisan Review* 6, no. 2 (Winter 1939).

56. André Breton and Diego Rivera, "Towards a Free Revolutionary Art," *Partisan Review* 6, no. 1 (Autumn 1938): 50.

57. Ibid.

58. Ibid., p. 52.

59. Herbert S. Gershman, *The Surrealist Revolution in France* (Ann Arbor: University of Michigan Press), pp. 105–6.

60. See Trotsky to Breton, October 27, 1938, cited in *Writings of Leon Trotsky, 1938–1939* (New York: Pathfinder Press, 1974), p. 93.

61. Nadeau, *History of Surrealism*, p. 210.

62. Gershman, *Surrealist Revolution*, p. 108.

63. Clement Greenberg, "Avant-Garde and Kitsch," *Partisan Review*, Autumn 1939, pp. 34–49.

64. Ibid., p. 38.

65. Artists were fleeing Paris, and the vacuum left behind by this emigration was astutely analyzed by Greenberg: it was now possible for a New York avant-garde to replace the defunct avant-garde of Paris, and it was on this basis that Greenberg forged an alliance with the editors of *Partisan Review*, who had been fighting for years to create a literary avant-garde. The moment seemed propitious for the development of such a movement.

66. See the writings and letters of Trotsky and Breton cited above, notes 55, 60.

67. Greenberg, "Avant-Garde and Kitsch," p. 36.

68. Ibid., p. 35.

69. Ibid., p. 36.

70. Mass culture was analyzed by a number of intellectuals during the forties. See, for example, Louise Bogan, "Some Notes on Popular and Unpopular Art," *Partisan Review* 10 (1943): 391–401; Max Horkheimer, "Art and Mass Culture," *Studies in Philosophy and Social Science* 9 (1941), reprinted in Max Horkheimer, *Critical Theory* (New York: Seabury Press, 1972), pp. 273–90; Irving Howe, "Notes on Mass Culture," *Politics* 5 (1948): 120–23; and Milton Klonsky, "Along the Midway of Mass Culture," *Partisan Review* 16 (1949): 348–65.

71. Greenberg, "Avant-Garde and Kitsch," p. 40.

72. Trotsky, "Art and Politics," p. 4.

73. See ibid., p. 36. This idea came, as Greenberg himself mentions in note 1 of "Avant-Garde and Kitsch," from the professor and artist Hans Hofmann.

74. Greenberg, "Avant-Garde and Kitsch," pp. 48–49.

75. Ibid., p. 40.

76. As we have seen, for some this process began with the announcement of the Popular Front, continued when news of the Moscow Trials reached the West, and progressed even further with the news of the Russo-German pact of 1939. All these events were reported in different ways by the left-wing press and gave rise to polemics between *Partisan Review*, *New Masses*, *New Republic*, and the *Nation*. It should be noted that most artists could at this time be regarded as fellow travelers.

77. Malcolm Cowley (who at the time was a Marxist and defended the Stalinist cultural line against the avant-garde represented by *Partisan Review*) for once agreed with Trotsky in his suspicion of the magazine, which seemed to forget the working-class struggle. See Gilbert, *Writers and Partisans*, p. 199.

78. Ibid., p. 158.

79. In particular, the group known as "the Ten" (Mark Rothko, Adolph Gottlieb, Ben-Zion, Ilya Bolotowsky, Louis Harris, Jacob Kufeld, Schanker, Joseph Solman, Tschacbasov, and later Lee Gatch) and the AAA group connected with the "abstraction et création" movement.

80. George L. K. Morris, "Some personal letters to American Artists recently exhibiting in New York" Partisan Review, March 1938. Pp. 36–41.

81. George L. K. Morris, "American Artists' Congress and American Abstract Artists," Partisan Review, spring 1939. P. 126.

82. He was in fact closer to the Communists than he thought; cf. Vaillant-Couturier, see above pp. 18–19.

83. Greenberg, "Avant-Garde and Kitsch," p. 49.

84. Clement Greenberg, "The Late 30's in New York," Art and Culture (Boston: Beacon Press, 1961), p. 230.

85. A third of the members of the League of American Writers resigned. See Caute, Fellow Travellers, p. 189.

86. The league criticized the United States drift toward war, which it felt would mean the end of culture. See Partisan Review, June 1939.

87. Nation 149 (August 10, 1939): 228.

88. At about this time a number of works on the same subject were published: George Counts, The Prospect of American Democracy (1938); Arthur Garfield Hay, Democracy Works (1939); Alfred Bingham, Man's Estate (1939).

89. Gilbert, Writers and Partisans, p. 203.

90. Authors as different as Mike Gold and Dwight Macdonald were agreed that the wave of political consciousness and passing interest in the left was a fashion to be made use of without deluding oneself that a fundamental change of attitudes had occurred. Artists, they said, were too bourgeois, and as soon as they met with criticism or as soon as economic and social conditions improved they would quickly find their way back into the capitalist system and individualist ethic.

91. This was the case with Frederick L. Schuman, editor of Soviet Russia Today, who defended Soviet policy by saying that it had been made necessary by the refusal of England and France to defend Europe against the Nazis. Liberals like Corliss Lamont defended the pact in similar terms.

92. Norman Holmes Pearson, "The Nazi-Soviet Pact and the End of a Dream," in America in Crisis, ed. Daniel Aaron (New York: Knopf, 1952), p. 344.

93. Granville Hicks had in fact tried in vain to organize a non-Stalinist left during the fall of 1939. A group including Richard Rovere, Paul Sweezy, Robert Lynd and later Matthew Josephson and I. F. Stone met at Max Lerner's home. See Aaron, Writers on the Left, p. 388.

94. New Republic, September 22, 1939, p. 198. It should also be noted that the liberals, although allied with the Communists, did not accept the notion of class struggle. As Warren notes, "When the program was most revolutionary, during the early 30's, it was least influential among liberals. People like Bruce Bliven, Soule and Freda Kirchwey, who were sympathetic to Russia, did not accept the communist party's revolutionary program. When communism was least revolutionary, in the late 30's, it was most influential among liberals. In fact, throughout the 30's, it was not the communist party or communism as a philosophy that had the greatest impact on liberalism. It was the existence of Russia" (Liberals and Communism, p. 225).

95. Gerald M. Monroe, "The American Artists' Congress and the Invasion of Finland," Archives of American Art Journal 15 (1975): 15.

96. Meyer Schapiro signed two letters/petitions that appeared in Partisan Review in the fall of 1939: "War Is the Issue," pp. 125–26, and "A Letter to the League of American Writers," October 5, 1939, p. 127.

97. A complete list appears in Monroe, "The American Artists' Congress."

98. In his article Monroe explains the malaise that Schapiro's position engendered among artists: "Probably no more than thirty or so officially resigned, though many more did so passively. Most members were likely to be at least vaguely in support of some social change and were reluctant to publicly condemn Communists who seemed to be dedicated to serving mankind and willing to make great sacrifices for their belief. The political issues were confusing to many of the artists and any overtly anti-USSR action seemed uncomfortably reactionary" ("The American Artists' Congress," p. 17).

99. "17 Members Bolt Artists' Congress," letter to newspapers. Archives of American Art, Federation Papers. The artists concerned were Milton Avery, Peggy Bacon, Ilya Bolotowsky, Morris Davidson, Dorothy Eisner, Parla Eliosoph, Ernest Siene, Hans Foy, Adolph Gottlieb, Louis Harris, Rennee Lahm, Mark Rothkowitz (Rothko), Manfred Schwartz, Jacob Getler, the sculptor José de Creeft, and Lewis Mumford and Meyer Schapiro of the Columbia University art department.

100. Irving Sandler and Dore Ashton are among those who disagree. There were at times direct relations between Frank O'Hara and New York avant-garde artists, Arshile Gorky and André Breton, Abraham Rattner and Henry Miller.

101. Monroe, "The American Artists' Congress," p. 19.

102. Geoffrey Perret, Days of Sadness, Years of Triumph: The American People, 1939–45 (New York: Coward, McCann, 1973), p. 129.

103. Foreword of the constitution of the federation: "The purpose of this organization shall be to promote the welfare of free progressive artists working in America. It will strive to protect the artist's economic and cultural interests and to facilitate the showing of his work. We recognize the dangers of growing reactionary movements in the U.S. and condemn every effort to curtail the freedom and the cultural and economic opportunities of artists in the name of race or nation, or in the interest of special groups in the community. We condemn artistic nationalism which negates the world traditions of art at the base of modern art movements. We affirm our faith in the democratic way of life and its principle of freedom of artistic expression and, therefore, oppose totalitarianism of thought and action, as practiced in the present day dictatorship of Germany, Russia, Italy, Spain, Japan, believing it to be the enemy of the artist, interested in him only as a craftsman who may be exploited. Our organization shall be free from obvious or concealed political control. We shall admit to membership independent artists whose work has sufficient merit, irrespective of their religious or racial status, providing only that they share with us the belief in the integrity of the artist and the opposition to the oppressive forces we have named."

104. Each artist agreed to send "announcements" to clients to arouse interest in the new movement. At the first meeting a list of 700 names was drawn up and 200 announcements were sent to test the system. Federation of Modern Painters and Sculptors, Meeting of November 4, 1940, Archives of American Art, N 69/75.

105. The impression one gets from reading the federation archives is of repeated attempts to beat the American Artists' Congress on its own ground. The Communists were the favorite target, particularly Hugo Gellert, head of Artists for Victory. See "Report of the City Coordination Committee," FMPS Coordination Committee Meeting, April 25, 1941: "Attempt to keep us out of everything on Gellert's part. . . . Methods used were typical Congress methods—many members are unaware of the political implications of the city coordination committee."

106. The House-Senate Coffee-Pepper bill proposed combining four artistic programs into a single continuing program of federal aid to the arts. The bill was defeated in Congress because a majority favored art work done individually, independently, and freely. There were also fears of political controls resulting from such a program. Arthur F. Brinckerhoff, president of the Fine Arts Federation explained this in House Committee on Patents, Department of Science, Art and Literature, Hearings, 75th Cong., 3d sess. (Washington, D.C.: Government Printing Office, 1938) pp. 71–73.

107. Arthur A. Ekirch, Jr., *Ideologies and Utopias: The Impact of the New Deal on American Thought* (Chicago: Quadrangle, 1971), pp. 156–57.

108. Cited in Edward Alden Jewell, *Have We an American Art?* (New York: Longman, 1939), pp. 41–42. Things were quite different in 1946 when American films were imposed on France as a result of the Byrnes-Blum agreements, which destabilized the French film industry.

109. Jewell, ibid., p. 31.

110. Ibid., letters sent to Jewell at the *New York Times* and reproduced in his book, pp. 128–29. "Our modern civilization is an international civilization. The modern artist must ignore petty loyalties and conceive of himself as a part of one of the international systems of political thought that will eventually dominate the earth: one leading to nationalism and thus barbarism and international conflict in the cause of nationalistic supremacy, the other to some form of international collectivism—the rather trite phrase 'citizen of the world' fairly well describes the new and inevitable role of the modern artist. We must accept the fact that we as a nation were born too late for the development of an 'American Art,' and that the world of today opens the way to a new art and to a new school: the International school."

111. Forbes Watson, *American Painting Today* (Washington, D.C.: American Federation of Arts, 1939), p. 15.

112. Paul Sachs, *Museum of Modern Art Bulletin* 6, no. 5 (July 1939); cited in Russell Lynes, *Good Old Modern: An Intimate Portrait of the Museum of Modern Art* (New York: Atheneum, 1973), p. 200.

113. What the Museum of Modern Art was seeking was European rather than American art, in spite of repeated protests by such American groups as the AAA and the federation.

114. Elaine de Kooning had this to say: "Around 1940, almost everyone had a change of mind concerning his work. The W.P.A. in 1939–40 was going to pieces and most artists quit rather than make posters which is what they were asked to do." From an interview with Elaine de Kooning by Francis Celentano. See his "The Origins and Development of Abstract Expressionism in the United States" (Masters thesis, New York University, 1957), p. vii.

Sanford Pollock is also informative on the pressures put on artists (in particular on Jackson and himself) working for one program or another under the auspices of the WPA: "They are dropping people like flies on the pretense that they are Reds, for having signed a petition about a year ago to have the C.P. put on the ballot. We remember signing it so we are nervously awaiting the axe. They got 20 in my department in one day last week. There is no redress. The irony of it is that the real Party People I know didn't sign the damn thing and it is suckers like us who are getting it" (Letter from Sanford to Charles Pollock dated October 22, 1940, cited in Francis V. O'Connor, *Jackson Pollock* [New York: Museum of Modern Art, 1967], p. 25).

115. Although the federation's program was rather ambiguous, it emphasized not only the modern character of the group (meeting of September 15) but also the importance of the individual as well as electicism of the sort Trotsky referred to in his letter to Breton: "The Federation wants to stress that no art is modern, only contemporary. That individual expression of each artist is what counts" (Federation Papers, Meeting of July 7, 1941).

116. Discussed in the course of the meeting of the Cultural Committee on December 1, 1941 (Gottlieb and Rothko, chairmen). "Protest letter read, sent to critics, on Carnegie and Whitney shows. Policy of Cultural Committee is to send protest letters whenever required [with the marginal notation, as though an afterthought: "as well as letters of praise and agreement"]. Proposed that we give shows of portraits of artists—or portraits of important people [at some gallery]" (Federation Papers).

117. Discussed at general meeting of September 15, 1941: "Tent show discussed, it should draw great crowds and we should make money if we charge a small sum as entry fee. Suggested we have lots of advance publicity featuring the *Modern* aspect of our particular

group (about 45,000 attended the 1st Sculptor guild out of door show). Rent for 4 weeks, $280 tent. This includes everything, labor, construction, lighting, 102 paintings can be accommodated" (Federation Papers).

118. The director of United American Artists was Rockwell Kent, and the editors of the magazine were Jack Tworkov (chairman), Harold Amebellan, Robert Cronbach, Ruth Chaney, and James Lechay.

119. Editorial, *New York Artist* 1, nos. 3–4 (May-June 1940): 3. The layout had been designed by Ad Reinhardt.

120. Ad Reinhardt interviewed by Francis Celentano, September 2, 1955; Celentano, "Origins and Development," p. xi.

Chapter 2

1. Editorial, *Shreveport (La.) Times*, June 1940. Cited in William A. Lydgate, *What America Thinks: Editorials and Cartoons* (New York: Thomas Crowell, 1944), p. 1297.

2. "Christianity Fights for Life," *Daily Oklahoma* (Oklahoma City, Oklahoma), April 14, 1940, cited in ibid., pp. 1001–1003.

3. Henry A. Wallace, "The Price of Free World Victory," May 8, 1942, cited in Edward and Frederick Schapsmeier, *Prophet in Politics: Henry A. Wallace and the War Years* (Ames, Iowa: Iowa State University Press, 1970), p. 32.

4. Cited by William Appleman Williams, "The Large Corporation and American Foreign Policy," in *Corporations and the Cold War*, ed. David Horowitz (New York: Modern Reader, 1970), p. 91.

5. They explained their position in "Ten Propositions on the War," published in *Partisan Review*, July–August 1941, pp. 271–78.

6. Harold Rosenberg, "On the Fall of Paris," *Partisan Review* 7, no. 6 (December 1940): 441. Rosenberg was then a writer/poet who signed the Trotskyite manifesto "War Is the Issue," in the fall 1939 issue of *Partisan Review*.

7. Ibid., p. 442.

8. Editorial, *Plaisir de France*, July 1939, special issue on the New York World's Fair.

9. Ibid.

10. Rosenberg, "The Fall of Paris," p. 448.

11. Ibid., p. 445.

12. Archibald MacLeish was Librarian of Congress. In 1941 he wrote *American Cause*, which continued his attack on intellectuals who had not been mobilized in support of the war effort.

13. Archibald MacLeish, "The Irresponsibles," *Nation* May 18, 1940, pp. 618–23.

14. Ibid., pp. 224–25.

15. For a discussion and critique of this episode, see Macdonald, "Kulturbolshewismus and Mr. Van Wyck Brooks," in *Memoirs of a Revolutionist*, pp. 203–14. This article was originally published in *Partisan Review*, November–December 1941. In it, Macdonald adopts the term "degenerate art" first given currency by Hitler.

16. James T. Farrell, "On the Brooks-MacLeish Thesis," *Partisan Review*, January–February 1942, pp. 38–47.

17. Macdonald, *Memoirs of a Revolutionist*, p. 213.

18. Gilbert, *Writers and Partisans*, p. 228.

19. Ibid., p. 229. Many writers were opposed to MacLeish but at the same time very suspicious of Macdonald and his revolutionary proposals. MacDonald opposed the war in the pages of *Partisan Review* until 1943, when after a dispute with Rahv and Phillips he left the *Review* to found his own magazine, *Politics*.

20. In fact Washington had long been in the running to become the new intellectual capital of the world. In the very first issue of the monthly journal *Right Angle*, published in 1947 by the fine arts department of the American University of Washington, the well-known diarist Caresse Crosby explained that Washington had hoped to become the world's

leading city during the war. Shortly after the war ended, however, she reported that "Washington is out of the big league, it is back in the Styx—or nearly so" (p. 5). Crosby herself ran an art gallery in Washington from 1943 to 1946. The hope of seeing Washington become a world art capital lingered on in the mind of another gallery director, James H. White, who in the second issue of *Right Angle* (April 1947) wrote that "Washington can yet become the artistic capital of this country and a challenge to the rest of the Nation. What we need now above all is faith—faith in our own potentialities in the future" (p. 4).

21. To borrow from the title of Robert A. Divine's *Second Chance: The Triumph of Internationalism in America During World War II* (New York: Atheneum, 1967), which describes America's failure to become an unchallenged world leader after the First World War.

22. Some of these caricatures dated back to 1914 and were revived for the Second World War, suggesting that Germans were hereditary brutes.

23. See Pleynet, *Art et littérature*, p. 239.

24. "Modernism" was the name given to an art tradition that originated in Paris and was sponsored in the United States by the Museum of Modern Art. It was a tradition that followed in the wake of Manet's avant-garde and gave expression to modern life in a way that the American "establishment" found hard to assimilate, despite the impact of the 1913 Armory Show. In the United States "modern art" stood for an art that was hard to understand, elitist, European, and provocative. Burned by the ridicule heaped on those who had attacked the Armory show, American critics found themselves in a difficult situation. They therefore set out to accept modernism but in so doing to alter it, Americanize it, empty it of its explosive content.

25. "Buy American Art," p. 6, text published for Buy American Art Week (November 25–December 1, 1940).

26. The *MOMA Bulletin* reports that the number of museum members doubled in 1940. From 3,110 it rose to 6,846 by April and to 7,309 by July. In order to tap into this growing interest President Roosevelt called upon "Thomas J. Watson, president of International Business Machines Corporation and number one salesman of the U.S. business world" (*Time*, December 8, 1941) to launch the second campaign.

27. The WPA program ended in 1943.

28. *Time*, December 9, 1940, p. 59.

29. Rebroadcast by NBC on November 24, 1940.

30. Transcription of radio program, p. 10. Despite the enthusiasm of the participants, they still harbored some doubts as to the homogeneity of American culture. MacLeish and Roosevelt had the foresight to add a few words intended to bring unhappy dissidents back into the fold:

WIRTH: Should artists express honestly whatever they feel even though it be unpopular, radical and revolutionary?

ROOSEVELT: Of course. That is what we should all do when we feel it.

FADIMAN: We should indeed. We have natural democratic checks and processes upon people who do go too far.

31. Following the attack on Pearl Harbor, James Thrall Soby became director of the Armed Services Program at the Museum of Modern Art. During the war years the museum signed thirty-eight contracts with the Office of War Information for a sum total of $1,590,234. For further information see Lynes, *Good Old Modern*, pp. 236–38; and Cockroft, "Abstract Expressionism," pp. 39–41.

32. Byron Browne, *New York Times*, August 11, 1940, section 7, p. 6.

33. George Biddle, "Can Artists Make a Living? How the Market for Art Is Changing," *Harper's* 181 (September 1940): 397.

34. Clarence Streit's book was conceived in 1933 but not published until 1940. Cited in Divine, *Second Chance*, pp. 38–39.

35. Henry R. Luce, "The American Century," *Life*, February 17, 1941, pp. 61–65.

36. Ibid., p. 63.

37. Ibid., p. 64.

38. Ibid., p. 65.

39. Commentary by Dorothy Thompson, *New York Times*, February 21, 1941, reprinted in *The American Century*, edited by Luce Henry Robinson (New York: Farrar and Rinehart, 1941), p. 46.

40. Commentary by Quincy Howe on radio station WQTR, February 17, 1941. Published in *The American Century*, p. 52.

41. Roosevelt and Churchill were making preparations toward the same end at the Newfoundland Conference.

42. Dwight Macdonald, "The (American) People's Century," *Partisan Review*, July–August 1942.

43. Gilbert, *Writers and Partisans*, p. 230.

44. Melvin Hildreth in *Changing World*, September 1943, cited in Divine, *Second Chance*, p. 100.

45. Cited in John Morton Blum, *V Was for Victory: Politics and American Culture during World War II* (New York: Harcourt Brace, 1976), p. 275. The American Legion also favored participation at this time: see Divine, *Second Chance*, p. 133.

46. See Bernard Bailyn and Donald Fleming, eds., *The Intellectual Migration: Europe and America, 1930–1960* (Cambridge, Mass.: Harvard University Press, 1968); Charles John Wetzel, *The American Rescue of Refugee Scholars and Scientists from Europe, 1933–45*; Varian Fry, *Surrender on Demand* (New York: Random House, 1945). *Partisan Review* also attempted to come to the aid of European intellectuals. The Museum of Modern Art saved a number of artists through the International Rescue Committee; for details, see Lynes, *Good Old Modern*, pp. 231–33. Louis Aragon reports that Matisse was invited to the United States by the committee but turned down the offer: see his *Henri Matisse* (Paris: Gallimard, 1971).

47. See note 20 above.

48. John Peale Bishop, "The Arts," *Kenyon Review* 3 (Spring 1941), pp. 179–90. Bishop was not a nationalist. A specialist in French culture, he was a poet and editor of *Vanity Fair*.

49. Editorial, *Art News* 1, no. 14 (October 1941): p. 2.

50. James T. Soby, catalog for the Artists in Exile show held at the Pierre Matisse Gallery from March 3 to March 28, 1942 (unpaginated).

51. A native of Virginia and student of law, Samuel Kootz was a connoisseur of the American modern art that was shown at Stieglitz's gallery in the twenties. In 1934 he worked for a silk manufacturer. During the forties he worked in public relations for the film industry. He made a name for himself in the art market with Baziotes and Motherwell as his protégés.

52. Kootz's letter to the *New York Times* is cited in Edward Alden Jewell's article, "The Problem of Seeing," *New York Times*, August 10, 1941, section 9, p. 7.

53. Samuel Kootz, *Modern American Painters* (New York: Brewer and Warren, 1930), treats such artists as Marin, Sheeler, Dove, Hartley, and Weber.

54. Interview with Samuel Kootz by Dorothy Seckler, April 13, 1964, in the Archives of American Art.

55. Kootz had sent an earlier letter to the *New York Times*, published on December 20, 1931, in section 8, p. 11, under the title "America über Alles." Concerning this letter, see Irving Sandler, *Triumph of American Painting*, p. 42, n. 10.

56. The Museum of Modern Art was interested almost exclusively in modern European art, while the Metropolitan was interested in contemporary academic American art. Hence

American modern artists were cast off the summits of Olympus. The federation reacted vehemently with a letter to the *New York Herald Tribune* published on November 25, 1941:

> Much publicity has been given to the so-called new opportunities that have come to the younger artists via this season's Carnegie and Whitney exhibitions. One writer's picture of "doors opening—of new life that comes pulsing in" is indeed an exciting one. We wish, however, in the interest of creative artists to make some comments on the subject. At the Carnegie "Directions of American Painting," the idea was apparently warped by its jury and so it was disturbing to see so large a quantity of framed commercialisms underscored. . . . Our acquaintance with a portion of the rejected paintings leads us to be certain that an "exhibition of the rejected" would reveal enough genuine artists to fully justify the experiment. . . . Perhaps it is not too late. . . . The genuine but unheralded artist still waits and hopes for "that door to open." The publicized valiant effort to discover the younger artist under forty, or over, seems to us, no more than a perfect trompe l'oeil.

57. "During the past year I have from necessity communicated a great deal with museum people. I have come to know them a bit better and it is truly astonishing how remote they are from contemporary art values. I have a number of letters from museums, and two from the Metropolitan particularly, one from Taylor and one from Wehle, which are astonishing in their academic snobbery and frankness" (letter from Stuart Davis to Emily Genauer, August 25, 1940, Emily Genauer Papers, Archives of American Art).

58. Sandler, *Triumph of American Art*, p. 32.

59. Seventy-two artists were represented, including Davis, Avery, Morris, Holty, Graham, Matulka, Gorky, Rothko, Gottlieb, and Browne.

60. Peggy Guggenheim, *Art of This Century: Informal Memoirs* (New York: Dial Press, 1946), and *Confessions of an Art Addict* (New York: Macmillan, 1960).

61. Aline Saarinen, *The Proud Possessors* (New York: Random House, 1958). Along with its defense of creativity the gallery took a dramatic stand against the fascist slaughter of the Jews.

62. Press release published by the gallery in October 1942, Guggenheim folder, New York Public Library.

63. Interview with Peggy Guggenheim in the *Trenton (N.J.) Times*, November 6, 1942, Archives of American Art, N-253.

64. It was also important that works by American artists were shown alongside works by established French artists. In an interview with Dorothy Seckler, Lee Krasner recalls how impressed she was to see one of her works hung between a Picasso and a Léger (November 2, 1964, Archives of American Art, p. 10). The more prestigious the names with which her work was associated, the more important it seemed. Krasner was referring to the MacMillen show, held in 1942, which also featured works of de Kooning, Pollock, and Graham. Guggenheim liked to tell how with this system a collector who came to her gallery to buy a Picasso sometimes left with a Motherwell.

65. Cited in Saarinen, *The Proud Possessors*, p. 336.

66. Barnett Newman Papers, Archives of American Art. On the prospectus/catalog for the American Modern Artists show the following words were written by Mrs. Newman: "This was a protest show against the Metropolitan Museum exhibition Artists for Victory 1942. This foreword written by Barnett Newman 1943." One hundred fifty-nine works by ninety-five painters were presented, including works by Avery, Browne, Constant, Gottlieb, Greene, Graham, Krasner, Margo, Rothko, Shanker, Spagna, and Ceron.

Newman was a popular figure of the avant-garde. An "underground" hero, he, unlike Gorky, had political connections. Admiration for his was only increased by the independence he showed by not participating in the American Artists' Congress. Newman preached anarchism and in 1933 ran for mayor of New York on a platform calling for artists to be

integrated into public life (for details see Thomas B. Hess, *Barnett Newman* [London: Tate Gallery, 1972], pp. 13–14). An intellectual, he became the theorist of the avant-garde without losing any of his anarchist convictions, which led him to approve of romantic individualism.

67. See the list of prize-winning painters in *Art News*, January 1–14, 1943, pp. 8–10.

68. In the general meeting of September 15, 1941, the federation had already considered copying the tactics of the French avant-garde. The possibility of holding a tent show was discussed (see chap. 1, n. 117). In the second annual Wildenstein Gallery catalog the group drew a parallel between its own activities and those of the French artists' federation in 1871, defending the painter who threw himself into his work while war raged around him:

The early get-togethers of this new generation were equally stormy. The world was already badly shaken, invading forces were trampling the lowlands of Belgium, Holland collapsed between meetings and France was doomed as well. The artists with visions of tomorrow felt the repercussions as strongly as though they were only yards away. There were those present who insisted on the immediate formation of a political unit in view of the growing emergency but eventually another course was taken. Each and every man was to perform his social obligation to keep and protect freedom. Their Federation was to stand for the kind of artistic independence the world struggle symbolized.

See the Federation Papers in the Archives of American Art.

Art News for June–July 1942 published a response to this text by the critic Doris Brian:

Like [the 1871 federation], the present Federation wishes guarantees of complete freedom for the artist. But if one can judge from the temper of their work, by no means necessarily a criterion, members of this Federation are probably a calmer lot. We just can't imagine any of them gesturing against symbol by pulling down a U.S. equivalent of the Vendôme column as did the communards in '71. . . . But in the majority of the exhibits a middle course is maintained in subject matter and technique. It is after all, to insure the right of survival of just such art, which has no other purpose than to please the spectator and to improve its own methods, that an organization like the Federation has its raison d'être. (p. 21)

69. Introduction to catalog to first group show of American Modern Artists at Riverside Museum, January 1943.

70. See note 66.

71. Edward Alden Jewell, "New Artists' Group Opens First Show: Attempt to 'Clear Cultural Atmosphere for Future Art Center of World,' " *New York Times*, January 19, 1943, p. 24. Jewell's description of the show throws some light on what kinds of painting were being shown: abstract and expressionist. "The work," he writes, "is installed in several galleries on the first and second floor of the Museum. One of them is devoted almost entirely to non-objective abstractions. Aside from these, the paintings are very largely expressionists."

72. Byron Browne show at the Pinacotheca, March 15–31, 1943.

73. Byron Browne was known because he had helped Rosalind Bengelsdorf set up the AAA. A friend of Gorky and Graham, he was one of the best modern artists in New York and was very popular. Concerning the AAA, see Susan C. Larsen, "The American Abstract Artists: A Documentary History, 1936–41," *Archives of American Art Journal* 14, no. 1 (1974): 2–7.

74. Introduction by Samuel Kootz to the catalog for the Byron Browne show at the Pinacotheca.

75. In 1951 Samuel Kootz gave his entire stock of Byron Browne paintings to Gimbel's to be sold in bulk at cut rates. The artist never recovered from this "dumping" of his work. Author's interview with Rosalind Bengelsdorf-Browne, New York, February 12, 1978.

76. Introduction to Samuel Kootz, *New Frontiers in American Painting* (New York: Hastings House, 1943), p. 5.

77. Ibid., p. 6.

78. For example, the Cultural Committee (Rothko and Gottlieb) sent a protest letter to the papers in regard to the Carnegie and Whitney shows: letters were sent to the *Evening Sun* (published on February 2, 1942, under the title "Modern Museum Accused of Laxity") and to *Art Digest* (published on January 1, 1942, p. 14, under the title "Artists in Defense"). They also attempted to establish a private market by drawing up a list of people who might be interested in buying their work. Letters were sent to about a hundred people, including Cornelius Bliss, Chester Dale, Conger Goodyear, Samuel Lewisohn, Nelson and John D. Rockefeller, Edward M. Warburg, Lloyd Goodrich, Alfred Barr, and Dean Acheson.

79. Statement by the Coordinating Committee to the members of the federation, November 12, 1941, Archives of American Art.

80. See Salvador Dali, *Comment on devient Salvador Dali* (Paris, 1973).

81. Letter sent to the papers by the federation on the occasion of their third show at the Wildenstein Gallery, June 2–26, 1943. The original text read as follows: "We condemn artistic materialism" (Archives of American Art, FMPS file). Materialism was later crossed out and replaced by the word nationalism. The slip and correction say a great deal about the position of the group, which was opposed to both political extremes.

82. Edward Alden Jewell in the *New York Times*, June 6, 1943, part 2, p. 9.

83. *New York Telegram*, March 15, 1943, unsigned, Federation Papers, Archives of American Art.

84. American critics developed a fear of being held up to ridicule after their rejection of the Armory Show.

85. Edward Alden Jewell, "Globalism Pops into View," *New York Times*, June 13, 1943, section 2, p. 9. The strategy worked so well that in 1944 Gottlieb received the annual prize of the Brooklyn Museum.

86. They differed from the surrealists in that they rejected the incorporation of any political viewpoint into their art or their ideology. See Ashton, *The New York School*, pp. 121–25.

87. Not only Jewell but other art critics, too, missed the ideological significance. For example, it is clear that the liberal critic Breuning did not understand the tactics being used: "There is a further affirmation of belief in democracy and its 'principles of freedom of artistic expression.' No one would doubt the soundness of this political credo but many of us would be bewildered to discover any example of past or present interference with 'artistic freedom.' . . . 'Progressive' seems to me an extremely illogical term to apply to any of its forms. And as to 'static academic art' if any of the exhibitors in this group would visit a current showing of the Academy, they would find in the exhibition as much life, sprightliness and freshness of ideas as in their group showing" (see Margaret Breuning in *Smart-Set New York*, March 23, 1941, p. 10).

88. As historians of this period have noted, this new strength was not unrelated to the impact of professional artists from Europe.

89. Letter sent by Gottlieb and Rothko to the *New York Times*, June 7, 1943.

90. These galleries were intended to provide a haven for pure creative work, cut off from politics and from daily pressures, a place where the artist could work and not have to justify what he was doing.

91. Their hatred of the museums was not only deeply felt but also part of a strategy intended to win recognition of their work as modern painters by the Museum of Modern Art, the symbol of international modern art. Acceptance by the MOMA was the one sign

of distinction required to be recognized as "modern." The New York avant-garde was not fighting to change and replace accepted values or to dismantle an existing social system but rather to be recognized within the framework of current values.

92. Francis H. Taylor, director of the Metropolitan Museum of Art from 1940 to 1954, referred to the Museum of Modern Art as "that whorehouse on Fifty-Third Street." Cited in Lynes, *Good Old Modern*, p. 250.

93. Despite some internal dissension, Alfred Barr, aided by Nelson Rockefeller, managed to follow a modernist line. See Lynes, *Good Old Modern*; and Dwight Macdonald, "Profile: Action on West Fifty-third Street," *The New Yorker*, December 12, 1953, pp. 49–82.

94. Stuart Davis, "What about Modern Art and Democracy?" *Harper's*, 188 (December 1943), p. 37. In this article Davis attacked the "renaissance" extolled by Biddle as being patronized by "big business." This was his response to George Biddle, "The Victory and Defeat of Modernism: Art in a New World," *Harper's* 187 (June 1943): 32–37. On the subject of anti-isolationism, see Barnett Newman, "What about Isolationist Art?" (1942), cited by Hess in *Barnett Newman*, pp. 20–22.

95. This was outside the context of surrealism because it was too antihistorical and antipolitical, even if Breton, repeatedly disappointed by his relationship with the Communist party, was at this time also taking up an ahistorical position which ultimately led him into mysticism.

96. Gottlieb and Rothko, letter to the *New York Times*, June 7, 1943.

97. Ibid.

98. Ibid.

99. Edward Alden Jewell, "The Realm of Art: Current Activities," *New York Times*, June 27, 1943, sec. 2, p. 6.

100. Ibid.

101. See especially Meyer Schapiro, "The Nature of Abstract Art," *Marxist Quarterly* 1 (January–March 1937): 78–97. Also see Delmore Schwartz's answer, "A Note on the Nature of Abstract Art," pp. 305–10, and Schapiro's comments, ibid., pp. 310–14.

102. Ashton, *The New York School*, pp. 161–63.

103. Letter from Robert Motherwell to William Baziotes, Amagansett, September 6, 1944 (William Baziotes Papers, Archives of American Art, N 70/21, no. 139). In this letter Motherwell warned Baziotes of the danger of associating with certain surrealists, whom he considered too nihilistic and cynical:

And I beg you to break with the young Surrealists David, Michel, Catherine, Jacqueline and the whole crowd—this can only confuse you—and they are cynical, ignorant and sterile. If I did not greatly care about you, I would say nothing, but one of the things you least understand—if I may say so—is how to make your energy productive, and one of the chief ways of doing this is to remain only in milieus which make you *want* to paint. The Reis Surrealist milieu is the precise opposite of this, and you ought to be strong enough to resist them.

104. Robert Motherwell, "The Modern Painter's World," *Dyn* 6 (November 1944): 9. Text of a lecture "Pontigny in America," given at Mount Holyoke College, August 10, 1944.

105. See Meyer Schapiro's "The Social Bases of Art," paper given at the First American Artists' Congress, New York, 1936.

106. Ibid., pp. 9–10.

107. In his letter to Baziotes (see note 103), Motherwell focused on the strategies to adopt in order to be able to paint and to be productive: "If you are going to do the first [go to France], you ought to do certain things, from a strategic point of view—which I will tell you about when I see you."

108. Motherwell, "The Modern Painter's World," p. 13.

109. Ibid., p. 14.

110. Clement Greenberg, "Surrealist Painting," *Nation*, August 12, 1944, p. 192.

111. Motherwell, "The Modern Painter's World," p. 14.

112. Robert Motherwell, "Painter's Objects," *Partisan Review* 11, no. 1 (Winter 1944): 93–97.

113. Ibid., p. 95, Wallace Stevens, "The Poems of our Climate":

> Say even that this complete simplicity
> Stripped one of all one's torments, concealed
> The evilly compounded, vital I
> And made it fresh in a world of white.
> A world of clear water, brilliant-edged,
> Still one would want more, one would need more,
> More than a world of white and snowy scents.

114. Ibid., p. 95.

115. Ibid., p. 96.

116. Sweeney had a long relationship with the MOMA (for which he wrote three catalogs between 1935 and 1943). He was a member of the museum's Advisory Committee and in 1945 became director of the painting and sculpture department, a key position in the world of modern art (see Lynes, *Good Old Modern*, pp. 270–75). He resigned from this post in November of 1946, to the great detriment of artists.

117. See the chapter entitled "Fired" in Lynes, *Good Old Modern*, pp. 240–63. Barr organized the show of the work of naive painter Morris Hirshfield, catalog by Sidney Janis. In 1942 Barr staged a show around a shoeshine stand decorated by its proprietor, Joe Milone (who had been discovered by Louise Nevelson).

118. B. H. Friedman, *Energy Made Visible: Jackson Pollock* (New York: McGraw, 1972), p. 71.

119. James Johnson Sweeney, cited in ibid., p. 59. Introduction to the first Pollock show at Guggenheim's Art of This Century Gallery, November 9–27, 1943.

120. Clement Greenberg, "Art," *Nation*, November 3, 1943, pp. 565–66.

121. Clement Greenberg, "Art," *Nation*, November 11, 1944, p. 598. Manny Farber, critic for the *New Republic*, described Motherwell's work in similar terms. He was struck by the dissonant character of a number of compositions: "Some of his designs look like those public playgrounds where four or five ball games are carried on at once." Farber also emphasized the modernity of Motherwell's work as well as what he called its "reality":

> A nobility of craftsmanship is evident in the crisp, sure manner of brushing on paint, in the brashness of the statements which lack worry, meanness or deadness, and in the willingness to show everything he has done, whether it is good, bad or indifferent.

All this was always presented in a positive light:

> I think it has been true of Western art that it has felt a necessity to be far too harmonious, which has a tendency to kill the life in individual forms by subjecting them to the domination of the harmonizing idea. . . . Probably the most likable characteristic shared by them is their over-all good cheer, their lack of inhibition, and a valuable recklessness mixed with a good common sense about painting.

See Manny Farber, "The Art of Contrast," *New Republic*, November 13, 1944, p. 626.

122. Letter from Sanford Pollock to Charles Pollock, May 1940, cited in O'Connor, *Jackson Pollock*, p. 24.

123. James Johnson Sweeney, in his article "Five American Painters" (*Harper's Bazaar*, April 1944, p. 126), an article written to introduce the artists and to instruct the public, explained that Pollock's paintings gained strength from being antiharmony:

Harmony would never be a virtue in his work. An attempt to achieve it would necessitate toning down all his expression and lead to its final emasculation. . . . He has power and curious animal imagination.

Sweeney also stated his view of what the new American artist should be:

Each of these men in his vitality, individuality of outlook, and present freedom from obvious debts to his predecessors, holds the promise of a new and encouraging phase of American art. We all recall the illustrative, social, political and historical character which dominated government-subsidized painting and even spread to independent efforts among the young artists throughout the 1930's.

124. Cited in O'Connor, *Jackson Pollock*, p. 34. See Sidney Janis, *Abstract and Surrealist Art in America* (New York: Reynal Hitchcock, 1944).

125. Lee Simonson, "Viewpoints: Post War Painters and Patrons," *Magazine of Art* 36 (February 1943): 52.

126. *MOMA Bulletin*, 1941.

127. *MOMA Bulletin*, 1942.

128. Road to Victory show catalog, Museum of Modern Art Library. The show traveled through South America, accompanied with text in Spanish, with help from Nelson Rockefeller's Office of Inter-American Affairs. Cited in *MOMA Bulletin*, 1943. See also Peter Collier and David Horowitz, *The Rockefellers: An American Dynasty* (New York: Holt, Rinehart, 1976), pp. 227–43.

129. Cited in *MOMA Bulletin*, 1943.

130. Artists like de Kooning, Clyfford Still, and Arshile Gorky tried the experiment. Still's works were shown in a number of shows and exhibitions in 1944. De Kooning was used in an ad placed in *Fortune* by the Container Corporation of America extolling its cardboard boxes; his contribution was an expressionistic Dutch landscape (see *Fortune*, January 1945). He was also featured in "Modern Art in Advertising," Art Institute of Chicago, 1945, catalog no. 57. From *Art News*, August–September 1942, we learn that the MOMA held a show of "practical abstract works" featuring rugs designed by various artists: "Arshile Gorky, ferocious black figure like a Lipchitz, bull in silhouette, which makes the most dashing rug in the show." The show also featured works by Stuart Davis, John Ferren, I. Rice Pereira, and Loren MacIver.

131. See Francis E. Merrill, *Social Problems on the Home Front* (New York: Harper, 1948), p. 232; Blum, *V for Victory*, p. 91.

132. Joseph C. Goulden, *The Best Years, 1945–50* (New York: Atheneum, 1976), p. 93. See also Conrad Alexander Blyth, *American Business Cycles, 1945–1950* (London: Allen and Unwin, 1969), p. 61: "For 3 ½ years, 1942 to mid-1945, the U.S. economy was operated at full capacity to produce large quantities of goods and services for war while still maintaining high standards of civilian consumption. Taxation and patriotic saving reduced private spending, supplemented by a wide range of direct controls over production, purchases, wages and prices. Unemployment declined in 1944 to 2% of the civilian labour force. Residential construction and production of consumer durables virtually ceased. The gap between consumer aspiration and fulfillment grew as household purchasing power rose. The effect of these reduced and retarded purchases was that during the 4 years 1942–45, personal consumption was below normal by amounts which totaled about $95 billion at the end of 1945 (at 1945 prices)."

133. Blum, *V for Victory*, p. 98. On the third anniversary of Pearl Harbor Day, December 7, 1944, Macy's staged the largest sale in its history.
134. On inflation see ibid., pp. 226–29.
135. Information based on data in *Fortune*, September 1946, p. 144. This new boom was what depressed Clement Greenberg. In an article in the *Nation* (February 23, 1946) about the 1946 Whitney annual, readjusting his argument of avant-garde and kitsch to postwar American culture, he lamented the subtle vulgarization of the contemporary cultural sphere:

> The middle class in this country—though swelled by war prosperity with millions of new recruits who may be no easier to assimilate culturally than the previous 1918–1928 wave—is now surging toward culture under the pressure of anxiety, high taxes, and a shrinking industrial frontier. All this expresses itself in a market demand for cultural goods that are up to date and yet not too hard to consume. . . . This state of affairs constitute a much greater threat to high art than Kitsch itself—which usually keeps the distinction'clear. The demand now is that the distinctions be blurred if not entirely obliterated, that is, that the vulgarization be more subtle and more general. . . .
>
> The future of art and literature will brighten in this country only when a new cultural elite appears with enough consciousness to counterbalance the pressure of the new mass market. The other alternative is socialism, of course—but right now who talks of socialism in America? (p. 241)

136. Eugenia Lea Whitridge, "Trends in the Selling of Art," *College Art Journal* 3, no. 2 (1944): 58.
137. Jean Baudrillard, *Pour une critique de l'économie politique du signe* (Paris: Gallimard, 1972), pp. 76–77.
138. Aline B. Louchheim, "Who Buys What in the Picture Boom?" *Art News*, July 1, 1944, p. 23.
139. Ibid., p. 14. Ironically, the reason for the change in the art world was the liquidation sale of art from WPA studios: "Paintings from the W.P.A. Project were sold for a few dollars each at a secondhand shop in New York in 1944. Purchased from a government warehouse for four cents a pound after the liquidation of the project they represented the work of numerous artists during the depression years" (*1945 Britannica Book of the Year*, p. 72).
140. Aline Loucheim, "Second Season of the Picture Boom," *Art News*, August 1945, pp. 9–11.
141. Cited in *Newsweek*, June 28, 1943, p. 82.
142. Ibid.
143. Blum, *V for Victory*, p. 102. As Blyth correctly notes, however, Congress passed laws that helped the housing industry considerably. The Housing Act of 1948 (signed on August 10) liberalized the program of loans for low-cost construction. On April 2, 1948, Congress overrode a presidential veto and approved the Revenue Act of 1948, cutting taxes and increasing personal deductions: "Not only did this benefit buyers of new homes, but with rents continuing their rise, the profitability of speculative building increased throughout 1949" (see Blyth, *American Business Cycles*, p. 126).
144. Goulden, *The Best Years*, p. 139. Initially, the program goal as well as the needs of the country pointed toward a major increase in home construction, but the results were inadequate and concentrated mainly in the area of luxury housing. See Barton J. Bernstein's article in *The Truman Years: The Reconstruction of Post War America*, ed. Joseph Hathmacha (Hinsdale, Illinois: Dryden Press, 1972), p. 119.
145. Jean Baudrillard, *La société de consommation* (Paris: Gallimard, 1970), should be cited here:

The domain of consumption is socially structured. Not only goods but needs themselves as well as various cultural traits are conveyed from a model group, a guiding elite, to other social groups as these groups "rise" relative to others in the hierarchy. . . . Innovation takes place at the top, in reaction to the devaluation of previously distinctive signs and in order to restore social distance. (pp. 82–83)

In this connection, it is worth noting a May 1946 *Art News* article entitled "Broker Buys American" analyzing the motives of stockbroker Roy Neuberger in collecting art:

Confining his investment theories to stocks and bonds, Mr. Neuberger alleges neither interest nor illusions about his paintings as gilt-edged securities. He thinks of them as an intellectual investment, and receives dividends in the form of recognition by others in the art world. He "gets a kick" out of having his judgment reinforced by reproductions in newspapers and art magazines, by acknowledgments from museum directors of his paintings' popularity on their frequent loan appearances, and by such a compliment as *Fortune* magazine's choice of his Ralston Crawford for its November 1944 cover.

146. "Department Stores Popularize Art," *Life*, January 3, 1944, pp. 44–47.

147. *Harper's Bazaar*, April 1944. It is interesting to note that in 1944 the majority of collectors were wives of industrialists and lawyers.

148. Baudrillard has written some brilliant pages on the process of status differentiation, which support our argument and are worth citing at length. The second passage is relevant to understanding the period of frantic consumption that began in 1944, consumption in which painting and art in general were caught up.

Status differentiation, a fundamental social process whereby each individual takes his place in society, has both a subjective and a structural aspect, the one conscious, the other unconscious, the one ethical (involving the morality of deference, status competition, and prestige ranking), the other structural: the individual comes to be subjected, for good, to a code of behavior in which the rules of significance and structure are beyond his reach, much as the rules of a language are. (*Société de consommation*, pp. 78–79)

The difference—which is of fundamental importance—between aristocratic potlatch and consumption is that today "differences" are industrially produced and bureaucratically programmed according to collective models rather than resulting from reciprocal, personal relations involving challenge and exchange. What is at work in status competition is only a "mass-mediated" sham competition. . . . Questions of prestige obsess our industrial societies, whose (bourgeois) culture has never been anything but a shadow of aristocratic values. (*Pour une critique de l'économie politique du signe*, p. 138)

149. Baudrillard, *Pour une critique de l'économie politique du signe*, p. 36.

150. *Fortune*, December 1946, pp. 157–64.

151. "The accompanying portfolio is an attempt to bring home this macabre warfare. Ralston Crawford, in civil life an abstract painter, was chief of the Visual Presentation Unit, Weather Division, Headquarters A.A.F., during the war. He developed a notably successful application of principles of abstraction to meteorological maps and charts. Both in Washington and in the C.B.I. theater his total experience of war convinced him that the meaning of war lies not in individual battles or even in the sum of human tragedy but far deeper—in the all-encompassing force of destruction itself. . . . The extraordinary photograph above was taken almost at the instant of the bomb explosion. In Crawford's even more extraordinary painting, similar circular forms can be identified. 'But,' says the

artist, 'my forms and colors are not direct transcription; they refer in paint symbols to the blinding light of the blast, to its colors, and to its devastating character as I experienced them in Bikini Lagoon' " (ibid., p. 158).

152. Ibid., p. 160.

153. Betty Parsons, interview with the author, New York, February 16, 1978. Between 1944 and 1947 large collectors were somewhat hesitant in choosing artists but bought works by American artists that were being shown by avant-garde galleries. After 1947 the abstract expressionists were quite popular. Roy Neuberger, who had been collecting American art by Davis, Shahn, and Avery, bought Tamayo in 1943, Holty and Baziotes in 1945, Browne in 1946, Gottlieb in 1947, and Pollock in 1950. The famous collector Edward Root bought Stamos in 1945, Gottlieb in 1947, and Pollock in 1949. John D. Rockefeller bought Pollock and Rothko in 1949.

154. *Art News*, January 15–31, 1946. P. 21.

155. See Robert Goldwater, "The Teaching of Art in the Colleges of the U.S.," *College Art Journal* 2, no. 4, supplement.

156. Alfred Barr, *College Art Journal*, May 1945, Introduction.

157. Betty Parsons, interview with the author, New York, February 16, 1978.

158. Henry Miller, *The Air-Conditioned Nightmare* (New York: New Directions, 1945), pp. 49, 129.

Chapter 3

1. Luce, "The American Century," pp. 61–65.

2. For further details, see David W. Eakins, "Business Planners and America's Post War Expansion," in Horowitz, *Corporations and the Cold War*, pp. 143–71.

3. For a discussion of ideological differences within the American left, see Alonzo H. Hamby, *Beyond the New Deal: Harry S. Truman and American Liberalism* (New York: Columbia University Press, 1973), pp. 29–85.

4. The second "New Deal," which began in the late thirties, was organized around a dynamic, competition-based version of capitalism coupled with a program of Social Security and strict government fiscal policy. Its foreign policy revolved around a program of exchange and international expansion.

5. Freda Kirchwey, "Program of Action," *Nation*, March 11, 1944, pp. 300–305.

6. On the "Open Door Policy," see so-called "New Left" historians in general and, in particular, Williams, *Tragedy of American Diplomacy*.

7. Hamby, *Beyond the New Deal*, p. 88.

8. Ibid., p. 101.

9. Grace and Morris Milgram, "The Man from Missouri," *Common Sense* 13 (October 1944): 347–51.

10. John Lukacs, *1945—Year Zero: The Shaping of the Modern Age* (New York: Doubleday, 1978), p. 174.

11. Dwight Macdonald, *Henry Wallace: The Man and the Myth* (New York: Vanguard Press, 1947), p. 24.

12. Macdonald, *Memoirs of a Revolutionist*, p. 298, citing a *Politics* article from November 1946.

13. Harry S. Truman, *Memoirs*, vol. 1, p. 552, cited in Hamby, *Beyond the New Deal*, p. 117.

14. See Hamby, *Beyond the New Deal*, p. 100: "Most liberals felt these points were overshadowed by near-jingoistic passages celebrating U.S. power, proclaiming America's everlasting righteousness, and reiterating the refusal to share A-bomb secrets."

15. Cited in Hamby, *Beyond the New Deal*, p. 117.

16. Telegram dated February 22, 1946. For a full discussion of this document, see Lloyd Gardner, *Architects of Illusion: Men and Ideas in American Foreign Policy, 1941–49* (Chicago: Quadrangle, 1970), p. 277.

17. Thomas L. Stokes to Ralph Ingersoll, May 4, 1946, cited in Hamby, *Beyond the New Deal*, p. 102.

18. Details in Joseph R. Starobin, *American Communism in Crisis, 1943–1957* (Berkeley: University of California Press, 1972), pp. 125–26.

19. The Progressive Citizens of America was in fact an alliance of the National Citizens Political Action Committee (NCPAC) and the Independent Citizens Committee of the Arts, Sciences, and Professions (ICCASP).

20. The ADA was headed by Mrs. Roosevelt.

21. Macdonald, *Memoirs of a Revolutionist*, p. 189.

22. Ibid., p. 175. Originally published in *Politics* in September 1945.

23. Ibid.

24. Ibid., p. 169.

25. See chapter 2. John Hersey, "Hiroshima," *New Yorker*, August 31, 1946.

26. Macdonald, *Memoirs of a Revolutionist*, p. 180: "As I say, his piece apparently affected a great many readers. But I must note that it didn't for some reason affect me; in fact, I found it so dull that I stopped reading it halfway through. For one thing, I don't like *The New Yorker*'s suave, toned-down, underplayed kind of naturalism (it might be called "denatured naturalism," as against the cruder—and, to me, preferable—variety of Dreiser and the early Farrell)."

27. Robert Motherwell, interviewed in *Newsweek*, August 12, 1946, p. 107.

28. Adolph Gottlieb, interviewed in ibid.

29. The article later became a book (with the same title). Dwight Macdonald sheds his Marxism, using a phrase from Marx agaisnt Marx and focusing the discussion on "man":

> In the spring of 1946 I published a two-part article, "The Root is Man" whose title came from an early (1844) statement of Marx's: "To be radical is to grasp the matter by its roots. Now the root for mankind is man." This was partly a demonstration that Marxism is no longer a reliable guide to either action or understanding, partly a discussion of the problem of values in politics and the limitations of the scientific method, partly some rather desparate suggestions for a new kind of radical approach—individualistic, decentralized, essentially anarchist. The crucial distinction was between "Progressive" and "Radical": The Progressive makes history the center of his ideology. The Radical puts man there. (p. 29)

The radical is less optimistic; though skeptical, he is more stubborn, more revolutionary.

30. Gilbert, *Writers and Partisans*, p. 254. In 1945 the editors of *Life* tried to launch a new cultural magazine with an optimistic outlook as an alternative to the black pessimism of the intellectuals. It was to present a constructive picture of the new era in store for the United States. For a severe critique of this position, see Macdonald's 1945 "Memo to Mr. Luce" reprinted in *Memoirs of a Revolutionist*, pp. 254–61.

31. Arthur Koestler was a fashionable writer at the time. See Gilbert, *Writers and Partisons*, pp. 254–55.

32. William Phillips, *Partisan Review* 11 (Winter 1944): 120.

33. See Barnett Newman, "What about Isolationist Art?" in Hess, *Barnett Newman*, pp. 20–22.

34. William Barrett, *Partisan Review* 13 (Summer 1946): 283, 286–92.

35. For a discussion of the liberals' positions and radical leftist attacks on them, see Macdonald, *Memoirs of a Revolutionist*, pp. 292–96, a reprint of his 1945 article "What Is Totalitarian Liberalism?"

36. Gilbert, *Writers and Partisans*, p. 263.

37. He was not alone: the defense of individualism was à la mode. This accounts for the success of Ayn Rand's book *The Fountainhead*, which described the coming battle

between individualism and collectivism and the ultimate inevitable victory of individualism. Three hundred fifty thousand copies of this book were sold between 1943 and 1946.

38. See Sandler, *Triumph of American Painting*, chap. 4, pp. 62–71: "The Myth Makers."

39. Cited in Richard Chase, "Notes on the Study of Myth," *Partisan Review*, Summer 1946, p. 338.

40. Ibid., p. 338.

41. Lawrence Alloway, *Topics in American Art since 1945* (New York: Norton, 1975), p. 20.

42. Editorial by Kenneth Lawrence Beaudoin in *Iconograph*, Spring 1946.

43. Alfred Russell in *Iconograph*, Fall 1946, p. 3.

44. Peggy Guggenheim Papers and the New York Public Library: Catalog for the first Charles Seliger show at the Art of This Century Gallery, October 30–November 17, 1945, text by Jon Stroup. (The drawing entitled *The Kiss* was already part of the James Johnson Sweeney collection.) Charles Seliger was born in New York in 1926. In 1941 he did a series of drawings and gouaches. Later he met Jimmy Ernst and in 1945 was included in the Painting and Prophecy show at the David Porter Gallery in Washington, D.C. In 1947 his works were shown in the Surrealist and Abstract Art in America show in Chicago.

45. Gottlieb and Rothko, "The Portrait of the Modern Artist," radio interview on Art in New York conducted on WNYC by H. Stix on October 13, 1943, cited in Sandler, *The Triumph of American Art*, pp. 63–64.

46. Roland Barthes, *Mythologies* (Paris: Seuil, 1957), p. 231.

47. Ibid., p. 228.

48. Art of This Century, April 23–May 23, 1946. Teresa Zarnover had been the leader of the constructivist movement in Poland and had edited the Warsaw avant-garde journal *Blok*.

49. The Pepsi Cola prize of $2,500 had been awarded in 1946 to Boris Deutsch for *What Atomic War Will Do to You*, a painting that graphically depicted the horror of Hiroshima. It was "impossible representation" of this sort, crude and inept, that radical artists and intellectuals like Macdonald rejected violently. There was a world of difference between Deutsch's work and, for example, Pollock's *Eyes in the Heat* or *Shimmering Substance*.

50. Barnett Newman, text accompanying the Teresa Zarnover show at the Art of This Century Gallery, April–May 1946. Peggy Guggenheim Papers, Archives of American Art, Film ITVE 1, no. 202.

51. Clement Greenberg was adamantly opposed to the extreme liberalism that tolerated all these mediocrities. What was urgently needed, he felt, was the sort of intolerance that guarantees quality: "The extreme eclecticism now prevailing in art is unhealthy and it should be counteracted, even at the risk of dogmatism and intolerance" (see *Nation*, June 10, 1944).

52. Hilda Loveman, review of Whitney show *Limited Edition*, December 1945, p. 5. This article (and not, as Sandler says on p. 2 of his book, that of Robert Coates, "The Art Galleries," *New Yorker*, March 30, 1946, p. 83) was the first to discern an "abstract expressionist" tendency in art. In her description of the Annual Show at the Whitney, Loveman describes the changes that had taken place on the American art scene:

The Eighth Street museum, which has taken a lambasting for years on the charge of emphasizing the conservative side and its own favorite "regulars" has this year dropped a number of old timers, added fifty new names, and keynoted the abstract-expressionist trends in painting.

Among the names mentioned by Loveman are Gottlieb, Holty (whose work she felt was too intellectual and deficient in "feeling"), Tobey, Callahan, Motherwell, Rothko, Ernst, Knaths, Marin, Rattner, and Bearden. She emphasized the changes that had taken place in painting styles:

Both social and American scenism so popular in the 30s, have practically vanished. Instead, the landscapes, still lifes and figure studies which make up the bulk of any show of American art, have turned romantic or fantasist. (p. 5)

53. Editorial, *Art News*, July 1946, p. 13.

54. Lester Longman writing in the First Summer Exhibition of Contemporary Art catalog (State University of Iowa, unpaginated): "The melting pot has reached a new boiling point and is fashioning a synthesis of forthright American directness, boldness and energy, with European subtlety, refinement and theoretical control."

55. Pollock, Gorky, Guston, de Kooning, Baziotes, Kline, Motherwell, Rothko, and Still did not fight in the war and therefore had the opportunity to attract attention to their work in the many shows devoted to American art. See Milton Brown, "After Three Years," *Magazine of Art* April 1946, pp. 138–66.

56. Ibid.

57. Ad Reinhardt, "The Rescue of Art," *Newsweek*, August 12, 1946.

58. Brown, "After Three Years," p. 138.

59. Ibid.

60. Ibid. Brown apparently understood the artist's difficulty in treating the new world, even though he regretted it: "Those artists who were concerned with a more serious exploration of the social scene seem to have discovered an inadequacy in their means and find themselves in something of a dilemma. The expression of a complex social idea in terms of simple human experience is, theoretically at least, possible—it has even been done in the past—yet few modern artists have proved capable of achieving a valid solution. Unfortunately, we are too often prone in our sophistication to consider such direct statements as cliches. Perhaps complexity is basic to our times" (p. 166).

61. Lester Longman, Second Summer Exhibition of Contemporary Art catalog, State University of Iowa, 1946, unpaginated. The show contained 160 paintings by 132 painters. Later on Longman became an ardent adversary of abstract expressionism.

62. On the subject of eclecticism, Howard Devree's "The Armory 1945—Critic's Choice," *Art News*, October 1–14, 1945, is very interesting for what it reveals of the preferences of art critics and collectors in late 1945. The choices varied widely, but everyone hoped to see a strong, international American art emerge, as Devree explains: "Just as the democracy we pride ourselves on has emerged from a melting pot, so our art is being forged into a new thing, national in its internationalism, finally and finely American."

63. Clement Greenberg, *Nation*, December 1, 1945, p. 604.

64. Clement Greenberg, *Nation*, April 5, 1947, p. 405.

65. The State Department had organized a show, "Advancing American Art," which was halted after Senator Dondero attacked the work of painters affiliated at one time with the Communist party. See Mathews, "Art and Politics in Cold War America," p. 777.

66. George Biddle, "The Horns of Dilemma," *New York Times*, May 19, 1946, section 6, pp. 21, 44.

67. Ibid., p. 45.

68. Howard Devree, "Straws in the Wind: Some Opinions on Art in the Post War World of Europe and America," *New York Times*, July 14, 1946, section 2, pp. 1, 4.

69. Ibid.

70. Edward Alden Jewell, "Art American?" *New York Times*, September 1, 1946, section 2, p. 8.

71. Ibid. Jewell asked whether it was possible to have an art that was both American and universal: "But does this mean that universal art may not also be distinctively American art? By no means. Art to be American in the only sense worth talking about is the creative expression of the individual, the individual creating art out of his own experience, the individual who acknowledges first of all the citizenship of selfhood. The true objective is within, not without. And following that objective, the artist, if he be American, will,

without deliberate attempt, create American art—not superficially so, but in the deepest, the universal sense."

72. Show staged by Barnett Newman. Twenty-eight works were shown, six of them for sale.

73. "Northwest Coast Indian Painting," catalog written by Barnett Newman, Betty Parsons Gallery, September 30–October 19, 1946.

74. Ibid.

75. Ibid.

76. Elsa Maxwell, "Party Line," *New York Post*, December 20, 1946.

77. Between 1940 and 1949 a new museum was established every 10.5 days: from Alma S. Wittlin, *Museums: In Search of a Usable Future* (Cambridge, Mass.: MIT Press, 1970), p. 174. New collectors were also interested in the question. See James T. Soby, "Collecting Today's Pictures," *Saturday Review*, May 25, 1946, pp. 42–44. On the Neuberger collection see Aline B. Loucheim, "Stockbroker Buys American," *Art News*, May 1946, pp. 54–55, 68.

78. Henry McBride, *New York Sun*, April 20, 1946.

79. Samuel Kootz, "Building a Modern Collection," May 13–June 1, 1946. Catalog text in Samuel Kootz archives, Archives of American Art, NY 65/1.

80. Ibid. There was also Christmas advertising in 1949:

For an unusual Christmas gift for yourself or friends. Make this a memorable gift, one that will not be forgotten. Give a framed modern water color or gouache by an important American artist. For $100, 150, 200 as you may prefer, you may send a gift certificate to your friends entitling them to a selection from the work of the following artists:

William Baziotes Hans Hofmann
Byron Browne Carl Holty
Adolf Gottlieb Robert Motherwell
or we shall be delighted to make the choice for you and enclose your card with your gift.
Simply fill out the blank below.

81. Samuel Kootz archives, Archives of American Art, NY 65/1.

82. Frederic Taubes, "Painting," *Encyclopedia Britannica: Book of the Year, 1947*, p. 573.

83. Clement Greenberg, "L'art américain au XXᵉ siècle," *Les Temps Modernes*, nos. 11–12, (August–September 1946): 351–52.

84. Ibid., p. 352.

85. Stephane Pizella, "Au royaume du dollar," *Minerve*, September 29, 1945; "Etapes américaines," *Minerve*, October 19, 1945, p. 1. Ossip Zadkine, "L'Exil à New York," *Minerve*, November 30, 1945. Claude Roy, "Clefs pour l'Amérique," *Lettres françaises*, November 1, 1946.

86. Robert Escarpit, "En remontant Broadway," *Le Monde*, February 26, 1946, section I-C.

87. Pizella, "Au royaume du dollar." For his starved French public, Pizella marvelled in describing people in New York who threw away half-smoked cigarettes and half-eaten sandwiches of delicious marmalade.

88. René Huyghe, "Letter from Paris: Conflicting Tendencies," *Magazine of Art*, November 1945, pp. 272–73.

89. *Union nationale des intellectuels*, Bibliothèque historique de Nanterre, 0 document 28382 (brochure, unpaginated).

90. Ibid. This project was preceded, in March of 1945, by a manifesto proclaiming a French resistance circulated by the Communists and intended to recruit support for efforts to rebuild the complexity and diversity of French culture:

France must be perpetuated in such a way as to preserve all the dimensions of the French spirit. We all know how much the French spirit owes to the past. How could we hope to do anything worthwhile without accepting our full heritage? Hence none of the spiritual families of France is to be excluded. It would be criminal to allow the great well that replenishes our national genius to run dry.

A varied list of artists and other figures supported this undertaking, including Aragon, Eluard, Joliot-Curie, Corbusier, Matisse, Perret, Picasso, General Dassault, Robert Debré (of the Academy of Medicine and father of later prime minister Michel Debré), and others.

91. For details see Jean Philippe Chimot, "Avatars de la théorie de l'art dans *Art de France* (1945–49)," *Art et idéologie*, pp. 144–57.

92. The "journey" referred to was the infamous tour of Germany made by French artists in 1944, including Derain, Vlaminck, Friesz, and Segonzac. See *L'Amour de l'Art*, no. 2 (July 1945): 27. *L'Amour de l'Art* was a monthly review whose editorial board was chaired by René Huyghe, with Germain Bazin as managing editor.

93. Ibid.

94. Ibid.

95. Carlu, "Carlu est revenu d'Amérique," *Arts*, November 9, 1945, p. 2.

96. Léon Degand, "Le retour d'un grand peintre, F. Léger," *Lettres françaises*, April 13, 1946, p. 1.

97. Walter Lippmann, "La destinée américaine," *Les études américaines*, no. 1 (April–May 1946): 1.

98. Waldemar George, *Le Littéraire (Figaro)*, April 24, 1946, p. 4.

99. Aramov, *Opinions d'un peintre d'aujourd'hui* (Paris: Presses Benaud, 1946), p. 20. On the reemergence of a form of sacred art, see Laude, *Art et idéologies*, pp. 36–37.

100. Jacques Baschet, *Pour une renaissance de la peinture française* (Paris: Baschet, 1946), p. 112.

101. Roger Garaudy, "Artistes sans uniformes," *Art de France* 9 (November 1946): 17–20.

102. Louis Aragon, "L'art, zone libre?" *Lettres françaises*, November 29, 1946, p. 1.

103. Roger Garaudy in *Lettres françaises*, December 13, 1946, p. 1.

104. Ibid.

105. Ibid.

106. Georges Pillement took a position opposite to that of Léon Degand: "Inhuman and intellectual, abstract art is the last paroxysm of fever in a crisis from which modern art has been suffering for the past thirty years. Its oversized ambitions will not be long in giving rise to a reaction that will bring artists back to that which is constantly teaching them new and worthwhile lessons: nature" (see *Lettres françaises*, December 25, 1946, p. 4).

107. Bernard Buffet, Critic's Prize, 1948. Cited in Raymond Moulin, *Le marché de la peinture en France* (Paris: Editions de Minuit, 1967), p. 166.

108. This is why France stubbornly carried on with its prewar cultural policy. In 1945 the foreign ministry established a "general directorate for cultural relations" as distinct from the directorates responsible for political and economic relations. The first director in charge of cultural relations was Henri Laugier of the Faculté des Sciences of Paris. The budget was 460 million francs, thirty-six percent of the total budget of the ministry of foreign affairs. See Anthony Haigh, *La diplomatie culturelle en Europe* (Strasbourg: Conseil de l'Europe, 1974), pp. 69–75.

109. Léon Degand, "Au service de l'art," *Lettres françaises*, November 15, 1946.

110. Althea Bradbury, "Review of Modern French Painting at the Pearl Gallery," *Critique* 1, no. 2 ;(October 1946).

111. Clement Greenberg, "Art," *Nation*, February 8, 1947, p. 228. Fiske Kimball, director of the Pennsylvania Museum, had the same reaction, as he explained to Raymond Cogniat:

"To begin with, I must tell you that the exhibition of contemporary art that you sent to New York and Philadelphia last year, which was supposed to show us some of the work done by your artists during the war, was rather a disappointment for us. Our overall impression was that the newcomers were in fact epigones. After visiting Paris, though, my feelings are quite different. I have never seen such an intense artistic life, and Paris has never had so brilliant a season or so many important shows. At the same time, though, it seems to me that as far as creativity is concerned, you are in a slack period, which doesn't mean that France is going to lose her rank, because you always have plenty of talented artists and promising work spread over several generations" (see *Lettres françaises,* August 22, 1947, p. 1).

112. Reviews appeared in *Arts* as well as in the weekly *Juin* (by Jean Laude, Edouard Jaguer, and René Guilly). Léon Degand also reviewed avant-garde work for *Lettres françaises.* For further information, see Georges Mathieu, *De la révolte à la Renaissance* (Paris: Gallimard, 1972).

113. René-Jean in *Le Monde,* March 26, 1946, p. 5.

114. The artists mentioned were Gines Parra (Spain), Geer Van Velde (Holland), Vasili Kandinsky (Russia), Bercot (Franche Comté), and Jean Couty (Lyon).

115. The accords were of extreme economic and symbolic importance, as the violence of the French reaction attests. In fact they mark the beginning of the collapse of the French cultural system, the end of France's international supremacy. Painting was to be the next target of attack, more cautiously approached. It is ironic that the downfall of Paris began with film, when the French had so admired American film in 1939.

116. This clause was rather well concealed in the terms of the agreement, since the press did not discover it until June 8: see *Le Monde,* June 8, 1946, p. 8.

117. The *New York Times* in fact reported that Léon Blum had bluntly told leaders of the French film industry that he was ready to sacrifice their interests in order to obtain the needed American aid. See the *Times* of June 22, 1946, p. 14.

118. Georges Huisman, chairman of the French film control board, wrote in *Opéra.* His remarks appeared in translation in the *New York Times,* January 10, 1946, p. 29.

119. Georges Bidault was described by the *New York Times* on March 22, 1946, p. 1, as inclined to accept Soviet aid, but on the following day he contradicted himself. See also *Le Monde,* March 22, 1946, p. 1.

120. Charles Tillon, minister of weaponry; Maurice Thorez, minister of state; Marcel Paul, minister of industrial production; Ambroise Croizat, minister of labor; François Billoux, minister of national economy.

121. Léon Blum, *Le Monde,* March 23, 1946, p. 1.

122. André Philip, *Le Monde,* June 1, 1946, p. 1. This interview was important because it dealt with a nationalization bill then under consideration by the National Assembly. On April 25 the assembly nationalized the gas and power companies.

123. Great Britain had signed accords with the United States just one month before Blum's arrival in Washington. See Richard M. Freeland, *The Truman Doctrine and the Origins of McCarthyism* (New York: Schocken, 1971), pp. 47–49.

124. For a detailed analysis see André Siegfried, *L'année politique, 1946* (Paris: Presses Universitaires de France), pp. 135–41.

125. It should be noted that the Communists in the government signed the accord, though with some hesitation. Still, Maurice Thorez attempted to claim credit for the agreement on behalf of the French Communist party by saying that the United States had agreed to provide funds because it recognized the value and qualities of the French working class. America trusted the French worker (*Le Monde,* June 31, 1946, p. 3).

126. *Le Monde,* March 31, 1946, p. 1.

127. See Alfred Grosser, *La IVᵉ République et sa politique extérieure* (Paris: Armand Colin, 1972), p. 217. See also Alexander Werth, *France, 1945–1955* (London: Robert Hale, 1956), p. 295.

128. Harold Callender, "French Socialists Ask U.S. Support," *New York Times*, April 2, 1946, p. 13.

129. In 1945 the French Communist party took 26.1% of the vote, the MRP 23.9%, and the socialists 23.4%.

130. *New York Times*, May 7, 1946, p. 4; May 28, p. 10; June 1, p. 7.

131. France and Italy were seen as strategically important to the United States in part because of the domino theory: see "United States Assistance to Other Countries from the Standpoint of National Security," *Foreign Relations of the United States*, vol. 1 (1947), pp. 738–50, reproduced in *Containment: Documents on American Policy and Strategy, 1945–50*, ed. John L. Gaddis and Thomas H. Etzold (New York: Columbia University Press, 1978), pp. 71–83.

132. "American Relations with the Soviet Union: A Report to the President by the Special Counsel to the President," September 24, 1946, Harry S. Truman Papers, cited in Gaddis and Etzold, *Containment*, p. 67.

133. This was essentially George F. Kennan's message in his long telegram from Moscow. As John L. Gaddis says, "Because Kennan saw the problems as psychological, his solution, too, was psychological in character: to produce in the minds of potential adversaries, as well as potential allies and the American people, attitudes which would facilitate evolution of a congenial international environment for the U.S." (see Gaddis and Etzold, eds., *Containment*, p. 30). Kennan had argued in favor of cultural "intoxication" of the Soviet Union in his September 24, 1946, letter "American Relations with the Soviet Union" (reprinted in ibid., p. 68):

To the greatest extent tolerated by the Soviet Government, we should distribute books, magazines, newspapers and movies among the Soviets, beam radio broadcasts to the U.S.S.R., and press for an exchange of tourists, students, and educators.

Though Kennan is here speaking of the Russians, it was clear that the same methods could be used more subtly and successfully in the Western world.

134. Thomas M. Pryor, "Mission of the Movies Abroad," the *New York Times*, March 29, 1946, p. 6. Barney Baladan, president of Paramount Pictures, was quoted in this article as saying "that a State Department sponsored informational film program, such as now is being contemplated, would not be nearly as successful as one carried out privately by commercial interests. He feels that a picture endorsed by our government would be regarded abroad with much the same suspicion as we are inclined to view a story coming from Russia under a Pravda or Izvestia banner."

135. After the signing of the accords Léon Blum argued that France had obtained an advantage over England and Italy. France was responsible for thirty percent of production, a higher percentage than Italy's seventeen and England's twenty-two. See the *New York Times*, June 22, 1946, p. 14. Things did not go as well as predicted, however. Whereas France produced forty-eight films during the second half of 1946, it produced only forty during the first half of 1947 and thirty during the second half. In two articles devoted to the cinema in *Le Monde* (November 14, p. 3, and November 15, p. 4), Henri Magnan gave further details:

A study of film programming in Paris during the second half of 1947 reveals that category A theaters showed thirty-three French films during this period for a total of 184 weeks, compared with sixty-four American films for a total of 340 weeks. The seriousness of the problem becomes more apparent when one takes account of the fact that, because of the different terms for rental and projection under which French and American films of equal artistic value may be shown, a theater manager can in some cases make three times as much with the American movie compared with the French.

Pierre Frogerais said: "that in the accords there is a grave danger for the French movie industry, because a quota of four weeks out of thirteen only allowed the production of forty-eight French films a year while our studios are technically equipped and have personnel to produce seventy or eighty" (*Le Monde*, June 8, 1946, p. 8).

By 1948 the crisis had reached such proportions that film artists were demonstrating in the streets (including Jean Marais, Madeleine Sologne, Roger Pigault, Claire Maffei, Simone Signoret, Raymond Bussière, and the director Jacques Becker, among others).

136. George F. Kennan, "Moscow Embassy Telegram," February 22, 1946, cited in Gaddis and Etzold, *Containment*, p. 63.

137. Louis Jouvet, *Le Monde*, June 17, 1946, p. 3.

138. According to an article by Robert Delaroche, "L'agonie du cinéma français vendu à Truman par Léon Blum," *L'Humanité*, January 3, 1948.

139. Bertrand de la Salle, "As a Frenchman Sees Us," *Nation*, March 15, 1947, pp. 296–97.

140. This retreat was plainly not as precipitous as it was said to have been at the time. The Labour government in England began discussions with the United States in 1945 concerning the economic problems of Greece and Turkey, proposing that the United States share the burden of dealing with these difficulties. In September 1946 James F. Byrnes assured Ernest Bevin that if England continued to aid Greece, the United States would make aid funds available. For an in-depth analysis of the situation, see Freeland, *The Truman Doctrine*.

141. This was more a strategic matter than a real emergency, but the point was to impress Congress and the public. Though deemed vital, the funds did not reach Greece for a year after the beginning of the debate.

142. U.S. Congress, Congressional Record, 80th Congress, 1st sess., 1947, pp. 1980–81.

143. Truman, *Public Papers*, 1947, p. 176, cited in Freeland, *The Truman Doctrine*, p. 85.

144. Cited in Freeland, *The Truman Doctrine*, p. 96.

145. In particular, see Kennan's famous letter, published under the name "Mr. X," in *Foreign Affairs:* "The Sources of Soviet Conduct." Discussed in Gardner, *Architects of Illusion*, p. 276.

146. Cited in Freeland, *The Truman Doctrine*, p. 101.

147. Robert Lash, editor of the *Chicago Sun*, memorandum to Marshall Field, March 26, 1947, cited in Hamby, *Beyond the New Deal*, pp. 176–77.

148. Ronald Rubin, "The People Speak," *Progressive*, April 7, 1947, p. 1.

149. George Elsey, memorandum, August 1947, Elsey mss., cited in Hamby, *Beyond the New Deal*, p. 175.

150. Henry Wallace, cited by Frank Ross Peterson in "Harry S. Truman and His Critics: The 1948 Progressives and the Origins of the Cold War," *The Walter Prescott Webb Memorial Lectures* (Austin: University of Texas, 1972), p. 37.

151. *New York Times*, April 5, 1947, p. 6.

152. See Hamby, *Beyond the New Deal*, p. 178.

153. The question of whether the danger was illusory is discussed by almost all "revisionist" historians. There were in fact difficulties over the issue of how various zones were to be divided between the United States and the Soviet Union. The illusion was that there was a danger of immediate war. Freeland is quite convincing in his treatment of the way in which this danger was manipulated for domestic political reasons.

154. Cited in Freeland, *The Truman Doctrine*, p. 89.

155. Ibid.

156. Dwight Macdonald, "Truman's Doctrine, Abroad and At Home," in *Memoirs of a Revolutionist*, p. 189.

157. Clyfford Still, interview with Ti-Grace Sharpless, published in the catalog *Clyfford Still* (Philadelphia: Institute of Contemporary Art, University of Pennsylvania), p. 4. The Still show ran October 18–November 29, 1963.

158. American leaders had been suspicious of the Communist party ever since the Russian Revolution. Between 1919 and 1935 Congress had carried out four investigations of the activities of the Party but found nothing to reproach. In 1938 the Dies Committee (House Unamerican Activities Committee) was established and in 1945 became a permanent committee of Congress.

159. *New York Times*, June 6, 1947, p. 1.

160. Cited in Hamby, *Beyond the New Deal*, p. 186.

161. Truman cited in Edwin G. Nourse, *Economics in the Public Service* (New York: Harcourt Brace, 1953), p. 167.

162. In fact, the Marshall Plan, and Kennan in particular, took great pains to see that Soviet participation would be impossible: "It would be best . . . to stimulate initiative in the first instance from the E.C.E. but to do so in such a way that eastern European countries would either exclude themselves by unwillingness to accept the proposed conditions or agree to abandon the exclusive orientations of their economies." See George F. Kennan, *Memoirs, 1925–1950* (New York: Bantam, 1969), pp. 358–59.

163. Henry Wallace, "Too Little, Too Late," *New Republic*, October 6, 1947, p. 11.

164. Freeland, *The Truman Doctrine*, p. 215.

165. Thomas Clark, *Washington Post*, November 22, 1947. Cited in Freeland, *The Truman Doctrine*, p. 227.

166. U.S. Office of Education, Annual Report, 1947. See the long discussion of this topic in Freeland, *The Truman Doctrine*, pp. 230–31.

167. Ibid., p. 231.

168. Ibid., p. 234.

169. For an analysis of opposition to the Marshall Plan by Henry Wallace and Idaho Senator Glen H. Taylor, see Peterson's important article, "Harry S. Truman and His Critics," p. 46.

170. Barnett Newman, "Ideographic Picture." Text cited by Barbara Rose, *Readings in American Art*, p. 146. The show included the following paintings: Hans Hofmann: *The Fury, I* and *II*; Pietro Lazzari: *Burnt Offering, The Firmament*; Boris Margo: *Astral Figure, The Alchemist*; Barnett Newman, *Gea, The Euclidian Abyss*; Ad Reinhardt: *Dark Symbol, Cosmic Sign*; Mark Rothko: *Tiresias, Vernal Memo*; Theodore Stamos: *The Sacrifice, Imprint*; Clyfford Still: *Quicksilver, Figure*.

171. Victor Wolfson, Catalog of Kootz Gallery, January 1947, Samuel Kootz Papers, Archives of American Art.

172. Text by Samuel Kootz published in catalog of a show of Carl Holty and Byron Browne held at the Kootz Gallery, May 20–June 7, 1947, Samuel Kootz Papers, Archives of American Art.

173. Harold Rosenberg, "Introduction to Six American Artists," for the catalog of the show of Bearden, Baziotes, Browne, Gottlieb, Holty, and Motherwell held at the Maeght Gallery in Paris in the spring of 1947; also published in *Possibilities* 1 (Winter 1947–48): 75.

174. This strategy is now well known thanks to the work of various historians, particularly Christopher Lasch, "The Cultural Cold War: A Short History of the Congress for Cultural Freedom," in *The Agony of the American Left* (New York: Random House, 1968), pp. 63–113; and Eva Cockroft, "Abstract Expressionism," pp. 39–41; as well as a number of journalists, especially Jason Epstein, "The C.I.A. and the Intellectuals," *New York Review of Books*, April 20, 1967, pp. 16–21; and Thomas W. Braden, "I'm Glad the C.I.A. Is Immoral," *Saturday Evening Post*, May 20, 1947, pp. 10–14. Epstein explains the workings of the system that was set up to control European intellectual life to the maximum possible extent. The funds allocated to private institutions such as museums and art galleries were part of the same plan as the money given to the French trade union Force Ouvrière in 1947 for the purpose of fighting against communism:

The money we spent was very little by Soviet standards. But that was reflected in the first rule of our operational plan: "Limit the money to amounts private organizations

can credibly spend." The other rules were equally obvious: "Use legitimate, existing organizations, disguise the extent of American interest; protect the integrity of the organization by not requiring it to support every aspect of official American policy." (p. 14)

In order for the enterprise to succeed, a certain dose of criticism was essential. During the course of my research in Paris, I was unable to interview Mr. Maeght about this famous show. I was also unable to consult the Maeght archives, though I tried regularly to gain access over a two-month period and repeatedly had my hopes raised, only to have them dashed by the gallery. The subject of how the Maeght show was organized and paid for is apparently still taboo, since Samuel Kootz first agreed to an interview in New York, then cancelled it upon learning the special interest I had in this question. There are pools that apparently stink if they are stirred.

175. A great deal about the show did not meet with everyone's favor. For example, Monroe Wheeler of the MOMA while on a visit to Paris complained to Maeght that the exhibition was one-sided, incomplete, and an advertising stunt designed to promote Kootz's version of American art in Paris:

Monroe Wheeler was here during or right after the show, and told Maeght and others that ours wasn't really representative American painting; he gave Maeght a list of the artists in America he thought worthwhile, but naturally Maeght misplaced it. Naturally this should not be an incentive for any one of you to rip our dear Monroe's balls.

Letter from Samuel Kootz to the painters of his gallery, dated July 5, 1947, Personal archives of Rosalind Bengelsdorf-Browne.

176. This idea was popularized by a number of American publications printed in Europe after 1945. In France these included the *Bulletin quotidien USA, Arts et Lettres, Bulletin de la quinzaine, Informations et Documents, Rapports France–Etats-Unis* (the review of the Marshall Plan), *Profils,* and *France USA.* For further information, see *Telling America's Story Abroad: The State Department Information and Educational Exchange Program* (Washington, D.C.: Office of Public Affairs, 1951).

Every effective medium of communication is used to tell people in every part of the world about the U.S. and its way of life, to make available factual news of world developments, and to correct the distortions and lies circulated by Communist propagandists. (p. 4)

On this subject see also Charles A. H. Thomson, *Overseas Information Service of the U.S. Government* (Washington, D.C.: Brookings Institution, 1948).

177. *Arts,* April 11, 1947, p. 1.

178. Ibid.

179. Laurent Casanova, *Le Communisme, la pensée, et l'art,* Eleventh National Congress of the French Communist Party, June 25–28, 1947, published by the Communist Party Press. On October 24, 1947, *L'Humanité* published an article entitled "America Degrades the Mind."

180. Edmond de Semont, *Le Monde,* April 2, 1947, p. 5.

181. Letter from Kootz to the artists of his gallery. See note 175 above.

182. Denys Chevalier, "Introduction à la peinture américaine," *Arts,* April 4, 1947.

183. André Warnod, *Le Figaro,* April 3, 1947, p. 2.

184. Jean-José Marchand, "Introduction à l'art américain contemporain," *Combat,* April 9, 1947, p. 2.

185. Ibid.

186. Ibid.

187. Ibid.

188. René-Jean, "Les difficultés du commerce des oeuvres d'art," *Le Monde*, January 21, 1947, p. 5.

189. *Carrefour*, April 9, 1947, p.l 7, unsigned.

190. Frank Elgar, "L'art abstrait en Amérique," *Carrefour*, August 6, 1947, p. 7.

191. Ibid.

192. Jean Franklin, editorial in *New Iconograph*, 1947 (8,000 copies). The magazine was published in 1946 by Kenneth Lawrence Beaudoin under the title *Iconograph*. Beaudoin also owned an art gallery (Gallerie 9). In 1947 it changed its title to *New Iconograph*, under a new managing editor. Oscar Collier and Jean Franklin were hired as editors. They wanted the magazine to be "modern, contemporary, and experimental" and emphasized the influence of Indian art and of Paalen's magazine *Dyn*.

193. On page 95 of the magazine there appeared a photograph of two soldiers (one from ancient Greece, one from modern) shaking hands, which, taken out of context, would be hard to understand. The photo had been taken at the Acropolis, a Greek restaurant in New York, and was entitled "The State Shaking Hands With Its Victim." It ran with a commentary by Carlo Levi, the author of *Christ Stopped at Eboli*. Appearing as it did in an art magazine, this photo was like a whispered rumor; it was not easy to insert political statements into mythological discourse about art (the photo came at the end of an article on myth by Andrea Caffi). But *Possibilities* nevertheless made more of a statement than the other avant-garde magazine, *Tiger's Eye*. When one realizes that Congress was at this point debating the allocation of the funds needed to save Greece from "Communist rebels," the photograph takes on the character of an ironic commentary.

The detached, cynical commentary of the libertarian philosopher Levi set the tone and established the position of the avant-garde magazine with respect to world politics in the postwar era, a tone of comprehension coupled with splendid detachment. Seen in the light of its relation to history, the bizarre image of two Greeks shaking hands in the pages of an art magazine recovers its full meaning, revealing the sentiments of the avant-garde in regard to a major episode in United States foreign policy.

194. Robert Motherwell and Harold Rosenberg in *Possibilities* 1 (Winter 1947–48). The editors of the magazine were Robert Motherwell for art, Harold Rosenberg for literature, Pierre Chareau for architecture, and John Cage for music.

195. Ibid.

196. Andrea Caffi, "On Mythology," ibid., p. 87.

197. Mark Rothko, "The Romantics Were Prompted," ibid., p. 84.

198. Motherwell and Rosenberg, editorial, in ibid.

199. Karl Marx, *Early Writings*, ed. T. B. Bottomore (New York: McGraw-Hill, 1963), p. 127.

200. Rothko, "The Romantics Were Prompted," p. 84.

201. Pierre Dommergues, *L'aliénation dans le roman américain contemporain*, vol. 1 (Paris: Union Générale de l'Editions, 1976), p. 249. Alienation was quite popular in postwar America both as a concept and a way of being, as can be seen from the vogue for novels that deal with the subject directly or indirectly: Norman Mailer, *The Naked and the Dead* (1948); Flannery O'Connor, *A Good Man Is Hard to Find and Other Stories* (1955); J. D. Salinger, *The Catcher in the Rye* (1951).

202. Mark Rothko, "The Romantics Were Prompted," p. 84.

203. As all the specialists on this period explain. Abstract expressionism was never a coherent movement but rather a congeries of individual personalities.

204. Dommergues, *L'aliénation*, p. 271.

205. Rosenberg, Maeght show catalog, cited in *Possibilities*, p. 75.

206. Ibid.

207. Clement Greenberg, "The Present Prospects of American Painting and Sculpture," *Horizon*, nos. 93–94 (October 1947): 28–29.

208. William Phillips, "Portrait of the Artist as an American," ibid., p. 19.
209. Greenberg, "The Present Prospects," p. 22.
210. This is why he rejected the art of Graves and Tobey. Ibid., p. 25.
211. Ibid., pp. 25–26.
212. Ibid., p. 28.
213. Ibid., p. 28.
214. Ibid., p. 30.
215. Ibid., pp. 27–28.
216. Clement Greenberg, "Art," *Nation*, March 8, 1947, p. 284.
217. Ibid.
218. Ibid.

Chapter 4

1. James Burkhart Gilbert, in his study of *Partisan Review*, implies but does not document that the CIA played an important role in this change. See Gilbert, *Writers and Partisans*, pp. 274–75, n. 31. The magazine became a monthly for the first time since 1938 thanks to a $50,000 annual contribution from New York poet Allan Dowling.

In his memoirs, William Barrett also insists on this mysterious "gift" to *Partisan Review*: "The magazine had suddenly acquired an angel, Allan Dowling, who had seemingly appeared, as angels do in the Bible, out of nowhere. The financial aspects of the patronage could not have been very large; everything was so much more modest in those days. But in any case these were matters that Rahv and Phillips, as owners of the magazine, kept to themselves, and I did not ask" (*The Truants: Adventures among the intellectuals* [New York: Doubleday, Anchor Press, 1982] p. 144).

2. The individual rather than history became the focus of investigation. A young Columbia philosopher, William Barrett, called attention to the neurotic artist, whose history he traced from the time of ancient Greece.

3. A great many intellectuals were eager to be "recycled" and resume their place on the soft pillows of culture. Writing in *Partisan Review* on the traditional hostility between the artist and American culture, James Burnham put it this way: "These relationships were not so clear or so desperate a generation ago. What has happened is not that American culture has become better in that time, but the world much worse" (see James Burnham, "Our Country and Our Culture," *Partisan Review* 19 (May–June 1952): 291.

4. William Phillips, "Our Country and Our Culture," *Partisan Review* 19 (September–October 1952): p. 586. This idea was not new. It had already been criticized by the left in 1947: see Milton Howard, "Partisan Review: Esthetics of the Cage," *Mainstream*, Winter 1947, pp. 46–57. Howard here criticized the direction taken by the magazine since it abandoned Marxism. The magazine's attitude, according to Howard, was an opportunistic one, comparable to Gide's attitude during the war, which Howard characterized as thinly disguised collaborationism: "*The Man in the Cage:* Again it was Gide who gave us this image when, during the occupation of France by the Germans, he confided to his diary that he 'could live happily even in a cage. The secret is to establish oneself equidistant from the four walls.' "

5. Editorial in the avant-garde magazine *Tiger's Eye*, October 1949.

6. George C. Marshall, House Committee on Foreign Affairs, Hearings on Postwar Recovery Policy, cited in Freeland, *The Truman Doctrine*, p. 259.

7. *Public Opinion on Foreign Policy* (New York, 1949), p. 52.

8. See Freeland, *The Truman Doctrine*, p. 264.

9. For a complete analysis of these events see: Radomír Luža, "Czechoslovakia between Democracy and Communism, 1945–1948," in *The Origins of the Cold War and Contemporary Europe*, ed. Charles S. Maier (New York: New Viewpoints, 1978), pp. 73–106.

10. Ibid., p. 270.

11. *New York Times*, March 14, 1948.

12. *New York Times*, March 18, 1948, cited in Freeland, *The Truman Doctrine*, p. 272.

13. Speech at Berkeley on March 19, at Los Angeles on March 20.

14. *New York Times*, March 13, 1948.

15. *Washington Post*, March 13, 1948.

16. See James Aronson, *The Press and the Cold War* (Boston: Beacon Press, 1970), p. 82.

17. Clement Greenberg, "The Situation at the Moment," *Partisan Review* 5 (January 1948): p. 82.

18. Ibid.

19. Ibid. "The activity that goes on in Paris, the talk, the many literary and art magazines, the quick recognition, the tokens of reward, the crowded openings—all these, which once were signs of life, have now become a means of suppressing reality, a contradiction of reality, an evasion. Whistling is perhaps as real as the dark but it is not as real as the fear it dissembles."

Paris was depicted as an aging coquette, no longer strong enough to act but only to dress up, to seem.

20. See Thomas Crow, "Jacques Louis David's Oath of the Horatii: Painting and Revolutionary Radicalism in France" (Ph.D. dissertation, UCLA, 1978).

21. Greenberg, "The Situation at the Moment," p. 82.

22. Pollock had been eager to paint murals since 1947, when he applied for a Guggenheim fellowship with the following proposal: "I intend to paint large movable pictures which will function between the easel and mural. I have set a precedent in this genre in a large painting for Miss Peggy Guggenheim which was installed in her house and was later shown in the 'Large Scale Paintings' show at the Museum of Modern Art. It is at present on loan at Yale University. I believe the easel picture to be a dying form, and the tendency of modern feeling is towards the wall picture or mural. I believe the time is not yet ripe for a *full* transition from easel to mural. The pictures I contemplate painting would constitute a halfway state, and an attempt to point out the direction of the future, without arriving there completely" (see O'Connor, *Jackson Pollock*, pp. 39–40).

23. Clement Greenberg, "Art," *Nation*, January 10, 1948, p. 51.

24. Ibid., p. 52.

25. Ibid. He continued his analysis of Gorky in the March 20, 1948, issue of the *Nation*, pp. 231–32, in which he said: "Gorky should rely more on the movement of his whole arm rather than of his wrist or elbow alone."

26. This article caused a sensation because it was the first time that an American art critic rated American art as the best in the world. To some this was so surprising and irritating that George L. K. Morris, a modern painter with affinities to cubism and a former Trotskyist and financial backer of *Partisan Review* published a fierce critical attack on Greenberg in the pages of his magazine. He stated his astonishment at the sudden announcement of the death of Parisian art. He attacked American critics in general, including Greenberg, for being incapable of explaining the secrets of modern art to the public: "This approach—completely irresponsible as to accuracy or taste—has been with us so long that we might say that it amounts to a tradition." Greenberg's argument, he said, was based on nothing: "It would have been rewarding if Greenberg had indicated in *what ways* the works of our losers have declined since the 30's." Morris was a follower of Picasso and could not accept the surprising early death of cubism. See "Morris on Critics and Greenberg: A Communication," *Partisan Review*, no. 6 (1968): 681–84; Greenberg's response appears on pp. 686–87.

27. Clement Greenberg, "The Decline of Cubism," *Partisan Review*, no. 3 (1948): 369.

28. Clement Greenberg, "Irrelevance versus Irresponsibility," *Partisan Review* 15, no. 5 (1948): 579.

29. Stephen Spender, "We Can Win the Battle for the Mind of Europe," *New York Times Magazine*, April 25, 1948, pp. 15, 31–35.

30. Ibid., p. 15.

31. Ibid., p. 33.

32. Ibid., p. 33.

33. Introductory note to the show of the Federation of Modern Painters and Sculptors, cited in *New York Times*, June 6, 1943.

34. Jackson Pollock in *Arts and Architecture*, February 1944. Cited in Rose, *Readings*, p. 151.

35. Robert Motherwell, in *14 Americans*, ed. Dorothy Miller (New York: MOMA, 1946), p. 36.

36. Kootz, *New Frontiers in American Painting*, p. 6.

37. Clement Greenberg, "The Present Prospects of American Painting and Sculpture," *Horizon*, October 1947, p. 26.

38. Clement Greenberg, "Art," the *Nation*, February 1, 1947, pp. 138–39.

39. Ibid. On February 22 of the same year, Greenberg continued along the same lines in a critique of the Whitney show: "If the Americans seem stodgy and dull, the liveliness and the knowingness of the French are empty. Nor, contrary to expectations, are the French more facile or tasteful. They are just as inept for the most part—and hysterical in the bargain" (*Nation*, February 22, 1947, p. 228).

40. Robert Motherwell, in the course of the symposium held at Studio 35 from April 21–23, 1950. Published in Robert Motherwell and Ad Reinhardt, eds., *Modern Artists in America* (New York: Wittenborn, 1952).

41. Ibid.

42. Ibid., pp. 12–13.

43. Clement Greenberg, *Nation*, February 19, 1949, p. 221. Nicole Dubreuil-Blondin describes the pathway to success in Pollock's case in "Number One towards the Construction of a Model," *Jackson Pollock: Questions* (Montreal, 1979), p. 48.

44. Samuel Kootz, in the catalog for his show "The Intransubjectives," September 14–October 3, 1949. Each artist presented a single canvas. Included were Baziotes, de Kooning, Gorky, Gottlieb, Graves, Hofmann, Motherwell, Pollock, Reinhardt, Rothko, Tobey, Walker Tomlin.

45. Byron Browne, quoted by Greta Berman, "Byron Browne: Builder of American Art," *Arts Magazine*, December 1978, p. 98.

46. Ibid., p. 102.

47. Carl Holty, letter to Hilaire Hiler, February 1, 1946, Archives of American Art, N-670 (384).

48. Among the cafes and other meeting places of the avant-garde, like the Waldorf cafeteria and Subjects of the Artist (a new art school), the "Club" was the most important and most famous. Founded in 1949, it was run by Philip Pavia, who in 1958 published the magazine *It Is*. Discussions of art and aesthetics were carried on among specialists, assisted by guest lecturers. For a list of titles of lectures given at the Club, see Irving Sandler, "The Club," *Artforum* 4, no. 1 (1965): pp. 27–31. See also Archives of American Art, D 176. In 1951, certain members of the Club organized, with the help of Leo Castelli, a show in a rented building at 60 East Ninth Street. The so-called Ninth Street show presented the work of sixty-one artists, mostly abstract expressionists (except for Baziotes, Gottlieb, Newman, and Rothko). It was quite well received by the public and the press. In the same year the American government sent a huge art exhibition to West Berlin. One hundred thirty canvases, including some abstract expressionists, were shown. *Time* called this show "painting's Voice of America." Leo Castelli also helped pay the rent ($75 per month) of the Club's meeting hall. The total cost for the month of January 1951 was $89.15, covered by a check from Castelli for $82.79 and $20 from John Ferren.

49. It is ironic that Byron Browne's career was launched when Kootz staged a show at Macy's and that it ended tragically in another large department store, Gimbel's.

50. Although the sales prices do not seem very high by current standards, for 1948 they were considerable. Pollock's *Gothic*, for example, sold for $1,200 ($500 was a standard price for contemporary French and American paintings, e.g., Masson, $500). Beginning in 1947

Betty Parsons sold large numbers of paintings by Walter Murch (very realistic canvases going for $10,000 in 1948), but at the same time sold paintings by Pollock (six of them at a price of $1,950).

In 1949, shortly after the publication of the *Life* article on Pollock ("Is He the Greatest Living Painter in the U.S.?" August 8, 1949), sales increased at an incredible pace. In October four paintings were sold to the wealthy painter Alfonso Ossorio. Thirteen more were sold at $3,600 during a one-man show judiciously held from November 21 to December 10. The year proved a profitable one, since Pollock sold thirty-five canvases for a total of $13,870 ($4,578 of which went to the gallery). Apparently everybody got into the act, including many famous collectors who did not hesitate to invest in Pollock, such as John D. Rockefeller, Ossorio, Edward Root ($3,200), Lee Ault (president of Quadrangle Press, $1,900), Russel Cowles, the Museum of Modern Art, Duncan Phillips ($2,000), Grace Borgenicht, and institutions such as *Vogue* magazine and Carnegie Illinois Research Laboratory. In the following year Pollock sold for $13,600 and Rothko for $8,950. Note, too, that after the war large collectors started buying from Parsons. In 1945 Root bought Stamos and Rothko; other buyers included Alex M. Bing (real estate), Emily Hall Tremaine (art director of the Miller Co.), and Lynn Thompson.

At $8,950 per year, these artists were not on the brink of poverty, despite the still current myth about their financial difficulties. Recall that in 1951 fifty-five percent of American families fell below the poverty line for a family of four (Bureau of the Census, *Income Distribution in the United States*, p. 16). In 1948 two-thirds of all American families lived on less than $4,000 per year (see Hamby, *Beyond the New Deal*, p. 664).

51. Peyton Boswell, "Chicago Surveys the Abstract and Surrealist Art of America," *Art Digest*, November 15, 1947. Boswell recalled the incident in the January 1, 1948, issue of the same magazine. For him it was a symbol of the decadence of American art:

This year was a bad one. America, the only free nation left economically able to support a great art movement was not taking its tide at the flood. This interest in the abstract reached its apex at the Art Institute of Chicago, where director Daniel Catton Rich replaced his annual all-American exhibition with a nation-wide survey of abstract and surrealist American art. The Rich-Campana prize ($1000) went to William Baziotes for a pigmental mistake casually entitled *Cyclops*.

In the November article Boswell praises the survey for its discovery of new artists showing a "good" side of modern art. However, he makes sure to devaluate artists such as those of "57th street regulars" like Motherwell, Calder, Gorky, Pollock, Burlin, Avery, etc.

Also, compare the plastic stuttering of the exhibits by Lee Gatch, David Burliuk, A. D. F. Reinhardt and Mark Rothko with the vital, new works by Russell Twiggs, Knud Merrild, Howard Warshaw, Audrey Skaling, Margaret Tomkins, Leon Bishop, Julius Engel, George Harris, Richard Koppe . . .

The common denominator linking these exhibitors is respect for craftsmanship; they are skilled in draftsmanship, color harmonies and the basic verities of design relationships, disproving the popular fancy that the abstract is the refuge of those who cannot draw. (p. 9)

Boswell attempts here to save abstraction from automatism and from expressionism. He finds in these "new" artists qualities opposing what the avant-garde was then defending.

52. Boston Institute of Modern Art, cited in Lynes, *Good Old Modern*, p. 292. The institutions were also responding to the uproar that Baziotes's award had caused in the middle classes. See T. H. Robsjohn Gibbings, "Decadence of Modern Art," *American Weekly*, February 22, 1948, with a drawing by E. C. Van Swearingen. The subtitle of this article was,

"A Noted Expert Explains That Painting Today Is a Revival of the Profane Black Magic Used by Witch Doctors to Obtain Power."

53. Cited in Lynes, *Good Old Modern*, p. 293.

54. Paul Burlin, "The Modern Artist Speaks," MOMA forum, May 5, 1948, Archives of American Art, No. 69/112, folder 59-66. Stuart Davis, Adolph Gottlieb, George L. K. Morris, and James Johnson Sweeney also commented on the critical situation.

The meeting was attended by thirty-six artists, including Pollock (see O'Connor, *Jackson Pollock*, p. 42) and an audience of nearly two hundred.

55. Ibid.

56. Ibid.

57. Stuart Davis, ibid.

58. Ibid

59. "Today as art reaches into unexplored regions, turning away from the imitation of natural appearances, the critic is obviously eager to understand. No critic wants to be the comic footnote in some future history of art, each one would like to be the perceptive crusader who 'discovered' tomorrow's genius" (Aline Loucheim in the *New York Times*, May 9, 1948, section 2, p. 8).

60. Jerome Mellquist, "New Isolationists in Art," *Commonweal*, October 7, 1949, p. 625.

61. Ibid., p. 628.

62. Emily Genauer, *Best of Art* (New York: Doubleday, 1948), p. xii.

63. *Partisan Review*, July–August 1948. This advertisement was a reflection of what was going on in the real estate business, buoyed by a construction boom. The country in fact stood in great need of an ambitious construction program. What actually took place is analyzed by Richard O. Davies, *Housing Reform during the Truman Administration* (Columbia: University of Missouri, 1966), p. 136. See also J. Joseph Huthmacher, *The Truman Years: The Reconstruction of Postwar America* (Hinsdale, Illinois: Dryden Press, 1972).

64. In 1946 Congress authorized construction aid to help build 1.2 million homes, continued in 1947 (Patman Act) with further aid for 1.5 million homes. But only half this number were actually constructed owing to poor organization and greater interest on the part of the housing industry in luxury construction. Finally, in 1949, Congress passed the National Housing Act as part of Truman's "Fair Deal." This provided low-interest loans for the construction of 810,000 homes.

65. Cover of *Partisan Review*, September 1948.

66. "We asked Avant-Garde to draw this Pictograph to help tell *PR* readers what County Homes is doing about housing. This is the first of a series by contemporary artists, all of whom find it unusual to illustrate a real estate advertisement. *The Unusual*, however, is our business" (ibid.).

67. On this subject, see "Old or Modern, Art That Is Good Enhances Any Room, Painter Holds," *New York Times*, July 27, 1948, p. 28. To an audience of decorators Doris Rosenthal presented the "advanced" idea that any work of art, whether realistic or completely abstract, could be used as a standard element of interior decoration. See also *Vogue*, April 15, 1950, for a discussion of the use of Rothko paintings to decorate a modern house, presumably to the dismay of the artist. The article was entitled "One Picture Wall—Many Picture Wall" and emphasized the idea that the new style, the wave of the future, was to have one large canvas covering the whole wall (in fact, the page featuring the Rothko was in color, while the other arrangement, a real dust-catcher, was shown in black and white).

68. *Life*, August 8, 1949. Before this article appeared, *Time* had devoted several lines and a photo to Pollock (in response to a Greenberg article in the *Nation* in which Pollock was hailed as the best American painter). See "The Best?" *Time*, December 1, 1947, p. 55.

69. *Life*, October 11, 1948, p. 56. This panel discussion was the second of a series devoted to modern subjects. The first appeared under the title "Pursuit of Happiness." The "dis-

tinguished critics and connoisseurs" included Aldous Huxley, Georges Duthuit, Meyer Schapiro, James Johnson Sweeney, James Thrall Soby, and Sir Leigh Ashton.

70. Ibid.

71. Ibid., p. 56.

72. Bernard Harper Friedman, *Energy Made Visible: Jackson Pollock* (New York: McGraw-Hill, 1972), p. 123.

73. Leslie A. Fiedler, "State of American Writing," *Partisan Review* 15, no. 8 (1948): 870–76.

74. Ibid., p. 875.

75. Clement Greenberg, *Partisan Review* 15, no. 8 (1948): 876–79.

76. Ibid., p. 877.

77. Ibid., pp. 878–79.

78. René d'Harnoncourt, "Challenge and Promise: Modern Art and Society," *Art News,* November 1949, p. 252.

79. Ibid.

80. This book became the bible of the new liberals, but a number of books featuring the same ideology were published in 1949. Among them were Leland Stowe, *Target You;* Max Ascoli, *The Power of Freedom;* and Irwin Ross, *Strategy for Liberals. The Vital Center* articulated and popularized ideas expressed earlier by Reinhold Niebuhr. According to Alonzo Hamby, this "vital center" was in fact a move toward the right: "Implicit in the new liberal self-image were a slight tendency toward moderation, a decline of utopian hopes and aspirations, a somewhat stronger suspicion of powerful government, increasing doubts about the goodness of human nature" (see *Beyond the New Deal,* p. 277).

81. Ibid., p. 354.

82. Ibid., p. 355.

83. The editor of the *New York Post,* T. O. Thackrey, a Wallace supporter, was removed from his position and replaced by James A. Wechsler, an ADA leader and notorious anti-Communist.

84. Anticommunism spread within labor unions, where Communist groups lost considerable ground: "The Congress of Industrial Organizations expelled popular front unions. 'We in American labor will fight totalitarianism from the right of the left,' declared Philip Murray, the president of the C.I.O. 'We regard the human welfare state as America's middle way' " (cited in Alonzo Hamby, "The Vital Center, The Fair Deal and the Quest for a Liberal Political Economy," *American Historical Review* 77, no. 3 [1972]: 653–78).

85. Arthur M. Schlesinger, Jr., *The Vital Center: Our Purposes and Perils on the Tightrope of American Liberalism* (1949; rev. ed., Boston: Houghton Mifflin, 1962), p. 248.

86. Ibid., p. 56.

87. Charles A. Thomson and Walter H. C. Lawes, *Cultural Relations and Foreign Policy* (Bloomington, Ind.: Indiana University Press, 1963). He adds: "[The United States's] program should not be a miscellany of good will activities but must be designed 'to support U.S. foreign policy in its long range sense and to serve as an arm of that policy.' "

88. Oren Stephens, *Facts to a Candid World* (Stanford, 1955). This was also the period when Radio Free Europe became quite popular with Congress. Thomson and Lawes explain: "In the 1946 Congress debates, the Voice of America was subjected to more severe attack than any other activity; in 1947, it proved to be the most popular, the most wanted, the most understood, and the least vulnerable" (*Cultural Relations,* p. 65).

89. James T. Soby, "Does Our Art Impress Europe?" *Saturday Review,* August 6, 1949, p. 143.

90. Ibid., p. 145.

91. Ibid., p. 147.

92. A well-known and oft-cited remark of de Kooning's, which here takes on a new dimension owing to its historical resonance.

Conclusion

1. Here is the way Clement Greenberg described the problem in 1948: "There is a persistent urge, as persistent as it is largely unconscious, to go beyond the cabinet picture, which is destined to occupy only a spot on the wall, to a kind of picture that, without actually becoming identified with the wall like a mural, would spread over it and acknowledge its physical reality. . . . Abstract painting, being flat, needs a greater extension of surface on which to develop its ideas than does the old three-dimensional painting, and it seems to become trivial when confined within anything measuring less than two feet by two. Thus, while the painter's relation to his art has become more private than ever before because of a shrinking appreciation on the public's part, the architectural and presumably social location for which he destines his product has become, in inverse ratio, more public. This is the paradox, the contradiction, in the master-current of painting" (*Partisan Review*, January 1948, p. 83).

2. See Jane de Hart Mathews, "Art and Politics in Cold War America," pp. 762–87.

3. A very good discussion of the subject's importance may be found in E. A. Carmean, Jr., and Eliza E. Rathbone, *The Subjects of the Artist* (Washington, D.C.: National Gallery of Art, 1978), especially pp. 15–40.

4. Rico Lebrun won the Harris Prize for *Composition Verticale*, a stylized portrait of broken axles symbolizing the violence of the holocaust. His traditional draftsmanship and above all the poignant content of his compositions had a false ring. His *Mary Magdalene* of 1948 elicited laughter rather than tears owing to its exaggerated mimicry and bodily contortion. The technical perfection of the drawing in a sense killed the reality of the feelings.

5. In this connection here is what Jackson Pollock said in 1950: "My opinion is that new needs call for new techniques. And modern artists have found new ways and means of making their statements. It seems to me that the modern painter cannot express the present age of the airplane, the atom bomb, and the radio in forms of the Renaissance or of any other past culture. Each age finds its own technique [retranslated from the French—trans.]" Pollock was commenting on a film produced by Hans Namuth and Paul Falkenberg, 1950–51. See Jackson Pollock Exhibition catalog (Paris: Centre Georges Pompidou, 1982), p. 284.

6. The totem-like figure is fairly clearly visible on the left, though it is never mentioned in works on Pollock. I suppose that "all-over" reading of the canvas has prevented critics from seeing a part of the substance of the painting. The same motif also occurs in the following works: *Pasiphae* (1943), *Male and Female* (1942), *The Guardian of the Secret* (1943), *The Totem Lesson II* (1945).

7. *Number 22A* and *Number 4* clarify the procedure. In *Number 22A* Pollock, as if by accident, gives the free-flowing line a humanoid shape: we can make out several totemic figures with genitals, male on the left, female on the right. The line remains an invisible presence though interrupted by erasures. The figuration, applied in an uncontrolled way, does not succeed in making its point. This is clearer in *Number 4*, where a human figure with raised arms in the center of the composition is swept away and annihilated in a sudden assault by the linear movement of the surface, which obliterates and covers up what has been drawn beneath. These drawings, which so clearly disclose the pictorial mechanism of *Number 1, 1948* that it seems reasonable to think that they may have been preliminary sketches for that work, mark the crucial moment when the painter chose to accentuate the battle that was then raging in the world of art, as it were, sharpening the razor's edge on which he was attempting to maintain a precarious balance.

8. In a letter to *Partisan Review*, Irving Howe complained that no socialists were included among the symposium participants: "Don't you think the list of people you have in your future of socialism rather one-sided: That is most of them have for one reason or another abandoned active participation in the socialist movement, as well as orthodox Marxism" (Irving Howe to Catherine Carver, March 1947, Partisan MSS., cited in James B. Gilbert, *Writers and Partisans*, p. 269).

9. Dwight Macdonald, "The Root Is Man," p. 99.

10. Schapiro's argument has been refuted in a series of unpublished papers written for Otto Karl Werckmeister's seminar on medieval art at UCLA in 1974–75. In particular see Werckmeister's study, "The Art of the Monks of Silos in the Beginning of the Twelfth Century" (UCLA, 1976). According to Professor Werckmeister, these musicians may represent the Old Testament scene of music playing in the Temple court cited in 2 Maccabees. This pericope is read in the Mozarabic rite on Octave Sunday after Easter when the story of Doubting Thomas is read.

11. My assessment of Meyer Schapiro relies in part on unpublished sources including Carol Knicely, "A Critique of the Art Historical Work of Meyer Schapiro in the 30's and 40's" (University of California at Los Angeles, 1975); Toby Smith, "Meyer Schapiro's Concept of the Individual, 1936–1947" (University of British Columbia, 1982); and Kay Dian Kriz, "Meyer Schapiro in the 1950's: Modern Art and the 'New Radical' " (University of British Columbia, 1982).

12. Meyer Schapiro, "On the Aesthetic in Romanesque Art," in *Romanesque Art* (New York: George Braziller, 1977), p. 1.

13. The avant-garde magazine *Tiger's Eye* and *Vogue* could accordingly publish photos of Newman, Rothko, and Pollock canvases without noticing any insurmountable contradictions.

14. Gottlieb and Rothko said as much in their famous 1943 letter to the *New York Times:* "It is our function as artists to make the spectator see the world our way—not his way" Cited in Dore Ashton, *The New York School*, p. 128.

15. The fact that the right wing along with much of the middle class rejected the immense canvases of the abstract expressionists in no way discouraged the proponents of the new liberalism: if the vast color fields and meaningless gesticulations of the new painting were unprofitable to look at, mere gratuitous expenditures of energy, so too was the Marshall Plan unprofitable and apparently gratuitous. Indeed, many people viewed the plan as a total loss. Yet it did reap enormous if intangible benefits, political and ideological rather than economic in nature.

16. Schlesinger, *The Vital Center*, p. 52.

17. Clyfford Still to Betty Parsons, March 20, 1948, Archives of American Art, N 68/72.

18. Bear in mind that various anti-Communist committees such as the House Unamerican Activities Committee were expanding their investigations and devices such as the Attorney General's List were in wide use. Attempts were made to keep Marxists out of university teaching positions. Sidney Hook (himself a former Marxist) was among the more vocal advocates of these efforts: "Communism and the Intellectuals," *American Mercury* 68, no. 302 (1949): 133–44.

19. Schlesinger, *The Vital Center*, p. 52.

20. Ibid., p. 57.

21. Ibid., p. 207.

22. Ibid., p. 10

23. Schlesinger outlined his philosophy in an article published in the *New York Times Magazine* on April 4, 1948. There he mentions Léon Blum's "third force" as liberalism's best hope of defeating authoritarianism in France. See "Not Left, not Right, but a Vital Center," pp. 7–11. When *The Vital Center* was reprinted in 1962, the cover used abstract art to symbolize the balanced center position. A red line à la Barnett Newman rises virilely through the center of the frame, set against a background à la Kline of violent brush strokes symbolizing the energy of the two opposing tendencies. Thus it occurred to at least one book designer in 1962 that abstract expressionism represented the new liberalism.

24. The "third force" was a loose coalition of centrist parties in France which refused both Communist and Gaullist alternatives. Despite holding on to power for few a years, it was a weak grouping.

25. James T. Soby, *Saturday Review,* November 5, 1949, p. 30.

26. James T. Soby, "Postwar Painting, in the Shadow of Guernica," in *America and the Mind of Europe*, ed. Lewis Galantière (London: Hamish Hamilton, 1951), p. 114. This publication illustrates the scope of American propaganda in France: Galantière, according to the book's introduction, was "chief policy adviser to Radio Free Europe and an active spokesman for the interdependence of the U.S. and Europe."

27. At the 1948 biennial, Gorky, Stamos, Rothko, and Tobey were represented among seventy-nine American painters. In fact it was the Museum of Modern Art which, for reasons of domestic politics following the difficulties of 1946, managed the American pavilion at the Venice biennial. Thus American culture was represented by the private sector, as journalist Bernard Denvir pointed out: "At the (1954) Biennale at least, artistic conservatism and communism go hand in hand, whilst free enterprise is linked to the more adventurous forms of artistic explorations" ("Mayfair to Manhattan," *Artist*, November 1954, p. 35).

Thus the MOMA indirectly aided the government, itself held in check by right-wing opposition. It was actually with State Department blessings, and not over State Department opposition, that avant-garde art achieved international dominance. It was not uncommon during the fifties for private organizations to receive indirect subsidies from the federal government. For a study of the relations between the State Department, the CIA, and high culture during the Cold War, see Christopher Lasch, "The Cultural Cold War," *Nation*, September 11, 1967, pp. 198–212.

28. Betty Parsons Gallery sales records: author's interview with Betty Parsons, New York, February 16, 1978.

29. On the Club see Irving Sandler, *Artforum* 4, no. 1 (1965).

30. Robert Motherwell, *The School of New York* (Beverly Hills, California: Frank Pearls Gallery, 1951).

31. See the April 1950 issue of *Vogue*. Cecil Beaton photographed fashion models in front of Jackson Pollock's work shown at Betty Parsons Gallery for *Vogue*, March 1951. In 1953 the well-known collector Roy Neuberger was proudly showing the entire country the Hans Hofmann abstract work he had in the office of his brokerage house. See *Look*, November 3, 1953.

32. See Lasch, "The Cultural Cold War," pp. 63–114.

33. Dwight Eisenhower used the term in San Francisco, October 8, 1952: "Our aim in "Cold War" is not conquest of territory or subjugation by force. Our aim is more subtle, more pervasive, more complete. We are trying to get the world, by peaceful means, to believe the truth. . . . The means we shall employ to spread this truth are often called "Psychological" . . . "Psychological warfare" is the struggle for the minds and wills of men . . ." (cited in Blanche Wiesen Cook, *The Declassified Eisenhower* [New York: Doubleday, 1981], p. 121).

In a letter to William E. Daugherty (July 17, 1952), C. D. Jackson—an important cold warrior very close to the Eisenhower administration who was among other things the president of the National Committee for a Free Europe (NCFE)—wrote that "for maximum effectiveness psychological-warfare organisations in peacetime required adequate funds, the freedom to operate on a no holds-barred basis and to be in a position to have no questions asked." As Blanche Wiesen Cook says, "For success, psychological warfare in the United States depended on its ability to appear independent from government, to seem to represent the spontaneous convictions of freedom loving individuals" (ibid., 126–27).

Cultural propaganda gained in subtlty and diversified its targets. Avant-garde works were sent to Paris and Berlin while more traditional paintings were shipped to Italy, where the public found the work of a painter like Ben Shahn more to its taste. At home avant-garde art was liberals' favorite. On October 2, 1952, Samuel Kootz gave a clear indication of the ties between the avante-garde and liberalism. He staged a fundraiser in his gallery for Adlai E. Stevenson's presidential campaign and prepared a long speech in which he

emphasized the importance of anti-Communist individualism and made clear that his gallery intended to pursue an international audience. See Samuel Kootz Papers, Archives of American Art, Washington, D.C.

34. Among the consultants we should mention were James Agee, Malcolm Cowley, James T. Farrell, Alfred M. Frankfurter, Melvin J. Lasky, Robert Motherwell, Norman Holmes Pearson, Duncan Phillips, Meyer Schapiro, Arthur Schlesinger, Jr., Delmore Schwartz, and Lionel Trilling. A grand reconciliation. See *Profils*, no. 1 (October 1952): 5–6.

35. The following were among the many European exhibitions:

1951: Amerikanische Malerei, Werden und Gegenwart. Berlin, Munich.

1951: Véhémences Confrontées. Galerie Nina Dausset, Paris.

1952: Regards sur la peinture Américaine. Galerie de France, Paris.

1953: Opposing Forces, Institute of Contemporary Art, London.

1953–54: Twelve American Painters and Sculptors. Paris, Zurich, Dusseldorf, Stockholm, Helsinki, Oslo (presented by the MOMA).

1955–56: Modern Art in the United States: Selections from the Collections of the MOMA. Zurich, Barcelona Frankfurt, London, Vienna, Belgrad.

1956: Junge Amerikanishe Kunst. Dusseldorf.

Bibliography

Archives of American Art, Washington, D.C.
William Baziotes, N 70/21
Byron Browne, NBB2m 97
Emily Genauer, GN 1
Clement Greenberg, N 70/7
Peggy Guggenheim, ITVE 1
Samuel Kootz, NY 65/1
Barnett Newman Papers
Ad Reinhardt, N 69/99 and N 69/104
Artists for Victory Papers, 115–16
Federation of Modern American Painters and Sculptors (Federation Papers), N 69/75
Willard Gallery Papers, N 69/114–N 69/116

Interviews, 1977–1978
Rosalind Bengelsdorf-Browne
Eva Cockcroft
Oscar Collier
Clement Greenberg
Sidney Janis
Reuben Kaddish
Lester Longman
Charles Pollock
Betty Parsons
Jack Tworkow
Hugh Weiss

Books and Articles
For a basic bibliography on abstract expressionism, see Irving Sandler, *The Triumph of American Painting* (New York: Praeger, 1970).
Aaron, Daniel. *Writers on the Left*. New York: Avon, 1969.
————. *The Strenuous Decade*. New York: Doubleday, 1970.
————. "Thirty Years Later: Memories of the First American Writers' Congress." *American Scholar* 25 (Summer 1966): 495–516.
Abell, Walter. "Industry and Paintings." *Magazine of Art*, March 1946, p. 83.
Adler, Les K., and Paterson, Thomas G. "Red Fascism: The Merger of Nazi Germany and Soviet Russia in the American Image of Totalitarianism, 1930–1950." *American Historical Review*, April 1970, pp. 1046–64.
Adler, Mortimer. "This Pre-War Generation." *Harper's* 181 (October 1940): 524–34.
Agar, Herbert. *The Price of Power*. Chicago: University of Chicago Press, 1957.
Albee, Louis. "Education as an Implement of U.S. Foreign Policy, 1938–1948." Ph.D. diss., Yale University, 1948.
Allen, Frederick Lewis. "Who's Getting the Money?" *Harper's* 189 (June 1944): 1–10.
Alloway, Lawrence. *Topics in American Art since 1945*. New York: Norton, 1975.
Alperovitz, Gear. *Cold War Essays*. New York: Anchor, 1970.
Ambrose, Stephen E. *Rise to Globalism: American Foreign Policy since 1938*. Baltimore: Penguin, 1971.
American Artists' Congress. *First American Artists' Congress*. New York, 1936.
Arnavon, Cyrille. *L'américanisme et nous*. Paris: Del Duca, 1958.
Aron, Raymond. *The Imperial Republic: The United States and the World, 1945–1973*. Englewood Cliffs, N.J.: Prentice-Hall, 1974.
Aronson, James. *The Press and the Cold War*. Boston: Beacon Press, 1970.
"Art Boom." *Fortune*, September 1946, pp. 144–51.
"Art for Profit's Sake." *Colllier's* 114 (November 25, 1944); 22–30.
Ashton, Dore. *The Unknown Shore*. Boston: Little, Brown, 1962.
————. *The New York School: A Cultural Reckoning*. New York: Viking, 1973.
Bailyn, Bernard, and Fleming, Donald, eds. *The Intellectual Migration: Europe and America, 1930–1960*. Cambridge: Harvard University Press, 1968.
Barr, Alfred H., Jr. *What Is Modern Painting*. New York: MOMA 1943.
Barr, Sharrar. *Artistes en exil, 1939–1946*. Paris: Mazarine, 1968.
Barrett, William. *The Truants: Adventures among the Intellectuals*. New York: Doubleday, Anchor Press, 1982.

Barthes, Roland. *S/Z*. Paris: Seuil, 1970.

———. *Mythologies*. Paris: Seuil, 1957.

Barry, Joseph A. "To Them, Picasso Is an Old Hat." *New York Times Magazine*, January 8, 1950, p. 19.

Bataille, Georges. *La part maudite*. Paris: Editions de Minuit, Collection le Point, 1967.

Baudrillard, Jean. *Pour une critique de l'économie politique du signe*. Paris: Gallimard, 1972.

———. *Le système des objects*. Paris: Denoel-Gonthier, 1976.

———. *La société de consommation*. Paris: Gallimard, 1970.

Bauer, George Howard. *Sartre and the Artist*. Chicago: University of Chicago Press, 1969.

Bazelon, David. *Power in America: The Politics of the New Class*. New York: New American Library, 1967.

Beauvoir, Simone de. *L'Amérique au jour le jour*. Paris: Gallimard, 1954.

———. *La force des choses*. Paris: Gallimard, 1963.

Bell, Daniel. *The Cultural Contradictions of Capitalism*. New York: Basic Books, 1976.

Benjamin, Walter. "The Author as Producer." *New Left Review* 62 (July–August 1970): 89–96.

———. *Illuminations*. New York: Schocken, 1973.

Benson, E. M. "Viewpoints: The Role of Art in a Democracy." *Magazine of Art* 38, no. 2 (February 1945): 54.

Benson, F. R. *Writers in Arms*. New York: New York University Press, 1967.

Bernstein, Barton J., and Matusow, Allen. *The Truman Administration*. New York: Harper and Row, 1968.

———. *Politics and Policies of the Truman Administration*. New York: New Viewpoints, 1970.

Bettelheim, Claude; Martinet, Gilles; and Naville, Pierre. *Y-a-t-il crise dans l'Art français?* Paris: Essai et Documents, 1945.

Biddle, Francis. *The Fear of Freedom*. New York: Doubleday, 1951.

Biddle, George. "Can Artists Make a Living? How the Market for Art Is Changing." *Harper's* 181 (September 1940): 394–401.

———. "The Government and the Arts." *Harper's* 187 (October 1943): 427–34.

———. "The Horns of Dilemma." *New York Times*, May 19, 1946, section 6, p. 21.

———. "The Victory and Defeat of Modernism: Art in a New World." *Harper's* 187 (June 1943): 32–37.

Bidwell, Percy W. *Mobilizing Civilian America*. New York: Council on Foreign Relations, 1940.

Bigelow, Karl. "The Challenge of Art in a Time of Crisis: Art Education in a Free Society." *Yearbook of the Eastern Arts Association*. Kutztown,

Pa. 1947, pp. 33–46.

Billiet, Joseph. *Introduction à l'étude de l'art français: conditions générales de l'art.* Paris: Editions Sociales, 1945.

Billoux, François. *Quand nous étions ministres.* Paris: Editions Sociales, 1972.

Blum, John Morton. *V Was for Victory: Politics and American Culture during World War II.* New York: Harcourt Brace Jovanovich, 1976.

Blyth, Conrad Alexander. *American Business Cycles, 1945–1950.* London: Allen and Unwin, 1969.

Boas, George. "The Social Responsibility of the Artist." *College Art Journal* 6 (Summer 1947): 270–76.

Bonitzer, Pascal. *Le regard et la voix.* Paris: Union Générale d'Editions, 1976.

Boswell, Peyton. *Modern American Painting.* New York: Dodd, Mead, 1939.

Bourdieu, Pierre. *Question de sociologie.* Paris: Editions de Minuit, 1980.

Braden, Thomas W. "I'm Glad the CIA Is Immoral." *Saturday Evening Post,* May 20, 1967, pp. 10–14.

Breton, André. *La clé des champs.* Paris: J. J. Pauvert, 1967.

———. *Entretiens.* Paris: Gallimard, 1969.

———. *Position politique du surréalisme.* Paris: Denoël Gonthier, 1972.

Breton, André, and Rivera, Diégo. "Towards a Free Revolutionary Art," *Partisan Review* 6, no. 1 (Fall 1938): 49–53.

Brock, Clifton. *Americans for Democratic Action: Its Role in National Politics.* Washington, D.C.: Public Affairs Press, 1962.

Brown, Gordon. "New Tendencies in American Art." *College Art Journal* 11, no. 2 (Winter 1951–52): 103–10.

Brown, Milton. "After Three Years." *Magazine of Art,* April 1946, pp. 138–66.

———. "American Art a Year after Pearl Harbor." *Art News,* December 1–14, 1942, p. 9.

Browne, Byron. "The Artist and His Market." *New York Times,* August 11, 1940, section 2, p. 7.

"Bull Market in Art." *Newsweek,* March 20, 1944, pp. 22–30.

Byrstyn, Marcia. "Art Galleries as Gate Keeper: The Case of Abstract Expressionism." Ph.D. diss., New York University, 1978.

Cahill, Holger, and Barr, Alfred A., Jr. *Art in America.* New York: Halcyon House, 1939.

Calmer, Alan. "Portrait of the Artist as a Proletarian." *SRL* 16 (July 31, 1937): 3.

Cannon, James P. *The History of American Trotskyism.* 2d ed. New York: Pioneer Publishers, 1974.

Cantril, Hadley. "How Real Is America's Internationalism?" *New York Times Magazine,* April 29, 1945, p. 9.

———. "Opinion Trends in World War II: Some guides to Interpretation." *Public Opinion Quarterly* 12 (Spring 1948): 30–44.

Cargill, Oscar. *Intellectual America: Ideas on the March.* New York: Macmillan, 1941.

Carmean, E. A., Jr., and Rathbone, Eliza E. *The Subjects of the Artist.* Washington, D.C.: National Gallery of Art, 1978.

Carroll, Wallace. *Persuade or Perish.* Boston: Houghton Mifflin, 1948.

Casanova, Laurent. *Le P.C., les intellectuels, et la nation.* Paris: Editions Sociales, 1949.

Cassou, Jean. *Débat sur l'art contemporain.* Neuchatel: Baconnière, 1948.

Caute, David. *The Fellow Travellers—A Postscript to the Enlightenment.* New York: Macmillan, 1973.

———. *The Great Fear.* New York: Simon and Schuster, 1978.

Celentano, Francis. "The Origins and Development of Abstract Expressionism in the United States." Master's thesis, New York University, 1957.

Chandler, Lester V. *Inflation in the United States, 1948–49.* New York: Harper and Row, 1951.

Chase, Richard; Trilling, Lionel; and Barrett, William. "The Liberal Mind: Two Communications and a Reply." *Partisan Review,* June 1949, pp. 649–65.

Cheney, Martha Candler. *Modern Art in America.* New York: McGraw Hill, 1939.

Cockcroft, Eva. "Abstract Expressionism: Weapon of the Cold War." *Artform* 12 (June 1974): 39–41.

Cowley, Malcolm. "A Remembrance of the Red Romance." *Esquire* 41 (March 1964): 124–30.

———. *Think Back on Us: A Contemporary Chronicle of the Thirties.* Carbondale: Southern Illinois University Press, 1967.

Crossman, Richard, ed. *The God that Failed.* New York: Bantam, 1950.

Damish, Hubert. "La figure et l'entrelacs: l'oeuvre de Jackson Pollock." *Les lettres nouvelles,* no. 33 (December 9, 1959): 36–43; no. 34 (December 16, 1959): 35–38.

Davenport, Russell, ed. *USA: The Permanent Revolution.* New York: Prentice-Hall, 1951.

Davie, Maurice R. *Refugees in America: Report of the Committee for the Study of Recent Immigration from Europe.* New York: Harper and Row, 1947.

Davis, Stuart. "Abstract Art in the American Scene." *Parnassus* 13, no. 3 (March 1941): 100–103.

———. "What about Modern Art and Democracy?" *Harper's* 188 (December 1943): 16–23.

Debord, Guy. *La société du spectacle.* Paris: Champ Libre, 1971.

Delmas, Gladys. "A New Group of French Painters." *Magazine of Art,* November 1945, pp. 268–70.

De Roussy de Sales, Raoul. *The Making of Tomorrow.* New York: Reynal and Hitchcock, 1942.

————. *The Making of Yesterday.* New York: Reynal and Hitchcock, 1947.

Desanti, Dominique. *L'année ou la terre a tremblé.* Paris: Albin-Michel, 1947.

Devree, Howard. "Straws in the Wind: Some Opinions on Art in the Post War World of Europe and America." *New York Times*, July 14, 1946, section 2, p. 4.

Divine, Robert. *The Illusion of Neutrality.* Chicago: Quadrangle, 1962.

————. *Second Chance: The Triumph of Internationalism in America during World War II.* New York: Atheneum, 1967.

————. *Foreign Policy and U.S. Presidential Elections, 1940–1948.* New York: New Viewpoints, 1974.

Dollot, Louis. *Les relations culturelles internationales.* Paris: P.U.F., 1968.

Domhoff, William G. *Who Rules America.* Englewood Cliffs, N.J.: Prentice-Hall, 1967.

Dos Passos, John. *State of the Nation.* Boston: Houghton Mifflin, 1944.

Dudley, Drew. "Moulding Public Opinion through Advertising." *Annals of the American Academy of Political and Social Science* 250 (1947): 105–12.

Edman, Irwin. "The Civilizing Influence of Art." *Art News*, April 1947, p. 17.

Egbert, Donald Drew. *Socialism and American Art.* Princeton: Princeton University Press, 1967.

Eisinger, Chester E. *The 1940's: Profile of a Nation in Crisis.* New York: Doubleday, Anchor Press, 1969.

Ekirch, Arthur A., Jr. *Ideologies and Utopias: The Impact of the New Deal on American Thought.* Chicago: Quadrangle, 1971.

Ellul, Jacques. *L'empire du non sense: L'art et la société technicienne.* Paris: P.U.F., 1980.

Epstein, Jason. "The CIA and The Intellectuals." *New York Times Review of Books*, April 20, 1967, pp. 16–21.

Epstein, Marc Joel. *The Third Force: Liberal Ideology in a Revolutionary Age, 1945–50.* Ph.D. diss., University of North Carolina, 1971.

Estienne, Charles. *L'art abstrait est-il un académisme?* Paris: Editions de Beaune, 1950.

Estivals, Robert. *L'avant-garde culturelle parisienne depuis 1946.* Paris: Guy le Prat, 1962.

Etzold, Thomas, and Gaddid, John Lewis. *Containment Documents on American Policy and Strategy, 1945–1950.* New York: Columbia University Press, 1978.

Farber, Many. "The Art of Contrast." *New Republic*, November 13, 1944, p. 626.

Farrell, James T. *The Fate of Writing in America.* New York: New Directions, 1946.

———. *The League of Frightened Philistines.* New York: Vanguard, 1945.

———. *A Note on Literary Criticism.* New York: Vanguard, 1936.

Fiedler, Leslie A. *An End to Innocence.* New York: Stein/Day, 1971.

———. "Partisan Review: Phoenix or Dodo?" *Perspective U.S.A.*, no. 15.(Spring 1956): 82–97.

Finkelstein, Sidney. "National Art and Universal Art." *Mainstream* 1, no. 3 (Summer 1947): 345–61.

Focillon, Henry. *Témoignage pour la France.* New York: Brentanos, 1945.

Fonvieille-Alquier, François. *La grande peur de l'après guerre.* Paris: Laffont, 1973.

Forbes, John D. "The Art Museum and the American Art Scene." *Journal of Aesthetics and Art Criticism*, Winter 1941–42, pp. 3–11.

Fortune Magazine, ed. *The Changing American Market.* New York: Hanover House, 1955.

Frankfurter, Alfred M. "Freedom to Paint." *Art News* 50 (December 1951): 17.

Freeland, Richard M. *The Cold War and Domestic Communism.* Ph.D. diss., University of Pennsylvania, 1970.

———. *The Truman Doctrine and the Origins of McCarthyism.* New York: Schocken, 1971.

Frost, Rosamund. "Adolph Gottlieb." *Art News*, February 1944, p. 23.

———. "Has Advertising Art Improved?" *Art News*, September 1–30, 1944, pp. 9–13.

———. "First Fruits of Exile." *Art News*, March 15, 1942, p. 23.

———. "Has Advertising Art Improved?" *Art News*, September 1–30, 1944, pp. 9–13.

———. "This Business Ties Art into a Neat Package." *Art News*, May 15, 1945, p. 13.

Fry, Varian. *Surrender on Demand.* New York: Random House, 1945.

Fuller, Peter. *Beyond the Crisis in Art.* London: Writers and Readers, 1980.

Galantière, Lewis. *America and the Mind of Europe.* London: Hamish Hamilton: 1951.

Garaudy, Roger. *Le communisme et la renaissance de la culture française.* Paris: Editions Sociales, 1945.

Gardner, Lloyd C. *Architects of Illusion: Men and Ideas in American Foreign Policy, 1941–49.* Chicago: Quadrangle, 1970.

Gaudibert, Pierre. *Action culturelle: Intégration et/ou subversion.* Paris: Casterman, 1977.

Genauer, Emily. *Best of Art.* New York: Doubleday, 1948.

———. "The Fur-Lined Museum." *Harper's* 189 (July 1944): 129–38.

———. "Still Life with Red Herring." *Harper's* 199 (September 1949): 88–91.

Gilbert, James Burkhart. *Writers and Partisans: A History of Literary Radicalism in America.* New York: Wiley, 1968.

Gillam, Richard. *Power in Post War America*. Boston: Little, Brown, 1971.

Glicksberg, Charles I. "The Decline of Literary Marxism," *Antioch Review*, Winter 1941, pp. 452–62.

Goldman, Eric F. *The Crucial Decade, 1945–60*. 2d ed. New York: Vintage, 1960.

Goodman, Jack, ed. *While You Were Gone: A Report on Wartime Life in the U.S.* New York: Simon and Schuster, 1946.

Gottlieb, Adolph. "The Artist and the Public." *Art in America* 42, no. 4 (December 1954): 266–71.

Gottlieb, Harry. "Art Criticism, a Symposium." *Art News*, December 1945, p. 306.

Goulden, Joseph C. *The Best Years, 1945–50*. New York: Atheneum, 1976.

Graebner, Norman A. *Cold War Diplomacy, 1945–60*. Princeton: Anvil, 1962.

Grattan, C. Hartley. "What Business Thinks about Postwar America." *Harpers*, February 1944, pp. 199–209.

Greenberg, Clement. "L'art américain au XXe siècle." *Les Temps Modernes*, no. 11–12 (August–September 1946): 340–52.

———. "Art." *Nation*, December 6, 1947, pp. 629–30.

———. *Art and Culture*. Boston: Beacon Press, 1961.

———. "Avant-Garde and Kitsch." *Partisan Review* 6, no. 5 (1939): 34–49.

———. The Decline of Cubism." *Partisan Review* 15, no. 3 (March 1948): 366–69.

———. "The European View of American Art." *Nation*, November 25, 1950, pp. 190–92.

———. "Irrelevance versus Irresponsibility." *Partisan Review* 15, no. 5 (May 1948): 573–79.

———. "The Present Prospects of American Painting and Sculpture." *Horizon*, no. 93–94 (October 1947): 20–30.

———. "The Situation at the Moment." *Partisan Review* 15, no. 1 (January 1948): 81–84.

———. "Surrealist Painting." *Nation*, August 12, 1944, pp. 192–93; August 19, 1944, pp. 219–20.

Greenberg, Clement, and Macdonald, Dwight. "Ten Propositions on the War." *Partisan Review* 8, no. 4 (July–August 1941): 271–78.

Grosser, Alfred. *La IV République et sa politique extérieure*. Paris: Armand Colin, 1972.

Gruen, John. *The Party's Over Now*. New York: Viking, 1972.

Gruskin, Allan. *Painting in the U.S.A.* New York: Doubleday, 1946.

Guggenheim, Peggy. *Out of this Century: Confessions of an Art Addict*. New York: Universe Books, 1979.

Hagen, Oskar. *The Birth of the American Tradition in Art*. New York: Scribner, 1940.

Haigh, Anthony. *La diplomatie culturelle en Europe*. Strasbourg: Conseil de l'Europe, 1974.

Hamby, Alonzo L. *Beyond the New Deal: Harry S Truman and American Liberalism*. New York: Columbia University Press, 1973.

Harnoncourt, René d'. "Challenge and Promise: Modern Art and Modern Society." *Magazine of Art* 41 (November 1948): 250–52.

Harper, Alan. *The Politics of Loyalty: The White House and the Communist Issue, 1946–52*. Westport, Conn.: Greenwood, 1969.

Henderson, Harry, and Shaw, Sam. "Art for Profit's Sake." *Collier's* 114 (November 25, 1944): 22–30.

Heindel, Richard H., ed. *American Influences Abroad, an Exploration*. New York: Carnegie Endowment for International Peace, 1950.

Hellman, Lillian. *Scoundrel Time*. New York: Bantam, 1977.

Hess, Thomas B. "Is Abstraction Un-American?" *Art News* 49 (February 1951): 38–41.

Hicks, Granville. *Where We Came Out*. New York: Viking, 1954.

Hobbs, Robert Carleton, and Levine, Gail. *Abstract Expressionism: The Formative Years*. New York: Whitney Museum, 1978.

Hobson, G. *Some Thoughts on the Organization of Art after the War*. London, 1946.

Hoehling, Adolph A. *Home Front U.S.A.* New York: Thomas Lowell, 1966.

Honisch, Dieter, and Jensen, Christian. *Amerikanische Kunst, von 1945 bis Heute*. Koln: Dumont, 1976.

Hook, Sidney. "Academic Integrity and Academic Freedom." *Commentary* 8 (October 1949): 329–39.

———. "Communism and the Intellectuals." *American Mercury* 48 (February 1949): 133–44.

———. "The New Failure of Nerve." *Partisan Review* 10, no. 1 (January–February 1943): 2–23.

Horowitz, David, ed. *Corporations and the Cold War*. 2d ed. New York: Modern Reader, 1970.

———. *The Free World Colossus*. New York: Hill/Wang, 1965.

Howard, Milton. "Partisan Review: Esthetics of the Cage." *Mainstream* 1, no. 5 (Winter 1947): 46–57.

Howe, Irving, and Coser, Lewis. *The American Communist Party*. Boston: Beacon Press, 1957.

Huthmacher, J. Joseph, ed. *The Truman Years: The Reconstruction of Post-War America*. Hinsdale: Dryden Press, 1972.

Huyghe, René. "Letter from Paris: Conflicting Tendencies." *Magazine of Art*, November 1945, pp. 272–73.

Irons, Peter Hanlon. "America's Cold War Crusade: Domestic Politics and Foreign Policy, 1942–48." Ph.D. diss., Boston University, 1973.

Janis, Sidney. *Abstract and Surrealist Art in America*. New York: Reynal

and Hitchcock, 1944.

———. "L'art américain." *L'Age Nouveau*, no. 24 (December 1947): 20–29.

Jay, Martin. *The Dialectical Imagination*. Boston: Little, Brown, 1973.

Jerome, Victor Jeremy. *Grasp the Weapon of Culture*. New York: New Century, 1951.

Jewell, Edward Alden. "Art American?" *New York Times*, September 1, 1946, section 2, p. 8.

———. "Art in Advertising." *Art News*, May 1–14, 1942, pp. 30–31 and 41–42.

———. "Globalism Pops into View." *New York Times*, June 13, 1943, section 2, p. 9.

———. *Have We an American Art?* New York: Longman, 1939.

Jonas, Manfred. *Isolationism in America, 1935–41*. New York: Cornell University Press, 1966.

Jones, Alfred Waworth. "The Making of an Interventionist on the Air: Elmer Davis and CBS News, 1939–41." *Pacific Historical Review* 42 (1973): 74–93.

Kees, Weldon. "Robert Motherwell." *Magazine of Art* 41, no. 2 (February 1948): 87–88.

Kirkendall, Richard S. *The Truman Period as a Research Field*. Columbia: University of Missouri Press, 1974.

Kirstein, Lincoln. "The State of Modern Painting." *Harper's* 197 (October 1948): 46–53.

Klein, Lawrence R. "The Role of War in the Maintenance of American Economic Prosperity." *Proceedings of the American Philosophical Society* 45 (1971): 507–16.

Kolko, Gabriel. *The Roots of American Foreign Policy*. Boston: Beacon Press, 1969.

———. *Wealth and Power in America: An Analysis of Social Class and Income Distribution*. New York: Praeger, 1962.

Kolko, Gabriel, and Kolko, Joyce. *The Limits of Power*. New York: Harper and Row, 1972.

———. *The Politics of War, 1943–45*. New York: Random House, 1968.

Kootz, Samuel. *Modern American Painters*. New York: Brewer and Warren, 1930.

———. *New Frontiers in American Painting*. New York: Hastings House, 1943.

Kostelanetz, Richard. "Men of the Thirties." *Commonweal* 81 (December 3, 1965): 266–69.

Kozloff, Max. "American Painting during the Cold War." *Artforum* 13 (May 1973): 43–54.

———. "The Critical Reception of Abstract Expressionism." *Arts* 40, no. 2 (December 1965): 27–33.

Lacoste, René. "Idées et problèmes d'aujourd'hui: La critique dans son miroir." *Arts de France* 23–24 (1949): 108–16.

Larsen, Susan C. "The American Abstract Artists: A Documentary History, 1936–41." *Archives of American Art Journal* 14, no. 1 (1974): 2–7.

Lasch, Christopher. *The Agony of the American Left.* New York: Random House, 1968.

———. *The New Radicalism in America, 1889–1963.* New York: Vintage, 1965.

Lawson, Alan R. *The Failure of Independent Liberalism, 1930–41.* New York: Capricorn Books, 1971.

Levering, Ralph. *American Opinion and the Russian Alliance, 1939–45.* Chapel Hill: University of North Carolina Press, 1976.

Lewis, Wyndham. "The End of Abstract Art." *New Republic* 102, no. 2 (April 1, 1940): 438–39.

Lingeman, Richard. *Don't You Know There's a War On?* New York: Putnam, 1970.

Louchheim, Aline B. "ABC (or XYZ) of Abstract Art." *New York Times Magazine,* July 11, 1948, p. 16.

———. "Abstraction on the Assembly Line." *Art News,* December 1947, pp. 25–29.

———. "Betty Parsons, Her Gallery, Her Influence." *Vogue* 118, no. 6 (October 1, 1951): p. 140.

———. "A French Viewpoint—Visiting Writer [Duthuit] Sums Up the Post War Scene." *New York Times,* June 27, 1948, section 2, p. 6.

———. " 'Modern' or 'Contemporary' Words or Meanings?" *New York Times,* February 22, 1948, section 2, p. 8.

———. "Second Season of the Picture Boom." *Art News,* August 1945, p. 9.

———. "Who Buys What in the Picture Boom?" *Art News,* July 1, 1944, p. 12.

Luce, Henry R. "The American Century." *Life,* February 17, 1941, pp. 61–65.

Lukacs, John. *1945—Year Zero: The Shaping of the Modern Age.* New York: Doubleday, 1978.

Lynes, Russell. *Good Old Modern: An Intimate Portrait of the Museum of Modern Art.* New York: Atheneum, 1973.

———. "Suitable for Framing." *Harper's* 192 (February 1946): 162–69.

McCausland, Elizabeth. "Art in Wartime." *New Republic,* May 15, 1944, pp. 676–79.

———. "Why Can't Americans Afford Art?" *Magazine of Art,* January 1946, p. 18.

———. *Work for Artists: What? Where? How?* New York: American Artist Group, 1947.

Macdonald, Dwight. *Memoirs of a Revolutionist.* Cleveland: Meridian

Books, 1963.

———. "Profile of Alfred H. Barr, Jr." *New Yorker*, December 12, 1953, pp. 49–82.

MacLeish, Archibald. "The Irresponsibles." *Nation*, May 18, 1940, pp. 618–23.

McMurry, Lee. *The Cultural Approach: Another Way in International Relations*. Chapel Hill: University of North Carolina Press, 1947.

McWilliams, Carey. *Witch Hunt: The Revival of Heresy*. Boston: Little, Brown, 1950.

Maddox, Robert James. *The New Left and the Origins of Cold War*. Princeton: Princeton University Press, 1973.

Magnillat, André. *Est-ce la décadence de la France?* Paris: Pichou et Durand, 1947–48.

Maier, Charles S. *The Origins of the Cold War and Contemporary Europe*. New York: New Viewpoints, 1978.

Markowitz, Norman D. *The Rise and Fall of the People's Century*. New York: Free Press, 1973.

Marshall, George C. "Announcement of Secretary of State Marshall: No More Government Money for Modern Art." *New York Times*, May 6, 1947, p. 24.

Martin, James J. *American Liberalism and World Politics*. New York: Devin-Adair, 1964.

Matthiessen, Francis Otto. *The American Renaissance*. New York: Oxford University Press, 1941.

Mead, Margaret. *And Keep your Powder Dry*. New York: Morrow, 1942.

Mellquist, Jerome. *The Emergence of an American Art*. New York: Scribner, 1942.

———. "New Isolationists in Art." *Commonweal*, October 7, 1949, pp. 626–28.

———. "Wanted: Art Critics." *American Mercury*, December 1939, pp. 491–96.

Miller, Henry. *The Air-Conditioned Nightmare*. 2d ed. New York: New Directions, 1970.

Millet, Fred B. *The Rebirth of Liberal Education*. New York: Harco, 1945.

Monroe, Gerald M. "The American Artists' Congress and the Invasion of Finland." *Archives of American Art Journal* 15, no. 1 (1975): 14–20.

Morin, Edgar. *Auto critique*. Paris: Seuil, 1970.

Morris, George L. K. "On Critics and Greenberg: A Communication." *Partisan Review* 15, no. 6 (June 1948): 681–84.

Motherwell, Robert. "Painter's Object." *Partisan Review* 11, no. 1 (Winter 1944): 93–97.

Motherwell, Robert, and Reinhardt, Ad, eds. *Modern Artists in America*. New York: Wittenborn, 1952.

Nash, George H. *The Conservative Intellectual Movement in America since*

1945. New York: Basic Books, 1976.

Pach, Walter. "Art Must be Modern." *Atlantic Monthly* 185 (May 1950): 44-48.

Padover, Saul K. "The American Century?" *American Scholar* 17, no. 1 (Winter 1947-48): 85-90.

Pagano, Grace. "Contemporary American Painting." *Encyclopaedia Britannica*. New York, 1945.

Paris-New York. Paris: Centre Georges Pompidou, 1977.

Paterson, Thomas G., ed. *Cold War Critics: Alternatives to American Foreign Policy in the Truman Years*. Chicago: New Viewpoints, 1971.

Pearson, Norman H. "The Nazi-Soviet Pact and the End of a Dream." *America in Crisis*. New York: Knopf, 1952.

Pearson, Ralph M. *Experiencing American Pictures*. New York: Harpers, 1943.

———. *The Modern Renaissance in American Art*. New York: Harper and Row, 1954.

Peet, Creighton. "Russian 'Amerika,' a Magazine about the United States for Soviet Citizens." *College Art Journal* 11, no. 1 (Fall 1951): 17-21.

Perret, Geoffrey. *Days of Sadness, Years of Triumph: The American People, 1939-1945*. New York: Coward, MacCann, 1973.

Perroux, François. *Le plan Marshall ou l'Europe nécessaire au monde*. Paris: Librairie de Médicis, 1948.

Peters, H. F. "American Culture and the State Department." *American Scholar* 21, no. 2 (Spring 1952): 265-74.

Pleynet, Marcelin. *Art et littérature*. Paris: Seuil, 1977.

———. *Transculture*. Paris: Union Générale d'Éditions, 1979.

Poggioli, Renato. *The Theory of the Avant-Garde*. New York: Harper and Row, 1968.

Porter, Sargent. *The Continuing Battle for the Control of the Mind of Youth*. Boston: Sargent, 1945.

———. *Education in Wartime*. Boston: Sargent, 1942.

Polenberg, Richard. *War and Society*. Philadelphia: Lippincott, 1972.

Rattner, Abraham. "An American from Paris." *Magazine of Art*, December 1945, pp. 311-16.

Read, Herbert. *Culture and Education in World Order*. New York: MOMA, 1948.

Rezler, André. *L'intellectuel contre l'Europe*. Paris: P.U.F., 1976.

Rogin, Michael Paul. *The Intellectuals and McCarthy: The Radical Specter*. Cambridge: MIT Press, 1967.

Rosenberg, Harold. "Notes on Fascism and Bohemia." *Partisan Review* 11, no. 2 (Spring 1944): 177-82.

———. "On the Fall of Paris." *Partisan Review* 7, no. 6 (December 1940): 440-48.

Rourke, Constance Mayfield. "Have We an American Art." *Nation*,

November 11, 1939, pp. 527–29.

Rowell, Margit. *La peinture, le geste, l'action.* Paris: Klincksieck, 1972.

Sandler, Irving. *The Triumph of American Painting.* New York: Praeger, 1970.

Sartre, Jean-Paul. *Question de méthode.* Paris: Gallimard, 1960.

Schapiro, Meyer. "The Nature of Abstract Art." *Marxist Quarterly* 1 (January–March 1937): 78–97.

———. "The Social Bases of Art." In *First American Artists' Congress,* pp. 31–37. New York, 1936.

Schapsmeirer, Frederick. *Prophet in Politics: Henry A. Wallace and the War Years.* Ames, Iowa: Iowa State University Press, 1970.

Schlesinger, Arthur, Jr. *The Vital Center: The Politics of Freedom.* Boston: Riverside Press, 1962.

Schwarz, Arturo. *Breton/Trotsky.* Paris: Union Générale d'Éditions, 1977.

Scott, James D. "Advertising When Buying Is Restricted." *Harvard Business Review,* November 1976, pp. 443–54.

———. "Advertising When Consumers Cannot Buy." *Harvard Business Review,* October 1976, pp. 207–29.

Seeley, Carol. "On the Nature of Abstract Painting in America." *Magazine of Art* 43 (May 1950): 163–68.

Seitz, William C. "Abstract Expressionist Painting in America." Ph.D. diss., Princeton University, 1955.

Selz, Peter. "Younger French Painters of Today." *College Art Journal* 11, no. 1 (Fall 1951): 10–17.

Seuphor, Michel. "Paris–New York." *Art d'aujourd'hui,* no. 6 (June 1951): 4–13.

Shannon, David A. *The Decline of American Communism.* New York: Harcourt Brace, 1959.

Shapiro, David. *Social Realism, Art as a Weapon.* New York: Frederick Ungar, 1973.

Shapiro, David, and Shapiro, Cecile. "Abstract Expressionism: The Politics of Apolitical Painting." *Prospect* 3 (1976): 175–214.

Siracusa, Joseph. *New Left Diplomatic Histories and Historians: The American Revisionists.* New York: Kennikat Press, 1973.

Soby, James Thrall. *Artists in Exile.* New York: Pierre Matisse Gallery, 1942.

———. "Collecting Today's Pictures." *Saturday Review,* May 25, 1946, pp. 42–44.

———. "Does Our Art Impress Europe?" *Saturday Review,* August 6, 1949, pp. 142–49.

———. "The Younger American Artists." *Harper's Bazaar,* September 1947, p. 194.

Solberg, Carl. *Riding High: America in the Cold War.* New York: Mason and Lipscomb, 1973.

Sorenson, Thomas C. *The World War: The Story of American Propaganda.* New York: Harper and Row, 1968.

Spaeth, Eloise. "America's Cultural Responsibilities Abroad." *College Art Journal* 11, no. 2 (Winter 1951–52): 115–20.

Spanier, John. *American Foreign Policy since World War II.* New York: Praeger, 1964.

Spender, Stephen. "We Can Win the Battle for the Mind of Europe." *New York Times Magazine,* April 25, 1948, p. 15.

"The State of American Art: Symposium." *Magazine of Art,* March 1949, pp. 86–101.

Starobin, Joseph R. *American Communism in Crisis, 1943–1957.* Berkeley: University of California Press, 1972.

Stanford University School of Education. *Education in Wartime and After.* New York: Appleton, 1943.

Steele, Richard W. "Preparing the Public for War: Efforts to Establish a National Propaganda Agency, 1940–41." *American Historical Review* 75 (1970): 1640–53.

Steigman, Benjamin M. "Big Business and the Arts." *American Mercury* 65 (1947): 473–81.

Steinke, John, and Weinstein, James. "McCarthy and the Liberals." *Studies on the Left* 2, no. 3 (1962): 43–50.

Stone, I. F. *The Truman Era.* New York: Isidor, 1973.

Stowe, Leland. *Target: You.* New York: Knopf, 1949.

Summers, Robert E., ed. *America's Weapons of Psychological Warfare.* New York: Wilson, 1951.

Sutton, Denys. *American Painting.* London: Avalon Press, 1948.

———. "The Challenge of American Art." *Horizon* 118 (October 1949): 268–84.

Sweeney, James Johnson. *Plastic Redirections in Twentieth Century Painting.* Chicago: University of Chicago Press, 1934.

Sweezy, Paul. *The American Ruling Class: The Present as History.* New York: Monthly Review Press, 1953.

Tagg, John. "American Power and American Painting: The Development of Vanguard Painting in the U.S. Since 1945." *Praxis* 1, no. 2 (1976): 59–79.

Talmadege, Irving D. *Whose Revolution? A Study of the Future Course of Liberalism in the United States.* New York: Howell, Soskin, 1941.

Taylor, Francis H. "Modern Art and the Dignity of Man." *Atlantic Monthly* 182 (December 30, 1948): 30–36.

Theoaris, Athan. *Anatomy of Anti-Communism.* New York: Hill and Wang, 1969.

———. *Seeds of Repression: Harry S Truman and the Origins of McCarthyism.* Chicago: Quadrangle, 1971.

———. *The Specter.* New York: New Viewpoints, 1973.

Thirion, André. *Révolutionnaires sans révolution*. Paris: Laffont, 1972.

Thomas, Norman. "Totalitarian Liberals." *Commonweal* 37 (January 22, 1943): 342–44.

Trilling, Lionel. *The Liberal Imagination*. New York: Scribner, 1976.

Trotsky, Leon. "Art and Politics." *Partisan Review*, August–September, 1938, pp. 3–60.

Université de Saint-Etienne. *Art et idéologie: l'art en occident, 1945–49*. St. Etienne: Centre Interdisciplinaire d'Études et de Recherches sur l'Expression Contemporaine, 1978.

Vincent, Gérard. *Les Français, 1945–1975: Chroniques et structures d'une société*. Paris: Masson, 1977.

Wald, Alan M. *James T. Farrell: The Revolutionary Socialist Years*. New York: Gotham, 1978.

Warren, Frank A. III. *Liberals and Communism: The "Red Decade" Revisited*. Bloomington: Indiana University Press, 1966.

Watson, Forbes. *American Painting Today*. Washington, D.C.: American Federation of Arts, 1939.

Wells, Manning Lloyd. "The Defense of 'Big Business,' 1933–53: A Study in the Development of an Ideology." Ph.D. diss., Princeton University, 1955.

Weinberg, Sydney. "What to Tell America: The Writer's Quarrel in the Office of War Information." *Journal of American History* 55 (1968): 73–89.

Whitridge, Eugenia Lea. "Trends in the Selling of Art." *College Art Journal* 3, no. 2 (January 1944): 58–63.

Williams, William Appleman. *The Tragedy of American Diplomacy*. New York: Dell, 1959.

Yarnell, Allen. "The Democratic Party's Response to the Progressive Party in 1948." *Research Studies* 39 (March 1971): 20–32.

———. *The 1948 Presidential Election as a Test of Post War Liberalism*. Los Angeles: University of California Press, 1974.

———. *The Post War Epoch*. New York: Harper and Row, 1972.

Zimmer, Christian. *Procès du spectacle*. Paris: P.U.F., 1977.

Index

Aaron, Daniel, 18–19
Abstract art (abstraction): and art boom, 95–98; and atomic age, 96–97, 108, 113, 196–97; French critics on, 128–31; Motherwell on, 83; Newman on "purist," 113–14, 120; Schapiro on social conditions of, 24–26; vogue for, 116
Abstraction-Creation group, 114–15
Academicism: Greenberg on, 35, 117–18; Trotsky on, 30
Acheson, Dean, 139–40
"Advancing American Art" (show), 118, 150
Advertising: art used in, 89–90; of avant-garde art, 89–90; by Kootz Gallery, 123
"Age of Revolution, The" (show), 13
Alexandrianism, 34, 35
Alienation: avant-garde based on, 155–60, 165; Greenberg on, 162; Harnoncourt on, 189; Partisan Review on, 28–29; Popular Front ends, 19; Schlesinger on, 201–2
Aliénation dans le roman américain contemporain, L,' (Dommergues), 158, 159
Alsop, Joe, 162
American Abstract Artists, 29–30, 36–37, 59, 76
"American Art a Year after Pearl Harbor" (Brown), 88
American Artists' Congress, 19–21, 26, 37, 39–40, 45, 72
American Art since 1900 (Rose), 6
"American Century, The" (Luce), 60–61, 101

American Committee for the Defense of Leon Trotsky, 27
American Communist party, 22, 23, 40, 46, 52, 140, 184, 189–90; attacks on, 105, 106; and nationalism, 20–21; and Popular Front, 18, 19
"American Culture: Studies in Definition and Prophecy, The" (symposium), 63
American Federation of Arts, 188–89
American Federation of Teachers (AFT), 147
American Indian art, at Parsons Gallery, 119–21
American Institute, 150
American Modern Artists show, 69–70
American Painting Today (Watson), 42, 44
"(American) Peoples' Century, The" (Macdonald), 61
Americans for Democratic Action (ADA), 106, 141, 144, 190, 191
American Writers' Congress, 19, 23, 38
Amour de l'Art, L,' 126
Anarchism, 110, 199–200
Anticommunism: in America, 105–6, 143–44, 146–47, 167–68, 195–96; and avant-garde art, 187, 188, 198–205; of Greenberg, 172–73, 188; of Partisan Review, 38–39, 109; and "vital center," 190–92
Anxiety and avant-garde art, 191–92, 196–97
Aragon, Louis, 22, 129–30
Aramov on realism and abstract art, 129
Armed Services Committee, 168
Armory Show, 124, 207n. 2, 218n. 24

Spender, Stephen, on American cultural influence in Europe, 173–74
Stalin, Josef, 28, 50, 106; pact with Hitler by, 21, 27, 29, 38, 39, 109
Stalinism, 21, 23, 30, 37, 39–40
Stamos, Theodoros, 121
Steichen, Edward J., 88
Stevens, Wallace, 83
Stieglitz, Alfred, 207n. 2
Still, Clyfford, 110, 142, 201, 225n. 130
Streit, Clarence, 60
Studio 35, 176
Subversives list, 146, 156
Surrealism: and American avant-garde, 73–75, 110–13, 116, 197; attacked, 81–82, 111–12, 114; and Museum of Modern Art, 84; and Pollock, 86–87, 96–97
"Surrealist Painting" (Greenberg), 82
Surrealist Revolution in France, The (Gershman), 33
Surrealists and Popular Front, 22
Sweeney, James Johnson, 165; on Pollock, 83, 84, 85–86, 87
Syrian Bull (Rothko), 73, 74

Tamayo, Rufino, 162
Taubes, Frederic, on independence of American art, 124
Taylor, Glen (Senator), 141, 201
Tchelitchew, Pavel, 112
Temps Modernes, Les, 124
Thompson, Dorothy, 60
Thorez, Maurice, 234n. 125
"Three Centuries of American Art" (show), 42–44
Tiger's Eye, 155, 166
Time magazine, 56, 60
Times Herald, 168
Tobey, Mark, 69
"Towards a Free Revolutionary Art" (article in Partisan Review), 32
Trachtenberg, Alexander, 211nn. 9, 25
"Trials of the Mind" (Rahv), 28
Trilling, Lionel, 165
Triumph of American Painting (Sandler), 6, 7–8, 210n.7
Trotsky, Leon, 36, 37; on "Art and Politics," 29, 30–32, 35; manifesto with Breton and Rivera by, 32, 34, 40–41; trial of, 27–28
Trotskyism: and American Artists' Congress, 39–41; and avant-garde art, 33, 34–35, 68, 69–70, 77, 209n. 20; and Mos-

cow Trials, 27–28, 29; and Popular Front, 21, 22, 24
Truman, Harry S., 105, 106, 205; and isolationism, 50–51; and liberals, 102, 104, 165, 190; on modern art and politics, 4; policies of, 102–3, 138–45, 167–68, 190–91, 192
Truman Doctrine, 138–42, 143–44, 147, 192
Turkey and Truman Doctrine, 139–40, 143–44

U.S. Foreign Policy: Shield of the Republic (Lippman), 62
Unconscious: and Pollock, 86; and surrealism, 73, 81
Union Nationale des Intellectuels, 125–26
Union Now (Streit), 60
United American Artists, 46
United Nations, 61–62, 103, 104–5
United States Information Service (USIS), 4, 150
"Universal" art: Jewell on, 44, 119; and postwar American avant-garde, 174, 177–78
University of Chicago, Art and Our Warring World symposium at, 57
Utrillo, Maurice, 132

Vaillant-Couturier, Paul, 26
Vandenberg, Arthur H., 103
Venice biennial exposition, 180, 204
Villeboeuf, André, on American painting, 43
Vital Center, The (Schlesinger), 3, 184, 189–92, 200, 201–3
Vivin, Louis, 132
Vlaminck, Maurice de, 132
Vogue, 204
Volks Bulletin, 172

Wallace, Henry, 62, 147; candidacy of, 105, 106, 165, 168, 184, 189–90; on fight against fascism, 50; and internationalism, 61; and radicals, 104, 143–44; and Truman policies, 141, 145
Ward, Lynn, 20–21, 40
Washington Post, 168
Washington Times Herald, 167
Watson, Forbes, on French reaction to American art, 42, 44
Weber, Max, 20, 27
"We Can Win the Battle for the Mind of Europe" (Spender), 173–74